The Art Crowd

P. 121 Discussion: Role of Critics

THE ART CROWD

Sophy Burnham

AN AUTHORS GUILD BACKINPRINT.COM EDITION

The Art Crowd

All Rights Reserved © 1973, 2000 by Sophy Burnham

AN AUTHORS GUILD BACKINPRINT.COM EDITION

Published by iUniverse.com, Inc.

For information address:
iUniverse.com, Inc.
620 North 48th Street, Suite 201
Lincoln, NE 68504-3467
www.iuniverse.com

Originally published by David McKay Inc.

ISBN: 0-595-00804-6

Printed in the United States of America

*To my parents
and my husband, David.*

Contents

Introduction

early 1970s

Introductions are intended to be read last—or perhaps not at all. Certainly, I expect any red-blooded reader to plunge into the heat and dust of the book; if, floundering, he backs out to glance at the directions and charts of the Introduction . . . well, little help he'll find from this one.

Now, you may ask why I don't tell about art in the rest of the country—why the book is limited primarily to New York. It is simple. First, New York is the nerve center for contemporary art. The buying and selling takes place in New York. The dealers are largely here. The auctions are here. The art magazines are published here. Museums and collectors may be dotted

around the fifty states, but every curator plans a trip to New York once or twice a year to see what is new. Collectors fly to New York to buy. Likewise, the artists follow the market. They gravitate to New York and its dealers the way screenwriters once gravitated to Hollywood. Nothing so illustrates this centripetal pull as the difficulty encountered by the magazine *Artforum* when it established headquarters on the West Coast. It simply could not operate, and therefore moved itself to New York.

Secondly, New York is a microcosm, with all events exaggerated by the concentration of space and time, which makes them easy to observe. Everything happens first in New York, and whatever happens here will happen, you may be sure, in the rest of the country. To a lesser degree, perhaps, and a little later in time, but eventually it will come.

As for why the center of art should be found in New York, I have my own explanation, based on no scientific research. I have observed that when a man's life is pleasant, active, psychologically satisfying, and surrounded by the beauties of nature, art has little importance for him. San Franciscans, for example, living in one of the most beautiful cities in the country, find little need for art. Nature repels art. Art is an urban pastime. It follows then that the uglier the city in our country, the more difficult to live in, the more artificial its pleasures and the more bruising to the senses, the greater need its people will have for their own artifacts and art.

New York obviously takes top honors in brutality, followed by Los Angeles, Chicago, Dallas, and all the secondary art centers of our United States, and if the theory falls to pieces upon inserting Paris or Rome in the equation, this is because Europeans have a different approach to art, and a different history. So it is, I believe, that New York is the center for contemporary art, and therefore that I concentrate on the New York scene.

The facts recounted in this book will certainly offend as many people as they entertain, and are sure to be charged with every degree of falsity and fabrication. Indeed, during the

course of research and before a word was in print, I was threatened with so many libel suits that I began to believe the old adage that the greater the truth, the greater the libel.

The fascination of the art world is that it is the real world in microcosm. The same principles adhere, the same passions and sins. There is good as well as bad, and I have met some delightful people, some scum, and one or two who could be termed noble. The art world is just like the rest of the world except that it is more openly homosexual at times, and more pretentious at others. Pomposity is a business necessity. Theodore Rousseau of the Metropolitan Museum of Art observed that any business that is engaged in selling pleasure, whether in the form of women or art, is subject to charges of pimping. Andre Emmerich used the same analogy of art and women. Art is like a beautiful woman, he said. You take her out. She captivates you. After you talk a while, you discover that she is really dumb. Another woman grows on you; the more you see of her, the more you like her. But who is to say she is better or worse than the first? The same decision must be made with a painting.

The reaction of the art crowd to an interview is also worth observing. Some are candidly open, enjoying the opportunity to talk. Others are catty, bitchy, sidling up to the chance to spew out their venom. Much of what the latter say is untrue or distorted and must be treated, like acid, with great respect, each tiny comment triple-checked. In the end the information often must be discarded as untrustworthy. Still other people are guarded, wary, grilling the reporter before an interview is reluctantly granted: What is the name of the book? What is its intent? Why? Who is the writer? Who is the publisher? One dealer insisted on knowing in advance every question I would ask before he consented to consult his colleagues on the possibility of an interview:

"What have other dealers done? Did they see you?"

"If this is about New York, why ask about London?"

"You are marvelously discreet," I murmured to one, in admiration of his limitless ability to listen without even correcting a tantalizing mistake casually tossed in.

"What do you mean?" he tensed. "I haven't said anything yet."

"That's what I mean," said I, and watched his shoulders relax. He rose, polite. "I will see if we'll grant you an interview. We like the art to speak for itself, you know. The rest is not important." And, explaining further, with cautious reserve: "We have been burned. We have had reporters before. We answer questions in the friendliest way, then see it in print. It is all lies. Half truths. We are understandably uneasy."

And well he might be, when we consider the peculiar, shameful treason of a writer. A stinking life, dipping his fingers into the sticky muck of other men's lives, snooping, smiling, charming, consoling, teasing, laughing, questioning, coy, sly, sweet, with open friendliness, until the subject's ego opens to reveal the secret caves of character. And all the while the reporter really *likes* the fellow, but phrases flicker through the back of his mind, like brilliant-plumaged parrots flitting through the jungle roof high overhead while the shadows play on the forest floor. Is he any better than a dealer charming the willing collector into a sale?

Poor victim. Caught like a bug on a pin until the interview is over and he is free to fly away. And all that is captured on paper is that one frozen moment of an hour's interview, as if a man's soul were a steady beam of unflickering light. At least the art world hangs together—it has its loyal code. Silence. Secrecy. The reporter blabs it all. Let the reader judge which is the worse example of human behavior.

A few people were so helpful on this book they deserve mention. Elizabeth Sand, Sarah Vass, and Mark Gorbulew, who did research; my friends Joan and Gene Vass (Sarah's parents, who have seen the art world from the artist's point of view), and

another friend and artist, Idelle Weber, whose curiosity comforted me that the subject would be of interest to someone. And finally to Eleanor Rawson, my editor, whose enthusiasm and good sense soothed my troubled nerves and brought the book to completion.

—SOPHY BURNHAM
Brooklyn, New York

October 1972

All art is a revolt against man's fate.

—ANDRÉ MALRAUX
VOICES OF SILENCE

"Tele-Sculpture"

Friday, January 3, 1969. An icy wind whipped the cold stones of New York. The smell of snow chilled the air, and in the marble garden of the Museum of Modern Art, where Picasso's gravid goat and the thrusting bronze breasts of "Standing Woman" jutted cold against the bare, birch trees, a sooty patch of snow lay ghastly white among the shriveled ivy. Here Takis took his stand. "I take a stand," the artist said; and if he'd dared, if it was not humiliating really, he might have shaken his fist at the building that surrounded him, the Museum of Modern Art, MOMA, the Great Mother, Manna, Mammon.

He was one man against the museum. Who could know

that his pitiful defiance would catalyze the art world and result in marches and meetings, chanting, cheering, in parades and pamphleteering, in yowling and howling as if everyone had gone mad?

In fact, some people thought the art world really had gone mad. It was running amok, like lemmings, those Arctic rodents that every few years, suddenly, inexplicably, start running, swarming, racing across the countryside. The lemmings run through houses. They fall into wells and streams. If they reach the ocean, they dive into the waves, dying by thousands in their forward push. At this point the art world was like that, set on self-destruct. No one knew how it would end, or even where it was going. The excitement was terrific.

It began that cold, Friday afternoon with the artist, Takis Vassilakis, removing his sculpture from the Museum of Modern Art. Takis is known in the art world for his kinetic, or moving, sculptures. One was to be included in the MOMA exhibit "The Machine as Seen at the End of the Mechanical Age." At first the museum had intended to transport a modish, new Takis work from his Paris studio for the show. Later, due to budgetary considerations, it thriftily substituted an earlier piece, "Tele-Sculpture (1960)," which had the advantage of reclining already in MOMA's warehouse storage.

The artist was furious. He wanted to be represented by his later, larger, more important work. "Tele-Sculpture" was made of cork and wood with magnets. It no longer represented him, he felt, "at the End of the Mechanical Age." He demanded its removal from the exhibition; better not to be in the show at all than to be represented by an obsolete work. The museum smiled at his arrogant demand and proceeded as planned to put "Tele-Sculpture" in the show.

It was more than the selection of an art work that enraged Takis. It was a larger question: What is the position of the artist in the art world? Is he a thing, a commodity to be shuffled

about, bought and sold, and tossed aside? Is his work, his opinion, of no value at all?

Takis was not the only artist offended by the art interests. And so on January 3, when Takis made his stand in the garden of MOMA, five friends were there to help him carry "Tele-Sculpture" physically out of the museum. There was Willoughby Sharp, the critic who is reported to have taken off his clothes at a panel discussion at New York University; Farmon, the poet; Wen-ying Tsai, a successful artist who likewise felt abused by the museum; an unknown, beautiful, red-haired woman who telephoned a warning to the museum from a phone booth.

"Hey," called the guard, at the well-rehearsed rape of the sculpture from the crowded gallery. The artists stood in the chilly garden beside the machine explaining to the press (fortuitously notified beforehand) why a work of art was being removed from MOMA.

Indoors, the museum was in a twit. Nothing like this had ever happened before. Liz Shaw, director of the Department of Public Information, burst into the museum director's office, her straw-colored hair flying round her head. "We should see them. They demand we meet with them in the garden."

Bates Lowry had been director for only six months, but despite his inexperience he had a clear idea of how a director should act. "I have no intention of 'meeting demands' in our garden." He was convinced it was a publicity gimmick to attract attention and money to Takis—a not unnaturally cynical view, given the peculiarities of the art market. "If they have a legitimate grievance, they can meet me in my office and we will work it out in a decent, civilized fashion. I will be glad to see them, or their representatives, tell them, in my office."

He returned to the papers on his desk. But the rest of the museum was agog. It was just the sort of thing to delight the museum: Takis sitting in the darkening garden guarding his "Tele-Sculpture."

It was getting cold. Pretty soon, the artist and his friends prowled up to Lowry's fifth-floor office, where they talked for a passionate hour without the press. Lowry agreed to return "Tele-Sculpture" to storage, and another meeting was arranged to discuss the tortured relationship of artists to museums.

The artists drew up four demands. Later these were raised to ten, and then to thirteen, and again to fourteen, but by then Takis's group had grown to nearly fifty artists. They were organizing! Lowry had consulted with some of the museum's trustees, and negotiations were proceeding in mutual annoyance and misunderstanding and an almost inconceivable incomprehension of each other's social forms, as if the art museum and artists derived from different cultures, so that each side was continually offending the other or taking offense and escalating the cause.

How uncertain were the artists, torn by contradictory images and myths. The position of the artist in the art world is ambivalent. In one sense he is totally unimportant. His work is what interests the world: dealers, critics, museums, and collectors. The artist stands like a rock in a stream. He creates his art and sends it forth, to be swept off by the currents of buying and selling that swirl about him. He is in the art world, but not a part of it, and he is torn between wanting its respect and deriding its commerce.

The artist participates in the art world primarily in the myth, and it is impossible to understand the art world, or what Takis and the other artists were protesting, without understanding the pathos and paradox of the myths.

The first myth is that there are only a very few real artists in a society at any one time. Actually, there are thousands upon thousands of artists, of whom only a few hundreds are recognized, and only a fraction of these are known beyond the perimeters of the art crowd. Thousands upon thousands are struggling to live in New York, Chicago, Los Angeles, Alaska. In New

York City alone at the end of the 1960s there were untold hundreds of unknown artists. Most artists cannot support themselves as artists. They teach to support their art, or they live as taxi drivers or house painters, or odd-jobbers, or else they have an independent income or a working wife in order to afford the luxury of creating art. Does this make them less of an artist? The question contributed to the uneasiness of many artists— that plus the realization that other artists were making hundreds of thousands of dollars a year, were millionaires, and that never before had contemporary art been so publicized, or consumed with such gluttonous lust.

Who is an artist? Is he the man whom everyone acclaims as an artist and whose work sells in four digits? That is how most people define an artist, though we know that Jackson Pollock and Mark Rothko and Morris Louis were not critically acclaimed until the end of their lives, that Van Gogh never sold a painting in his lifetime for more than 400 Belgian francs, that Modigliani died a pauper, and Cézanne was not exhibited at the Salon de Paris until the age of forty-three. Were they not artists even when unknown? And what of someone like Andrew Wyeth or Norman Rockwell, adored by the public and ignored by many critics of contemporary art? Are they considered artists?

There is a sculptor, Tom Doyle, who lives on the Lower East Side. He has no dealer. He receives little critical attention, and though his work has been exhibited in museums, it is not widely known. He does not care, he says. He has no time to worry about acclaim. His work pours out of him, huge abstract shapes like plowshares, in wood, metal, plastic, and he defines success in terms of each artistic endeavor while the unsold objects pile up from floor to ceiling in a dark corner of his studio. Is he an artist?

And what of the man of fifty, who has tried for thirty years for recognition and remains unknown, while younger men rocket to instant renown? Is he so bad? Are they so very good? Or the man hailed as a genius in his twenties, but who in his

forties cannot sell a single work? Did he simply stop being good? Or is there some fault implicit in the system of art? The artists were tormented at being rated on a materialistic scale.

Another myth defines an artist by how he lives. The real artist, it is said, leads a life of unkempt debauchery. This is not true. Usually he lives, our composite artist, in a sparsely furnished apartment. His one luxury is space, and after space comes light. As soon as he gets money, he decorates, with meticulous attention to color and the visual harmony of furnishings and space. He may have only one sofa, two chairs, and some plants, but they create a harmonious whole, an effect of dappled light and space, of cleanly order.

Order and cleanliness. The artist's working space occupies one part of his apartment. It is spotlessly clean. At the end of the day, when he washes up, there is no smell of paint, no dirty cans and brushes left about, and so common is this orderliness that when *Life* magazine recently printed a picture of the artist Larry Poons in his studio, surrounded by dripping paint cans and colors splattered in a frenzy of mystical creation, some fellow artists reacted with contempt. "He must have been putting it on," they said angrily. "Look at that mess. No one can work in a place like that."

The myth persists, however, of the artist possessed by mad spirits of creativity, though he actually is as controlled, as disciplined in his craft, as a mathematician. The necessity of living up to the artistic image is a strain. At moments of despair he knows the image does not correspond to the reality of his life, and he cannot help but question his credentials as an artist. Particularly when he lacks the reassurance of fame and fortune. Is he an artist, do you think?

Most people have an idea of the artist as an abandoned, vital spirit, unencumbered by normal inhibitions, a joyous companion, gay, and entertaining. This, too, is myth. Most artists are unbelievably dull. This is because artists are often inarticulate. The artist is a visual person. He expresses himself best vis-

ually, in paint, or metal, or whatever is his chosen medium, and when faced with the necessity of proving himself at a seated dinner for twelve, he is often helpless, knowing that he was invited to demonstrate the artistic sensitivity of the host, the collector.

There is a fourth myth—that the artist is poor—and a fifth—that he prefers poverty. The first, at least, is often true. Yes, some artists live in many-mansioned splendor in East Hampton or commute from Paris, ride in limousines, and, like Picasso, have a wife to guard against uninvited guests and a secretary to snatch each moist masterpiece from the master's hand in order to catalogue and store it up for future profit. Yes, some hire numerous assistants and sell each painting for $10,000 and more, but they are a decimal-point minority, and most artists lead decent, quiet, boring little lives, just like the rest of humanity.

They are happily married or not so happily. They are anxious about their kids and the school bills and paying the rent and what to buy their mothers for Christmas. Their wild romantic affairs may be with obscure working women like department-store clerks, and when you hear an artist worrying about his grown daughter who is living unwed with a long-haired youth, or about the critical reviews of his last exhibit—why, it sounds most *petit bourgeois*.

Still, the myths circulate, though the art world knows that for the most part they are untrue. They circulate first because it is good business. Far better to perpetuate the image of the artist as a higher being wrapt in the mysteries of the muses than to admit that he is merely dull; and if the wealthy collector finds him inarticulate, or lacking in subtlety, or selfish, or a sot, let the fault be ascribed to the collector, whose business has corrupted his spiritual sensitivity. A second reason for the persistence of the myths is that it is uncharitable to say that your friends are boring. The third reason (and, who knows, perhaps the most important) is we like the myths. We cling to our

dreams of a carefree artist, excused from social responsibility. They fulfill perhaps some forgotten need of our own fettered lives—as they do apparently for the artists as well, for there is a germ of truth to all the myths. It is possible to find examples that feed the dream, and to a certain degree it suits some artists to live up to the image. How else to prove that, though impoverished and undiscovered, they too are real artists?

So the artist finds himself acting (as did Larry Poons, as does Dali) according to our image of an artist. Is that hypocritical? It is only human. He appears, for example, at a museum opening or gallery party (for it is politic to circulate in the art crowd). He mingles with the black-tie patrons of the arts, with museum curators and critics and dealers, and acts his iconoclastic part, rebelliously dressed in blue jeans and a turtle-neck sweater. But his jeans are not always ordinary jeans. They are perhaps clean, $200 jeans, especially faded to the proper pallid tone and decorated to taste with spangles, bells, bars, or leather patches, the ensemble covered perhaps by a $300 ankle-length, suede military coat.

Poor artist. He, too, is trapped by the myths, and acts his part to the best of his ability and with varying degrees of success, and all the while hating what he is doing: the dancing with a prospective patron, the posing, while at the back of his mind lurks this terrible doubt about the place of art in our society. Why do people court the artist and applaud him, invite him to parties and compliment him and curry his favor—but never trust his judgment, never ask him to advise a museum, or run for city office, or sit on the board of directors of the Chase Manhattan Bank? What is he, some freak?

The artists, many of them, were unsure about their relations to dealers, to critics, to museums, to all the congeries of people that compose, if there is such a thing, the art crowd. They were torn by the schizophrenic desire of wanting art-world recognition and despising its mercantilism. They responded by talking largely of esthetics. There is nothing new to their anguish. A

Chinese epigram by Hung Tzu-ch'eng of the Ming Dynasty illustrates the timelessness of their lament:

> Mountains and forests are scenes of wonder. Once they are frequented by people they are debased into marketplaces. Calligraphy and paintings are things of beauty. Once they are craved by people, they are degraded into merchandise.

Art had become a commodity. Collectors bought art as a profitable speculation. Museums bought what their trustees (these same collectors) demanded they immortalize. Critics pushed art in which they had financial interests. Moreover, the artist had no part in these exchanges. Once his work passed out of his hands (and lucky he felt at the time to receive a few hundred bucks), he received no further royalties. He watched the prices rise, the dealers and collectors get fat, and if a work being praised was not his own—well, he watched that too, anxiously questioning the very standards by which art is judged.

There was a time when art was easy to define. It was craftsmanship, painful of drops of paint and sweat contrived by aching hand and labored art to seem easy. Not so in the 1960s. Art was whatever would sell. The Matisse signature was more important than the drawing it accompanied. Art was what was collected in a museum. In reaction the artists began to create art that could not be bought and sold. Look at the art of the Sixties, run rampant, spinning crazily off with peals of laughter. Art was made of dirt and grease, even of steam: sixteen eight-inch jets of steam coming out of the ground were exhibited at the Corcoran Gallery in Washington, D.C., and became—by virtue of their exhibition in an art museum—a work of art. Robert Indiana printed LOVE, and it was art. There was Environmental Art, Destructive Art, Reductive Art, Minimal Art, Conceptual Art. The successful artists frequently conceived an idea and farmed out to laborers the boring execution of its multiple copies. Art was no longer—if it ever had been—the unique creation of a single mind or hand.

Frank Stella painted stripes. Larry Bell built a clear glass box. The Dwan Gallery gave an exhibit of "Earthworks," to which Claes Oldenburg contributed a Plexiglas cube filled with night crawlers and humus; Robert Smithson entered five woodbins of ore (containing 140 minerals), and Robert Morris strewed 1,200 pounds of dirt and peat moss and jellied industrial grease over the gallery floor, while the sages of the art world nodded and mumbled about the profundity of art. The exhibit also contained a photo of some holes that Michael Heizer dug in Nevada, and another of a field outside New Haven that Dennis Oppenheim sprinkled with aluminum chips. Somewhere out West an artist was digging (it was said) a mile-long trench in a straight line, for which a collector would pay. Perhaps the pinnacle of "conceptual art" was reached in an exhibit at the Radich Gallery, when Toshio Odate gave a sculpture show composed of the labels that described what the artist would have done had he decided to execute the ideas.

What a joke! Had not Clement Greenberg, the distinguished critic, written a few years earlier that "relevant works" of art today are conceived beforehand and executed impersonally, for manual skill, "once the vessel of inspiration," is too easily copied now, he had said, and "no longer therefore original enough to denote in itself good art." Hereafter, he had proclaimed, the ideas would overshadow execution. Toshio Odate had merely carried Greenberg's words to their logical conclusion. But his was also the artist's savage gesture at the cupidity of his public.

Some people were annoyed. Were artists never satisfied? they asked. If no public exists for art, as was the case twenty-five years ago, the artists complain of their uncivilized reception. When the public grasps enthusiastic at their artistic output, acclaiming each new entry as "revolutionary" and "a breakthrough," the artists turn on their audience—which, yes, it is true, would drop each worn-out "breakthrough" in headlong scramble after the next revolutionary fashion—and try to cre-

ate art that cannot be bought. Minimal, Reductive, Conceptual Art. How was the public to react?

The joke soured. Even the uncollectible was collected, and a rope tossed in a living-room corner, or two Brillo boxes stacked up, or a plastic bag hanging in the library filled with trash and garbage, was oohed, ahed, admired with lip-smacking anticipation of the avant-garde.

So quickly collected, so highly acclaimed was the uncollectible that sometimes the artists forgot that its creation had been originally a joke. One day a sculptor, Mel Bochner, walked into the Bykert Gallery on East Eighty-first Street, dragging his level, dejected, despairing. He was greeted by the gallery director, Klaus Kertess.

"What's wrong? You look so sad."

"I've just destroyed a work of art," said the artist, leaning heartsick against the wall. "I spent three days creating it, and I just destroyed it."

It seems he had been asked to enter the Whitney Annual. He was a "minimal artist," and he had drawn one line at the base of a wall. That was his art. (*Ergo*, the level in his hand.) Then the museum had put a Bob Lobe sculpture in front of his line, and he objected. He took it to the highest museum official he could find. "What are you trying to do?" he protested. "Don't you understand? You ask me to exhibit, and then you put another piece right in front of my sculpture! How can anyone see it?"

He turned to us, appealing. "Claes Oldenburg agreed with me. He said how sorry he was. He agreed that sculpture shouldn't be there, blocking my work, but what could he do? So I threatened to remove my work from the show, and they said they couldn't do any better than what they had done. So I did. I took it off the wall. I just destroyed a work of art."

We clucked our tongues. It is bitter to see a man so brave, so sad.

"Oh well," Klaus comforted him. "The Whitney Annuals.

You know they really don't count any more. Besides, you've
been in the Annual before. What difference does it make?"

He brightened. "Yes, that's true. No one cares about the
Whitney Annual anymore."

The story might be funny, if it were not sad. But if Ken
Noland can sell six stripes on unsized canvas for $10,000, why is
a stripe on a wall not equally significant? Why is Bochner not as
good an artist as Noland? And treated with equal respect? Be-
cause Noland's stripe can be bought and sold for cash? If art can
be a urinal,* a bicycle wheel,† a coat on a canvas,‡ a machine
that blows up,§ a Happening,‖ a Be-in, a Love-in, a Sit-in, an En-
vironment¶—if art is anything, then anything is art. A pro-
test demonstration is a work of art, a social change, a revolu-
tion!

* Marcel Duchamp, "Fountain," 1917.
† Marcel Duchamp, 1st Version, 1913.
‡ Jim Dine, "Green Suit," oil and cloth, 1959.
§ Jean Tinguely, "Homage to New York," March 17, 1960, MOMA Sculpture
Garden.
‖ Allen Kaprow, April 15, 1958, the first official happening, sponsored by Doug-
lass College, New Brunswick.
¶ Museum of Contemporary Crafts, 1968.

Revolution!

How hard it is to remember how we felt in 1969. We were burning, blinded with rage, with the accumulated horror of the decade, of three political assassinations, and the Vietnam War, and the riots at the Democratic Convention the year before. There were riots everywhere it seemed: Nanterre, Paris, Tokyo, Detroit, Watts, Washington, D.C., New York, and in the universities at Columbia, Berkeley, Harvard. Then there were the problems peculiar to New York. Lines, dirt, war, poverty, rent strikes, taxi strikes, subway strikes. The threat of strike is as bad as the accomplishment—worse in the anxiety of its anticipation. There was at once the lack of good housing, of space, and

13

for most, of money. In contrast there was the opulent display of 1969 pre-recession wealth by others: the chauffeured limousines double-parked at Bonwit's, the men in sables, and sleek-legged women mincing down Madison Avenue leashed to Lhasa Apsos, the advertising, the rugs and china, the antique chairs, the magnificent paintings and dainty toys, the silverware, scarves, books, and baubles of New York's Fifty-seventh Street. The stores bulged with possessions. The irony was so few could afford them.

Was there anyone unaffected by the times? A terror was in the air. Some, like myself, cowered in intellectual corners, heart squeezed by anguished impotence; but others—brave bands—laughing, battered at the palace doors to demand an accounting. Among them were the members of the Art Workers' Coalition.

The Coalition grew out of Takis's defiance that January day. Within a month, AWC numbered fifty angry artists and within a year they were a hundred or two hundred strong. The group of friends suddenly erupted into a society, one of the few known in New York in which artists met to discuss not art and esthetics, but the system of art. They talked about the gallery system, the museums' ignorance of art, about how critics use the artists and collectors acquire them, and the artists are the pawns of the economic system of art.

The art workers were not themselves necessarily interested in money. They had ideals toward society that translated into a concept that all of living should be art. They believed, with Lenin, that ethics are the esthetics of the future.

There is nothing new about artists hating the system, but heretofore it had exploded largely in individual expression. Mark Rothko, for example, when commissioned to paint a series of canvasses for the walls of the most exclusive rooms of an expensive restaurant in the Seagram Building, set out maliciously to "ruin the appetite of every son of a bitch who ever eats in that room." (The paintings were never hung in the Seagram res-

taurant. Not long before his death, Rothko arranged for them to be hung in a special nondenominational chapel in Houston commissioned especially for these holy works.) As early as 1919, a Cubist exhibit in Paris proclaimed its purpose to be the elimination of "parasitic wealth."

Opposition to the system, then, was not new. What was new was organizing to destroy it. Artists had gathered in groups before. In the 1930s they formed the American Artists' Congress, and joined the League Against War and Fascism. In the 1940s they formed the American Abstract Artists' Association and later The Club and the Tenth Street Cooperative galleries. These last were largely social gatherings to discuss artistic values in perfect faith at finding them. The purpose of AWC was to change the system of art.

Despite the messy, structureless "participatory democracy" (which was the *modus operandi* of all revolutionary organizations at that time), three members were prominent. They formed a triumvirate: Alex Gross, Barry Schwartz, and Lauren Reichen.

None of them was an artist. Barry, the son of a Brooklyn furrier, was an art critic; Alex was an unpublished playwright and reporter for a radical Greenwich Village newspaper; Lauren was a sociology professor.

Under the three proconsuls was a potpourri of personalities. Farmon, the Persian poet with the rough, scraggly black beard. His goals seemed satisfied by taking the floor at AWC meetings—physically placing himself, that is to say, in the center of the group. There was something thrilling, he found, about rising slowly to his feet when recognized by the Chair (most people remained seated to speak) and from his height surveying the fifty-odd upturned faces of his friends. "I just want to say something," he would begin, in ponderous Slobbovian accents, moving at the same time to the magical emptiness of the circle's center, where, once centered, encircled by the others, he would stand on one hip and perorate with elaborate bows, shrugs,

thrusts of his black beard and gesticulating arms, expounding at hopelessly inarticulate length. The others were patient with him. He had been with Takis on Founders' Afternoon, and he maintained a position in AWC somewhat similar to that of a pet mastiff, approached with amused respect.

Nearby would be Benno, his Santa beard pouring down his chest, his cane between his knees. Benjamin Benno was sixty-nine years old. Acclaimed as a genius at seventeen, he had exhibited in 1935 with Picasso, Kandinski, and Léger. His work was in the Gertrude Stein collection. He had known Edna St. Vincent Millay, drunk with Henry Miller, and lived in France, England, and the United States. Now he lived in two rooms at the back of a slum tenement, quarreling with the landlord over heat and the leaking roof, and living in terror of rain or snow, lest water pour through the clear plastic sheeting that billowed and balooned across his cavitatious ceilings to protect his forgotten art.

There was Tom Lloyd, a black artist who worked with electric lights and who figures prominently later in our story, Poppy Johnson and Kestutis Zapkus, Jean Toche, Jon Hendricks, Frazer Dougherty. Why go on? Few know the names. Their work is not collected by the art crowd, or celebrated in the press. There was also Lucy Lippard, a critic who belonged to the art establishment by virtue of writing for it and who was therefore much respected by AWC, whose avowed purpose was to destroy the establishment.

The Establishment. Many people in the art crowd claimed the members of AWC were not artists at all, and they pointed out that few of them had ever exhibited anywhere and that the ranks of the organization were swollen with critics and writers and motion-picture cameramen—anyone, in fact, who could be enticed to join or cared to call himself an artist.

They noted with derision that the big names were absent from the Art Workers' Coalition: Warhol, Wessleman, Jasper Johns, Rauschenberg, Oldenburg, Noland, Olitski, de Kooning,

Gottlieb, or any of the hundreds of stars and superstars whom one thinks of when he thinks of an artist.

True artists, they said, are too busy creating to care about radical revolutionary politics, or changing society. True artists (they would add, with the tiniest smug smile) are consumed by demonic pursuit of their art. They are madmen, almost, so pure, so afflicted that they cannot keep from painting. If he wanted social change, the artist would be a politician, not an artist.

The Coalition, on the other hand, argued that anyone—everyone—is an artist today. Art is not limited to paint, they said. Any act is art, including social protest. Rarely was this brought home so passionately as by the thin, slight young man at one AWC meeting. His eyes burned with enthusiasm.

"What kind of artist are you?" he was asked.

"I'm a destructive artist," he answered fiercely.

"Oh." And then, "What do you destroy? I mean, do you make sculpture like Tinguely's self-destructing machines?"

"Listen," he said, and his eyes flashed with pure artistic pleasure, "I do not believe that you have to use painting and sculpture to be an artist. That is stupid. I work with society. Look, when Hutchinson went down to Tobago last year, what did he do? He calls himself an artist. He got a lot of gourds and he floated them on Tobago Bay and he poured oil on them and then he set fire to the oil and photographed it. And he calls himself a destructivist artist!" He drew himself up scornfully. "*I* was in the hills with the Indians, who have been oppressed and impoverished for two hundred years, first under French and now English colonialism. I work on society. That is destructivist art."

(Actually, the artist was confused. Peter Hutchinson had created underwater works, using rocks, calibashes, plants, and fruits placed in bags and dropped on fifty-foot ropes to the ocean floor. It was Dennis Oppenheim who spread inflammable red dye on the waters of the bay and then set fire to it, thus creating the artwork "Route 20," in honor of the American highway.)

If only AWC had been better organized! The meetings started as a forum to gather information, and they developed into a comforting repetition of abuses and gossip, as pleasant and about as fruitful as scratching a scab. A meeting was held every Monday night in a communal loft called "Museum." It would begin with a drifting-in of artists, who would walk shyly around the exhibit or gather in twos or threes until the room was filled with fifty or a hundred long-haired men and women, all dressed in tough, no-nonsense jeans and shirts. A scraping of chairs, the voices rising in a deafening din, until someone would sing out:

"Come on, let's get this f——— show on the road."

"Let's go. We'll be here all night."

A chairman would be picked as casually as you pick a stone:

"Who's chairman?"

"Lauren, you be chairman," and Lauren (or Lucy, or Poppy, or Alex, or Tom, for in participatory democracy, the choice makes little difference) would be chairman for that evening. The artists would settle down, talking noisily during the reports of the various committees: on women in the arts, on galleries, dealers, business in the arts, decentralization.

The Coalition was so much a collection of forces that no one could agree on what it was they were trying to do. Everyone was in it for his own reasons. Tom Lloyd, the only black, was trying to gain recognition for black artists; Juliette Gordon for women artists. Lauren Reichen wanted redistribution of power. Ed Lynch wanted "decentralization" of museums. Kes Zapkus wanted to change the way artists sell their work, to take the profits out of art. Alex Gross wanted to change not how art was sold, but how it was produced. He talked of forming workshops, a "Community of Artists," though later his ambitions enlarged and he decided to form a trade union of artists instead. And Farmon, Jon Hendricks, and Jean Toche wanted Revolution.

No one had any positive alternative to the present sys-

tem. It was enough to destroy it. Many artists saw nothing lack-
ing in this negative approach. Kes's goal, for example, stopped
at taking the profit out of art, and though he had no idea either
how to achieve this or what to substitute for profit, he was con-
vinced that the profit motive was unprofitable. Kes was a
painter himself. He had exhibited in the Whitney Annual. He
had experienced a smattering of success. He saw three kinds of
profit in art: financial profit (for the dealer), social profit (for the
collector), and historical profit (for the artist). His democratic
aim was to eliminate elitism and the stars of the art world, those
artists who command prices in the tens of thousands of dollars.

His idea was based, you see, on the idea that every work
of contemporary art is equally good, equally valid, each giving
an equal degree of pleasure. In which case his own art would be
as good as Michelangelo's.

No wonder it was hard to organize the artists. One eve-
ning the Coalition was invited to present its views over WBAI
radio. The program opened with a scream: *"Awk! Awk!"* cawed
a voice. "This is the Art Workers' Coalition," and a babble of
voices broke in and continued for forty-five minutes of incoher-
ent hubbub with an occasional decipherable phrase—"If you
would be quiet," or "I once heard"—lifted like a swimmer by the
crest of a wave, before being boiled in the crashing surf and
drowned. A listener could have gained no information from the
program, though he would have learned something about the
Coalition. The Art Workers, on the other hand, were sure they
had got their message across.

The first year of effort was spent trying to define their
identity. The negotiations with MOMA were so quixotic that I
shall not bother to describe the miasma of demands and counter-
demands, the press releases and ultimata. The dissension among
the art workers themselves was so open that they soon discov-
ered they were united only in action. They could rally together
in picketing and demonstrations, and while they tried to drama-
tize "the increasing grip and manipulation by big business on

our cultural institution" and demonstrate that the "sani-pak cultural pastiche" that is passed off as art benefits only the "money-power collectors and dealers," and while they tried to show that the artist is helplessly manipulated by the Establishment, they became more and more involved, almost against their wills as it were, with protesting the Vietnam war. The war symbolized all the wrongs of society, the greed and cynicism of dealers, museums, and collectors.

The artists wanted to change the system of art, to redefine art, to make artists respected. They wanted to make the art world see that the people who ran the galleries and museums were the same people who governed the country and were responsible for the Vietnam war. No one would listen. Once four artists burst bags of blood in the lobby of the Museum of Modern Art. They demonstrated against the Metropolitan Museum of Art, the Jewish Museum, and the Whitney. And if their demands seemed anti-art, this was due, they felt, to the perversions of the present system of art.

Once they demanded that MOMA sell one million dollars' worth of art from its collection and donate the money to the poor "of all races in this country." They demanded that MOMA open its board of trustees to "the people," so that "anyone, regardless of condition or race, can become involved in the actual . . . control of the museum." They demanded that MOMA be closed until the end of the Vietnam war.

They circulated a petition requesting Pablo Picasso to remove his painting "Guernica" from the walls of MOMA in protest against the war. How strange: They were asking that an artist remove a painting, itself an anti-war statement, from public exhibition, as an anti-war statement. Did that make any sense at all?

Another time they demanded the resignation of all the Rockefellers from the MOMA board. Their manifesto was drawn out of these men, these artists as a long belly-howl of pain. Who can imagine the discipline required to perform even

the minimal research involved in this call for resignation? Who can imagine the pain, the bruised sensitivity, that could express itself only as a blood bath? They were not in jest, these artists, but heartsick and sickened at their own incapacity to make anyone understand what they were saying. Why did people laugh?

A CALL FOR THE IMMEDIATE RESIGNATION OF ALL THE ROCKEFELLERS FROM THE BOARD OF TRUSTEES OF THE MUSEUM OF MODERN ART

There is a group of extremely wealthy people who are using art . . . as a cover for their brutal involvement in all spheres of the war machine.

These people seek to appease their guilt with gifts of blood money and donations of works of art to the Museum of Modern Art. We as artists feel that there is no moral justification whatsoever for the Museum of Modern Art to exist at all if it must rely solely on the continued acceptance of dirty money. By accepting soiled donations from these wealthy people, the museum is destroying the integrity of art.

These people have been in actual control of the museum's policies since its founding. With this power they have been able to manipulate artists' ideas; sterilize art of any form of social protest and indictment of the oppressive forces in society; and therefore render art totally irrelevant to the existing social crisis.

1. According to Ferdinand Lundberg in his book, *The Rich and the Super-Rich*, the Rockefellers own 65% of the Standard Oil Corporations. In 1966, according to Seymour M. Hersh in his book, *Chemical and Biological Warfare*, the Standard Oil Corporation of California—which is a special interest of David Rockefeller (Chairman of the Board of Trustees of the Museum of Modern Art)—leased one of its plants to United Technology Center (UTC) for the specific purpose of manufacturing *napalm*.

2. According to Lundberg, the Rockefeller brothers own

20% of the McDonnell Aircraft Corporation (manufacturers of the Phantom and Banshee jet fighters which were used in the Korean War). According to Hersh, the McDonnell Corporation has been deeply involved in *chemical and biological-warfare* research.

3. According to George Thayer in his book, *The War Business*, the Chase Manhattan Bank (of which David Rockefeller is Chairman of the Board)—as well as the McDonnell Aircraft Corporation and North American Airlines (another Rockefeller interest)—are represented on the committee of the Defense Industry Advisory Council (DIAC) which serves as a liaison group between the *domestic arms manufacturers* and the International Logistics Negotiations (INL), which reports directly to the International Security Affairs Division in the *Pentagon*.

Therefore we demand the immediate resignation of all the Rockefellers from the Board of Trustees of the Museum of Modern Art.

Supported by: New York, November 10, 1969
The Action Committee GUERRILLA ART ACTION GROUP
for Art Workers' Jon Hendricks
Coalition Jean Toche
 Poppy Johnson Silvianna

Poor artists. Poor Coalition, helplessly, futilely nattering. Do you understand the senselessness of their situation? In a way the artists were in their predicament because they believed in all the art-world myths that artists are higher, more sensitive beings, that given a chance they can right the wrongs of the world. They were organized against the art interests that define artists and art, but they had no money, no time, and no experience to prove collusion, conspiracy, and market manipulation. The art world for the most part ignored them. It had other things to do.

Dealers of Art

The business of art did not affect the Coalition. It hardly touched them at all—which added to their anger and jealousy and hurt. Most of the art workers had no dealers and therefore no direct experience with the art business.

The dealers affect more established artists. These artists, too, are often unaware of what happens once they hand a work of art to their dealers. For weeks they hear nothing. They receive financial statements, or sometimes a check or a phone call. But often, if effort is not made on their part, they know little of the dealer's transactions.

Leave the artists for a moment. We will return. Let us

look at the art market and the behavior of dealers and critics, the buying and selling of art.

Art dealers have a bad reputation. It is hard to find another business, except maybe horse trading, with a poorer reputation. Dealers are viewed by the general public with suspicion, for almost everyone has heard of someone who has been insulted, swindled, or tricked by a dealer, but their reputation among artists makes the rest look sweet.

A discussion of dealers, however, is inseparable from the marketplace, the economics of art, and first there are some things to learn.

Attention, then. A few preliminaries . . .

The first thing to recognize is that there are many art markets. There is a market for horse paintings, another for primitives, for Oriental art, for watercolors, for Academic portraits. The market the Art Workers were concerned about is "High Art," the museum/collector market. It is not easy to define High Art. It encompasses numerous countries and long periods of time. The significant factor seems to spring not from the art, but from the attitude of the art crowd toward the artists. The artists share the attitude. They all believe that what they are doing is really going to make a difference to the history of vision. They see the artist as hero, rather than craftsman. His prices reflect his responsibility.

The next thing to recognize is the smallness of the art world. It is so small that the same names recur repeatedly. Everyone knows each other: dealers, critics, collectors, curators. They pass back and forth from one occupation to another, and this, too, has its affect on what happens and why things turn out as they do. It accounts for the persistent rumors of manipulation in the art world, of a Mafia of art, and conspiracy and collusion of the Establishment.

I cannot overemphasize the importance of this Lilliput. It is one of the art-world jokes: "There are two-hundred-fifty col-

lectors of avant-garde artists in the country—and we know them all," boasts Ivan Karp, the exuberant, bouncy, sandy-haired dealer who has done as much as any dealer for the marketing of Pop Art.

"California is a big scene," he quips. "Five years ago there were eight collectors. Now there are nine."

The whole art market may comprise, according to one curator and ex-dealer, 2,500 people. It is 75 percent Jewish. ("Eighty percent!" cries Karp with characteristic enthusiasm.)

Art Gallery Magazine lists 800 to 1000 galleries in New York City. Hardly more than a dozen deal in High Contemporary Art. The only way to learn their names is to know someone in the art world who will take you around. It is hard to compile a list for publication, first, because galleries, like schools and styles, go in and out of fashion, and second, because it is almost impossible to know where to draw the line. Do we count galleries that handle Cubist or Surrealist art as Contemporary? Do we include Saidenberg, which represents Picasso, but neglect Pierre Matisse Gallery, which handles Miró? And what of the dozens of small galleries whose taste may not coincide with yours? Are they to be included as dealers of High Art? Safer, say the dealers, to provide no lists and tell the collector instead to call a local museum curator to ask for the galleries that represent the art he wants. Pusillanimous advice! The museums are as reluctant as dealers to provide selective names to strangers, on the theory that omission stains a gallery's reputation.

There are three kinds of art galleries. The public dealers hang public exhibitions, changed every three to four weeks. The private dealers work out of their $15,000-a-year private apartments by appointment only, and usually hang no changing public shows. I shall not talk much of them. They are subordinates in the sales of art.

The vanity galleries hang shows of any amateur artist, including student and housewife, willing to pay the costs. The exhibition will not be reviewed in the art journals, despite the

claims of the vanity gallery, and no one except friends of the artist will attend. The chances of a sale are so low that most artists agree that exhibiting at a vanity gallery is useless. Vanity galleries have no place in High Art.

Here is a list prepared by one avant-garde gallery of the "most important" galleries of contemporary art in New York as the 1970s began. It coincides almost exactly with the favorite galleries of one museum curator who swings twice a month around the circuit, adding a few other galleries because they are along the way or have a show of a particular artist he wants to see, skipping others on the list when he has no interest in their shows. They are:

BYKERT GALLERY, 24 East Eighty-first Street. Deals with some of the best younger contemporary painters and sculptors, such as:

> *Ralph Humphrey* ($2,000–$4,000*). Paints vibrant lines on changing fields of color (very good).

> *Alan Sarat* ($600–$3,500). One of the best sculptors of a group mislabeled as "antiform." Deals with pliant materials such as rubber and chicken wire in organic configurations.

> *David Novros* ($1,800–$3,000). Makes paintings of modular L-shapes in iridescent colors.

> *Brice Marden* ($600–$2,200). Richly painted monochromatic paintings made with oil and wax. Difficult but good.

> *Chuck Close* ($2,000). Large portrait heads at once totally photographic and "painterly."

> *Lynda Benglis* ($200–$1,500). Colored free-form paintings made of rubber poured on the floor.

CASTELLI GALLERY, 4 East Seventy-seventh Street. The most established gallery dealing with contemporary art from Pop Art to a few younger artists, including:

> *Jasper Johns* ($10,000–$60,000).

* The artists' prices represent the period 1969–70.

Andy Warhol ($5,000–$15,000).

Roy Lichtenstein ($8,000–$25,000).

Robert Rauschenberg ($10,000–$75,000). One of the best-known of the Pop artists. A good painting of Johns's is difficult to obtain but worth the trouble. Only Rauschenberg's earlier work can be recommended.

Frank Stella ($10,000–$40,000). Certainly one of the most important and innovative abstract painters of the Fifties and Sixties. The best paintings are those done between 1959 and 1964.

Ron Davis ($3,000–$5,000). One of the more interesting younger painters. Makes "shaped" paintings, loosely painted on the back of clear Fiberglas in strong colors.

Don Judd ($3,000–$8,000). *Robert Morris* ($3,000–$10,000). Two of the best contemporary sculptors.

Richard Serra ($1,000–$3,000). *Keith Sonnier* ($1,000–$3,000). Two of the best of the younger sculptors who have come into prominence in the last two years.

DWAN GALLERY, 29 West Fifty-seventh Street. Deals mainly with "Minimal" sculptors and "Earthworks," including:

Carl André ($3,000–$8,000). One of the finest (and most difficult) sculptors in America, currently working on a variety of metals, making low-lying grid patterns that hug the floor.

Sol LeWitt ($3,000–$7,000). Interesting sculptor currently working with pencil drawings directly on the wall.

Dan Flavin (c. $5,000). The best artist dealing with electric light. An important influence on many of his contemporaries.

ROBERT ELKON GALLERY, 1063 Madison Avenue. Deals in small but fine twentieth-century masters and contemporary artists. Among them:

Agnes Martin ($8,000). Paints subtle lyric paintings with transparent washes of white and penciled lines.

John McCracken (*c.* $1,500–$3,000) makes highly polished planar slabs and boxes.

ANDRÉ EMMERICH GALLERY, 41 East Fifty-seventh Street. Deals mainly in color field and stain painters whose mature work started in the mid-Fifties, such as:

Morris Louis ($15,000–$38,000). One of the most important American painters, whose misty "Veil" paintings and brightly colored poured-stripe paintings have influenced many younger painters.

Helen Frankenthaler ($5,000–$15,000). Considered the first "stain" painter. A very fine painter whose work bridged the gap between Jackson Pollock and more contemporary artists.

Jules Olitski ($5,000–$15,000). Overrated but good painter who sprays misty fields of color over wide areas of color.

Kenneth Noland ($5,000–$55,000). Perhaps the most important of the "Color Field" painters, making long, narrow canvases divided into long, narrow stripes.

FISCHBACH GALLERY, 29 West Fifty-seventh Street. Deals with a wide variety of relatively younger artists, plus:

Tony Smith ($10,000–$20,000). Considered one of the more important older sculptors.

Robert Mangold ($500–$2,000). Makes interesting shaped earth-colored monochrome paintings.

SIDNEY JANIS GALLERY, 6 West Fifty-seventh Street. Has an excellent selection of twentieth-century French and American masters, as well as some good contemporary artists:

George Segal (*c.* $10,000). Makes eerie white plaster-cast figures in everyday situations.

Ellsworth Kelly ($5,000–$10,000). Makes multisectioned paintings in primary colors and very subtle sculpture made of thin colored planes of metal.

Claes Oldenburg ($8,000–$15,000). Mocks contemporary culture with large-scale objects like fans, sinks, etc., made of soft materials like stuffed vinyl. An excellent and important sculptor.

KNOEDLER, 21 East Seventieth Street. Deals mainly with masters and rather boring contemporary Europeans, but does handle two of the most important "Abstract Expressionist" artists:

Barnett Newman ($15,000–$70,000).

Willem de Kooning ($20,000–$70,000).

MARLBOROUGH GALLERY, 41 East Fifty-seventh Street. Has a very large and impressive inventory of nineteenth- and twentieth-century masters, a banal selection of contemporary European artists, and represents the estates of a major group of "Abstract Expressionists," as well as Clyfford Still who is still alive:

Jackson Pollock ($30,000–$100,000).

Clyfford Still ($35,000–$75,000).

Mark Rothko ($30,000–$60,000).

Also the estate of *David Smith* ($20,000–$75,000), who is, to date, probably the most important sculptor.

PACE GALLERY, 32 East Fifty-seventh Street. The sleekest gallery in town, but it does represent a number of interesting artists from the West Coast:

Robert Irwin (c. $5,000). Makes very delicately colored discs that float on the wall.

Larry Bell (c. $5,000). Makes iridescent mirrored-glass boxes.

James Thurrell (c. $3,000). An interesting young artist who deals with three-dimensional images of light projected on the wall.

LAWRENCE RUBIN GALLERY, 49 West Fifty-seventh Street. Shares such artists as Olitski, Noland, and Stella with the Castelli and Emmerich galleries.

To the general public, the art world is a frightening confusion of names. The galleries vary from the sleek chrome and white of Richard Feigen gallery to the mouse-brown velvet of Knoedler's (which is pronounced "Nerd-lers"). They are all uncomfortable. Many galleries go out of their way to be rude. Indeed, one rule of the art world might be that the more "important" the gallery, the more haughty it will be. Accessibility and consideration for the feelings of others are left to Bloomingdale's department store or Sears, Roebuck, or to the schlock art galleries that dot our cities and cater to the one-time sale. The gallery of High Art is so discriminating, so refined, deals in such a precious artistic sensibility and at such prices, that it affects an ambience commensurate with its wares. It sells usually to people whom it knows, cultivates, currys. To the novitiate it is humiliating.

Often the gallery is inaccessible from the street. Our novitiate (and every artist was once himself an innocent) must climb a flight of stairs or rise by elevator to the gallery, sometimes high in an office building. He may have to ring a doorbell to be admitted—thus proclaiming the seriousness of his business interest, and then sustain the glare of the receptionist sitting at a desk reading *Art News*. She glances up with cold contempt. She does not need to be kind. She knows the man off the street will never buy. Her gray eyes follow him as he tries uncomfortably to look at the paintings. He leaps to the privacy of a second room, away from her cruel disdain—only to realize that he is probably being observed over closed-circuit TV. He hardly dares read the labels (the thought persisting that if he belonged, he would know the artist's style without peeking at the name; he wonders if the receptionist looks at labels), and, with palms clammy, he flees to the comfortable anonymity of the sidewalk.

With practice, he will become experienced. The experienced gallery-goer does not care if he is snubbed. He knows—as our novitiate does not—that the girl behind the desk is an art major fresh from Michigan State, who got a job through her fa-

ther's connections with a glamorous New York dealer, that it took her about six minutes on her first day's work to realize that there is nothing to do, and that she must sit all day at her desk, occasionally performing a minor secretarial duty, or chatting with a friend who drops in. She has read *Art News* until it is memorized, and she knows she must not speak to the real clients, the collectors, who are the province of the Master himself. The experienced gallery-goer snubs the girl as effectively as she snubs the others, breezing in and out in a matter of minutes, it seems, one cursory glance determining his interest, a long look at one or two objects satisfying it.

For the man off the street, a visit to the art gallery has always the suggestion of an ordeal. The rules of courtesy do not obtain in the close-knit world of art, except toward others of the art world and most particularly to the collector, who is known as a "client," and for whom the dealer becomes suddenly exquisitely cordial, striding out from the back room, all smiles and handshakes and, depending on the relative status of the two— the monied collector and the picture dealer—a delicate hand on the collector's shoulder, guiding him to an inner room to sit and talk, with just a gesture, perhaps, an aside on the way, about a new acquisition. "I'm glad you could drop in. Did you hear how . . ."

The art world thrives on money.

In 1961 there were around 450 dealers of all sorts in New York City. By 1970 there were about 1,000. Never in the history of the United States has there been such a demand for pictures. The schlock art stores were doing good business, buying for a dollar and selling for fifty or a hundred. The department stores opened art galleries. Sakowitz, a Houston specialty store, offered a "Masterpiece of the Month" Club in its 1969 Christmas catalogue. For one million dollars, the store promised to deliver a painting by a twentieth-century master each month for a year. Artists included Picasso, Chagall, and

Matisse. This comes out to roughly $83,333 a painting on the average, plus commissions to the store. The *Wall Street Journal* estimated that the potential United States market for the fine arts could climb to $5 billion a year.

Art was the visible consumption of wealth. Art was a strong enough business to support peripheral ones. The framers were making money, each with his own spiel: "Art is limitation. The essence of every picture is the frame." Art books thrived. Harry Abrams, publisher of beautiful art books, could afford "one of the most extensive assemblages of contemporary art in the world," and so prolific was the output of art books that George Wittenborn, crammed in his unpretentious bookstore-cum-mail-order-service, advised his customers to buy rare art volumes only, as these would increase in value. People became accustomed to the idea of profit in art.

Inevitably, people talked in terms of investment. As early as 1955 *Fortune* magazine brought out a two-part series on "The Great International Art Market," describing the price pattern on paintings in the language of stocks and bonds. Others have followed the lead. Sears, Roebuck's art buyer, Jeffrey Loria, wrote a book implying that one should buy art from Sears for fiscal appreciation, and, grossly exaggerating the ease with which the occasional fake or fraud can be detected by the flick of an inexperienced eye, suggested that one need have little fear for his life's savings invested in art.

Richard Rush, a Washingtonian, specialized in a series of books on various markets for investment: *Antiques as an Investment*, for example, and *The Techniques of Becoming Wealthy*. His first, brought out in 1961, was *Art as an Investment*, pocked with graphs and charts and descriptions of low downside risks in the Old Masters Market. This was the climate of art in the 1960s. People couldn't buy art fast enough. Art was a hedge against inflation. Art was big business. The Chase Manhattan Bank bought contemporary original art to hang in its offices, pleased by the lack of depreciation. By 1970, investment companies were

speculating in art by buying a great painting, placing it temporarily in a renowned museum (thus raising the value of the work), and selling it while it was hot. Some of the finest scholars of the art world were advising the art-investment companies. But the investment companies were new only in being formal organizations. The profitable practice of art buying had been going on for quite some time in the United States of America and, according to some people, since the end of World War II.

In the United States, the art collector gets a lot for his money. He gets esthetic pleasure in the form of art. He gets a hedge against inflation. He gets (if he handles things right) a tax break—the same tax benefit he could get from any other investment. A collector who gives a painting to the proper non-profit charitable institution (a museum, for example) may deduct up to 30 percent of his adjusted gross income for the gift. If he has an income of $100,000 and gives a $30,000 painting to a museum, he can deduct the entire value of the painting from his taxes. This is especially attractive if the $30,000 painting was bought for $10,000.

For many years the collector could bequeath the painting to a museum, deduct the value of the painting from his taxes, and keep the picture on his walls during his lifetime. There is no longer a charitable deduction allowed for such a gift, though a good collector and a happy museum may still combine, I have heard, to approximate the situation. For example, the collector may give away an undivided 10-percent interest in the picture over a period of ten years. If he gives the museum a $100,000 painting (bought for $10,000), he can deduct $10,000 a year from his taxes for ten years, and it is probable that he may keep the picture in his own possession for at least a part of that time.

It is wise for us poor schnooks to remember that High Art is usually bought in the tens of thousands, and also that, according to Gerald Reitlinger's *The Economics of Taste: the Rise and Fall of Picture Prices, 1760–1960*, which is a classic of its kind, caution should prevail. The giant price rises so well publicized

are sometimes illusory. "For a painting to have retained its standing over the past 200 years, it will have multiplied its first price a hundred times over and more." It is not that the price of art has always appreciated, but that the purchasing power of money has, with inflation, declined.

In the eighteenth century one thousand pounds was a lot of money for a work of art, not because people did not apreciate art, but because capital was tied up in land. Only kings and caliphs could afford the astronomical sums which are paid today by merchant princes, because only kings and caliphs had liquid assets. In 1754, when the King of Saxony gave eight thousand five hundred pounds for Raphael's "Sistine Madonna," it was the highest price that had ever been paid for a painting, and a piddling price it seems today, compared to the $5 or $6 million plus that the National Gallery of Art paid for da Vinci's "Ginevra de' Benci" in 1967. But inflation has had almost as much to do with the booming art prices as the rarity of the pictures; in terms of real purchasing power the two paintings may not be that far removed.

Art remains an investment in the sense that if one buys, oh, with exquisite wisdom, he may come out even—or maybe not lose much when it comes to sell. Mr. Reitlinger's depressing book is recommended also for its cautionary charts, which show the great numbers of paintings that were bought at the peak of their popularity by our ancestral speculators and never reached such figures again.

This is not to say that some people in the art world do not make their 6 percent per annum and more, but things are not always easy for them either. Some mordant cynics say that the dealers are the only ones who make money in the art world, but they miss the point so frequently made by dealers—that art is a pleasure not undertaken for profit.

The Marketplace

It is a remarkable characteristic of the art world that, for all their rudeness, so many people are charming. I cannot think of any other occupation where charm is so necessary a qualification—not among lawyers, surely, or doctors, as everyone knows, or scientists, or bankers. But art is less concrete than the law. Buying requires the buyer's confidence, and in the art world almost everyone is charming except perhaps the artists, who are expected to be difficult and whose behavior is excused on the grounds of their nervous, artistic temperaments.

Dealers use charm. And when a dealer's charm is enormous and his artists have fame, then his only problem lies not in

selling but in finding paintings to sell. Castelli is a case in point. Leo Castelli, who rose to eminence in the early Sixties and around whom swept a furor of controversy: the Svengali of Pop.

Castelli is a fragile figure. His delicate hands move in small refined gestures. Everything about him is crystalline: his faint Italian accent, his perfectly tailored gray suit, the conservative striped tie, so at odds with the flashy, ornamental Pop Art he is selling, which itself is at odds with his background as a former banker and sweater manufacturer. Some people say that Castelli is a boring man, and others say that he has no "eye," though exactly whose eye is credited with the astounding success of his gallery is also disputed. Some say the eye belonged to Ivan Karp, his former assistant ("Ivan found Lichtenstein"). Others say it was Castelli's ex-wife, Ileana Sonnabend, who had the eye. ("She got him into art in the first place"). And still others claim the honor for Dick Bellamy, who ran the Green Gallery in the early 1960s and discovered many of the stars who later appeared at Castelli's—though not having himself the . . . what is it? the "business head" for dealing; you see, his gallery closed. In the end, discussion of the "eye" is immaterial, for ultimately responsibility for the shows rests with Castelli anyway.

Castelli knows everyone. He appears everywhere. An article in *Vogue*, a spread in *Life*, a piece in *The New York Times Sunday Magazine*. He talks endlessly on the phone to collectors, artists, and other dealers.

"It's a beautiful painting," he murmurs. "Yes, it stands up very well." His interest is not feigned. But he is a master at the three requisites of selling: rarity, placement, pricing. A former employee described his technique. It is the technique of most dealers. First, what he sells is rare.

"I want you to have a Poons for your collection," murmurs Castelli (or used to when he was handling Poons), "but this is not an artist who tosses paint on a canvas. Everything has to be perfect. Perfect. He only executes three or four a year." So

quintessential are these works of art that the artist can create only four a year. The dealer promotes rarity.

"I'd love to see one," says the collector. He is quivering for a Poons. "I'd love to have one. When can you get me one, Leo?"

"No," says Castelli. "I will let you have nothing but an *important* Poons for your collection. Perhaps some people will take just any. But I know your collection. I know what you need. Listen. Be patient. I shall think of you. As soon as I get one *good* enough . . ."

A dealer practices placement. A dealer does not sell a painting. He "places" it. Then he advertises which collector or museum has "demonstrated faith" in that artist by the purchase. Let us say that Marlborough Galleries has a fine Robert Motherwell to sell. The dealer asks himself: Where should it be placed? A museum? Which museum? The Museum of Modern Art recently acquired a Motherwell, so the dealer does not need one there. But what about Chicago? Or Los Angeles? Or some museum abroad? Perhaps he should find an important collection where the picture will work for him—will raise the prices of other Motherwells—as successfully as if it were resting in a museum.

As he is thinking, a stranger enters. He sees the picture. He wants it.

"I'm sorry," says the dealer suavely. "That one has already been sold." For he does not want an unknown buyer kidnapping the painting to Keokuk, where it will never be seen again. Instead, he will show him something else, of lesser significance, knowing that if the fledgling interest is sincere, the client will work his way up to preferential treatment.

It is important to realize, however, that the situation is hypothetical. The stranger probably would never have the opportunity to see the painting. A dealer keeps his choicest items in hiding. This is in contrast to the practice of museums, where

frequently everything of value is on the walls. Despite the curiosity of many museum-goers, who imagine treasure-troves behind locked doors, the items in museum storage are often of insignificant value—worthless memorials left in the wills of merciless trustees. The dealer is more cautious of his trade. This is why speculators who think to outsmart fashion by buying what is out of style sometimes find few examples around. The dealers are buying, too, and hoarding in anticipation of the rage, knowing that the junk of the past is the treasure of the future.

Finally, the dealer practices pricing. He maintains a "coherent price structure." He thinks: Recently I sold two Motherwells at fifteen thousand dollars each. If I ask a high price for this important one and then revert to the former price, people will think the bottom has fallen out of the Motherwell market. If the price, on the other hand, is too low, I destroy the investment of my previously sold paintings. The price must be just enough to make all previous investments gain.

Jock Truman, the associate director of Betty Parsons Gallery, tells how he edged prices up for one of his artists. "The first picture was priced at four hundred dollars. I bought it myself. The next one was sold for five hundred dollars. Then I sold one for six hundred dollars, and another for seven hundred dollars, and so on, raising the price one hundred dollars each time. Now he sells in the thousands, and the price rises are higher."

And Ivan Karp, carried away by his own enthusiasm: "I have this artist," he bubbles. "Terrific! I sold his first painting for seven hundred fifty dollars. A year later—less than a year—he sells for eighteen hundred dollars! You won't be able to get him for three thousand dollars soon. He's fabulous!"

The "good" client, on the other hand, gets a price discount based on how much he has put out in the past. This may be 15 to 30 percent; it may, on occasion, go as high as 50 percent. ("Fifty percent!" snorted one dealer incredulously, then recollected. "The only collector I'd give a fifty-percent discount to," he added, "is Philip Johnson. I'd give that to get an artist in his

collection.") Placing a painting in a good collection may be as profitable as placing it in a museum.

The "good" client comes to expect the discount. The dealer anticipates. Prices quoted may vary. There is no fixed mark-up, just as there is no fixed discount. Museums likewise are given discounts on their purchases. Indeed, so anxious are dealers to place their artists' work in museums that they are known to badger museums with offers of discounts or even outright gifts. Once in the museum, the artists' prices rise. Museums know this, and though they snobbishly deny the allegations, when they lust after a particular work, the reality will be admitted as a bargaining point: "Give us a lower price. After all, you'll be getting higher prices on the rest of the artist's work, once this one is in the museum."

All these things make the artists and art workers talk of a Mafia—collusion and price-fixing in the marketing of art.

A dealer's sale is a private transaction, and no one but the dealer and buyer knows with certainty how much cash passes hands for a picture. They are not always willing to say. When Robert Scull bought James Rosenquist's "F-111" in 1965 for a reported $60,000, a murmur rose in the art world, a potlatch appreciation and pleasure at the lavish consumption of money. The painting consists of fifty-one panels and is ten feet tall and eighty-five feet, three inches long (more than one third of a city block). It depicts the plane plus a plethora of objects strewn over the canvas: a huge tire, a scuba diver, angel food cake, bowls of spaghetti, light bulbs, a nuclear explosion, a little girl sitting under a hair dryer against a background of brilliant green grass. It was "the most important statement made in art in the last fifty years," according to Scull, and, being too big to hang in anyone's library, was displayed at the Jewish Museum in New York, which adored Pop Art, and at the Metropolitan, and was immediately sent on a worldwide tour, presumably arranged by Castelli. The name of Scull was on everyone's lips, in articles, in gossip columns. The Sculls were seen at the right places, gave

the right parties, and became the great collectors of Pop Art, and though the taxi-fleet owner had been collecting Abstract Expressionist painting for years before with very little presence in the daily papers, he and his wife garnered prestige in the presumption of Pop. Some people said it might have been not so much the aura of Pop Art as the hiring of a public-relations firm that brought them to sudden vogue. But the prices of those paintings! Fantastic! How does anyone afford forty thousand, fifty thousand, sixty thousand for the F-111? Not everyone believes that that much money changed hands.

Castelli admits to getting $45,000. "You can look at my records. Anything I have is open to inspection," he said with a flip of his wrist that, the arm not following the grandiosity of the gesture, precluded any pursuit of the offer.

A dealer's prices are always secret, something between his conscience, his client, and the IRS. The veil of secrecy is as necessary to the collector as to the dealer (except in auctions, where the very opposite obtains, as we shall see later on). And because of the lack of knowledge, the gossip and speculation about prices and pricing is one of the hottest topics of the art world.

Rarity, placement, pricing. They are the troika of the art market. The fourth quality is enthusiasm. Enthusiasm is infectious. The dealer talks up the painter, talks down rival doubts, and none so enthusiastically, perhaps, as Ivan Karp. Ivan worked for more then ten years for Castelli before opening his own gallery downtown in Soho. He is the antithesis of Castelli's fastidious elegance. He bursts with energy, a joyous Jewish attack. He cons even himself.

His secretary covers the telephone with one hand. "It's ————," she says softly, naming another dealer. "She wants to know if you want a Warhol flower portfolio for five thousand dollars." They whisper back and forth. "Just a second," says the secretary sweetly into the phone. "I think he's just coming in

now." Ivan, seated comfortably ten feet away, counts to eight, then breathlessly picks up his extension. "Hello?"

The dealer has a client with the portfolio to sell.

"Five thousand is cheap," barks Ivan. A month earlier the boxed portfolio of ten prints came out for $3,000. In one month they have climbed to $5,000—and one "collector" is ready to sell.

"In two months," Ivan says into the phone, "they'll be worth nine thousand. You could buy them now and sell them in two months and you'd make four thousand."

The two dealers agree that in two weeks they will certainly be worth $5,000, so popular are these Warhol prints, so desirable . . .

"Who do we know who wants one?" Ivan hangs up. He is thinking. "Only five thousand, five hundred," he says, having already added his commission.

"How about those people in Virginia?" asks his secretary.

"No, they got two free. Warhol gave them two as presents because they gave him free supplies—cameras, film, stuff like that." The enthusiasm, communicated to the collector, contributes to the buying and selling.

For the dealers, this is good merchandising, protecting the investment, which in the art world, as in other businesses, extends to price supports and publicity. The dealers watch the auctions, ready to bid on a picture in order to maintain the artist's price structure. They buy ads in the art magazines to keep the artist before the public eye, for it gives a collector a comfortable feeling to see his artist advertised, especially in a highly speculative market.

A work of art is an indefinable thing, pleasing to one and not to another. In the end, the definition of a great work of art seems to be one which most people agree is a great work of art. It is that painting which over the years has maintained the good opinion of most authorities.

The problem with contemporary art (and also its delight)

is that not enough years have passed to establish a consensus. There are no answers. There are only opinions, and everyone is afraid lest he find that the beauty lies in the eye of the beholder rather than in the art. Scared, dependent, the art crowd flock together, asking each other over and over:

"Is this good?"

"What do you think?"

If enough people agree, then the work is good.

The market operates on enthusiasm. The value of a painting is exactly what someone is willing to pay for it, and it is up to the dealer to create the desire to pay.

The market operates, therefore, on waves of infectious enthusiasm, the same *folie à deux* that melts two schoolgirls with fits of uncontrollable giggling, or that overwhelms a pair of museum-goers with increasing appreciation: "Look at that! Beautiful." "Oh look."

One dealer explained his sales technique. The Smalls come into the gallery to buy a Jones.

"I show them a red Jones, a blue one, and a yellow one. It is my job to discern intuitively that they prefer the blue, and then find something positive to say about it to support the choice. I pat their hand, I show they chose right. I say" [and the dealer dropped his voice to an intimate murmur] " 'Jones did very few blue ones.' Or, 'His blues are considered more significant than the yellows.' Never lying, but emphasizing the positive: 'Yes, small Joneses are very rare.' Or, 'You have picked a large and important painting.'

"But if I say," the dealer continued, " 'Oh, Mr. Small, I think you've chosen wrong. His yellows are the classic!' then he will walk out of the gallery without buying either the blue or the yellow, and go buy a Smith from another dealer. People are insecure."

This is why advertising is so very important to art, whether by word of mouth or in art publications. And advertising creates the surging rumors of market manipulation. In the

mid-1960s, the rumors grew in proportion to the art boom. The
Art Workers were horrified at what they saw as conspiracy, the
collusion of forces which, by extension, entangled all parts of
our economy and politics. A conspiracy theory is as much the
vogue as the Communist conspiracy once was. The radical Left
finds conspiracy everywhere. To the Art Workers, then, the con-
spiracy of dealers was symbolic and petty in comparison to the
larger issues, but nonetheless reprehensible, nonetheless amoral
and wrong. They were filled with rage at the difference between
the ideal and the execution. In effect, they were holding up the
rhetoric of the country, our morals, to the pragmatic reality.

The artists were not the only ones who believed the ru-
mors, and the fact that the art market operates on luck, charm,
publicity, and personal relationships as much as by any artistic
talent embittered those dealers whose artists were not in vogue.

One day a New York dealer came to a dealer in the prov-
inces. "If that artist came to New York," he told his fellow
dealer, "he could be the vogue next year."

The provincial dealer was furious. "How do you know?"
he asked belligerently. "You don't make the vogue." But his
heart was bitter, because he knew (hunched in his cluttered,
shabby, dark-brown quarters where the framing brought in
more business than the sales of art) that it might be true: the ar-
tist would go to openings, talk to the right people, murmur the
right things, get his name in the right magazines, become the
fashion.

Another dealer told his artist: "If you wanted to stud
around, you'd make it big. I could make you in a year."

It takes talent and luck on the part of the artist. It takes
work on the part of the dealer. But when the dealer is successful
(as are so few, so very few), then murmurs rise of manipulation
—as they rose about Leo Castelli after the Venice Biennale of
1964. People raised questions about the prize. Some said that he
had artificially created the vogue for Pop Art. Not that he is the
only dealer to whom is attributed such Oriental cunning, but—

perhaps because Pop Art rocketed to success so quickly in the early 1960s, and to such enthusiastic acclaim, in contrast to the slow, labored drag of Abstract Expressionism—he is considered a master at promotion.

Castelli flies into a terrible passion at the idea of market manipulation. His brown eyes flash under mansard brows; his voice tightens, and only his hands lie limp on the round white table that serves as his desk.

He lists the eleemosynary efforts of a dealer:

"We are open to the public! We are open to museums! We give out information for free! We operate a virtual catalogue on all our artists. All this information *at no charge!* People think we are out to hurt them. And run only for profit, profit, profit to ourselves. If you think that, you had better go away and not write a book. I will tell you nothing."

Oh, the pretensions of art! Castelli considers his advertising a charity. "We must support the magazines. You think I care if I have an ad in *Art News?*" he asks, as his furry eyebrows rise like arching black caterpillars toward his receding hairline. "But we must support our magazines. They have so little money."

Castelli was born in Trieste in 1907. During World War I he lived in Vienna, later moving back to Trieste when, in 1917, the city returned to Italian domination. He got a law degree from the University of Milan, toyed with a literary career, dabbled with working at insurance, and played at being a playboy, before moving to Bucharest to work in the bank where his wife's father served as a director. In 1937 he had himself transferred to Paris, and there he absorbed the art of the day, which was Surrealism. He established the Place Vendome Gallery with the architect René Drouin. He came to the United States in 1941. In 1944 he returned to Rumania as an intelligence agent in contact with the Underground. After his army discharge, he became a sweater manufacturer in the New York garment center, dabbling still in art. He was the agent in the sale of some Kandinskys, worked on some joint ventures with the prominent

dealer Sidney Janis, summered with artists in East Hampton, and drank at the Cedar Bar. In 1957 he opened the Castelli Gallery. Within a few years everyone was talking about Castelli and his stable of comic-strip artists: Warhol, Rosenquist, Rauschenberg, Johns. Then Rauschenberg won the 1964 Venice Biennale.

It was said that Castelli first hand-picked the American Biennale Commissioner, Alan Solomon, Director of the Jewish Museum, then that he chose the eight American representatives (four of whom were attached to his gallery) and the American judge; then that he trotted off to Europe to persuade the other judges (two Italians, a Swiss, a Dutchman, a Brazilian) in his elegant, multilingual, gentlemanly style of the inevitable thunderous Rauschenberg landslide. On the day of judging, there was Castelli, the Gray Eminence, master of the media, sweeping down the Grand Canal in a gondola full of Rauschenbergs, heaving to with a bump of the gondola and unloading loudly at the Biennale Pavilion, to the busy buzz of the delighted press.

Rauschenberg won.

"Oh well, Venice, you know," sneered the art world. Everyone believed, or said he did, which came to the same thing, that the Biennale had been rigged, especially after it became known that the first person invited to be the American judge had turned down the job on grounds (he said) that he felt he would have been unable to exercise his own opinion in the face of American pressure. The protestations of Castelli and Alan Solomon and the rest of the Biennale officials could not quiet the art crowd's catty tongues, for, if there was not exactly a conspiracy, there was at least a coincidence of taste.

"I was somewhat responsible for the Rauschenberg victory," Castelli conceded later in an interview for *The New York Times Sunday Magazine*, "because I did a lot from the beginning, not just a month or two before the Biennale. Rauschenberg had much exposure. He had had great shows in England, Sweden, Denmark, Germany—everywhere. I was never uncon-

scious of Europe. And to Europeans Rauschenberg was obviously interesting.

"I always believed," he continued, "that a world reputation was necessary for my artists. For years and years I made sacrifices in sending paintings over to Europe, in seeing to it my painters had shows there.

"Of course, I didn't talk to the judges. I knew the American judge, but *he* wouldn't talk to me about his vote. And there was no mysterious canal ride."

He relates his side: Castelli was asked if the artists, Johns and Rauschenberg, could be shown in the American Consulate since there was no room at the Biennale Pavilion.

"Even though the Pavilion was the favored spot, I agreed. But then Rauschenberg was proclaimed the winner. There weren't any Rauschenbergs at the Pavilion, so I had to arrange quick transport. . . . Afterward some people decided that since it wasn't natural for an American to win the Biennale, the whole thing had to be rigged. But, you see, it was the most natural thing in the world for Rauschenberg to win."

Alan Solomon, the commissioner, wrote a letter to *The New York Times* protesting the suggestion, which "impugns not only my honor, my professional qualifications and standards and my basic intelligence, but also those of the officials of USIA who invited me to arrange the exhibition, the officials of the State Department who appointed me Commissioner, the officials of the Biennale who invited me to nominate jurors, the seven jurors chosen . . . and the Italian Council of Ministers which put up the prize money, let alone the artists and dealers Castelli is supposed to tell what to do."

But Castelli has his defenders as well. Dick Bellamy, Ivan Karp, who worked for him for eleven years. Bellamy admires Castelli's devotion to art. A dedication he has, a sincere belief in these artists as the best around: Lichtenstein, Warhol, Rauschenberg, Johns. Castelli saw them as a "movement" at a time when others were offended by the term "Pop Art." In the

National News

A Lifetime in Art

NEW YORK—Ileana Sonnabend, the art dealer who had shown work by significant American and European artists since the 1960s, died this fall at 92. Sonnabend was born in Bucharest in 1914 to a wealthy in-

Ileana Sonnabend.

dustrialist. She met her first husband, the gallerist Leo Castelli, when she was 17. The two married in 1935 and moved to Paris, where they be-friended the Surrealists and began collecting art. Four years later, with the backing of Sonnabend's fa-ther, Castelli opened Drouin

Gallery with his partner, René Drouin, but closed it the next year when Germany invaded France. Castelli, Sonnabend, and their daughter, Nina, fled in 1941. After a circuitous journey through Spain, Morocco, and Cuba, the family arrived in New York. The couple once again fell in with a circle of artists, this one including Jasper Johns, Willem de Kooning, Robert Rauschenberg, and other prominent figures in postwar Ameri-can art.

In New York, Castelli dealt privately for years. In 1957 he opened a gallery in the couple's Upper East Side apartment, showing work by Rauschenberg and Johns, among others. Two years later Sonnabend divorced Castelli, and she married Michael Sonnabend in 1960. They moved to Paris, where they operated Galerie Ileana Sonnabend from 1962 to 1980. For their first exhibition, they mounted a show of Johns's work, and soon after, they became known for introducing postwar American artists, including Andy Warhol and Roy Lichten-stein, to European audiences.

In 1970 Sonnabend opened a New York gallery on Madison Avenue, near 73rd Street. A year later she moved it to SoHo, becoming one of the neighborhood's first dealers—along with Castelli, with whom she maintained a close professional rela-tionship. Sonnabend Gallery opened with a performance by Gilbert & George, the British duo that remains among the gallery's stable of artists, which also includes Bernd and Hilla Becher, Ashley Bickerton, Candida Höfer, Jeff Koons, and Barry Le Va, among others.

Sonnabend relocated her gallery to Chelsea in 2000. She is survived by her daughter, Nina Sundell, and her adopted son, Antonio Homem, the gallery's director, as well as three grand-children and two great-grandchildren. —*Rachel Somerstein*

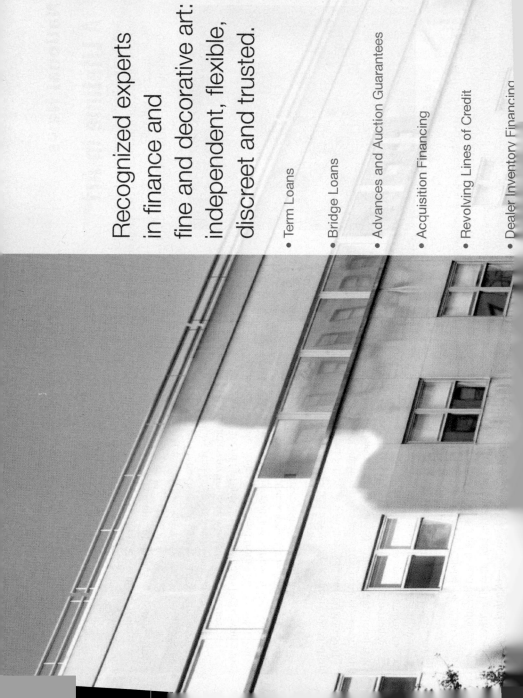

Recognized experts
in finance and
fine and decorative art:
independent, flexible,
discreet and trusted.

- Term Loans
- Bridge Loans
- Advances and Auction Guarantees
- Acquisition Financing
- Revolving Lines of Credit
- Dealer Inventory Financing

early Sixties Pop was the most explosive art around, and art people gravitated naturally to the gallery.

Karp, exploding with shot-gun sentences, likewise dismisses collusion. "There's no deviousness in him. He's the victim type. I know. He's a pushover. Everyone convinces him to lay out money—the art magazines for ads. *What* underhanded promotion? We should know. It's impossible. Look, we gave shows of Johns, Stella, Rauschenberg, Lichtenstein. The *Times* didn't carry a review for a year. *No reviews!* The gallery was jumping like mad. All you need are collectors. Ten collectors see the work, the place is jumping. There is very little conspiracy in the art world. Everyone talks about it. There is none. The Biennale. Big deal. Castelli heard Rauschenberg had won, but technically Rauschenberg hadn't met the regulations. The paintings were supposed to be in a particular building. So he moved them. Castelli moved them. Castelli was the only dealer over there who spoke fluent Italian. He interpreted the work of the artists. No one else could. Publicity is what every artist wants. The Biennale is a nothing. A prize. It's not an important occasion. It's a social occasion. You sit in the square and listen to the orchestra. You see princesses, dealers, artists. You go for a social thing. The buildings are lousy. The lighting is lousy. There's no money to mount a good exhibit. It's not like Documenta, or São Paulo, or even the Whitney Annual, that have a sense of scholarship. A museum mentality. It's not as important as a retrospective in a major museum.

"Conspiracy. Only conspiracy you find is professional jealousy. Light-weight gossip. 'What do you have that's good?' 'What artist is leaving his dealer?' 'Whose wife is living with whom?' Conspiracy!"

Nevertheless, the art crowd cheerfully believes what it wants.

And sometimes not so cheerfully, for nothing can ease the soul of the artist who does not make it. Make it? He deplores the term. Sell? Succeed? Crass, vulgar, commercialization of what

he is trying to do. He is torn by conflicting aims. Money, yes, because there are school bills for the artist just as for the lawyer, and the rent to pay and food to be bought; but there is another relationship for him too, the trinity of artist, work, and viewer. The perfect interaction of three forces. A thrill of pleasure that has nothing to do with buying and selling. Gene Vass, whose canvases and sculpture are in the collections of many museums and on the walls of private collectors, sold $150 worth of paintings one year, and nothing the following year. He started slashing his paintings. He stabbed them with a knife. He burned them, tossing drawings, oils, pencil sketches on the fire day after day, destroying his work. Afterward, he wept.

Dealing, according to dealers, is a chancey and profitless business. Most galleries of contemporary art sell on a commission basis. They take from one-third to two-thirds of the artist's selling price for their commission. A few buy works outright. The idea is to buy low, sell high. In galleries dealing with dead artists (there is nothing a dealer finds so desirable as the estate of a dead, famous artist), the lower the purchase price, the higher the markup—300 percent, 3,000 percent.

Castelli, whose gallery was by 1966 grossing close to half a million dollars a year, says he did not show a profit until 1968, eleven years after the gallery opened. And it is apparently true that it takes most dealers around five years for their artists to begin to sell.

Richard Feigen, a Harvard Business School graduate, who owns five galleries in Chicago and New York, explained how, even if he sells out a show, the dealer may lose.

"I gave a show of one contemporary artist. It sold out—ninety-six hundred dollars gross. I got three thousand dollars as commission. One thousand dollars went for mail advertising, one thousand dollars for rent. So much for salaries. I lost over thirty-five hundred dollars, and everything sold!" Feigen talks like the investment banker he once was.

"Your overhead and expenses go up in proportion to your artists' reputations. You have insurance, crating, shipping, six secretaries instead of one. You get more mail, answer questions. You become an information center about the artist. You have problems of copyright. Your artist goes to Chicago—you pay his hotel bills, rent him a car. I have a staff of eighteen, eating up three thousand, four thousand a week—more than that. The private dealers make money," he added wistfully. "If we make money on a contemporary artist, it will be by holding on to the work of the artist." He remembers how in 1959 he had the first Francis Bacon show in America, with paintings priced from nine hundred to thirteen hundred dollars. "I didn't hold on to any," he says with regret. Feigen has learned now and, if he follows his own advice, should be judiciously stockpiling. He may also be shucking some of his contemporary artists. One artist in his stable, Ray Donarski, tells how he brought slides of his recent work to Feigen's gallery director, Michael Findlay.

"I've brought in slides of what I've been doing for the last year. I think I'm ready for a one-man show," said Donarski.

Findlay was not even interested in seeing them. "No one-man shows. We're all booked up."

"Well, aren't you even going to look at the slides?"

"I'm busy now."

Donarski split with the gallery. He was not the only artist at the time to be trudging the streets looking for a new dealer.

Ivan Karp claims a dealer begins to make a profit when the average work of an artist brings $5,000 to $8,000 and he sells out a show. A sale of substance for Ivan is $250,000.

"The dealer's well off then. For Janis," he adds wistfully, "that means about one Giacometti or one Mondrian."

And since most dealers are not in this class, they support themselves by selling other things: pre-Columbian gold, as in the case of André Emmerich, or Old Masters as with Feigen, or by accepting on consignment a painting for resale, a practice

that nets 10 to 25 percent of the selling price with no cash out-
lay, even for exhibition space.

But the dry dust of economic discourse gives no idea of a
dealer's day. It cannot capture the glow, the glamor and clamor
and gossip of art.

John Bernard Myers, seated behind a desk in a tiny corri-
dor of the Tibor de Nagy Gallery, smokes cigarettes nervously,
legs crossed, his fingers doing tap dances on his desk top or his
knee. He is supercilious and sharp-tongued. What a youth he
must have been! He does not move his spreading bulk from the
swivel chair, but everything about him moves: his tossing head,
his pursing lips, his eyes rolling skyward, the flick of his wrist,
the flashing glance at a colleague, a pretty boy, leaning noncha-
lantly against the door.

Charles Cowles, Jr., publisher of *Artforum*, swings jaun-
tily in, whipping a cane, and followed by two companions, who
hang like bodyguards, a step behind.

"Johnny, I want to see you about—" he stopped cau-
tiously at the sight of the reporter, "—a mutual friend. A cer-
tain artist, you know."

"If you mean P.R.," said Johnny archly, "I don't want to
know anything about it." He sucked his cigarette from the cen-
ter of a pursed mouth.

"Look, he needs money."

"Look," said Johnny, "R.H. has two cold-water flats on
the sixth floor at Tenth Street on the East Side at eighty dollars
a month. Why does P.R. need two hundred and fifty dollars? I'm
not his father. I can't do business that way. I show him. He
thinks I'm Welfare." He sighed and glanced at his friend, the
boy in the doorway.

"He calls me every day," said Cowles. "He calls you every
day."

"I can't do it," said Johnny. "I can't do business like that.
Don't say anything about it. Don't even say you've come to see
me. I'm going to Europe next week. I'll be gone all summer."

And Charlie, having failed in his petition, turns, his two friends falling into step behind him, and sweeps cheerfully out.

Such a caustic tongue has John B. Myers, who now runs his own gallery on 57th Street.

"Jim Dine removed his works from the Biennale only for publicity. Did you see the *Post* yesterday on Morris's antiwar activities? The whole article was a summary of his work. Every time he protests the war, they summarize his work. I heard Castelli on WBAI the other day. He said: 'I am the leader!' And at a speech he gave at the Museum of Contemporary Art: 'I discovered every single artist of the past twenty years!' Who does he think he is?" asks Myers. "*I* discovered Louise Nevelson. *I* discovered Frank Stella. Oh, dealers are so dishonest [rolling his eyes heavenward]. I had a Fragonard to sell. The provenance was uncertain. In two big, important collections it was considered a Boucher. Then it turns up at another gallery, a *large, well-known* gallery, and it's a Fragonard. If it's a Fragonard," he tapped his cigarette, "it might be early. It's probably 'school of.' Then there are out-and-out cheats. There was a gallery at a hotel. I got the notice. 'Uh-oh,' I said, 'if there are Mirós . . .' Well, there were. The *vernissage* was terrific. But what can you say? Once a lady collector I know invited me up to look at her collection. They were all fakes. 'It must have taken some time to acquire them,' I said. What could I say? You have to be polite."

The Auctions

Fortune magazine dates, with the precision that magazine editors admire, the exact moment of change in the art market. It was, said *Fortune*, in 1948, when the Galeria Charpentier opposite the President's Palace in Paris was auctioning off the collection of Gabriel Cognacq. Auctioneer Bellier's gavel dropped to sell for 33 million francs ($477,200) Lot 28, Cézanne's still life *"Pommes et Biscuits"* to Mme. Jean Walter. Sophisticated dealers were awed by the total take that night: $860,000.

It was the beginning of the boom. Thereafter, the art market rose relentlessly, accompanied by admiring acclaim,

though some cynics reverse the order of events, proposing instead that the "ohs" and "ahs" of press statements contributed as much to the rise of prices as they reported on them.

Before World War II, 90 percent of the art business in New York was transacted through dealers. Prices were erratic and auctions poor, except for those of private estates. Since 1948, auction sales have grown until they account today for nearly 50 percent of the world art market, and no one can understand the art world without taking cognizance of auctions.

Auctions form the visible vertebrae of the art market. Auctions provide the only public records of sales, and only auctions provide open, competitive bidding on a particular painting. Pricing one painting through the comparative sale of another is chancey, subject to variables of size, quality, rarity, period, time, and place. It remains, however, the only way to determine the prices of art.

The museums make their insurance evaluations from auction catalogues. The dealers move prices up and down, and serious collectors learn the value of their works according to sales at auction. Auctions establish prices.

At the time of the events encapsulated here, which are roughly from 1968 to 1972, auctions were being carried on with as much energy and verve, and were studied as seriously by dealers and collectors, as if they were not founded on a kind of sham. But the auction was not a competitive arena in which each party had access to the same information. The secret reserve, the pre-auction bidding, the imaginary bids, made it a charade, and because the auction forms the basis of the entire market, it was a subject of constant speculation, everyone trying to outguess the others on who sold what and for how much and whether it was for real, and what it meant to the rest of the market. The dealers were unwilling to blow the whistle on the auctions for fear the blast would rock their own businesses.

On the other hand, they were equally concerned that auctions were unfair competition. They felt there was even some question as to whether the auctions were acting legally.

Auctions are big business, big enough for Parke-Bernet (and those in the know pronounce the faintest final *t*: Ber-nett') to have increased sales turnover 100 percent in three years. The combined gross for fiscal 1969 at Christie's and Sotheby's, the two leading auction houses of England and America, reached a record $133 million. Parke-Bernet, "America's largest fine arts auction corporation" and a subsidiary of Sotheby's, announced a sales turnover for the 1969–70 season of "over $38,524,966.00," an increase of 23 percent over the previous season. So important had auctions become that interest in the bidding was superseding interest in works of art. It was positively metaphysical. In its April 1970 issue, *Auction Magazine* inserted an L.P. recording of the bidding on Van Gogh's *"Les Cypres et L'Arbre en Fleur,"* sold at Parke-Bernet to a "mystery bidder" on the evening of February 25 for a record $1,300,000.

A big auction in New York, an "important" sale, as it is called, is an art-world event. It is a social necessity, an entertainment quite separate from any esthetic appreciation of art, though the tone, the sense of class, the subdued browns and red, and the rich dress have a certain artistic appeal. There are the bid spotters in black tie, the doorman who takes your "by ticket only" cards, the porters in green P-B uniforms who carry the paintings in and out and stand discreetly to one side, like movie footmen. No uppity blacks, these, though the high, bushy beehive of one Afro haircut at one recent sale seemed startling, out of place, as its bearer stalked proudly across the platform carrying $75,000 paintings. That hair style represents another life, one of pain and anger, which does not enter the lush rooms of Parke-Bernet. Here are furs and jewels and the refined smell of money.

One of the primary attractions of auctions has always

been the excitement of conspicuous public spending. Here is an 1887 description of a sale at Christie's:

> The moment the picture comes upon the easel, it is received with loud clapping of hands, repeated as often as bidders outvie one another in their advances of perhaps a thousand guineas, and when the hammer falls at last to a lumping sum, there is a perfect uproar, just as the crowd roars its delight when the Derby is run, for the Christie audience revels in high prices simply for money's sake, though of course some of the applause is meant for the picture.

The tone has become more pretentious now, commensurate with our hallowed exaltation of art. There is no stomping or yelling at an Important Sale. But the sale itself, the spending of money, remains the leading attraction, and people are disappointed by a long, dull evening, such as the sale of some of the Norton Simon collection on May 5, 1971, when the total take was $6.5 million and the bids were laboriously drawn up, sometimes in painful $500 denominations, while the crowd rustled restlessly, riffling the pages of the catalogue.

The spectacular rise in auction sales (and profits) took place largely after Parke-Bernet Galleries was acquired by Sotheby's in August 1964. Sotheby's has been in business under one name or another since 1744. It is four times the size of its closest competitor, Christie's, also of London. It calls itself the "world leader of fine art auctioneering." It has salesrooms or offices in Melbourne, Buenos Aires, Toronto, Paris, Florence, Beirut, Edinburgh, Johannesburg, Los Angeles, Houston, and New York.

Immediately following the acquisition, Sotheby's instituted the extensive reserve system that had been successfully in effect for years in London. New York is not London. The English system sat uncomfortably on the shoulders of the American market—until, at the end of the 1960s, some collectors began to

figure how to use it to advantage. The secret reserve is one reason that the art market reached such spectacular levels in the 1960s.

Here is how a Parke-Bernet auction works.

The seller (the consignor) brings in his paintings for sale. P-B appraises them, for a fee, based on the appraised evaluation. Appraising, P-B is quick to note, is not the same as saying what the item will bring at auction. Nor is it presuming to say what the painting is worth (it is worth whatever someone will pay for it).

"Appraising," said Thomas Norton, vice-president of Parke-Bernet, in charge of the painting department, "is an attempt based upon previous experience to project what will happen. It is predicting the future, and always the unknown factor is the human element. That comes the night of the sale." It is up to Parke-Bernet to attract the human element. This is done first by the atmosphere, an ambience carefully conceived, an image sustained by the public relations firm of Clark Nelson, Ltd., and the discreet advertising in the fashionable world that makes P-B synonymous with the world of fashion.

Then there is the publicizing of high prices paid at auction to attract first the potential sellers and then the audience to appreciate the scale. This publicity is counterbalanced by equally well-publicized statements that the clever buyer can buy at auction at between 10 and 75 percent of the retail value. Third, there is the skill of the auctioneer, whose job, according to Norton, is to produce "the excitement of the evening." The auction is a theatrical production, a performance. The auctioneer is supposed to build suspense . . . in order to achieve the highest bid.

Sometimes the appraised price varies considerably from the auction price. In October 1970 an unsigned Rembrandt portrait appraised at $350,000 never got higher than $150,000. On the other hand, a George Romney "Portrait of Capt. John Staples," appraised at around $7,000, was sold for $35,000, and a

Guardi, "Isola di San Giorgio," brought $130,000, about double its expected price.

Nevertheless, appraising is the only system available for determining the painting's worth—in other words, how much the owner wants for it.

At this point the owner may put an undisclosed reserve price on his picture. This is the lowest price he will accept, and if the bidding does not reach this level, the picture is automatically bought in (a buy-in, or B-I). The owner pays the auction gallery a 5 percent commission instead of the 12.5 to 20 percent that a legitimate buyer would have paid, and he takes the painting home again.

Now for about five years at the end of the Sixties and in the early Seventies, Parke-Bernet was listing buy-ins in its public sales records as having been sold. And here was the trick. Because the reserve was secret no one could say which items were legitimately sold. This is a long-standing practice in English auctions. At Christie's in London B-Is are still listed as sales today, and fictitious names are made up for the fictitious buyers. At Parke-Bernet the practice of listing B-Is as sales has been reluctantly dropped. The buyer's name, however, the owner's reserve, and exactly which paintings were bought back are still considered confidential. Until 1971 Parke-Bernet was listing B-Is in the public records first under "Sales Prices" and then— after considerable pressure from the art world—as "Final Bids Received."

Now it is a fact that, owing to the secrecy surrounding the secret reserves, many people in the art world believed that all Parke-Bernet prices were real. They had not heard of buy-ins. As late as the end of 1970, one associate curator at the Guggenheim Museum had never heard of the reserve system, and neither had James Brown, director of the Virginia Museum of Fine Arts and former curator to Norton Simon. Both used the auction catalogue price lists to verify prices and insurance valuations.

"I always check the sales prices carefully," he said. "I cover up the prices and try to guess what the painting or sculpture went for. Uusally I'm low."

If the reserve prices are carefully disguised from the art world, the way in which the auctioneer bids a reserve is equally secret.

"Well, of course, he doesn't peer down into his book," says Thomas Norton acidly, "and look up and make the bid."

He pretends the bid comes from the floor. We are assured that if the legitimate bidding stops before reaching the reserve, the auctioneer bids only to the next highest bid. For example, a painting with a reserve of $70,000 reaches $55,000 from the floor. The auctioneer then bids $57,800, or possibly $60,000— whatever is the next acceptable level of bidding—in order to buy in the painting for the owner.

But who is to watch over the auctioneer? If he is tempted to take the price higher, he can persuade himself that it is good for business, it is good for the reputation of the painting, and it is good for the general climate of the art market. Because much bidding is carried on in secret codes, raised eyebrows, and imperceptible nods, and because pre-auction bids have likewise been left with the auctioneer, no one could ever prove an illusory bid. And if his conscience hurts, can he not always explain to himself, and to the others (and has it not been often enough explained) that there was indeed a legitimate bid at $65,000, and another in fact at $70,000? They were the bids of the owner himself.

In fact, the prices may be bid sometimes right up to the reserve. Liz Robbins, the young, blonde, pretty public relations representative for P-B's Clark-Nelson, Ltd., admits the fact.

"Oh, I can tell," she laughed one day. "I've stood at the front of the room, and I can tell when the auctioneer's drawing bids out of the air. He may make two or three bids in hopes of drawing someone fresh into the bidding."

This is certainly not supposed to be done.

'Develop Your Eye, and Then Buy with Your Heart'

NEW YORK—André Emmerich, the eminent art dealer known for his representation of color-field artists, died in New York at the age of 82.

Born in Frankfurt in 1924, Emmerich moved with his family to the Netherlands in 1931. In 1940 they settled in Queens, New

André Emmerich.

York, after fleeing the Nazis. Emmerich attended Oberlin College in Ohio, where he studied art history and worked at the school's Allen Memorial Art Museum. He graduated at the age of 19.

He then moved to Paris, where his grandfather had been an art dealer, and spent nearly a decade there, writing for Time-Life International, the *New York Herald Tribune*, and *Réalités*. After returning to New York in 1953, he opened André Emmerich Gallery on East 64th Street, later relocating to the Fuller Building on East 57th Street. One of the first artists he showed was Adolph Gottlieb, a friend with whom he regularly sailed in Sheepshead Bay.

Emmerich maintained a close relationship with the critic Clement Greenberg, who championed many of the artists the dealer exhibited, including Morris Louis, Kenneth Noland, and

Jules Olitski. At a time when women met with prejudice in the art world—as he recalled in a 2002 interview with Avis Berman for the Archives of American Art—Emmerich made it a priority to show their work and represented Helen Frankenthaler, Judy Pfaff, and Miriam Schapiro, among others.

The dealer also collected and mounted exhibitions of pre-Columbian art and published two books on the subject. In time he added painters like David Hockney and Al Held to his roster of artists and took on the management of the estates of Hans Hofmann, Milton Avery, and John Graham.

In 1971 Emmerich opened a Zurich branch of his gallery, and the following year he became president of the Art Dealers Association of America, a post he held until 1974, and again from 1991 to 1994. In 1996 Emmerich sold his gallery to Sotheby's but retained the title of director. That relationship lasted only two years; the auction house closed the gallery in 1998.

In 1982 Emmerich purchased the 140-acre Top Gallant Farm in Pawling, New York, and transformed it into a private sculpture park, where he showed large-scale works by Alexander Calder, Anthony Caro, Beverly Pepper, and Mark di Suvero.

For the past several years, Emmerich had been composing his memoirs, which were published in September by Ruder Finn Press and are titled *My Life with Art*. Excerpts from the book appeared in the *New Criterion* and *ARTnews*. "The best advice I can give a collector is: develop your eye, and then buy with your heart—always, always with the heart," he wrote in 2003.

—*Rachel Somerstein*

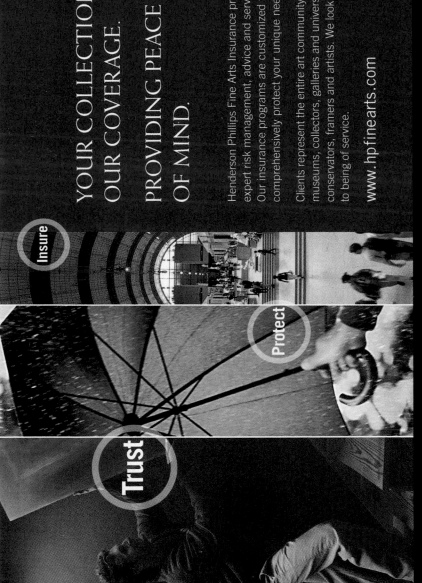

On May 13, 1970, an auction of Impressionists and Post-Impressionists including a number from the prominent collection of Mr. and Mrs. William H. Weintraub were put on the block. The collection brought $1,069,000. Rumors flew, until they were taken to be fact, that "almost half" the Weintraub collection was actually not sold but bought-in. A tall Giacometti bronze was B-I for $230,000. Now this was more than any Giacometti had ever sold for before at auction, and it exceeded the $150,000 Henry Moore which represented the highest price paid at auction for a piece of sculpture. And there was considerable discussion among the art world about how stupid the collectors were to ask such a price, *especially when there was a legitimate bid just below it.* Everyone knew that. "They could have sold the piece for two hundred and twenty-five thousand," said one curator, and a dealer agreed: "They put on too high a reserve."

"I told him," said Bill Rubin, curator of the Paintings and Sculpture Collection at the Museum of Modern Art. "That night when I saw him, I said, 'You made a mistake.'"

He did not add whether his gratuitous opinion was gracefully received and neither could he explain how he knew there was a legitimate $225,000 bid, except to say that of course there must have been, for was not the statue bought-in at $230,000? Therefore, the lower bid had to be legitimate. The auctioneer would not make up bids out of the air.

Yet the sale stirred controversy. For the first time, a number of people were offended by the performance. "It is completely phoney," exploded one dealer. "They aren't real prices. Someone puts on a high reserve. It's bid up to the reserve—and bingo! You've established a new record for your work. You take the picture back. All you pay is a 5-percent commission. In five or six years you put the painting up for sale again, and get your price."

The following night at a sale of Contemporary Art, seventy-five lots were sold for half a million dollars. An Andy Warhol "Soupcan with Peeling Label," which was expected to go for

around $40,000, was sold for the whopping sum of $60,000—to
an unknown bidder. No major Warhol painting had been sold at
auction before, and the highest dealer price was $50,000. Every-
one was guessing. It was said the bidder was a German dealer,
then that the picture was bought by a German museum. An-
other story had it that the German dealer bought it for the Ger-
man museum. Finally came the version everyone believed: that
the dealer had a large Warhol collection and, wanting to estab-
lish new prices, he invested a couple of thousands of dollars by
bidding surreptitiously against himself to drive up the price lev-
els of Warhols.

A German magazine, *Capital*, reported that the owner of
"Soupcan" was Peter Brandt, a young businessman and Warhol
collector, and that the buyer was Bruno Bischofberger, a Swiss
dealer and friend of Brandt's. The article asserted they may
have sold the picture together. There was a legitimate bid, ac-
cording to the article, at $55,000, which the Brandt-Bischof-
berger combine felt was too low, and bidding from the floor
themselves, they bought-in the painting at $60,000. The painting
was put up for sale at Bischofberger's gallery for $75,000.

Both Brandt and Bischofberger denied the allegations
that the picture was bid up to establish a higher market. But a
record price for Warhol had been established, and people were
talking about the mad, gay German market, where "they really
appreciate modern American art." People remembered how,
earlier, the Sculls were said to be selling their collection in
Switzerland. The deal had never gone through, but for months
speculation ran rampant and reports of negotiations and prices
were quoted. Moreover, "everyone knew" the Warhol sale was
legitimate, because they had seen the bidding come in from the
floor.

On November 18, 1970, P-B held another sale of contem-
porary art—"the most important sale of contemporary art we've
ever had," said one staff member enthusiastically. "People got
wind of it just by word of mouth. People flew in from all over

the country, all over the world! Otto Preminger tried to get tickets and could not. The catalogue was completely sold out. It will be a collector's item! I've never seen such a crowd! It was a happening! It was the 'chic' of being at that sale."

The room was packed with people standing two deep at the walls. They were young, and dressed in many styles: leather midi-skirts, mini-dresses, fringes and head beads, a fur hat, a mink coat thrown casually on the floor, ankle-length granny dresses; in the gallery long-haired kids with beards and beads and somehow the bread to bid, and in the halls an overflow crowd of more.

Fifty lots were sold that night, and the total reached $1,179,450. But by then, not everyone believed in the sale. It had occurred to some in the art world that the dupes in this might be themselves. Everyone was talking. The Reinhardt was in terrible condition. Awful. It should never have been sold. That's why it went so cheap. The Albers was above the dealer's price. Everyone knew, or pretended to know, which items were B-Is. Many people were willing to grab up a catalogue: "Well, I was there. I could tell which sales were real." Or, condescendingly: "When you've been around, you can tell."

Some B-Is were listed in *The New York Times*. The Jasper Johns, "Two Flags," of 1962, bought in for $105,000, short of its alleged $125,000 reserve. The Pollock, bought in at $70,000. Rothko's "16–1960" bought in at $85,000. Other guesses were impossible to confirm. Pretty soon rumor had it that "about half" the items were B-Is. Parke-Bernet would not comment. The aura of secrecy, a long-established Sotheby's practice, "protects the market." The *Times* listed "around ten" buy-ins. Liz Robbins, on being pushed, raised the figure. "You could say eleven or twelve," she said reluctantly. "Don't believe all the rumors you hear. They don't know what was sold anyway." Later it was said that the B-Is accounted for over $400,000 of the $1,179,000 gross. Parke-Bernet would not comment.

"It is P-B policy not to disclose all the items bought in."

The November 1970 sale of contemporary art was a kind of watershed. I shall not bore you with recitals of prices and bids asked and reported. Suffice it to say that the situation existed, and was played upon, like stock market speculation, to such an extent that sometime in 1970 faith was lost in the veracity of auctions; at which precise point in time the Art Dealers' Association, an association of prominent dealers established to maintain ethical standards for the trade, persuaded a reluctant Parke-Bernet to reexamine its policy and drop B-Is from the lists of "Final Bids Received." Parke-Bernet was not happy.

"I feel that the buy-in price of a picture is so close to what someone was actually prepared to pay for it," said Peregrine Pollen, President of Sotheby Parke-Bernet, in an interview with *The New York Times*, "that it's a bona-fide market reflection and should be included."

Nonetheless, in January of 1971, six years after the Sotheby takeover, the auction house agreed to stop listing B-Is as if they had actually been sold. Instead they were purged from the records, so that a sales list would read, for example, Lot 1, 2, 4, 5, 7, 10. To name a B-I would damage the reputation of the picture by indicating that no one wanted to pay more for it than its owner. Parke-Bernet emphasizes that if a reserve is unreasonably high, the auction house will not accept the consignment.

The reserve is a useful mechanism for protecting the market. Over the long run it lifts the prices and brings new buyers into the market. Dealers profit from the reserve. Sellers like it because it protects their sale and avoids humiliating negotiations with dealers.

The deceit of the auction market does not lie in the reserve, but in its secrecy. There are three defenses for a secret reserve. Two of them confuse the necessity for secrecy with that of a reserve.

The first is that it is sometimes occasion for charity. This was expressed by a spokesman for Parke-Bernet: "Look, the reserve is not always bad. A while ago there was a painting by

Rembrandt Peale, donated to be sold at auction for charity, a really *good* cause. It didn't make the price. The following year the same picture was put up for sale again, and this time it sold for a *fortune*. So you can see how good it was that there was a reserve."

The second defense for a secret reserve is the necessity for speed. According to one auction-house representative, the price lists must be printed and distributed within a week. Yet, a buy-in can often be sold after its unsuccessful auction, with the auction house acting as a private agent in the sale. This happened with a Thomas Eakins sent to Parke-Bernet for sale in May of 1970 and bought-in at $130,000. It was sold a few days later to Armand Hammer, the Los Angeles collector, a doctor, the brother of Victor Hammer, owner of the Hammer Galleries on Fifty-seventh Street, and himself wealthy on the ownership of Occidental Petroleum. Is it fair (asks the auction house) to penalize a good painting for not making its reserve, when a few days later it may reach the price? This is roughly the same argument that Mr. Pollen gives when he asserts that the reserve (secret) represents a bona fide market reflection.

The third defense is that secrecy combats dealers' rings. Rings are simple and illegal ventures. They are also profitable, and possibly, therefore, more common than the art world likes to acknowledge. It is only human nature that many dealers, after first denying the existence of rings, remember how "once" they came into contact with one. Here is how it works.

Let us say that four dealers are interested in the same item at auction. They agree in advance (collusion) that only one will bid for it. He gets the painting at a low $2,000. The four dealers then retire to hold their "knockdown." This may be done in a variety of ways. The simplest is for each dealer to drop his written bid into a hat. One bids at $5,000, another $6,000, a third $7,500, the fourth $8,000. The painting goes to the highest bidder. The winning dealer then deducts $2,000 to pay for the auction price, after which he owes $6,000, a sum that is divided

among the others, either according to some percentage system
or equally, each dealer receiving $2,000 for having done nothing
and risked less. The winner takes the painting, on which he may
expect a profit of from 30 to 300 percent.

It is said that some private art dealers exist primarily
through rings. This is usually said, wistfully, by "public" art
dealers with galleries.

John Bullard, curator of special projects at the National
Gallery of Art, was recently dickering with a dealer about a
painting. On hearing a high sum named, he raised one inquiring
eyebrow, for the painting had brought much less at its recent
auction. "Well, you know," said the dealer with instant compre-
hension, "I had to pay much more for it than that."

The Virginia Museum of Fine Arts was interested in a sil-
ver chalice, the asking price of which was $25,000. Discovering
that it had been bought at auction for about $4,000, the museum
suspected a ring. According to a spokesman, it refused for this
reason to buy. "We won't tolerate that behavior." On the other
hand, neither would the museum tell the dealer its suspicions.
"It wouldn't have done any good. See, we're dependent on the
dealers, too, don't forget. We're very low on the list. We have to
be on their good side."

It seems apparent that dealers' rings continue despite the
secret reserve. The real reason for the secrecy of the reserve is
an insidious fear that if the reserve were public, the auctioneer
would find himself facing an intolerant crowd. Knowing the re-
serve price, the interested bidder would supposedly sit back
mum, and when the piece had been withdrawn or bought-in, he
would approach the owner secretly to negotiate his private sale.
The auction house would be out a commission—perhaps soon out
of business.

You can see the insecurity of the art market. No one in
the auction business could conceive of using one of the other
auctioneering methods to replace the secret reserve. They did
not want to hear that at the Fasig-Tipton yearling sales, for ex-

ample, at Saratoga, New York, the untried yearlings are sold quite readily without a secret reserve. "There is a reserve of seventy-five thousand dollars," cries the auctioneer, seated on a platform high above the magnificent horse. "Do I hear twenty thousand? Twenty. I have twenty. I'm asking twenty-five." And up the bidding climbs in five- and ten-thousand-dollar sums to top the reserve.

The auction houses were, in fact, a little dubious about what would happen when, in 1971, Parke-Bernet opened a branch in Los Angeles, where California law prohibits a secret reserve. People assured each other that things would work out, because anything of value would be shipped for sale to New York or London, where the secret reserve was in effect. And indeed this is what happened. When Norton Simon, the Los Angeles collector, auctioned some of his works on May 5, 1971, the sale took place, not in downtown L.A., but in New York, where the market had a modicum of built-in protective devices.

And at this sale a new twist was added to the auctions. Instead of secret reserves on individual pictures, there was a "bulk reserve." The arrangements were "confidential," but dealers around town were muttering that what P-B was doing in effect was underwriting a consignment. It was guaranteeing a certain sum—as if it were a dealer and would itself buy in the pictures if they did not reach the bulk reserve. The dealers were not certain that this was a legitimate undertaking for an auction house. P-B refused to comment.

And so the dealers waited, uneasy—as did some collectors, perhaps, losing some confidence in the market and yet trusting overall to the mercantile system of Sotheby Parke-Bernet.

Let me tell about the pre-auction sale:
"I'm interested in this piece," says the good customer. "I can't be here for the sale. I'd like to leave a bid. How much do you think it will go for?"

The gallery employee is instructed to give a price range in which the piece is estimated to sell. He may disclose the reserve. In practice it is not unknown for him—how tempting, to lean toward the good client: "Well, you know, someone left a bid with me the other day for thirty-five hundred dollars. So it would have to be higher than that."

The first bidder was outbid before the auction began.

If this disturbed the dealers or the collectors who were trying to buy, it did not disturb them half so much as the post-auction sale. This is made privately to a client after the painting fails to reach the reserve. The auction house is acting then not as an auctioneer, but as a dealer. The other dealers were uneasy.

Eugene Thaw, head of the Art Dealer's Association, pointed out—as others had before—the unfairness of Parke-Bernet acting as a dealer when it was not subject to the same legal restrictions as a New York dealer. A dealer is supposed to guarantee the authenticity of a work. Parke-Bernet, in a disclaimer at the front of each sales catalogue, assumes "no risk, liability or responsibility for the authenticity of . . . the property identified. . . ." All property is sold "as is," and neither Parke-Bernet nor the consignor "shall be responsible for the correctness nor deemed to have made any representation or warranty of description, genuineness, attribution, provenance or condition of the property. . . ."

That seemed awfully unfair to other dealers. They noted that if a buyer finds a fake on his hands, he has only twenty-one days in which to report his charge and another fourteen to prove it "beyond a reasonable doubt"—which is short time for the amount of work involved. It seemed to the dealers that dealing with a reputable gallery was to be infinitely preferred. They did not consider the other problem: Where can a reputable dealer be found?

On Reputations:
Relations with the Collector

The art world feeds on gossip. The conversations are all about who bought what and for how much, and about fakes, copies, and authentications. It is not easy therefore for the general public to interpret the word "reputations." And hearing on the one hand of a dealer's reckless relations with his artists, or of another's overcharging his clients; or reading Elmyr de Hory's accounts of how his fakes were sold at the most respectable galleries (a fake Matisse at Knoedler's, for example); hearing perhaps further, if he dips his toe in the chill waters of the art world, of another large gallery forging a painting, or passing off "wrong" pictures with the dark joy of an exhibitionist flashing

his parts—what is he to think? And the talk is not only from customers describing actual thievery. There are endless tales of dealers doing dirt to fellow dealers, of critics selling their approvals and experts their authentications. With every word a reputation falls.

The art trade is no worse than any other industry. The milk business, law, medicine would probably turn up the same proportion of crooks, cranks, and charlatans, cupidity and greed. Moreover, the faults are not limited to dealers: collectors are also to blame. For many dealers, in fact, the trouble with the art market is collectors. Collectors set the market tone, the price; they are either naïve or greedy or both. The naïve are the ones most often blamed. They believe that art, being the highest form of visual expression, is governed by the highest moral code. Moreover, these general inexperienced customers confuse their esthetic judgment with commercial values. They have no other qualifications than the two eyes in their heads and the bankrolls in their pockets. This appalls the dealers. Appalled or not, they take advantage.

One Maryland couple is proud of dealing over dinner with their private dealer. It's his technique. They telephone New York.

"What have you got in? Anything nice?" He has. They bought for nine thousand dollars a silvery mirrored thing, and display it proudly over their Maryland mantel. It is worth a few hundred dollars, but how can their friends who know better tell them they have been bilked? The couple is proud of never haggling.

"We pay full price. You know me. I don't haggle," says Hilary. What annoys the art world is that this competent young investment banker in his striped shirts and flowered ties would never dream of investing in a stock without adequate research and a cold eye. Yet he buys art in a free-wheeling caveat-emptor market, taking no precautions at all. Is it the dealer's fault if he

sells our friend what he desires? Well, yes, in fact it is. And when the client eventually tries to sell the mirrored gaudy, he will find he's been bilked. He'll get a new dealer and may spread the word that his first one was a crook. The dealer will resent the aspersion. He believes that collectors deserve his behavior. Even a collector like Robert Scull, who spent thousands of dollars buying art, is accused by some dealers of dealing in pictures as one deals in stocks. The trouble with art, the dealers say, is that collectors are not interested in it. They are interested in money.

Some of the customers are thieves as well. One imperiously wealthy collector bought a painting on credit, kept it a year, and returned it without paying a penny for its rent. "It doesn't wear well," he said. What could the dealer do but, grinning horribly, take it back?

Another bought a John Clem Clarke from Ivan Karp with a promise to pay. A month later he phoned with an order to sell. The profit, he felt, was obviously his, though it was Karp's money, not his, that was being invested.

One collector bought a painting on credit. Two weeks later the dealer who sold it found it up for sale at auction—as if the art market were an unregulated stock exchange and not, as Francis Taylor, former director of the Metropolitan Museum, once called it, "the one remaining currency of civilized man."

Rarely do big collectors pay in full. Some continue their debts for years. This can be carried off only by the very rich. Sometimes it is the collector who bilks the gallery, as happened once to Wildenstein Galleries when a prize client skipped the country with $400,000 worth of Bonnards, Utrillos, a Sisley, and a Pissarro. The gallery sued. To its dismay, it found that the South American magnate had left behind only $875.45 in a New York bank.

The reputation of a dealer, however, is usually more vulnerable than that of a collector. For one thing, a dealer sustains

so many conflicting relationships—with curators, critics, artists, collectors—that if he manages a good reputation with one group, he will surely suffer with another.

Like a real-estate agent, the dealer represents both sides in a deal. Almost every transaction therefore hurts his reputation, since what is driving a hard bargain to one side is avarice and greed to the other.

One reputable dealer of nineteenth-century Americana was selling two horse prints when I was in his office. He was on the phone to his client:

"No, no. I talked to the owner. He said nine hundred was too low. Do you want me to see if I can get them for eleven . . . ? I couldn't say. . . . No, I really don't know. All I can do is try. I'll be glad to. All right. I'll get back to you."

He buzzed his assistant. "I think I've sold those two horse prints," he said, rocking back in his chair happily. "Where are they now?"

"They're at Incurables," said the assistant, meaning the Incurable Collector, another gallery on 57th Street, for it is not unknown for two dealers to cooperate, just like real-estate agents, and split a commission.

"We've been offered eleven hundred," said the dealer proudly.

"Eleven hundred!" whistled his assistant. He shook his head. "They're not worth more than nine. They really shouldn't go for more than that."

"Well," said the dealer brightly. "We've got more." He was very well pleased.

Most collectors are not unhappy with their charming dealer until it comes time to sell. Then Jekyll turns to Hyde, ferocious at the client's request. Why is the dealer so cruel to a seller? What is there in his make-up that demands gratuitous humiliation, the display of overbearing power? One collector of prints and oils—not a Mellon, assuredly, or a Norton Simon, but a New York collector of considerable means—decided to sell a

book of Dürer engravings in order to buy a painting. He set out jauntily to his dealer, the same one who had sold it to him, a man with whom he had frequent business, though always before as buyer. The dealer was inexplicably busy. The collector sat two hours with the book in his lap, and when he finally did see his friend, the charm was gone.

"Well, you know, Dürer . . . the market now . . . who can I sell a book like that to? I'd love to help you, but my hands are tied."

What a difference from the sales pitch! The collector was shaken.

"He came home ashen," cried his wife. "You should have seen his face! It was white! When he walked in the door and I saw the book still under his arm, 'Norman!' I said. 'What's happened?' "

I was waiting once to see one "reputable" dealer, the sort of man who would not dream of handling a "wrong" picture. As he came out of his office to welcome me, a woman stepped off the elevator with a parcel, wrapped in brown paper, that could only be a painting. He veered toward her, waving her backward with both hands.

"I'm sorry. We're not interested."

"But yesterday—"

"That was yesterday. Today we're not interested." He turned away. What could she do but disappear into the elevator?

"You were pretty rough," I said. "I gather she was selling, not buying."

"Listen—" His hand covered his heart. His eyes widened behind black-rimmed glasses. "I'm the world's nicest guy. Ask my wife. I'm a pushover for anyone. But that woman came in yesterday—I'll tell you the story. She has a painting. Not bad, not good. A nice picture. So I said we'd give her fifteen hundred dollars for it outright or sell it on consignment at twenty percent, in which case she might get two thousand dollars, but it would take awhile. She said, can't you give me the two thousand

dollars? I said, it's not usually done. I'll have to ask my partner. Okay. I went in and talked to him. The picture's not bad. We'll do her a favor. We decide we'll do it.

"So what does she do? She snatches up the painting and says, 'I'll have to think it over!'

" 'If you come back tomorrow, we don't want it.' I told her right then. I warned her. I knew she'd be back. I tell you, she won't get a higher price on it. I found out later she'd been peddling it all over town, seeing who'd give her the best price."

"Poor woman. How does she know how to sell a painting?"

"Oh, she was so rude. Our price was good. Look" he explained. "We sell it for three thousand dollars. We'd have to have it cleaned for one hundred eighty dollars, reframed for one hundred eighty dollars, photographed. Expenses run four hundred dollars. A six hundred-dollar profit is only twenty percent."

"Did you explain your pricing to her?"

"Of course not. Why should she need to know any of this?" he answered, annoyed that anyone should doubt his good intentions with only a 20-percent profit.

If a dealer's charm turns off for a seller, it likewise disappears when there is no trade at all. One day a woman entered the Castelli gallery with her friend. She was a well-dressed lady, in her affluent forties, and, passing thoughtfully through the gallery, she proceeded back to the inner sanctum that Leo shares with his young secretary, Barbara. It is no more than a cubicle, with a small desk for Barbara and a small round white table for Castelli's work. The two looked up coldly at the ladies in the doorway.

"How do you do, Mr. Castelli. Do you remember me? I sat next to you at dinner at the Detroit Institute of Arts last year." And she gave her name. She was speaking rapidly, suddenly made shy by his stare.

And Castelli—the Italian gentleman, the personification of elegance with his Dalmatian dog at his feet, Castelli, who

would surely know how to bow over a lady and kiss her hand, not with a disgraceful, vulgar contact of his lips against her flesh, but with the merest suggestion, the quick, airy motion of aristocratic breeding—Castelli did not even give a schoolboy bump of his bottom on his chair. He stared at the woman.

"No," he said. "I don't remember you."

"Oh surely," she waggled one nervous gloved hand. "It was at the Detroit Museum of Arts Banquet last March—" she stopped, appalled. "This is my friend, Mrs. Smith." She gestured in pathetic attempt to continue the farce of social amenities, because one cannot turn and run under the circumstances. Castelli looked at her coldly. The pleasures of art may be public, but the art world belongs to a private group. While there are degrees of belonging, desire is not considered a qualification. The only entry is usefulness. The two women stood in the doorway, slowly turning toward the public exhibition area, pointing out pictures to each other with murmurs of pleased appreciation, because the exit must not seem hurried after public humiliation: one tries to salvage self-respect. So they stood in the doorway a second, struggling toward a graceful exit, when suddenly Barbara rose from her typewriter, a flash of skinny blue sweater, her powder-blue make-up flaring around her eyes like a comic-strip blue racoon.

"Madam," she said with a toss of her curly head. What was she, the wolf protecting her young? "Madam," she stepped forward.

"Barbara!" Castelli spoke firmly, calmly, as if to his dog. "Barbara," he repeated. She sat. A moment later the two women had gone, and Castelli turned back to me with the flash of a charming smile, the grace, the cordiality, as it were, of equals, and his behavior so entirely normal that it never entered his head to think I thought it odd. Did he suppose that they were social-climbing by coming to see him? She is nothing to Castelli. She is not in the art world (despite a seat at the Detroit Institute of the Arts, which she misnamed Museum), and she matters not

a jot, this well-dressed lady who undoubtedly on the street had caught at her friend's out-of-town sleeve with her own out-of-town glove: "Come on. I'll introduce you to Leo Castelli. I sat next to him at the Detroit Museum of Art, just four months ago. He is the *most* charming man."

Charm. Each gallery lives on charm, and each exudes a different aura of charm, of which the most sophisticated perhaps is Wildenstein. The most important concern of picture dealers in the world is Wildenstein. Founded in Paris in 1875 by Nathan Wildenstein (who allegedly got his start in Strasbourg by selling ties), the gallery has gone through four generations. Nathan was followed by his son, Georges, who was followed by his son, Daniel, the present head, whose son, Alec, is now vice-president. There are branches in London, Buenos Aires, and New York (the Paris branch having been closed to the public after the death of Georges in 1964).

Wildenstein is in a class to itself. It was Wildenstein that completed the sale of the Prince of Lichtenstein's "Ginevra de' Benci" by Leonardo da Vinci to the National Gallery of Art in 1967 for five or six million dollars. It was Wildenstein that bought the Velasquez "Juan de Pareja" at Christie's auction for $5,544,000 in November of 1970, when many people were suffering from the recession, and when the gallery itself had four other Velasquezes in its warehouse bins. Only Wildenstein can afford to organize exhibitions on the level of the greatest museums: Carpeaux, Sisley, Renoir, Corot. Treasures from the Walters Art Gallery. Drawings from the National Gallery of Ireland. Degas's Racing World. One Hundred Years of Impressionism: a Tribute to Durand-Ruel. Italian Drawings from the Ashmolean Museum, Oxford.

The New York gallery, a townhouse, was built in the early 1930s. It takes up three buildings on East Sixty-fourth Street, with five floors above ground and two below, and it holds a treasure-trove of paintings and sculptures worth tens of mil-

lions of dollars and covering all periods of art except contemporary.

The gallery is from another era. Through large, white, double doors, the visitor steps into a hall with pink and white marble floor, boiserie walls, a gracious stairway, tapestries, and velvet settees. For the incipient collector, uncertain as yet of his tastes, the gallery can provide in five or six rooms a guided tour through the various periods of art. Does the collector lean toward early Italian masters? The gold angel of a Filippino Lippi annunciating to a Virgin flashes against the simulated stone walls and vaulted ceiling of a medieval keep. Does he like American art? Wildenstein's can show him American paintings displayed in a red velvet room. He prefers French Impressionists? (Such wise investments these days.) He may commune with them in a spacious French-style drawing room, the deep plush rug lapping at the leather above his shoe soles. Should that not appeal to the prospective client, he may visit a tiny room of eighteenth-century terra-cotta figurines, each brown statuette multiplied by mirrors; or an eighteenth-century French drawing room, complete in every detail, from boiseries, mirrors, wall sconces, to secretaries and furnishings.

"There is no museum in the world," said Monsieur Visson, director of exhibitions, "which has not bought at one time or another from us. And that means the trustees, too, who are also the collectors."

How do they buy? The answer is aggressive: "Very simple. They come. They look. They pay."

M. Vladimir Visson, dressed in a gray suit and vest that is only a half step removed from a morning suit, emits the vaguely oily demeanor, the secretive discretion, of an old-style diplomat. Wildenstein Gallery, he says, is open to all.

Once a pair of gentlemen (said Visson) came "off the street." They approached the elderly male receptionist at the eighteenth-century secretary.

"Do you sell Bracque?"

The concierge looked blank. He glanced at Monsieur Visson, who was at that moment passing by.

"Whom do you wish?" asked Monsieur Visson softly.

"Bracque."

"No," he said with patient disdain. "We have no Bracque."

"Do you have Picasso?"

"No. We have no Picasso."

"Do you have Fauves?" asked the determined stranger.

"Yes." Monsieur Visson inclined his head. "We have a few Fauves." He led them to an inner room. Was it one of the two display rooms, where walls and chairs are covered with rich, red velvet—the kind of place that in our imaginations is reserved for illicit sexual encounters? What collector could admit, sitting on the rich red chair that he did not have the loot to compete? From the inner rooms of the galleries come discreet porters carrying paintings. One at a time, the pictures—but only a rare, rare few—are set carefully against the red velvet display rack. The two gentlemen sat in their elegant chairs. M. Visson still did not know their names. "After all," he murmured, "we do not know all collectors by sight." Eventually he asked with utmost discretion if he might know to whom he was speaking.

At the end of the showing the gentlemen rose, and with a bow of thanks and a susurrus of consulting with sisters or wives, they departed, while Monsieur Visson padded complacently away, having demonstrated, you see, that the purpose of Wildenstein's, as of Castelli's, is to serve the public.

The gallery's reputation in the art world, however, is one of business acumen. During World War II the late Georges Wildenstein is said to have Aryanized his Paris gallery, put it under the name of his vice-director, a certain M. deQuoi, and then approached the great Jewish collectors. "Look, the Nazis are coming." It was a persuasive argument. He is said to have bought many paintings cheap.

In 1955 the reputation of Wildenstein Gallery increased

when Emanuel Rousuck, a vice-president of the gallery, was caught wiretapping a competitor. The law is clear on the matter of illegal wiretaps. The Federal Communications Act (47, U.S. Code, Section 605) passed in 1934 expressly forbids it. A spokesman for Wildenstein Gallery denies that the firm was associated "directly or indirectly" with the wiretapping, and claims to have a letter from the District Attorney to this effect, though he refused to show or release the letter.

At the time, a number of industries and private individuals were indulging in wiretapping through the services of a private investigator, John G. (Steve) Broady, who was paying an ex-employee of the New York Telephone Company $100 a week to lay on the taps. Lines tapped included Hazel Bishop, C. F. Pfizer & Co., E. R. Squibb & Son, Bristol Myers, a television actress, a former burlesque dancer, a chemical manufacturer, a Columbia University student, and at least one man keeping track of his wife. Broady was also tapping the phones of the oldest and foremost art gallery in the United States, Knoedler's, and of a private dealer and art historian, Rudolph Heinemann, who were jointly engaged in selling "The Rothschild Madonna" to the Frick Gallery for $750,000. At the trial, the evidence showed Broady sold the tapes of conversations to Mr. Emanuel Jay Rousuck, a vice-president of Wildenstein Galleries. (His fascinating testimony during the trial may be found in Appendix A.) Rousuck continued as vice-president of Wildenstein until his death in 1970.

On January 13, 1954, Broady was sentenced to two to four years' imprisonment. Judge Jonah J. Goldstein addressed the prisoner:

> In many years as a judge, I have made it a rule not to excoriate defendants when imposing a prison sentence. However, the public interest requires some comment concerning this case.
> The defendant, under the guise of practicing law, operated as a "private eye," and while so engaged, he partici-

pated in and procured others to carry on the dirty business of illegal wiretapping for pay.

Illegal wiretapping is a slimy activity, which directly and adversely affects our social and economic life. It cannot be condemned too strongly.

Ralph F. Colin, Knoedler's attorney in the case, returns every invitation to the charitable benefit exhibitions at Wildenstein's with a note across the top: "I will not enter Wildenstein Gallery because they wiretap."

There is something in art that corrupts even honorable men. David Durk, now a New York policeman, a crusader against corruptions in the department, was once a dealer in African art. He admits it was not all it should have been.

"We'd get in junk carved by Africans at railroad stations in Africa. Big shipment comes in. We'd cull it. Sell the best to one particular guy because he was honest. We'd sell the rest to stores in Greenwich Village, to museum sales desks, to dealers, department stores like Macy's, Korvette's. One buyer wanted a ten-percent kickback on anything he bought. Then the store or dealer ups the price three hundred percent. You can't sell an item for five dollars; add a zero and it's snapped up at fifty." He shakes his head, uncomprehending.

"Once we got a shipment of spearheads. No shafts. Just the heads. So we got a lot of broomsticks, soaked them in creosote till they came out a nice color, you know, black. Sold them. The Museum of Natural History loved them. Another time, we had all these baskets piled up. The stuff used to come over from Africa packed in baskets. That's the wrapping, the basket. A basket costs about fourteen cents apiece. Someone comes in one day, sees them. 'Hey, how about those? They're beautiful. How much for the baskets?' So we were selling the wrappings for twenty or twenty-five dollars each. The *wrappings!*"

I am told that frauds constitute an infinitesimal percent-

age of the whole art market, far out of proportion to the fear and fascination that keep the stories circulating. Still, the frauds are there, adding piquancy to the placid pretensions of art; and it is difficult for the general public to discover which is a reputable gallery and which is not, for the art world closes, like a sea anemone, libel-cautious, at a touch.

"I know nothing about them," said one lady with a heavy French accent, speaking of a rival gallery. "Nothing at all." Then, peeking under her lashes, she added. "When I first came to work here, I used to go to exhibitions at that place. During my lunch hour, I would stop in and come back to report. One day I was told, 'That name is not mentioned at this gallery.'"

Her eyes sparkled; a little smile played at the corners of her lips. "It is a very large and reputable dealer. I know nothing about them. Nothing at all. Knoedler, too, is very old," she said. "It is even more reputable."

A good address on a respectable street is no indication of respectability. Neither is the size or grace of the gallery, nor the richness of its decor. The buyer, or seller, is on his own.

It is not unheard-of for a gallery to accept a painting on consignment—and disappear. It moves around the corner under a different name, or it goes out of business, and forgets to notify the owner or return the painting consigned. These are not "reputable" galleries. The public is urged to avoid them.

A "good" gallery will let the buyer try out a painting in his living room, and will always give a written certificate guaranteeing the painting's provenance. Moreover, a "good" gallery will take back a painting if it turns out to be, as it is called, "wrong."

It is a strange fact, however, that every gallery seems respectable when you are buying. "Try it out," the dealer will say softly. And then: "This is a beautiful painting. I've seen many, many paintings in my day, but this one is really special . . . you have a good eye." Perhaps he will leave the client alone to commune with the picture for a while. And again: "Try it out for a

while. If you do not like it, you can always exchange it for anything I've got." (Not get money back.) So standard is the practice of trying out a picture for a while that one hardly blinks, after a time, at hearing one Washington dealer murmur, "I always let a client try out a painting for a week, at no interest."

Even celebrities are taken. Recently Artie Shaw, the exband leader and show-business producer, sent two pieces of pre-Columbian sculpture to the Selected Artists Gallery at 60th and Madison to be sold, he thought, on consignment, and so enchanted was he by the dealer's charm that he neglected to draw up a written contract. It did not occur to him to ask for one. Had he not once dealt satisfactorily with Knoedler's without the gratuitous exchange of formal papers? He assumed that trust formed the foundation of art. Later, when he asked for his pieces back, he was told that he had given one away, and the other would not be returned until the confusion over the first was straightened out. The only way he could recover them would be by suing, which would cost in legal fees more than the value of the two pieces.

Herbert Kende, the owner of the gallery, showed me one of the figurines in his storage shelves and agreed that it was Shaw's. "He can pick it up anytime," he said. The other piece, he explained, Artie had given to a mutual acquaintance, a businessman who had connections with the Kende gallery. The businessman offered to let Shaw buy it back if he liked, for $700.

Now none of this touched the artists of the Art Workers' Coalition, who were not collectors, and whose work no one wished to collect. They barely knew such practices existed, and cared less, believing with the dealers that collectors brought deceit on their own heads. Who cared if collectors were hurt? The artists agreed with the words of the dealer, Sidney Janis, that you "scratch a collector and you find a dealer."

They deplored the fact that the unethical practices were allowed to persist year after year, that no one was willing to call the galleries on it, or close them down, and they saw in this re-

fusal, this condoning of greed, the same collusion and conspiracy that they saw as characterizing the entire market.

But it is difficult to close an unethical operation. In the last fifteen years only about four galleries have been busted in New York, and these at great effort, and all through the intervention of Ralph F. Colin.

Colin is an attorney, a collector, a former trustee of the Museum of Modern Art, a former member of the board of directors of Parke-Bernet Galleries, and the founder of the Art Dealers' Association, of which he is administrative vice-president and counsel. We shall hear more of him. Here is how he busted a gallery selling fakes, and you can see the kind of joint that gets closed.

One day in the mid-Fifties, Colin was walking down Madison Avenue and saw a "Soutine" painting in a gallery window. "The only thing about it that was Soutine," he says, "was that it was all red." As the owner of sixteen Soutines, he turned to his wife: "If that's a Soutine, I'll eat it." Colin asked three experts to go look at the gallery. One was Monroe Wheeler, director of museum exhibitions at MOMA since 1940. One was Theodore Rousseau, curator of European paintings at the Metropolitan Museum of Art. The third was James J. Sweeny, director of the Guggenheim Museum. All dropped into the gallery at different times and confirmed the opinion: fake. Colin reported the fraud to the District Attorney.

About the same time, a client asked Colin to go see two private dealers who represented themselves as brothers, Jewish, who had fled Russia through China with their fantastic collection of art. One claimed to be a concert violinist. Colin made an appointment to see them at their West Side apartment, and one afternoon he and his wife knocked at the door. There was a scraping and clashing of bolts and locks. The door opened. They were confronted by a a man with a gun on each hip, and a large, silent German Shepherd.

"We were terrified," said Colin. "We went in, sat down on a sofa. The man said: 'What would you like to see?'

" 'What would you like to show us?'

" 'Would you like to see a Cézanne?'

"I said, 'Yes.' He brought out a supposedly early Cézanne. An academic male nude. He said it was Cézanne.

" 'What else would you like to see?'

"He brought out a Rouault—all black lines. Then he said. 'How about a Soutine?' He brought out a red painting. All Soutines were red. Anything with black lines was Rouault. Finally I stood up. 'Thank you very much.'

" 'What do you want to buy?'

" 'I'll have to talk to my client first,' I said. 'I'm delighted to have this opportunity to see your collection. . . .' "

So the Colins departed, glad to get out unhurt, with the concert violinist pleading with Colin to try to get him engagements through one of Colin's clients, Columbia Artists Management, Inc.

Collectors are bargain hunters. There is always a collector excited at finding something for nothing. One of these contacted Ted Rousseau, who was likewise subjected to an hour in the dealers' apartment, to the gun and the dog, and the brother, his pants wet from a loose bladder, and to the horrendous paintings. In addition, the dog was in heat and kept backing, lovesick, into the curator's legs, so that he came away sickened and moved by the pathetic plight of the two fugitive brothers, and disgusted by collectors who bay hot-foot after suspiciously low-priced paintings.

As a result of Colin's complaint, the D.A. arranged simultaneous raids on the brothers at the Madison Avenue gallery and at the West Side apartment, for it turned out they ran both places. The galleries closed.

Rousseau felt the raid was unfortunate, really. It seemed unfair to pick on such a pathetic pair, given the sophisticated

twists of the legitimate art market: the misrepresentations of a picture, as distinguished from the sale of a fake; the passing-off of unknown artists as the great names of Europe or America; the sale of a "private art collection" for charity, while the collection is, in reality, a thriving auction business; or any of a dozen other illicit and unethical practices, of which only the most glamorous constitute the sale of fakes.

Most of these practices are against the law in New York State. They occur anyway. And this is why the public is advised, if buying High Art, to deal with galleries that belong to the Art Dealers' Association, since this small group of eighty-five dealers, conjoined since 1962, are committed to some basic honesty about their art. Not that other galleries may not have exquisite items for sale—but one must be careful. And not that an ADA dealer may not overcharge for a picture—but the client is protected from the most nefarious behavior. The ADA, imperfect as it is, remains almost the only protection available to an inexperienced customer. Entry of a dealer to the association is by invitation only, and the invitation comes only after the dealer has been in business for five years, long enough, in other words, to have established a reputation regarding frauds. Absence from ADA membership, therefore, means something. The advice is so simple that many people refuse to believe it.

And so it was that around this time eyebrows went up when it was discovered that a date had been changed on a Gauguin painting offered to Norton Simon—a tiny change said to be worth tens of thousands of dollars. The story was circulating the art world. It was a small picture, no more than twelve inches square.

Simon is a cautious collector. Whenever he is offered a painting, he asks a restorer to check its condition, a scholar to check its provenance, and several dealers to check its price. This time he took a transparency of the picture to several authorities,

among them Alexandre Rosenberg, a man of such integrity and innate honor that even in the art world no breath of scandal touches his name.

"I know that picture," Rosenberg is said to have said. "My father sold that some years ago to a family in Paris. Where did you get it?"

Simon named a gallery. "It's pretty cheap for a Tahitian Gauguin, don't you think?"

"What do you mean, 'Tahitian Gauguin'?" Rosenberg said. "It wasn't done in Tahiti." Now it is hard to prove that a Gauguin painted in Tahiti in 1892 is more valuable than one painted in France in 1890, and some dealers will demur and hem, but others burst out laughing and gladly admit that in the American art market this mythical distinction accounts for thousands of dollars more.

"Look at the date," answered Simon. "It's Tahitian." The date read 1892. Whereat Rosenberg went to the basement files and pulled out an ancient brown photo of the picture taken years before when his father had sold it to the Paris family. There are two versions of the story here: one that the painting in the photo had no date, the other that its date read 1890. In either case, a date had been changed.

Simon did not buy the picture.

I heard the story from several sources. I approached Rosenberg. Alexandre Rosenberg is a tall, grave man, with a long face and serious, sad eyes. Collected, contained, he sat behind a small desk listening to the account as unfolded here. When it was ended, the room silent, he sat with his elbows resting on the desk, brows knit, slowly rubbing the palms of his hands together. Finally he glanced up.

"No comment."

"Is it true?"

"I will not say anything about it."

Asked if he would show the photograph of the painting, he refused. "No," he said. "That is mine."

Norton Simon would answer no queries.

A spokesman at the gallery asserted: "The story is inaccurate. We never offered Norton Simon such a picture. We haven't had any such Gauguin." And he called for the Simon records and leafed through the much-scribbled inky index cards. "The only Gauguin we offered Simon since 1969," he said, "is a big one, very famous, published everywhere."

He would not name the picture. This is not surprising. No dealer wants to sully the reputation of a good picture by having it known that a collector has rejected it. Was the little painting offered before 1969? An effort to probe more deeply ended in a threat.

"Listen, I will tell you right now that if you say one word, you will have a lawsuit! You are not a serious reporter! You don't know anything about the art market! You are interested in gossip! Anything discussed I don't want printed. I promise you, you know, you will have a lawsuit on your hands!"

It is, you see, impossible to track down the truth of such a story. Perhaps the truth is not the important thing. What is more interesting is that the stories circulate, and no one doubts the possibility of their truth for galleries of any type.

And what does the wise collector do when he discovers that the painting he has bought is "wrong"? He sells quickly, thankful if he does not lose too much. If he is hooked on art (and this happens too, for though we ignore it through most of this book, the appeal of art is real), he begins another collection, this time with more caution. The first is racked up to experience, and sold off for another poor sucker to buy. Rare indeed is the collector or dealer who, knowing a work is "wrong," destroys it. And so the frauds circulate, providing work for yet another class of people in the art crowd: the experts, the authorities on art.

These are usually scholars, museum curators, or art historians. When a man has associated in the art world for a while, he learns to distinguish among attributions, for some will sell a certainty.

Most museum curators will not authenticate a painting for a stranger. They are afraid of being sued. A doubt about the provenance of a painting can ruin its reputation as well as its price. This happened, for example, in 1920, when Mme. Andre Kahn was negotiating the sale of Da Vinci's *"La Belle Ferron-nière"* to the Kansas City Museum for $250,000. Joseph Duveen, the renowned dealer of Old Masters, pronounced, sight unseen, that it was a copy. During the resulting lawsuit, Duveen brought in the art critics Bernard Berenson and Roger Fry and the Director of the National Gallery of Art in London, Sir Charles Holmes, to back his word. Even so, the settlement out of court cost him between $60,000 and $100,000. The painting's reputation remained smeared. It was removed from the market.

Scholars, therefore, tend to give cautious informal opinions, discreetly worded, to indicate something wrong. One lady took a questionable Modigliani to Bill Lieberman at MOMA. He took one look at it: "Good heavens, Edith, get that picture out of my office." No more was needed, nor did he care to say more, because while there is an expert for every artist known, there is always another, somewhere, ready with the opposite view. The complexity of the market and the threat of libel is such that few people care to act on their stubborn principles.

Then, too, uncovering a new fake is not always easy. Elmyr de Hory, the brilliant creator of Matisses, Picassos, Utrillos, and Dufys, fooled all the experts for a while.

De Hory was not copying existing works. He was creating original works of art.

The reason that reputable authorities bought de Hory fakes is that a fake when brand-new often appears all right. But then it starts aging in a different fashion from the original. This is a chemical process. Most aging in an oil painting takes place in the first five years. Chagall in his early days used to let paintings sit for five years in his storage bins before he would sell them, so that he could watch them age. After five years, therefore, the fake looks nothing like the original anymore. And this is why a

false Picasso by de Hory or a fake Vermeer by the Dutch forger, Han van Meegeren, were accepted when new by the very experts who a few years later turned on them as fakes.

De Hory, the artist, was bitter about the art world. He could sell almost nothing of his own works. He attributes this to the fact that the "establishment knows nothing." But scribble the name Picasso, and "they were ready to peel out any amount of money. . . ."

Some people say de Hory was a genius who could create works as great as the Masters, others that he was a mediocre talent who could copy any style. But his story illustrates the complexity of a market in which a signature becomes more significant than the picture itself. In 1955 de Hory sold a Matisse drawing for $500. The dealer sold it for $1,000, a 100-percent profit on the trade. In 1969, had the drawing been "right," it would have been worth $7,000 to $10,000. But, being by de Hory instead of Matisse, it was, of course, worth nothing. The Art Workers found this hypocritical. Some of them would have done away with either the pictures or the signature. They reacted with loathing to the story of Picasso, approached one evening in a Montmartre restaurant by an artist friend borrowing money. Picasso took the restaurant napkin, scribbled his famous signature in one corner, and handed it to her. "Don't sell it too cheap," he said.

Months later the napkin was on display in the window of Knoedler's. The story is apocryphal, but the Art Workers never doubted the intent if not the literal truth of the story.

It summed up for them the hypocrisy of the art market, where collectors are buying autographs and the dealers sell frauds, and the artists, poor things, are at the mercy of the gallery system, dependent on the dealers for their very lives.

On Reputations:
Relations with the Artist

In the 1960s a rash of lawsuits broke out in the art world. The Art Dealers' Association sued Sears, Roebuck, Vincent Price, and *The Los Angeles Times* concerning an advertisement that deceptively described works of art for sale at Sears as part of the Vincent Price art collection. A dealer, P. S. Stooshnoff, sued the ADA for saying one of his exhibits consisted of fakes. He also sued the people who proposed the show.

Peggy Guggenheim sued Mrs. Jackson Pollock for $122,000, charging a failure to hand over at least fifteen works executed by her late husband between 1946 and 1948, when Miss Guggenheim was subsidizing him on the condition that he give

her everything he produced. Marlborough-Gerson Galleries sued the sculptor Naum Gabo, who reciprocated with a countersuit. Sidney Janis sued Willem de Kooning, who countersued. Betty Parsons sued Janis, charging that he threw her out of her gallery space. Wildenstein, Newhouse, Pace, and various other galleries sued defaulting clients, and one client sued Wildenstein, which initiated a suit against an art historian.

Every now and then a scandal broke out concerning a theft, forgery, or fake. Attorney General Louis Lefkowitz stirred up a hornet's nest by trying to pass legislation to control the cutthroat art market, and he succeeded in getting through the New York State legislature in 1967 and 1968 three new laws, controlling the relationship of dealers to their clients, of dealers to their artists, and of artists' rights in regard to their work. The Art Dealers' Association opposed the legislation. Hearings were held. Artists testified. Dealers testified. Dealers allegedly put pressure on their artists to oppose the legislation. Passage, when it came, did not seem to have an immediate affect on the art market.

The New York art scene is said to have changed over twenty years. The late Forties and the Fifties was a period of idealism, in which the Abstract artists and their dealers—Charles Egan, Peggy Guggenheim, Betty Parsons, and a coterie of others—spent their time in talking, talking, talking about art and esthetics. The dealers demonstrated their faith in unknown and unloved Abstract Expressionists (as Miss Guggenheim would be the first to note) by giving them their first shows, then watched them be seduced by other dealers offering "better terms." Janis was known for "offering better terms" to an artist just as he was on the verge of fame, though Janis insists that he never solicited any artist. Pollock, Kline, de Kooning—they all came to him. (Years later, in the mid-1960s, Janis was on the receiving end when Marlborough Galleries moved in and lured the biggest names from their doting dealers. Janis lost Rothko, Motherwell, Gottlieb . . .) By 1971, the Charles Egan gallery

was still in business, though barely prospering. No supercilious girl in his gallery; barely a gallery, in fact—one small room on one floor of chic 41 East Fifty-seventh Street, and Egan himself, balding, hulking, hunched at a little table by the door, sticking notices of a future show into envelopes, licking the stamps, affixing them, and staring at the art that stared back at him in the empty room. A year later the gallery was gone.

So much for the green romanticism of the 1950s, the Pleistocene of fakes and forgeries and ruthless competition in an unregulated economy. So savage was the business that the Art Dealers' Association was formed early in the 1960s to help raise the ethics and reputations of dealers.

It was not an easy time for artists. They found a quality of meanness in their relationships. Naum Gabo, close to eighty years old, is quoted by his lawyer, Lee Eastman, as saying: "New York has not been good to me." And another, savagely: "We haven't received any gifts." De Kooning's impression of his dealer, Janis, comes out in his lawsuit, as we shall see; and while it is true that most artists have inflated egos, requiring constant stroking, petting, continual reassurance (Franz Kline had a recurring nightmare of Janis standing over his work shouting, "Get that junk out of here!"), on the face of it, dealers seem unnecessarily ruthless at times with the artists they are supposed to serve.

This was why when Marlborough Fine Arts Ltd., of London bought out Gerson Gallery in 1963 and established the Marlborough-Gerson Gallery at 41 East 57th Street, it was received with anticipation by many in the art world. The artists, in particular, felt that the big international gallery with its seemingly limitless resources and chain of international connections would have a beneficial influence on the New York scene. Adolph Gottlieb recalls with pleasure how he was wooed by Marlborough with a rich lunch at Le Pavillon, followed by the tour of the spacious new showplace where his paintings would be shown. It is a large gallery, with white walls, a blue slate floor,

floodlights, spotlights, and movable panels that permit part of the exhibition hall to be closed off without disturbing a visiting collector.

What a difference Gottlieb found it from the attitude of other dealers! In 1963 Gottlieb had won the Grand Prix at São Paulo. Would Janis give him a show? No. Pop Art was the fashion. Janis had rented a store and jumped on the bandwagon with a huge Pop Art exhibit. According to Gottlieb, Janis showed no interest in the Abstract Expressionists who had been in his stable for years. Gottlieb adored, therefore, the candor of Marlborough's Frank Lloyd as he said over lunch, "I want to work for you."

Lloyd was not like those American dealers who thought they were artists, all pats and encouragement, but no sales—or those others who misunderstood their place with an artist, who saw themselves as employers of serfs.

"I want to work for you," purred Lloyd. "I'll take a commission in exchange for selling your work."

In addition, there were the "better terms," in the form of written contracts and strict bookkeeping, quite unlike the sloppy, friendly relationships that has existed traditionally, where the artist has no idea of the names or number of his paintings the dealer has in stock.

The business of Marlborough is to sell art. It does not forget that. What artists it handles! The estate of Franz Kline, estate of Jackson Pollock, estate of David Smith, estate of Mark Rothko, estate of John Marin . . . It represents living artists: Francis Bacon, d'Arcangelo, Henry Moore, Lipchitz, Motherwell, Rivers, Clyfford Still . . . In its back bins are works by Rodin, Magritte, Giacometti, Picasso, and examples of all the schools of modern art: Dada, Surrealist, Cubist, Abstract Expressionist.

Marlborough started in London in 1948, when Frank Lloyd and Harry Fischer, two Viennese refugees who had met during World War II in a British army unit, set up in art. The business was based primarily on some rare books owned by

Fischer and "twenty or thirty" pictures that Lloyd had hidden in France during the war. Twenty years later, there were branches in Rome, London, Zurich, Toronto, Montreal, Tokyo, and New York. The operations are mysterious and complex; each of the galleries is said to be independent, yet each is linked to a Lichtenstein corporation, Marlborough Gallerie, A.G., which holds the contracts that the others negotiate with artists. The galleries cooperate closely, with art works shuttling back and forth, and Frank Lloyd presenting himself as an "adviser" or a "consultant" but acting firmly as director.

Some people feel that a kind of cynicism descended over the art world at that time, and whether the cynicism was synchronous with the new bigness of the art business, of publicity, price supports, advertising, and other cooperative business practices of a capitalistic free-enterprise system, or whether it was in relation to hopes raised, then dashed—no one can truthfully say.

The relations of a dealer and his artist are like a love affair. When all is going well, it is sweet and pure. When it is on the rocks, nothing can repair the pain. It is a landlord-tenant relationship, in which both the owner of the building and the tenant claim the territory. Only the greatest sensitivity and discretion can maintain a semblance of social harmony, and these are not qualities for which either dealers or artists are known.

Most dealers sell an artist's work on a commission basis. The commission, as noted, may range from one-half to two-thirds of the sales price. The younger the artist and the less well-known, the higher is the dealer's commission. One struggling Oklahoman has a New York dealer who takes a 50 percent commission, and an agent who takes 10 percent, leaving the artist 40 percent of every sale. It is not unheard of for a dealer to ask 60 percent, and a young, unknown artist will sometimes beg a dealer to take him on, offering 65 or 75 percent to the dealer for his cut. Such arrangements do not make an artist happy with his dealer.

Some artists receive monthly checks. If the artist has sold nothing and owes the gallery, the payment is called a "stipend." If the gallery owes the artist for work sold, the payment may merely be divided into monthly paychecks. Some galleries act almost as a bank for the successful artist, issuing a monthly check for $2,000, $5,000, or $10,000 or more, and holding the rest of his funds in escrow, to save him the onus of a high income tax. Castelli reports this situation in connection with Andy Warhol. The artist may be issued checks, according to Castelli, from January through September, then telephone: "Hey, lay off the dough for a while. I've made enough." The money will be banked by Castelli, for the myth persists that artists are notoriously bad at investments. At the Castelli gallery, the excess money is used to support younger, struggling artists who are not yet earning their monthly allowance.

There are two interesting things about the practice. The first is that it may be tax evasion. If an artist makes a sale in any year and the purchaser paid the artist, he must pay taxes on the sums received, whether the funds are delivered to him or kept by his agent. The second thing to note is that it may not be the dealer's generosity that supports the young artists, but that of the established artists.

Occasionally a dealer will buy the artist's work outright. This is the system widely used in France. It is not common in the United States. When the artist has produced very little work, the gallery then lends him money, with the future work as collateral.

Only a few large established galleries can afford to give stipends to their artists: Castelli, Marlborough, Janis, Knoedler. They handle the stars. Even so, the artists earn their pay.

The gallery advances the artist, for example, $1,000 a month. This is an investment on the part of the gallery. It allows the artist to eat and buy brushes. At the end of, say, one year, the dealer gives the artist a one-man show. Let us say that he sells $13,000 worth of pictures. The artist, having already re-

ceived $12,000, gets $1,000, minus commissions. Possibly he receives less, for it is not unknown for a gallery to pass on to the artist some of the expenses of advertising, packing, framing, and moving. This, too, contributes to the natural antipathy between artist and dealer.

The artist sees the dealer as a leech. He is aware of the profits that are sometimes made, aware that dealer and collector Ambroise Vollard, when he died in 1939, was a millionaire ten times over who traced his fortune to the day he found Cézanne depressed in his studio and bought two hundred fifty canvases from him at an average of 50 francs apiece. He kept most until he could get 10,000 to 50,000 francs for each. Janis made enough money, first in shirt manufacturing and then in art, to have built an art collection worth three or four million dollars, and Marlborough Galleries boasts that annual sales of all the galleries exceeds $11 million, though it is true that most art dealers do not climb to these profitable heights.

But relations between the artist and his dealer are complicated also because the artist wants things too. When he gets an honorable dealer scrupulously devoted to his artists and their art, the artist may not always be satisfied. "What am I going to do?" he asks. "What am I going to *do?*" And, counting school bills and rent for his loft and the number of paintings sold, he deplores his plight. "My dealer is a wonderful person. But he isn't working for me. He isn't *selling.*" And when another dealer "offers better terms"—which he can manage by virtue of those tough business notions, the promotion and publicity that the artist loathes as much as he needs—what can the poor artist do? He goes. Betty Parsons's distaste for Janis is founded partially on this competitive urge, since Janis can afford higher terms than others. It is not lessened by his having once evicted her from her gallery. For fourteen years, she had rented gallery space at 15 East 57th Street, a coral-cluster of art dealers. When Janis wanted to move into the building, she helped him find space. Then one day she found a letter under her door, giving

notice to move in two weeks. She discovered that Janis was to enlarge his gallery into her space. She took the case to court: she had always paid her rent, been a proper tenant . . . Janis points out that the responsibility was the landlord's. In the end she unforgivingly relinquished her gallery space. Her satisfaction came when IBM later bought the building and evicted all the tenants, including Janis, though he offered to pay four times his rent if allowed to remain.

Most artists are close-mouthed about relations with their dealers. They do not like to talk about them even to other artists, some out of shame, perhaps, on the theory that if only they were better artists, their dealer relationships would be better; others because they are by nature close; or still others because they understand how insecure collectors are, how easily frightened by the prospect of an artist who cannot sell. It is best to start no rumors.

One French artist, represented in a number of museums, told of his New York gallery, which gave him a stipend of $200 a month. It was barely enough to support himself in Paris, but it was something.

Then came the one-man show at the gallery. The artist sent over a group of paintings. The dealer arranged that the gallery should get two paintings free; the rest were to be sold on consignment. The artist and his wife flew to New York for the important show. They could not get the dealer to pause long enough to say which paintings he chose as his two. "Oh, we'll talk of that later. Not now. Tell me, what do you think of the lighting?"

Only two paintings were sold from the exhibit. One was bought by a museum, the other by a collector. At the end of the show, the artist asked for his money. The dealer said, "Oh, those two paintings were mine."

The same artist had an exhibit in Milan. His European dealer flew him to Milan to promote the show. The exhibit was a big success. Everything sold, and the two returned happily to

Paris. At Orly Airport, forty-five minutes from Paris, the dealer remembered an appointment. "Well, good-bye."

"But wait," cried the artist, "I have no money."

"What do you mean, no money!" said the dealer in surprise.

"No. Look. None. I turn my pockets inside out. I have nothing."

The dealer gave him fifteen dollars.

A dealer in Germany wanted to give the artist an exhibit. The artist sent thirty or thirty-five paintings and waited and waited. He heard nothing. He could find nothing. The gallery had moved, taking his paintings with them.

"I have lost perhaps two hundred paintings without a penny," said this artist. Such behavior also occurs in New York, though it is larceny and against the law. It is hard to stop. An artist may leave his paintings on consignment, return in a few weeks or months and discover—nothing. The gallery may have moved only around the corner under a different name. The artist, with neither knowledge nor funds, is helpless to find it much less sue.

Our French artist had an exhibit in Paris. He went to see his show. He saw red dots everywhere. "Wonderful!" he said. "Big success." The dealer said, "Oh that. That is for psychology. We haven't sold all of those. That is to make it look good for the people, you know."

The artist turned as he told this story, the pain showing in his eyes. "Only they had," he explained. "They had been sold."

"Dealers," says Lee Eastman, the lawyer for many artists, "dealers are like the theatrical agent who looks at his movie star and says, 'That son of a bitch is getting ninety percent of my money.'"

Dealing is a difficult business—the first to feel the pinch of recession, the last to reflect economic exuberance.

"When I hear an artist talking about his dealer," said one dealer, who switched from contemporary to Oriental art, "I say,

'Don't give your dealer a hard time. I know. He's on the verge of collapse. Support him. He needs your help.' "

It is sometimes true. But the large and wealthy dealers are the ones with the worst reputations among artists. The richer the dealer, the more callous his behavior, it seems, if we care to believe artists.

One day in the early Fifties, de Kooning needed money. He called his dealer, Sidney Janis. It was a Tuesday. "I need three hundred dollars," he said.

"I don't have any money now," said Janis. "I'll have some on Friday. Call me back on Friday."

When de Kooning telephoned Friday, he found that Janis had left for Europe the day before. The story is told by Eastman, who represents de Kooning.

Years later the love affair landed in the law courts. What happened was this. Janis had been de Kooning's exclusive agent since 1952. For some twenty months in those early days, they had operated under a written contract. Janis gave de Kooning four hundred dollars a month as stipend, plus a charge account for artist's supplies. The contract expired in December 1953, and the oral agreement was reinstated, for in the art world, the written contract is not common: dealer and artist always begin as friends.

Twelve years later the love affair was over. De Kooning split from his dealer, and Janis was furious. De Kooning walked out. He did not put his decision in writing.

Janis sued the artist on eight counts, for sums totaling $500,000. One count said that de Kooning had split before the one-man show scheduled for later that year, which would have grossed $450,000 (according to Janis), giving Janis a $150,000 commission.

A second count was for recovery of $50,000. This was the amount that de Kooning had borrowed from the Chase Manhattan Bank, the loan having been *guaranteed* by Janis.

Janis kept the de Kooning pictures he held in stock.

De Kooning (who by then was wealthy enough to bring suit) filed countercharges that (1) he owned the paintings that Janis was holding and wanted their return; (2) Janis had failed to give him a full accounting of sales or an inventory of paintings in stock; (3) damages amounting to $250,000 were owed "by above improper sales, improper prices or otherwise improper dealing"; and (4) Janis was invading de Kooning's privacy by continuing to advertise him as one of the artists for whom he acted as dealer. De Kooning asked $150,000 damages for unauthorized use of his name.

He also filed a complaint that Janis, his brother, and his nephew had bought de Kooning's works. The artist never had known who bought his paintings. He was surprised and disgusted to discover it was Janis who had bought some, at a one-third discount, since he knocked off his commission.

As the suit continued, it came out that the paintings in Janis's possession were worth $500,000 (the amount of Janis's suit). Janis claimed they were being held as a lien against $3,948.68, which he claimed de Kooning owed him.

De Kooning denied owing $3,948.68. He offered, however, to put this sum in escrow if Janis would release the $500,000 worth of pictures to him.

In 1970, five years after the beginning of the proceedings, the Court of Appeals decided the paintings should be returned to the artist.

Meanwhile, Janis was accusing de Kooning of selling $46,000 worth of pictures directly from his studio, thus avoiding commissions that would have gone to Janis as his exclusive agent. In his suit, Janis demanded all the money back from de Kooning that he had ever paid out to him in support, beginning with that very first four hundred dollars a month. The case continued for six years. One day, when it was ready to go to trial, it was settled on about the same terms offered six years previously: namely, that Janis would give a one-man show of de Kooning's works in October 1972 and waive all other claims.

Suits occur even when contracts are spelled out in writing.

Paintings are money to a dealer. When the sculptor Naum Gabo quarrelled with the giant concern, Marlborough-Gerson Galleries, which claimed breach of contract and damages of $375,000, the gallery slapped an order of attachment on twenty-eight Gabo works being shown at the Albright-Knox Gallery in Buffalo and insured at the time for $1,500,000.

The order of attachment was brought on the grounds that the artist was living in Connecticut and had no property in the state of New York, an assertion that Gabo later contended was their perjured testimony, for the gallery retained three Gabo works, worth some $100,000. Gabo claimed them as his. He charged Marlborough with "capricious refusal" to return his work, and he hired Lee Eastman to vacate the order of attachment. It was as a result of this suit that the New York legislature passed a law making it illegal to bring an order of attachment on an artist's property while on museum exhibition.

Marlborough claimed that Gabo, by refusing to deliver his works for a New York exhibition, had deprived them of an anticipated profit of approximately $300,000. Gabo filed counterclaims of $105,000. He claimed that Marlborough was still advertising as his representative. "I am seventy-eight years old," he wrote in a deposition in March 1969, "and require the works for exhibition." And again, a year later: "I have suffered much privation in my lifetime and thoroughly understand the necessity for financial prudence. . . ." The twenty-eight works in the Albright-Knox Museum were "all my life's work, and all that is attached is my life's work, but I am in serious danger of having my life's work destroyed." Eventually the suit was settled, when Gabo agreed to sell six pieces of sculpture to Marlborough.

Only the most established, wealthiest artists are in a position to sue. Most artists are not in a position even to quarrel with their dealers, much less to go to court. Their problem is to establish any relationship at all, to find a dealer who will handle

them; and this for an unknown artist, or one passed by, is not easy.

"That's interesting," said one dealer when shown an artist's work. "Come back when you have twenty or thirty more paintings of that caliber."

The new artist is as lost in the New York gallery scene as our novitiate collector. He, too, has been subjected to the humiliation of a gallery's hauteur. He has struggled, confused, through the marsh of gallery names, lost his paintings to crooks, in desperation, perhaps, exhibited on the sidewalk of the outdoor Greenwich Village show. He may have tested the terms of a vanity gallery and wondered if this was the proper way to get a start, or joined an artists' cooperative as a "viable alternative" to the gallery system. But no buyers would come to the exhibits. A review was so rare as to create appalled discussion, pangs of jealousy, and hurt charges of bribery and collusion.

How then can he get his work before the public? How does he get seen? It is not easy. He trudges the streets showing slides of his work to gallery after gallery, leaving his slides, returning for his rejection, and the humiliation to which he is subjected makes the humiliation of the public appear to be courtesy.

Many dealers refuse to look at slides. "Oh, Christ! They're so bad," said one dealer. John Myers is quoted as saying over WBAI radio that he simply won't look. "Artists who send slides aren't very good," he said flippantly. Thousands of artists come to him every year. "I won't see them," he says. "I won't look." If they come to him, they cannot be good. The only time he will see an artist's work is if it is recommended by another artist.

An artist had a 3 P.M. appointment with one dealer. He did not know the owner by sight. "Tell him I'm not here," said the owner.

"I'm sorry, she's not in now," said the assistant.

"When do you expect her in?" A shrug. Because he could not recognize her, the artist waited in good faith. And waited. At 6 P.M. he was still there. The gallery was closing, and he stub-

bornly remained. In irritation the dealer said: "Well, what do you want? Maybe I can help you."

"I want to show my work, my slides." She flipped through the slides, holding them casually up to the light with swift determination.

"Okay. There. I'm sorry. We can't handle you."

An artist took his slides to the Larry Rubin Gallery. Poor fool. How was he to know that Larry Rubin takes on only artists recommended to him by his brother or the critic Clem Greenberg? The artist left his slides with a haughty girl. When he returned a few days later, the secretary said Rubin was out. "Didn't anyone tell you we aren't looking for new artists?"

"No. No one said anything." She flipped through the slides, supercilious, and tossed them back. "I suggest you take them to—" and she whipped off three names. "You know who they are, don't you?"

"Oh yes," he answered stiffly. In the elevator he scribbled down the names. He had never heard of any. And for a long time he was convinced she was making fun of him, that the galleries did not exist, for artists develop a paranoia about galleries.

The gentle tact and consideration of an Ivan Karp or Klaus Kertess, who make a point of seeing slides, is so unusual among dealers that it is remarked upon. It is discussed in the art world. Everyone approves, and people add their own story of how dealers do not look at slides, though Roy Lichtenstein got to Castelli's attention by taking around his slides, and Ernest Trova, now at Pace Gallery, was found through slides.

One art critic becomes furious at the dealer's behavior. "They have nothing to do all day. They should look at the work of every artist who comes in. One day I went up to a gallery. The owner throws her arms around me! 'I haven't seen anyone in three days!' she says. 'I'm so glad to see you.' But she probably refused to see ten artists with their slides in that time!"

How, then, does the artist become known? Not by knock-

ing at the doors of a museum. The Guggenheim Museum gets fifty calls a week from artists in Ohio, Iowa, Illinois. Most are turned away with a note that the museum is not in a position to help. Sometimes, out of courtesy, the curators will look at slides. But curators cannot often help. Museums are trackers after trends. They cannot give shows to unknown artists, but only to those already acclaimed by dealers and collectors, to those who have already reached the top.

How, then, does an artist find a dealer? The best way is through another artist already with that dealer. The dealers listen to their artists. They don't give a damn about most museum curators. They don't listen to most critics. Certainly they do not trust their own eyes. But they listen to their artists. An artist without a dealer, therefore, will make a point, as it were, of knowing the prominent artist in the loft below or next door or down the street, in the desperate hope that he will tell his dealer to see this friend, because while it happens occasionally that Castelli will find a Lichtenstein from his slides, or drop in at an unknown artist's studio and sign up Jasper Johns, it does not happen often. Referral is the preferred route.

On the other hand, sometimes one artist will steal an idea from another. If he can market it first, the fame will be his, for the execution, the craftsmanship, is not the important fact of art, but the idea.

This is why, in a cutthroat market, many artists lock their lofts against their fellow artists.

Critics of Art

Among the general public, critics, unlike dealers, enjoy a good reputation, and this is certainly due in part to the fact that critics do not come to public attention as often as dealers. Critics are scholars, or at least they are expected to be, and they are accorded all the benefits that society extends to learned men.

Art critics are rarely employed as critics full time. They are university professors, or museum curators, or the wives of artists struggling to pay the rent. Often they are former artists —people who once dreamed of being famous artists and found that, like the friendly track ponies that travel with race horses to keep them calm, they can as critics still breathe the air of the

world of art. It is said that some critics can make or break an artist, and the artists, being only humanly ambitious, are as aware of the value of a review as are the dealers and collectors.

One ex-critic, interviewed for this book in her ivory Park Avenue apartment, became increasingly upset. Her hands were in constant motion. She lit a cigarette, stroked her hair, sipped her coffee, played with a knickknack, put it down, stroked her hair, sucked her cigarette again, and turned away.

"My, you ask such big questions," she said. "Look, I saw a lot of things," she burst out, "the power-mad megalomaniacs doing things just for their egos. It wasn't always like that, but when art became Big Business, I saw all these power-hungry people—"

"Do you mean critics? Dealers?"

"No. Not dealers. I won't say. Museum people, the whole thing, doing things for meanness or to make a profit. I got out. I don't care to talk about it."

And she would not say another word, though an irreverent look at the history of contemporary art will show the tangled fate of artists and critics, and makes one wonder how much influence accrues to noted critics and how much can be exercised.

Throughout the history of American art, it has generally been conceded that there was none. American artists trotted humbly to Europe to study, where they were brushed off as imitators. The situation obtained until well into the 1930s, despite various futile efforts to establish American art on its own terms. No one believed in it. Not until the 1940s, when Europe was rocked by war, did American artists emerge with a stunning, romantic style, the New York School, or Abstract Expressionism, or "Action Painting," as it is sometimes called—not, as one might suppose, in open admiration of the free-swinging movement of the artist's arm in creating the forms and sweeps of motion, but because the artist encounters his canvas as on a field of

battle—and attacks! The result, the ensuing "action," is what the collector buys. A million words commingled with the movement, for the feeling prevailed that the paintings did not speak for themselves. The feeling ran especially high among the general public, which did not like the work at all. But Abstract Expressionism rode the crest for fifteen years—the first American International Art Style.

Critics sprouted to support it. There was Clement Greenberg, who revealed the "leadership" of Jackson Pollock and, according to other critics, systematized the history of art to show a linear evolution from the Renaissance to his own favorites. He became extremely influential.

Opposing him was Harold Rosenberg, who is generally credited with coining the term "Action Painting." Himself a poet, he saw art in terms of creative experience, personalities, and politics. His choice was Willem de Kooning, and the long-standing antagonism of the two critics is said to date from this period, when Greenberg's passions would erupt into fist fights in the Cedar Bar—an artists' hangout where the critics naturally hung out too.

Curiously, both critics seem content with their opposing critical territories. A critic makes his reputation by having a strong personal point of view. It must be simple, clear, and preferably controversial enough to invite attack by other critics, so that his fame rises with the dust of battle.

The 1950s was the heyday of *Art News*.

So enthusiastic .was *Art News* about Abstract Expressionism, Willem de Kooning, and his wife, Elaine de Kooning (herself both a critic and a painter) that it became embarrassing. One artist, who was also an Abstract Expressionist, remembers in the early 1950s going to the magazine's young editor, Thomas Hess:

"I do think there is such a school as Classical Art. Don't you think a broader point of view might help the magazine?"

The magazine evidently did not, for the idealization of the art style continued until the art crowd was joking about "Abstract Hesspressionism."

Art News was the most widely read art magazine of the 1950s. Others of the period were *Magazine of the Arts* (which died), *Art Digest* (which became *Arts Magazine*), *Art in America*, and *Art International*.

Then suddenly in the early 1960s, up popped a new art style: Pop Art. It happened, it seemed, spontaneously. It was in the air, and the winds of change blow on everyone. It burst open in 1962–63 with Rauschenberg and Jasper Johns, Warhol, Lichtenstein, Dine, Rosenquist, Wesselman, and others.

It is said that the artists did not know one another, and to their surprise discovered themselves working on the same problems. (In the literature, artists "solve problems.") Jim Rosenquist, for example, was a serious artist working as a billboard painter in order to earn enough to pursue his serious art. He would hang over Times Square on a scaffold, painting the nose of a face in five colors. In 1960 he stopped painting billboards when two men fell off a scaffold to their deaths. He got married. Then he stretched a canvas and painted three cows swimming across the top of the canvas, noses above the symbolic water, a huge woman's face intersected by a child's mouth, a salt shaker sprinkling salt on a man's lapel, and a nude man committing suicide. He showed it to some friends "Hey! Wow! Great!" they exclaimed, and Barbara Durkee told Alan Stone, who told Ileana Sonnabend, who told Dick Bellamy and Ivan Karp and Henry Geldzahler and Leo Castelli, who came down to the studio in that order to see the picture. Bellamy brought the collectors Robert Scull and Emily Tremaine. "You think you're the only one doing paintings with no drips in them," said Mrs. Tremaine. "There's a fellow over in New Jersey painting comic strips." Later Rosenquist discovered that other artists were working with the same ideas, that there was a movement—a School!— which Lawrence Alloway, the critic, would name Pop Art. If the

artists did not know about a school, the critics and dealers did. Pop Art is said to have been promoted in a fashion that made the presentation of Abstract Expressionism naïve. (Rosenquist painted over the canvas, leaving only a part of the woman's face and a tomato moist with dew. It is called "Zone" and is owned by the Tremaines.)

Art News remained faithful, throughout, to Abstract Expressionism. Meanwhile, Clement Greenberg was championing Color Abstraction, which became known as the "Washington Color School," or "Post-Painterly Abstract Expressionism." This consisted of such painters as Kenneth Noland, Morris Louis, Jules Olitski, Gene Davis, and others who were experimenting with colors juxtaposed in sharp geometric forms or blurred in veils and stains. The most famous of his protégés were Noland and Louis. Greenberg saw it as the "mainstream" style, "the only legitimate heir of Abstract Expressionism and by extension of the School of Paris."

By the end of the 1960s, Greenberg's Color School artists were being shown in four important galleries in New York, Paris, London, and Toronto. They were being collected by museums, including the Metropolitan, MOMA, and the Smithsonian, and considerable muttering could be heard, not always good-natured, about the Mafia and the Kosher Nostra.

So there were three art styles, like rivers, dividing and flowing down the decade of the 1960s: Abstract Expressionism, Pop Art, and Greenberg's Color School, as well as thousands of droplets of artists who belonged to no school and are never heard of in the literature. New critics came along: Lawrence Alloway, Barbara Rose, Michael Fried, Max Kozloff, all searching for their identities and espousing the avant garde with energetic ebullience, shifting from Pop to Op to Structural to Conceptual to Destructivist to Political. Some critics (Lucy Lippard, Barbara Rose) gave up art criticism for politics and the mass media. Some artists began writing criticism, so that it was possible to find in one issue of a magazine a critic interviewing an

artist and in another issue the same artist writing criticism. *Artforum* became the vehicle of the avant-garde, as *Art News* had been of Abstract Expressionism. *Art International* and *Art in America* became "more important" in the 1960s as *Art News* declined and, gasping for air, struggling to find its identity in a society that had set galloping off after another fashion, finally settled down by 1970 to reporting on art rather than promoting it. And no one considered, any more than they had ten years earlier, whether the job of a critic is to push a particular art style or to appraise it. Or whether there is a problem among critics of conflict of interest. No wonder the Art Workers' Coalition was concerned.

One day in early 1970 Barry Schwartz, who was himself a critic and qualified therefore to speak, brought up the subject at an AWC meeting. He delivered a soft-spoken denunciation of art magazines and critics and editors, explaining them as one more example of the collusion of the free-enterprise system.

The other artists listened with interest. They agreed to form a committee to investigate critics and conflicts of interest, and if it had not comprised such a giant job, they might have finished it too. They did not know that ten years earlier John Canaday, the art editor of *The New York Times*, had fired Dore Ashton (the only critic ever called on conflict of interest), or that Canaday was then censured by the Art Critics Association (the only critic thus censured), while the Association collapsed under the strain of its decision.

The story is worth telling, even though it happened some time ago, because it illustrates some important points about critics and their place in the art market.

The Ashton Affair

Dore (rhymes with Laurie) Ashton was art critic on *The New York Times* for about four years when, in 1959, John Canaday took over as editor of the art page. Both critics are still active in the art world—Dore as a free-lance writer and head of the Department of Art and Architecture History at Cooper Union, Canaday as senior art critic on the *Times*. Their fight revolves around the two most significant questions of art criticism: the audience to whom a review should be directed, and the position of the critic on the art scene. The clash left unhealable wounds.

Dore was twenty-nine years old. She had studied art in Paris and received an M.A. in art history from Harvard. She was

married to Abstract Expressionist painter Adja Yunkers. Young, passionate, romantic, she saw herself as a nineteenth-century critic, born of a literary tradition, a Baudelaire, perhaps, writing about art in order to explain to herself its profound attraction for her, believing in art as an uplifting, moving experience. Fierce, freckled, fiery, she is the antithesis of Canaday. He is a tall fellow who holds himself straight. His clothes hang strictly on his rectilinear figure. Everything about him, including his sardonic humor, is efficient, rectitudinal, severe.

Canaday had also studied art history in Paris, and had studied to be an artist at Yale University before quitting the profession with some relief. He then taught art, wrote seven murder mysteries (under the pseudonym Matthew Head) and several "Miniatures" for the Metropolitan Museum of Art, and all twenty-four series of "The Met Seminars in Art" before moving, at the age of fifty-two, to the *Times.*

In 1959 the *Times*'s art coverage was limited. Canaday was invited to join the staff because interest in art was rising in 1959, along with the prices, and the *Times* had decided (according to Canaday) to upgrade all its cultural coverage: theater, art, films, books, "all the way through."

Dore, passionate, accusatory, charges that Canaday had it in for her.

"He marked up my articles for one year with red pencil, analyzing them," she says, her voice catching with pain. " 'I wasn't prejudiced against you,' he told me. 'You're a bad writer.' "

She had already had a run-in with the Sunday editor, Lester Markel, about her vocabulary. "The commuter from Scarsdale does not carry a dictionary, Miss Ashton," he had told her.

One day a year after Canaday arrived, Dore found on her desk a memo. Four pages single-spaced, it left no possibility of misunderstanding. It struck Dore, just back from Europe, like a thunderclap.

There were two complaints: first, that her prose style and

the content of her pieces were not suitable for a wide, unspecialized newspaper audience. She wrote obtusely, incomprehensibly, said Canaday. She further tended to rate artists according to some abstract critical standards that may be common to scholars but are anathema to the masses.

Second, her position as the wife of an artist created a potential conflict of interest:

> We must correct during the coming months two situations with regards to your work on the Times, the first having to do with your way of writing for this paper, and the second . . . with a conflict between your professional position and your personal one as the wife of a painter and the close friend of a circle of painters and dealers. . . . The essence of the first problem is that the New York Times is a newspaper, and that those who write for it must justify their space by writing intelligibly and interestingly for a wide audience. This need not mean vulgarization in a derogatory sense of the word, but . . . you direct your gallery reviews to a very small audience of artists and related specialists.
>
> It is necessary for me to point out that you have been asked to redirect your writing but have not successfully done so.
>
> . . . Upon assuming my duties I talked over with you the character I expected your reports to take. Shortly thereafter I asked you to do your first piece on the subject of the coming season, directing it toward a wide audience to stimulate interest in the art shows just opened and those announced. I said that you might include conjectures as to what kind of season it promised to be.
>
> You categorically refused to try what I wanted, saying that you were hired as a critic and not as a reporter (a contention not supported by personnel's files) and that you would not do a "New Yorker gossip column" or perhaps you said "shopping column" under your byline. You finally avoided the issue, as I should not have permitted, with a routine listing [Sept. 9, 1959] of shows current and forthcoming.
>
> New in my job, I had to let things slide as far as your

articles were concerned while I learned my ropes. The result was that you continued to write as you pleased, which was the way I had wanted to change, and which the Managing and Sunday Editors agreed should be changed when I analyzed the Times art coverage for them before being offered the position of Art News Editor.

Things came to a head with Mr. Catledge's objection, shared by other editors that your January 6, 1960 article was incomprehensible. . . . We have managed to eliminate the most esoteric phraseology from your articles but they are not yet satisfactory to me or to the editors. Esoteric phraseology aside, you give the impression of having nothing to say to a newspaper reader.

. . . As an instance of your failure to do so: Your review of Frank Roth's show at Grace Borgenicht's was limited to a pointless description of his style which was neither criticism nor reporting. . . . When you do more than describe a show, you tend to "rate" the painter according to a limited and largely arbitrary standard. . . . We ask that you write . . . to a wide public.

This brings us to the second and extremely difficult problem of the confusion between your personal and professional life. Marriage to a painter and identification with a certain circle of dealers and other painters would automatically disqualify any candidate for a position on the art news staff of the Times. (Compare your position with that of Mrs. Nixon or Mrs. Kennedy, if they were trained political theorists, as political reporters on the Times.) In the words of Mr. Catledge in a memorandum on a related subject, ". . . it is wrong for any of us to put ourselves into a special or subjective relationship with anyone whom we may be called upon to criticize or deal with in the course of our work as reporters, critics or editors."

You are often difficult to defend against the charge of using the columns of the Times for the professional and financial advantage of your husband and friends, although I want to believe that you do not do so deliberately. Nevertheless you are incautious.

He gave examples from the work of the past two years: an article on the Baltimore Museum of Art at a time when the museum had recently acquired one of her husband's paintings, a glowing report of a new Ford Foundation grant to individual artists, one of which her husband later received.

Such stories reveal an attitude that makes the rest of your opinions suspect no matter how innocent your intentions. For instance, I could not help noticing that the only interview you sent from Paris this past summer was pegged to the publication of a book, one book among the hundreds of art books being published, by the Grove Press, which is also bringing out your book on Guston. You collaborated with Emmerich Gallery in the publication of your "Poets and the Past" in connection with one of their exhibitions, thus further identifying yourself commercially with the gallery that had already scheduled your husband's one-man show. . . .

On February 5 you covered a show at Trabia Gallery in which your husband and other painters were exhibiting, and gave it a laudatory notice that we may take for granted was deserved, but your covering the show was contrary to the agreement of long standing that you would not cover shows in which your husband's work appeared. Since then you have not done so. . . . But your disappointment in Mr. Preston's review of your husband's show (Paper of November 8, 1959) was so great and was expressed so emotionally that I asked him, as I should not have done, to make it a little more favorable if he could—which he did. I mention this to show that your association not only affects your own writing but is a deterrent to an objective point of view on the part of the other members of the staff.

In hunting a solution to the problem, we must begin with the flat rule not only that you cover no exhibitions where your husband's work appears but also no exhibitions in galleries where his work is for sale even if it is not on current exhibition. . . .

I am directed to make in this memorandum a clear

statement to the effect that you are receiving a final warning of discharge if your performance does not improve sufficiently within six months' time. We want to give you a fair trial and to make an earnest effort to assist you. Henceforth . . . your copy will be used only if it is found to be fully satisfactory. . . . If this results in an abnormal amount of rewriting or very little use of your copy, dismissal will be necessary. . . .

Dore blew her stack. When she answered Canaday in a memo a few days later,* she was spitting mad. She had spent the weekend drafting replies, and the more she thought about it, the madder she got. She decided she would resign before having her reputation impugned, her material rewritten. Rarely had she been so offended: "an earnest effort to assist you," he had said, "prejudicial personal and professional associations . . . Your copy . . . will be rewritten." The words were emblazoned on her mind.

Her answer, placed on Canaday's desk on Monday morning, was a diatribe, reviling her boss with references to Zenocrates and Zola, and throwing back at him his own published words. "I demand—" she wrote fiercely; "I categorically deny—"

"You have maliciously impugned my professional integrity. . . . Your attack sounds like a mad clamor to drown out a critical voice that differs from your own."

Meanwhile Canaday passed a memo to Dore's desk (for by now they were not speaking), as tersely phrased as if written between gritted teeth. "From now on, make . . . carbons," it said. "You may want to defend yourself. . . ."

I won't go into the bitter, ugly fight that ensued, and which so scarred the combatants that now, more than twelve years later, they are left with bitter gall, hoarding their separate manila files on the subject, the papers inside yellowing and cracking with age. Dore characteristically marked her file

* See Appendix B.

"L'Affaire," while Canaday called his "Ashton." ("I'll bet you'd like to see this," he said pulling the file out of his desk, ready at hand ten years later in the right-hand drawer. He slapped it down efficiently on the breadboard of a drawer pull. "But you won't.")

Looking back on it now, Canaday bows his head. "I was made a goat," he murmurs. "They should have done it, not me." For he was acting on the principles of his managing editor, Turner Catledge, and the Sunday editor, Lester Markel, who had crossed swords with Dore in years past about precisely the two topics of Canaday's memo: the proper style and content of art criticism, and the place of the critic in the art market. "Her relations with the Sunday Section were such that [the] . . . head would not accept material from her. I was made a goat."

Dore took the case to the American Newspaper Guild. They told her they could protect her job category, but not the fashion in which she was treated by her employer. Canaday was going to look over every word she wrote, give her assignments where formerly she had chosen her own. . . .

There was a scene at Canaday's desk with Dore, hurt and angry. "I'm not going down without a fight," she cried. Within two days, however, she had resigned.

Canaday outlined the kina of person he wanted for her job. He gave Dore a copy:

> We need a person, presumably young, with a sound knowledge of the arts to back up a wide acquaintance with contemporary art and a lively sympathy for it. He, or, of course, she, must be a good writer with enough of the journalist in him to be interested in making sense to a wide intelligent audience without specialized knowledge. . . .

Canaday breathed a sigh of relief. It was over. He had no idea that the matter would flare up again into a scandal that would burn him, Dore, and the Art Critics' Association, and be whispered about for years.

Dore had no intention of leaving matters where they were. If the charges were not unjust, why had the *Times* kept her on its rolls for four long years before Canaday arrived? Why had she received so many letters of congratulation, plaudits, praises for the sensitivity of her criticism? She had been married to Yunkers when the job was first offered to her. The paper had even wanted her enough to hold the job for a full year while she was away in Europe.

She sent Canaday's original memo around to art-world friends, crying out in her shame and hurt. She was Dido inveighing against the gods, the beggar displaying his sores.

Letters arrived at the *Times*. They came from both notables and nobodies in the art world, and they universally deplored Dore's dismissal.

"Not a lot," says Canaday. "Half a dozen letters." Then muttering, half to himself. "The *Times* doesn't fire people because people object." An odd comment. Was his job on the line too? The *Times* is sensitive to controversy. It must have been a bitter time for Canaday.

Meanwhile, he denounced in a three-column article the partisanship of some critics for their favored artists. He did not name names. He did not have to. Tom Hess, editor of *Art News*, knew just whom he meant, and so did the others. They were the cream of critics, who for ten years had made no bones about their heros, believed, in fact, that the function of the critic is to tell the masses whom to like. They were incensed also by the source of the attack, for since his takeover of the *Times*'s art pages the previous year, Canaday had been firing away at Abstract Expressionism. In doing so, he ranged himself against the dominant style of painting in the United States for the past fifteen years, and against the critics who supported it. More than this: he subscribed to the "conspiracy" theory of art-world politics, publicly denouncing back-room machinations of an art crowd who were putting something over, in effect, on the strong,

honest rest of the world. This did not make him popular with the art crowd.

"A dangerous man," people said of Canaday. (They say it still.) "He hates art. Deep, deep down, he hates art."

Now events took an unexpected turn. What had been (he thought) a minor personnel problem was abruptly a *cause célebre*—a Dreyfus affair, with overtones of Censorship and Freedom of the Press.

No wonder Canaday was hurt. No wonder he sits rigidly at his desk now when questioned about it, making his point again and again: "At *no* time, at *no* time, at *no* time, did we try to apply any censorship, or direct her point of view. Never, never, never, never." He shakes his head, as if to shake away the memories. "In that memo to her, I should have put in a sentence that 'of course you're a critic. Your opinions are your own.' But it seemed so obvious. Redundant."

He makes the point over and over. Dore was *not* rewritten. She was *never* edited without her approval, except once, when she wrote an article from Europe and could not be available for editing. The last article she wrote was not very good. "She knew it," comments Canaday. "She handed it in saying, 'This isn't very good.' It was rephrased, but there was no change of opinion."

The dispute swayed, centered over conflict of interest and the level of writing, scholarly vs. journalistic.

Dore marshaled her forces. They included Tom Hess, Meyer Schapiro, Leo Steinberg, Harold Rosenberg, Peter Selz, curator of Painting and Sculpture Exhibitions at MOMA (a personal friend and co-chairman with Dore of a "Journal" for the Committee for a Sane Nuclear Policy). Altogether, seven outstanding critics joined to write Robert Goldwater, president of the American section of the International Art Critics' Association, requesting a special session of the Association to take under consideration the Ashton affair.

The letter was written only two days after Canaday's attack on critics appeared in the *Times*. Given Dore's high qualifications and her length of time on the staff, it said, Canaday had offended her "rights and responsibilities as a critic" by ordering her to change her written opinions to accord with his, and by asking her to substitute for sound art history "gossip and speculation about sales, prices, and motives of collectors."

They wanted to expell Canaday!

The Art Critics' Association has never been particularly active in the United States. In fact, the Ashton affair is almost the only step it has ever taken. Founded in 1951, the American section concerns itself now with building a membership (mostly by not accepting resignations) and getting American delegates to attend the IAAC meetings overseas—which is not easy, given the poverty of most critics. Meetings are infrequent, dues are rarely collected. But in 1959 it was on its way to becoming a viable association.

First Canaday thought of defending himself. Clifton Daniel, Assistant Managing Editor at the *Times*, was aghast at the idea of his sending a letter. "The *Times* does not apologize," he explained to Canaday, and ordered him to get the letter back.

Canaday's only defense, therefore, lay in a stiff note drafted by Daniel:

> The charges against me contained in the letter signed by members of the IAAC appear to relate solely to my position as an editor of *The New York Times*. I respectfully submit that in that capacity I am answerable only to my employers. . . .

At the meeting with seventeen out of fifty members present, Canaday was not expelled. He was, however, "severely censured" for "having treated a fellow critic in a manner unbecoming to the profession of criticism, violating her dignity as a critic . . . aimed at forcing compliance with his own views and methods . . . of judgment. . . ."

He was censured in other words for embarrassing a fellow critic. As if the Association's act were not an equal embarrassment!

The *Times* was the only paper in the country to report the censure.

Canaday was shaken, but Dore was elated. "It was the first time," she said, "that the Art Critics' Association took a stand on freedom of the press!" Some time after Dore Ashton left the *Times*, she won the Mather Award for Art Criticism, the highest award that can be given by her peers.

It is quite obvious passions rose to such a pitch in this struggle that they completely obscured the serious issues that began things. One has the feeling that the art crowd suddenly realized the issues might sting them all and closed ranks in mutual, silent support. No one ever undertook again to question conflict of interest among critics or what the place of a critic should be, or what is the proper content of critical writing, although all these factors affect the buying and selling of art. In fact, everyone tried to forget the issues, and even today the participants of the Ashton affair avoid discussing how things exploded in 1960 and threatened to blow up in everyone's face the good reputation enjoyed by art critics.

Dealing in the Critics

The irony of the Ashton affair is that Dore was pulled up short by standards that do not apply in the art world. No wonder she was angry! If she liked a painter—and he happened to be her friend, even her husband—her enthusiasm was based (by art-world standards) on objective critical training alone. She was aghast at the idea that bias could affect her critical faculties. Moreover, compared to many critics, she was clean. She was not building an art collection. She had not taken money from a dealer. She was not pushing a group with whom she had financial interests. No wonder she was hurt. No wonder Canaday was nonplussed by what, to him, was her blindness to the potential

conflicts of her situation. They were working from different moral codes.

There are no formal qualifications for being a critic. There is no training required. There are no exams to be taken, no panels to pass. Not even an art-history degree is necessary, though one is generally recognized as useful, if only for throwing in an opponent's face.

Neither, however, is there any money in writing art criticism. *Art News* pays an average of $200 for a long article, plus expenses. *Artforum* pays $150 to $300, and in its salad days ten years ago paid only $50 to $100. You see why it is a virtue in the art world for a critic to be enthusiastic about the artist. He writes not for profit but for honor and prestige and the love of art. He believes in the artist and in the importance of his criticism to the life of the art. As he sees it, art is not a universal language, a smile or frown instantly understood. It is often a troublesome, bewildering, and terrible experience. Some art sometimes speaks to some people sometimes. But most art requires the services of a critic in order to be understood. Art languishes without criticism. Art cannot develop without the free flow of discussion about it, and this is why (the critic reminds himself in moments of doubt) the artists read art criticism more than anyone else. Collectors follow. People who *care* read criticism.

The critic's self-image is explored by Leo Steinberg, an art historian and Renaissance scholar who has also experienced the peculiar pleasures of critic of contemporary art. He writes in *Other Criteria:*

> A work of art does not come like a penny postcard with its value stamped upon it; for all its objectiveness, it comes primarily as a challenge to the life of the imagination, and "correct" ways of thinking or feeling about it simply do not exist. The grooves in which thoughts and feelings will eventually run have to be excavated before anything but bewilderment or resentment is felt at all.

For a long time the direction of flow remains uncertain, dammed up, or runs out all over, until, after many trial cuts by venturesome critics, certain channels are formed. In the end, that wide river which we may call the appreciation of Johns—though it will still be diverted this way and that—becomes navigable to all.

Most people—especially those who belittle a critic's work—do not know, or pretend not to know, how real the problem is. They wait it out until the channels are safely cut, then come out and enjoy the smooth sailing, saying, *who needs a critic?* *

The failing of John Canaday for many in the art crowd lay in his waiting for the channels to be safely cut. He did not dare to be engaged, to proclaim his beliefs, they said, and neither would he recant in print if he ever changed his mind. Therefore, he did not take art seriously, they said, and as a critic he could not be taken seriously.

Critics classify themselves in various ways. Some make a distinction between art historians and art critics. But for contemporary art the distinction is meaningless. Others divide themselves into the art "journalists," who write for mass media, and art "critics," who write for a tiny and specialized audience in a specialized journal. Still others distinguish between critics who know the artists they are writing about and those who make every effort not to. The last two classifications overlap, the journalists by and large being the ones who avoid knowing the artists. The two groups, journalists and critics, view each other with reciprocal scorn, but both are intent on forgetting that they influence the market. The money of art upsets them.

Two problems arise in talking about critics. First, to separate critics, journalists, and editors is nearly impossible. Is Harold Rosenberg, who writes for the *New Yorker*, considered a journalist or critic? Is Hilton Kramer, who was once editor of

* Leo Steinberg, "Jasper Johns: the First Seven Years of His Art," *Other Criteria*, Oxford University Press, 1972.

Arts and is now the critic on *The New York Times*, an editor, reporter, or critic? Or Tom Hess, who worked at *Art News* for more than twenty years and was formerly its editor—is he considered an editor or a critic? The offices overlap, despite the art-world classifications of a restricted post. I cannot untangle the mess, except to advise the reader that generally—unless specified to the contrary—I am talking about the critics who write for scholarly, specialized art magazines.

The second difficulty arises out of choosing examples. If I mention a minor or relatively unknown critic, the reader is lost. "Who?" he asks, with perfect justification. Yet to use only the leading critics as examples leaves the erroneous impression that the practices I am discussing are restricted to a very few. Far from it. It is the profession as a whole that I am talking about, and if I choose examples from those critics most likely to be known, it is only because . . . they are known.

It is distasteful for a critic to hear a dealer say, "I sold a Ken Noland today because of your review," or "I just raised the prices of all the paintings by a thousand dollars after your review." Barbara Rose, ex-wife of artist Frank Stella and a critic in her own right, shudders on remembering the first time it was brought home to her. Hilton Kramer, art critic for *The New York Times*, shrugs it off irritably: "I'm not interested. I don't care what the price is."

Prices remind the critic of a responsibility he does not want. He comforts himself that no one can know, anyway, how much influence he has, that there are no proofs, no scientific sets to determine that critic X made sale Y.

This is why a great deal of time is spent in the art world laughingly discussing how little influence this or that critic or art magazine or newspaper has.

For a critic to deprecate his efforts is not difficult. Numerous and conflicting views of every magazine and critic circulate

the art world, and comfort in the form of inconsequence is always at hand.

A favorable review in *The New York Times* (it is said) can pack a gallery. A picture in the *Times* will sell the painting by telephone sight unseen, before the morning is out. The opposite is likewise heard: a good review in the *Times* (it is said) is the kiss of death. The "real" collectors pay attention to "serious" critics in the scholarly art journals.

In fact, both statements are true. The dealer, faced with a reluctant collector, will believe his own words as he suavely explains, "Oh, the *Times*! That's not criticism! I haven't heard anyone taking the *Times* seriously in—Ah . . . but *Art in America* [or *Studio International* or whichever review he wishes to bring to the collector's attention], why just the other day I was talking to the editor, who said . . ."

Nonetheless, the dealer wants his shows reviewed in the *Times*, and on the next occasion that the review is good, he has no compunction about using its leverage to close a sale. That is his job.

So important is a review in *The New York Times* that the editors are occasionally telephoned by dealers: "What does it cost to get a review?" Or, with even less class: "I'll buy a half-page ad in the paper if you review my show."

It is the shadier, fringe gallery that behaves so improperly—often a foreign dealer unfamiliar with the distinction between the methods of art journals and American journalism. It is also the gallery that is never reviewed.

"It doesn't take any money," shrugs Canaday. "I just have to be interested in the art."

Dealers need their shows covered. They want listings in the popular magazines, such as *New York* or the *New Yorker*, and they want long, critical reviews in the small art magazines. The situation may be negative in that they do not want their shows ignored, for criticism is actually advertising. They are willing to pay for it. Most art magazines wade in the red and

most therefore borrow color plates from the galleries, dealers, or museums, to save money. Why not? they ask. The dealer is making them anyway for his catalogue, so why not use the pictures twice? If the dealer is making no beautiful catalogue, the costs of color plates will be shared between dealer and magazine, or between museum and magazine if the article is about a museum exhibition. The plates amount to a substantial contribution to the magazine, since these periodicals exist on the quality and number of their color reproductions. True, the cost, especially in small galleries, is sometimes passed on to the artist, for one cannot expect the dealer to risk his neck too far. The art magazine graciously provides preferential placement for an ad. It is no accident, for example, to find a long interview with Ad Reinhardt in *Artforum* and one page away a full-page black-and-white startling ad:

THE ESTATE OF AD REINHARDT IS HANDLED
BY MARLBOROUGH GALLERIES

Art is visual: even an unfavorable review is advertising, since it spreads the pictures of the artist's work. Moreover, the thrust of the review often does not matter, art criticism being as a rule so obtuse that most people cannot understand it anyway. No one who has read art criticism can help marveling that critics have any influence at all, or that a man who decided to dedicate his life to visual rhythms should be deaf to sound and sense.

The influence of a critic is derived, one suspects, not so much from his writing as from his personal contacts, from cocktails, lectures, cruises on collectors' yachts, and the passage back and forth between art trades. There is a constant movement of people around the jobs of the art world, from college professor to museum director to dealer to magazine editor, so that the influence of any one man is unable to be estimated. When he holds two jobs simultaneously, his influence is enormous.

Gerald Reitlinger in *The Economics of Art* describes how

in the late eighteenth century people wanted dark canvases, "hard and dry." The prejudice was almost two generations old and was coming to an end when in 1771 Sir Joshua Reynolds, one of the foremost painters of his time, laced into the entire sixteenth-century Venetian school—Titian, Tintoretto, Veronese—as mere decorators, obsessed with color at the expense of form. His teachings debased the market, and one could buy cheap Veroneses and Tintorettos well into the nineteenth century. At the same time, it raised the market of those seventeenth-century Italians, which were the proud possessions of the artist's patrons.

Sir Joshua Reynolds had a collection himself, and, being in addition both artist and critic, he managed to sustain the market. When he died twenty-four years later, his collection came under the hammer: four hundred and eleven pictures, which the executors believed included seventy-four Van Dycks, fifty-five Correggios, forty-four Michelangelos, twenty-four Raphaels, and eleven da Vincis. Unfortunately, the price realized represented less than twenty-five pounds a canvas. This happened before the time of auction reserves, and would not be allowed to occur today.

The relationship of critic to artist is rarely admitted in print in any art magazine, because in the art world everyone agrees that a critic "has a position on art" and uses another to promote it. (Indeed the crime that the inquisitory critics laid against Canaday was that he did not openly state his position, and this left them uneasy, uncertain of what he was going to say at any moment.)

Then, too, so small is the art world, so interrelated, that it seems impossible to find a man without ties. Moreover, if a man with connections may be biased by his involvement, a man without connections is helpless in the miasma of art movements. Add to this the reluctance of blowing the whistle on one's fellow professionals—of betraying them, as it were (which was Canaday's crime) and you understand why everyone ignores the situation

in the hopes that it will disappear, or perhaps under the naïve impression that it is inconsequential.

Moreover, relationship in itself is no evidence of venality. Many are merely the accident of time and chance. Those who know the ties and relationships will understand (the art world consoles itself) and those who do not are not being cheated or harmed by their lack of knowledge, their laziness, actually, since they could easily, it is said, find out the relationship themselves, just as the rest of the art crowd has done. Everyone puts out of his mind the idea that money is involved.

Alexander Liberman, an artist with Betty Parsons Gallery, was art (layout) editor at *Vogue*. His stepdaughter, Francine du Plessis, who was a contributing editor for *Art in America*, was married to Cleve Gray, an artist who also shows at Betty Parsons and was likewise contributing editor to *Art in America* and sometimes wrote for *Vogue*.

Brian O'Doherty, who followed Dore Ashton on the *Times*, is an artist and the editor of *Art in America*, as well as program director for the Visual Arts of the National Endowment for the Arts and an adviser for Abrams's art books. *Art in America* is owned by Whitney Communications Corporation, whose chairman, John Hay Whitney, is a collector, a trustee of MOMA, and the vice-president of the board of trustees of the National Gallery of Art. *Artforum* is published by Charles Cowles, who is the stepson of Gardner Cowles of Cowles Communications, who is a collector and a trustee of MOMA. Henry Geldzahler, curator of twentieth-century art at the Metropolitan Museum of Art, was program director for the Visual Arts of the National Endowment, a close friend of many artists, and friend and follower of Greenberg. No wonder the Art Workers were paranoid over plots, collusion, and conflicts of interest, especially those who were not making it.

The magazine critics, on the other hand, see themselves as governed by a certain ethic, not perfect perhaps, but better than some others; and they comfort themselves that there is in

the world somewhere, someone, whose activities are more suspect. One is reminded of the remark of a famous ballet critic who, when accused of writing only about people he had slept with, answered: "How else can you get to know them?"

In Paris critics are "owned" by dealers. This is not unethical (we are assured) because "everyone knows" that a particular critic works for a particular dealer. The cost of paying the critic is, of course, often the responsibility of the artist. Gonzalo Fonseca, an Uruguayan sculptor, had a show in Paris just after World War II. A critic came peering around the corner.

"Ah, you are the artist? Would you like a review?" he asked. "What kind of review would you like?" It was scaled according to price. "What about a twenty-six-thousand-franc [$300] review?"

"Oh, I can't afford that, really. That's too much."

Eventually they settled on a fifty-dollar review—lukewarm and short.

If the artist has no money, a painting will do. With the rising art market, the critic is glad to get a painting, and the practice has become so common apparently in Paris that it is almost automatic for a critic to receive a painting from an artist after a review.

Larry Rubin, a New York dealer who originally established his gallery in Paris, explained the morals. "It's not really corrupt, taking a painting," he said thoughtfully. "It's not like taking money." The dealer then proudly recounted how he bought several Dubuffets for $250 each from an art critic who was hawking them. It was a coup for Rubin, since Dubuffet was not then as expensive as he later became.

American art critics laugh at the French. They claim the custom can never take hold in New York. Hilton Kramer remembers having drinks with a friend, a French critic, in his Paris apartment.

"Doesn't it bother you," he laughed, glancing around the

room, "accepting paintings from the artists you write about?"

"Oh, I would never accept one from an artist I did not respect," he answered, much to Kramer's amusement. Mr. Kramer was editor and part-owner of *Arts* magazine before he came to the *Times*, and hardly an hour had passed after telling this story when he told of an artist who, having received enthusiastic reviews from *Arts* magazine, sent a case of whiskey to the staff and a painting to Mr. Kramer. Was he disturbed? "I'd already said everything good I could possibly say about the artist," he shrugged. "So it didn't make any difference. But I'd never accept a painting," he added seriously, "from an artist I didn't like."

Lawrence Alloway, formerly curator at the Solomon H. Guggenheim Museum and now professor of art at the State University of New York at Stony Brook, used precisely the same words to defend his gifts. "I'd never accept work from a painter I didn't respect," he said. And to critics this is accepted as proper, for he has not betrayed his convictions—as allegedly is the practice in France, as allegedly is the crime of Canaday.

None of the critics apparently understands that Alloway's sentence can be easily turned around: The work of a painter that the critic did not respect would never be good enough—would never be valuable enough later on—to bother accepting. Motives notwithstanding, the practice is suspect.

In New York an artist frequently gives a critic a painting. Is it a *pourboire?* To a degree one can understand why a young, unknown artist gives away a painting. When Richard Tuttle, an artist at the Parsons Gallery, was struggling, working seven and eight hours a day, his whole life involved in his art, and still had never sold a work; and when he then discovered a critic who liked his art—he was ecstatic! His work was liked. Was recognized. In gratitude, out of love for the painting, as it were, and to find it a home where it would be lovingly received, he gave the critic a painting. One can understand, even smile, at his naïve pleasure.

But why does Helen Frankenthaler, an Abstract Expressionist whose reputation was established more than ten years ago, give Barbara Rose a painting after a review in *Artforum* of a Frankenthaler exhibit? Out of friendship? Because she likes the work so much? So do many others, Miss Frankenthaler, and they pay $2,000 and up for a sizable canvas! Because the gift is tradition? Because the article was very warm and sincere and open in admiration?

And why does Miss Rose or any other critic accept it? Why not say, "Thank you very much. Thank you for the gesture. I cannot accept, but let me come and look at it occasionally on your walls because I value your friendship." What is the critic's need to accept the art? To possess the art?

Miss Frankenthaler was appalled when asked about the gift. "Oh, don't say that," she said in shocked, gentle voice. "The gift had nothing to do with the article, in terms of sequence of events. I've given her paintings before—the way I'd give a painting to my niece. I like her. I like the painting." Then she asserted that trying to bribe or reward a critic would do no good anyway: "You can't buy the truth," she said confidently. "*Don't* say I gave her a painting after the article . . . it's not kind . . . also, it's not true."

The irony is that a critic who would be shocked at taking money or a hundred shares of stock from an artist will make the extraordinary jump in logic to accept a beautiful painting—"Because we got to be quite close friends," he explains simply. Or, "He wanted me to have it." Or because "I didn't want to hurt his feelings. He would be hurt if I didn't accept it." It never crosses his mind that the artist does not hand a painting to every guy who walks into his studio. And the critic comforts himself that it is not something he is going to sell. Clem Greenberg, who openly sells these gifts when he needs money, takes a painting with the option that, if he later sees one he likes better, he can trade in the old model. If the artist offers him one he does not like, he rejects it. The late Barnett Newman told Harold Rosen-

berg of Greenberg's coming into his studio and asking for a painting. Barney was going to give him something small—a lithograph perhaps.

"I don't want that," said Greenberg. "I want that big one over there. It's your best picture." And Newman, inwardly raging, capitulated to his own ambitions and handed over the painting. Greenberg takes only the best. Can you imagine the affect on the art world of that thought? Or the reverse: he will not accept what is not best. Ken Noland relates that de Kooning at a party took Greenberg to his studio and told him to pick out anything he wanted—to Greenberg's embarrassment, for he is not fond of the artist's work. "I don't want anything," he said.

It is worth something to the artist to be seen on the right living-room walls; and if the critic has an undisclosed stake in the artist's reputation, it is not for the artist to question.

To a certain extent, the critic's position may be analagous to that of an investment adviser who, after examining an industry, recommends a securities position. If one agrees with the simile, then the critic is left in the ambiguous position of affecting the art market even without intending to. On the stock market the Investment Advisors Act of 1940 prohibits recommending a security without fully disclosing one's interests in it in advance. No such formal regulations exist in the art market, and most people, apparently surprised to discover that art has suddenly swelled to a multimillion-dollar business, still operate on the one-to-one relationships of a small town where human frailties are excused by loving acquaintance, and ethics are a matter of conscience. The art market is more complex than stocks. Who is to say that writing approvingly of an artist whose works hang on your wall is intended to affect the price? Still, it may be that the art world is also naïve to the point of simpleness, so natural does its behavior appear.

"You don't think," said one dealer in astonishment, discussing the practices of critics, "that the financial reporters on *The New York Times* or *Fortune* aren't boosting the stocks they

own? Everyone does it!" And this is the attitude of most of the
art crowd, who generally act surprised to learn that on business
journals reporters are prohibited from promoting their own in-
vestments. At *Fortune* a reporter cannot buy or sell stock in a
company that he investigates until a month after the article has
appeared in print, and men are occasionally fired or punished for
violating the rule. In the art world few standards exist even for
defining a critic's wrongdoing: whether it is proper for a critic to
accept paintings from an artist he will write about; to know the
artists personally; to have a collection; to sell pictures to raise
money. Among the art crowd almost all criticism is silenced if
the critic has not "betrayed his convictions" about the art.

In the United States, relations between an individual
critic and a gallery are more discreet than in France. At the ex-
treme they take the form of Marlborough Galleries asking Law-
rence Alloway, the English critic, if he would like a free trip to
Switzerland to see the artists abroad that they were going to
show (he refused); or, while Alloway was organizing a Francis
Bacon exhibition as a curator at the Guggenheim in 1963,
whether they could fly him to England to talk to the artist,
whom they represented. Marlborough, however, is a large and
business-like corporation with a down-to-earth, pragmatic view
of a critic's role. I suppose there must be critics who believe ac-
ceptance denotes no indebtedness to the gallery, else Marl-
borough would not make the offer.

Occasionally you hear of a critic being paid by a dealer.
This is considered so offensive that it either happens rarely or is
simply rarely discussed. I am not talking of the critic who writes
the preface to a gallery catalogue. This is merely the perform-
ance of a job, and it happens openly and frequently enough to
warrant no comment—unless by chance the critic were to pan
the artist's work. I am talking of the critic who produces an arti-
cle for an art magazine in return for which the artist's *dealer*
sends a check.

Sometimes the dealer pays a critic a little something to

review his show and then suggests that the critic try to sell the manuscript "on spec" to one of the large art magazines or to any of a dozen impecunious publications that circulate in universities and schools. As the magazines pay around $300 or less for an article (the less being the more common), and are therefore always hungry for articles, the chances of publication are pretty good. The critic receives a check from both the magazine and the dealer.

Sometimes a critic, all unsuspecting, will get an assignment from an art magazine and then, to his surprise, receive a check from the artist's dealer. There is no point in returning the check. The article is already in print. The critic was used to write a piece commissioned, in effect, by the dealer, who, knowing the critic's convictions, is assured a favorable review. In some cases the dealer sends his check to the magazine, which in turn issues it in its own name to the critic, so that the critic may never learn that his enthusiasm was bought by a dealer. The magazine is mum.

Leo Castelli admits indirectly subsidizing a critic. The ethics are sufficiently unclear for him to feel justified doing it.

"Why does anyone pay huge sums of money for a Cézanne?" Castelli was quoted in *The New York Times Sunday Magazine*. "Eight hundred thousand dollars. Why should it have value? Because it's a myth. We make myths about politics. We make myths about everything. I have to deal with myths from 10 A.M. to 6 P.M. every day. And it becomes harder and harder. We live in an age of such rapid obsolescence . . . Who decides what is art?" he continued, and his explanation explains everything about a dealer's ideals. "Not I. Certainly not I. I don't decide what art is. My responsibility is the myth-making of myth-material—which handled properly and imaginatively is the job of a dealer."

Art criticism is important to the making of images and myths.

In 1961 an Italian magazine, *Metro*, wanted to run an ar-

ticle on Jasper Johns, the Pop artist, who has become most famous, perhaps, for his targets and flags. The editor approached his friend Castelli. He wanted a good critic. The name of Leo Steinberg came up. The magazine could only pay $300 for an article, and Castelli said bluntly: "I don't think he'll do it for less than a thousand."

The magazine had no money. Castelli therefore dug into his pocket and found $700. "And seven hundred dollars in those days," he remembers, "was like—I don't know—thousands today, when I didn't know where my next money was coming from. I paid and I got one of the best articles ever written about a great artist. Johns is a great artist, and I believe a great artist rates a good essay. Was I wrong?" he asks appealingly. "Should I have not helped my artist, so you had a second-rate critic write a bad article? Would that have been better?"

And Steinberg? He knew nothing about it. It would have made no difference anyway, for he had not betrayed his convictions. Imagine him: thin, bearded, pipe-smoking scholar of Borromini. He had tried his hand at writing a monthly column of contemporary art criticism in the Fifties. He quit after ten months. He disliked the constant calls from artists and their wives, pleading for reviews. All his relationships were becoming politicized. He quit, pleased at winning the Mather Award for his criticism and liking the feeling of involvement that comes with working with contemporary art. But in 1960 he was in his forties, and confronted for the first time with the work of Jasper Johns. It bewildered him. It became a symbol, a last chance at fleeting youth, if he could only reach out and understand it. It was a life force. It became a challenge above mere observation of a work of art. He started to write an article, trying to work out in his own mind the iconography of Johns. One day at Castelli's, at an exhibit of Johns's work, he mentioned that he was thinking of an article on Johns.

"Do you have a place to publish?" asked Castelli.

"No," answered Steinberg. "I've given that no thought."

Castelli mentioned that *Metro* might like it.

"Fine," said Steinberg. "I don't care where it appears."

"They'll pay one thousand," said Castelli, and Steinberg was pleased by that.

"I'd never received so much for an article before. A thousand dollars. The most I'd ever gotten before was one hundred and fifty-six dollars from *Partisan Review* for an article I had worked on for two years. When I was writing for *Arts Magazine* in 1955, I was given seventy-five an article."

The piece took six months, and he did not know until years later that Castelli had put up some dough. Later the article was revised and republished by Wittenborn, and ten years after that it was again revised for inclusion in a book. By then the year was 1972, and Steinberg was fifty and reconciling himself to age. He had returned to his Renaissance, deciding that there is mission also in being the standard against which youth rebels. Well, he would be that. He would symbolize age. Now only two things interest him: sex and age, he avers, as if the two were different or less absorbing in one's youth.

"People will say I was buying a critic," said Castelli. "I wasn't buying a critic. I was making it possible for a critic to function. The article was first-rate, epoch-making. Not shoddy. There is no such thing as adequate myth-making."

He was not buying a critic. But he was buying an article, and the fact of its necessity to the artist would be more gracefully received had the magazine included a note to the effect that two-thirds of the critic's payment had come from the dealer who handled Jasper Johns.

No one knows how frequently the practice occurs, for it is not boasted about in the art world. The Art Workers believed it was common.

The business of criticism is murky. Not because promotion of favorites often occurs, nor that profits are made, but because the practices are subversive, sheathed in secrecy and the

pomposity of esthetic pretensions. Frequently, standards become so involuted and the ties and relationships so sweet that no one can untangle them. They are alluded to among the art crowd slyly, by innuendo and sordid insinuation—and to the outside world but rarely.

There are four kinds of suspect relationships between a critic and an artist:

1. There are critics whose closest friends are the artists they write about.
2. There are critics married to or sleeping with the artists they promote.
3. There are critics who collect works by the artists they write about.
4. And there are critics who are known to buy and sell—to deal in other words, in art.

In addition, some critics may actually be artists, a fact not always obvious from the magazine blurbs. For example, the artist Darby Bannard writes under the name of Walter D. Bannard. It is hard to get a much closer relationship.

Six defenses are used to justify a critic's personal associations with an artist.

The first defense is tradition, which points out that since the time of Xenocrates the historical role of the critic has been to interpret the artist's work from personal knowledge of the artist. How else does one understand his meaning, his intent? Without his personal information, art history would be the poorer.

Unfortunately, the definition confuses two functions: that of a biographer, whose purpose is to describe another person's life, and that of a critic, whose purpose is to judge that person's work. Moreover, the evil does not lie in the critic's knowing the artist or writing about him. It lies in hiding the liaison. It lies in writing about the artist as if speaking from the remote objectivity of art history and implying an oblivious unconcern for the artist's life.

The second defense commonly presented to justify a critic's close relationship with an artist is that it is desirable. This defense justifies even the collection of the artist's work, though a collection clearly gives the critic a stake in the artist's career. ("A critic learns so much," says one critic-cum-dealer, "by living with a work of art. There is no other way to learn.") The defense makes no distinction between a professional association governed by professional respect, and the closer relations of the friends one drinks, eats, socializes, and sleeps with.

The third defense claims that a close relationship is acceptable because "everyone does it."

The fourth defense states that conflict of interest does not exist, or that if it does, it represents so infinitesimal a fraction of the art world as to be insignificant, that a person sees what he wants to see, and if she's looking for dirt, if she's that kind of muckraker, she'll find it. The old saw about news stories is true: the every-day "dog bites man" makes dull reading, but "man bites dog" sells books—irresponsible though such a publication may be. There is no answer to this attack, as it is no defense.

The fifth defense, rarely heard, insists that there is nothing to be done about it. "What would you have?" comes the reply. "Government regulation?" And unless one favors this, he must agree that there is nothing to be done short of maintaining certain standards within the profession—or publicizing loudly that sometimes critics may be more than they appear.

The sixth defense is that the critic does not collect in order to sell. He is working in good faith. He is not dealing in art, and then the speaker, in saying this, will suddenly stop as he remembers the gossip about two critics . . . two. . . .

Do Critics Deal?

There are two critics whose activities surprise even the cynical art world, but despite the talk, the art crowd continues to court them, giving only an occasional sneer or covert, questioning look—to which each responds according to his own character. One is William S. Rubin, chief curator of the paintings and sculpture collection at MOMA. Another is Clement Greenberg, his friend.

Bill Rubin considers himself unjustly vilified, the victim of time and circumstance. He is sensitive to the suggestions about his reputation, and suffers in a position that he sees no way out of, and where the criticism against him is largely cir-

cumstantial—as he is quick to note. They are malicious assumptions. At MOMA he has organized exhibits of artists who are in his personal collection. His younger brother, Larry, is a dealer in New York, selling some of the same art that Bill collects, that the museum exhibits, and about which Bill may write or speak favorably in his capacity as a teacher, curator, and critic; and whether a person sees wrongdoing in the relationship of MOMA to Rubin depends on how respected, how influential as a taste-maker he considers the opinion of the Museum of Modern Art in New York; for Bill represents not merely his own opinion but that of the museum. He speaks for the museum. He is himself enough aware of its respect in the art community to appreciate his position on the staff.

Bill has formed, one after another, a number of collections in his forty-two years: German Expressionism, Surrealism, Abstract Expressionism, the Art of the Sixties. In the late 1950s he became a friend of Greenberg and, generally agreeing with his eye, started buying the Washington Color School, which a few years later became the rage. He also bought a smattering of Pop Art (which Greenberg dismisses), as well as Stella (whom Greenberg finds a minor artist). Rubin calls his collection a "working collection," in the sense that he learns from it.

"It keeps changing," he once explained, "as my ideas develop." And whether by accident or the peculiar delicacy of his vision, his ideas change with the times, so that he is ever a step ahead of the current vogue. When the Museum of Modern Art included Rubin's collection on a fund-raising tour of "visits to private collections" in May of 1962 (Rubin being an art history teacher at Sarah Lawrence at the time, not yet on the museum staff), the young scholar was dogmatic about the correct representation of his collection. "The Collection of Professor William S. Rubin," he asked that it be labeled, and where other collectors amiably allowed the program to give name, address, date, and a modest acknowledgment, "under the auspices of the Museum of Modern Art," before listing the paintings on their walls, Rubin

inserted: "These are selections of recent American paintings and sculptures from the 'working collection' of a professional art historian and critic."

He had Pollock, Still, two Nolands, two Morris Louises, two David Smiths, a Motherwell, a Helen Frankenthaler, an Ellsworth Kelly, and others—outrageously avant-garde in 1962. But what was curious was that the remains of his previous collections were to be found only in a few paintings by the Surrealist, Masson, one of which was evidently of sentimental value, since it was inscribed to Rubin personally. He insisted these should not be listed on the program, so that the visiting ladies paused in puzzlement over the unlisted pieces: "Is this the Kline?" they would murmur, groping for the program in confusion, uncertain why the paintings on the walls were not all listed as being in his collection.

Bill has tried to explain the confusion. He says that the Surrealists—Miró, Magritte, Tanguy—"wouldn't hang with" the Abstract Expressionists. He had put them in his mother's house. Bill sees his collecting as an enlarging, rather than a shedding, of tastes, a growing from the center out. His first collection, of German Expressionists, was formed when he was a graduate student. It consisted of two pictures, one a Kokoschka, which was later part of an exchange he made for a Jackson Pollock, the other a Kirchner, which he gave to MOMA in the early 1950s. His next interest was Surrealism. In the early 1950s he exchanged some of his Surrealist pictures for Abstract Expressionist pictures, though he has some Surrealists in his house in France. He still has the bulk of his Abstract Expressionists, and considers it one of the best collections in the country. The art of the Sixties represented another enlargement of his tastes.

Bill Rubin was born in Brooklyn, the grandson of a Russian immigrant, and the son of a man who made his fortune in the wool business. The oldest of three sons, Bill at forty-two is six feet tall, but stoops so much that he gives no impression of height. He is stocky with curly, brown hair turned steel gray at

the sideburns. His eyes are a deep calf-brown and slightly bulg-
ing, as if in perpetual surprise. An operation on a fractured disc
in his back (the result of a skiing accident) has left him with a
limp. He leans nonchalantly on a silver-headed cane, *très dis-
tingué*, smoking a pipe, and his hauteur is marred only when he
swings his broad face around and the words tumble out of his
mouth in broad-based New York accents, like sincere little frogs
tumbling over his proud effect. There is a pleasing naïveté in
Bill's approach, a humorless honesty, a fair-play, do-the-right-
thing directness that has little to do, of course, with the com-
plexity of his position. Bill is nice, and in the museum it is gener-
ally agreed that his recent marriage and the excruciating pain
from his back have mellowed his temper and the pomposity that
used to be frequently displayed.

In love with learning, he has graduate degrees in Italian,
musicology, history, and a Ph.D. in art history. Graduating from
Columbia at twenty-four, he got a job teaching at Sarah Law-
rence (a pleasant place, since his girl was there), and he re-
mained for more than ten years, enlarging and changing his
tastes and collections. It is only because of fraternal love, as he
is the first to admit, that he finds himself in the position he de-
plores today. His brother, Larry, six years his junior, was in
Italy in the late 1950s, with an Italian bride and without profes-
sion or pronounced ambitions in life. Larry is thinner than his
brother, with light brown hair and a passive expression in his
sleepy, hooded eyes, which helps account for the sometimes ex-
pressed, if erroneous, view of some that Bill is the brighter of
the two.

The opinion may not be true, for Larry knew nothing
about art dealing when he started, and he has done very well in-
deed. In 1958, as a visting curator at MOMA, Bill was organizing
an exhibit on Matta, an Ecuadorian Surrealist, who was repre-
sented at the time in his collection. Matta's second wife was the
second wife of Pierre Matisse, the distinguished dealer and son
of the painter, whose first wife later married Marcel Duchamp—

a pointless account of connubial bliss demonstrating nothing more than the Lilliputian scale of the art world. Matta was not happy with his dealer in Rome, and said over lunch one day with Larry and Bill, "Why don't you go into the art business, Larry, in Rome?"

The chance remark, thrown out at random, suggested a profession for Larry.

Larry apprenticed himself to a dealer named Schneider, near the Spanish Steps. Later, realizing that Schneider was catering to the tourist trade and that Rome was not a center of High Art—the money-making big-time—he transferred to Paris. Brother Bill and Clem Greenberg were his advisers. Larry is the first to admit the reliance. By his own admission, he acquired each of his artists by asking Greenberg, "Who looks good?" His brother, likewise, was putting him in touch with "younger" artists: Ellsworth Kelly, Ken Noland, Morris Louis; and the fact that they were often Greenberg-approved doubled their appeal. Bill suggested Larry give shows of Franz Kline, Gottlieb, Motherwell, Stella. Selling was not easy. These were unpopular artists in Europe, and Larry was handling them when few other dealers would take the risk. From the start, Larry bought the artist's paintings outright, as is the custom in France, rather than operating on the American commission basis. The pictures were cheap in those days, and from time to time he would gratefully give his brother a painting for having helped pick pictures from Stella's or Louis's studio when Larry was in Europe.

No one remarked on Bill's relationship to his brother's dealing until around 1967, when Larry returned to New York and almost simultaneously Bill was offered a job in the Museum of Modern Art. That caused some comment. Then, in 1970, after major shows of Surrealism and Abstract Expressionism, Bill organized an exhibit at MOMA of a ten-year retrospective of Frank Stella, an artist represented in his personal collection, a personal friend, and an artist in his brother's gallery. Stella was

only thirty-four, and his ten-year retrospective covered twelve years of work. Bill wrote the catalogue. Few people denied that Stella was good, despite his youth. That was not the point. The point was that Rubin was making art history for an artist in whom he had an interest. An exhibit such as Stella's at MOMA, which then travelled to the Tate and the Pasadena Museum of Art, can only enhance the value of an artist's paintings.

Rubin is careful to note that he had no part in the decision to give a Stella show. The choice was made by a staff committee around 1966, a year before Rubin was involved with MOMA. He was not even on the staff at the time. The museum, looking for younger artists to compete with the shows of other museums, decided on exhibitions of the work of Stella, Oldenberg, Caro, and Kelly. (Due to a scheduling conflict, the Caro show was later dropped.) When the Stella show was approved, Bates Lowry, the director, asked Rubin to organize it. Rubin was aware of the potential conflict of interest. He went to Bates to suggest that, given the fact that Stella sells in his brother's gallery, it might not be proper for him to do the show.

"Look, we trust you," said Bates. "You're exactly the person to do the show. You're Stella's close friend. You know him. You know the whole body of his work. The whole business with your brother was considered very carefully by the trustees before you came to the staff, and no wrong was found. Look," he continued, "if you did not do the show it would look strange. Besides, there's no one else with your qualifications to do it."

Now Bates was in an odd position here. First, he disapproved of Rubin's having been hired in the first place—not because of any suggestion or implication regarding his brother's business as a dealer, but because he felt as director that the choice of filling the important curatorship should have been his. But Rubin had been hired at the suggestion of Alfred Barr before Lowry took over. Lowry felt that since Rubin was a curator he had to be considered "clean." The museum could not waste money hiring outside people for every contemporary show in

which Rubin or his brother had an interest. Lowry, moreover, did not hear until after the Stella show left the museum that the artist had once owed Rubin some paintings.

Rubin has explained the "debt." It was no debt whatsoever. It was an *exchange*, a trade, in which "Stella never owed me one cent." In the early 1960s Stella had traded four pictures of his own for an Abstract Expressionist painting belonging to Rubin. Because Bill did not want the four Stellas all in the same style, they agreed that he could choose two of these pictures over the next few years, as Stella's work changed.

Later, when Bates was fired and Walter Bareiss, a trustee was acting as director at MOMA, Rubin again expressed his reservations about the wisdom of his undertaking the exhibit, in view of the gossip it might generate—and again he was overruled, this time in a written memo from Bareiss that called on the same logic of having trust in Bill and faith in the decisions of Bates (how odd it all was, when his firing demonstrated palpable lack of faith—and how like the art world to go off on a tangent about the curator's brother's dealing, quite ignoring the larger issue: that the curator in charge of the exhibition owns the artist's work, is a friend of the artist, and has a stake therefore in the artist's career).

The memo read:

> After further consideration of your request that the Stella show be done by another member of the staff, . . . I want to urge you to do it. . . . Your initial refusal to do the show . . . was based upon the fact that even long before your association with the Museum you had never written an article about a painter represented by your brother's gallery out of concern for propriety. This seemed to Bates not to be the issue—and I agree. You must know that at the time of your original appointment the question of whether the Museum should employ a curator whose brother was a dealer in modern art was raised and answered. The Museum's original decision was that you were the right man for the job, and this should

mean *any* job in connection with curatorial activities. . . .

The museum, which is the institutional extension of the individual critic, does not like to believe it has any influence, direct or indirect, on the marketplace.

Then it came out that during the same year, 1970, Rubin, needing money to build a $200,000 house in the south of France, sold a Clyfford Still from his collection. He sold the picture discreetly and with the most exacting propriety through his brother, to whom he paid the full 15-percent commission. But the painting had been exhibited the year before at the Metropolitan Museum of Art, in the controversial exhibit "New York Painting and Sculpture, 1940–1970," an exhibition organized by Henry Geldzahler. This in itself was not remarkable, for Rubin's "eye" is much respected in the art world. But one gallery complained that the transaction was improper—and this caused comment. Subsequently, the gallery conceded that it had been wrong. Rubin himself points out that collectors sell pictures so frequently that to be criticized for it is preposterous. He has owned only two Clyfford Stills, and while he sold the one, the other—a much larger painting—is a gift promised in writing to the Museum of Modern Art.

Bill Rubin is hurt by the gossip and swallowing his self-pity, justifies himself (defense number two) that he has done no wrong. All collectors sell off pictures occasionally, glean their collections, or trade one painting for another. Moreover, it seems almost a tradition that a curator should collect the same works that he exhibits in his museum. Henry Geldzahler collects works by Hofmann, Stella, Warhol, Kelly, and numerous other artists who were represented in his exhibition of "New York Painting and Sculpture, 1940–1970." Alfred Barr has a collection.

When James Thrall Soby, a distinguished scholar and critic, author of many books, a trustee of MOMA, and owner of what Barr called the finest collection of de Chiricos in the world,

put on an exhibit of de Chiricos at MOMA in 1955, five out of the twenty pictures belonged to him. And if he had not included them in the show, the exhibition, Rubin agrees, would have been less good.

Rubin included in the Stella show two works that belonged to him, because they were so important that they could not properly have been eliminated. It is interesting that neither the museum nor the curator addressed the question of a curator's collecting the same art that he exhibits in the museum, and yet this is the only grounds for criticizing the transaction. Whether he has included his own pictures in the exhibition or not, a curator opens himself to the suspicion of having boosted prices for personal profit. To some extent the suspicions are abolished if the curator does not sell. Soby, for example, in 1961 promised his entire collection of de Chiricos to MOMA. While he gets a tax break for his generosity, and while some critics charge that the tax benefits are greater because of the MOMA exhibition, nonetheless, the museum and the public also profit by the gift.

Rubin points out that he bends over backward to avoid conflict of interest, that many years before coming to MOMA, he had severed his professional assistance as adviser to his brother, and that his interests at the Museum are historical, largely entrenched in the art of the past. He tends to see art, he explains, in its historical context. He is careful within the Museum to separate his brother's activities from his own. At staff acquisitions committee meetings, for example, he never, by his own choice, says a word about artists in his brother's gallery. If a Ken Noland comes up for consideration, or an Olitski—"I shouldn't say anything. It wouldn't be proper," he explains, without seemingly realizing that words could carry no more weight anyway than his own acts and collection.

The Museum buys nothing from the gallery, and this is pointed out by both brothers.

"Actually, Larry's lost a hell of a lot of money from my being in the museum," said Bill candidly, "because a picture you might buy from the Rubin gallery, you won't. You go to Emmerich or someone."

Larry agrees. "Actually, I've lost a hell of a lot of money from his being in the museum. I just wish he'd leave," he said, not intending to be taken literally perhaps, but wishing to make the point that he makes no profit from his brother's position. "It would be better for me." Twice the museum bought elsewhere, once for a Noland and once for an Olitski.

If this defense does not sufficiently discount his influence, Bill argues that the influence of MOMA is overrated. Abstract Expressionism rose to prominence, he explains, with little help from the museum. Alfred Barr had some reservations about the importance of the art movement. It fell to Bill Rubin to expand the museum's exhibition and collection of Abstract Expressionists—and this at a time when their prices had already soared.

Bill's argument is supplemented by another, quite unusual: He is useful to the museum. This may not seem like much of a defense to anyone unfamiliar with the poverty of museums. It carries weight. Bill has brought in around $5.5 million in gifts of art, if we include the $3.5-million Janis collection. He has given $350,000 of his own art, including "Australia," an important David Smith, "because I love this museum," he says. "I was brought up with it." How could anyone betray his love? Rubin has more degrees, he protests, and has published more books and catalogues and organized more shows in his few years at MOMA than most other curators on the staff. Perhaps on any museum staff. And so he stays.

And being unwilling to give up anything—either his collection ("Most of my wealth is in paintings," he once said. "I don't think I have fifteen thousand dollars in the world."), or his position with the respected museum, or his closeness with his brother, or his teaching jobs, or the artists whose work he col-

lects—he is grieved by the suspicion, the meanness that people evince when they judge his situation by standards that he feels are abstractly unsympathetic. It seems terribly unfair.

Bill Rubin is not a museum director. The code of ethics of the Museum Directors' Association provides:

> The members of the Association of Art Museum Directors, maintaining that the position of a Museum Director is a professional one, requiring impartiality and public responsibility, declare that it should be unprofessional for a Museum Director a) to engage directly or indirectly in buying or selling works of art for personal profit . . . b) to recommend for purchase, whether to an institution or to a person . . . any work of art in which he has any undisclosed financial interest. . . .

Bill Rubin is not the only curator or art historian to find himself in an inadvertent position of market promotion. It is nearly impossible not to, given the circumstances of museums.

When MOMA exhibits a huge Olitski on the first floor, or a Barnett Newman or a Jasper Johns, the exhibit indicates to the public (for certainly the public so infers) that these are the Cézannes of the future. No label indicates whether a curator has interests in the artists, just as it does not mention whether he took part in their acquisition by the museum. When MOMA gave de Kooning a one-man show, Tom Hess, his friend and critic, was invited to be guest director—as if the Museum had gone out of its way to find a curator with de Koonings in his collection and a personal interest in the artist. When the Solomon R. Guggenheim Museum put on an exhibit in 1971 of the artist Wojcek Fangor, there was no mention that Guggenheim director Thomas Messer admired him enough to own Fangors and hang them in his living room. His motives may have been, as in fact, he protests, above suspicion and the result of timing and chance. But no wonder the Art Workers rebelled.

One wonders why American museums do not insist on the sort of rules that obtain in English museums.

At the Victoria and Albert Museum, a staff member is not allowed to collect in the field of his profession. A curator of textiles, for example, may collect pottery or pre-Columbian gold, but not textiles. At the Tate, the staff member may collect contemporary art, but if he decides to sell a work from his private collection, he must offer it first to the Tate at the price at which he bought it, and only after the museum has exercised first refusal is he free to sell it on the open market.

American museums make no such rules. The trustees have their own conflicts, as we shall see later—and, filled with doubts about museum ethics, and in the absence of any strong pressures, they shy away. "He's so sweet" is a valid excuse in the art world; and "It's not his fault. He tries so hard." And then the questions are so subtle. Not every apparent conflict of interest is the result of greed. Some arise from innocence and others from an almost inconceivable naïveté on the part of the people involved, and though ignorance is no excuse in the eyes of the law, in the eyes of the art world it is. Who is to say when interest becomes self-interest? Or what are the motives of a man?

Moreover, in the art world, as elsewhere, there is always someone else to point to. In this case—in the case of most museum curators—the someone else is the critic Clement Greenberg, who, having the virtue of being unaffiliated with any institution, is invulnerable anyway to discipline.

Clement Greenberg. The dark power. He is a shadowy figure in the art world, the unknown quotient, looming over the market and veiled in his own reputation. No other critic has so openly allied himself to the merchandising of art. His name often evokes a raised eyebrow, a smirk, the little smile that flickers across the lips like a lizard's tongue, or—among an angry few—an open disgust that does not hesitate to condemn.

He is alleged to have, to a certain extent, "created" the Washington Color School. He is criticized on two grounds: first,

that, forgetting his position as an objective critic, he consorts so
closely with the artists as to end by advising them what and how
to paint; second, it is said that he turns his influence to personal
profit, accepting free paintings, writing and lecturing about con-
temporary art, and selling the pictures high. He is viewed with
jealousy and awe. Yet, in a way his reputation is the result of a
perverse honesty, unusual in the art world, and it is this very
honesty which is also deplored.

His art collection has been judiciously acquired either at
rock-bottom prices or for free. When he wants money, he sells a
picture. He is not your pack-rat collector, the compulsive com-
piler of an historical series, who will pass a lifetime tracking
after a missing unit. Greenberg takes the best. He does not deny
it. "If the artist is going to give me a painting," he grins, "I cer-
tainly want to choose it."

Greenberg is executor of the estate of David Smith, the
sculptor. Smith was one of the artists highly praised by
Greenberg. From 1962 until March of 1971, Greenberg was ad-
viser to the widow of Morris Louis. For the first few years he
was not paid. Then he received a stipend of $2,000 a year from
Mrs. Louis. Later still, he received a painting a year. A nice
Louis painting will bring upward of $15,000. No one knew which
paintings he received or their value, but with his instinct for art
and money, and the enemies he keeps, the bets were laid that he
was making a handsome sum from these two sources alone.

Greenberg was said to feed the market in Louis
paintings, leaking them out as cautiously as a diamond mer-
chant, to keep the prices high. This is sensible if you are pro-
tecting a widow's estate. Unfortunately, it is considered the ac-
tivity of a dealer rather than of a critic. Greenberg says that he
had nothing to do with it, that it was the widow and dealers who
fed the market, while he was merely an adviser to the artist's
wife.

Some people say that Greenberg gets a percentage of the
gross sales of certain artists. Though there is no proof,

Greenberg is enough feared in the art world and enough envied so that the rumors persist.

"Did you hear I get fifteen percent of the gross of Noland and Olitski?" he asked, and denied it fiercely. "That's libelous if you use that."

"It's not libelous if I say you deny it."

"You better make that point loud and clear."

"How does he live?" people ask. "That's all I ask you. How does he live?"

And another retorts, palm uplifted: "He has an income in six figures. From his own mouth . . . no, not to me. To a mutual friend. But from his own mouth."

Greenberg is amused. "A hundred thousand dollars? Do they say that? No," he muses. "I've never made that much."

But the most severe criticism charges him with selling the paintings that were given him as gifts. It is true that when he received them, the pictures were often of no value, but they certainly had increased in value by the time they were sold. The stories circulate: An artist gave a picture to Greenberg, and it was worth—what? Two thousand dollars if anyone would buy it? Less perhaps. It was put up for sale with a dealer—word of honor—at $30,000.

Greenberg says he has sold only two dozens items of art in the fifteen years since 1957. This is about one and a half a year. Does this make him a dealer?

His friends, on the other hand, meet the rumors with anger and contempt. Greenberg has no sense of possessiveness, says one. Of all the people in the world, material possessions mean less to Greenberg than anyone you could find. And another asserts he has no money at all. She lent him a crib for his baby. So he sells a picture every so often in order to eat. So what?

From the last part of 1958 until February 1960, Greenberg was a paid consultant at $100 a week to French & Co., which opened a contemporary art gallery. Spencer Samuels,

then president of French & Co., and now a private dealer, persuaded him of the ethics.

"Look, you believe in these artists. You write about them. You want them to succeed. So what conceivable harm is there in your telling me which artists you think I should show? You would be a consultant," he said, "not a dealer."

Not everyone agreed with this distinction. Jealousy, rivalry add to the rumors, for Greenberg's influence on the art market is unmatched by any critic. He is the kingmaker. His power over artists, collectors, and dealers derives from the fact that everyone believes in his power. Galleries follow him. Museum curators pay attention to him. Artists cling to him. Collectors watch him. And this is due not only to his famous eye, that critical sensibility which even his enemies admire. It is also due to the strength of his convictions, the unshakable authority with which he delivers his opinions, so comforting in a field where all standards are a matter of opinion.

So influential is Greenberg, so hypnotic is his effect on the artists he sees, that they will not make a move, it is said, without his approval. Larry Poons, Olitski, Noland, the late Morris Louis, spending hours talking, talking to the prophet, straining for a hairline truth. Louis would allow no one in his studio while he was working. Not even his wife was allowed to enter while he spent seven, eight, nine hours a day, painting his stripes and veils in mad, driven incontinence. Greenberg was his judge.

Some artists boast of throwing Greenberg out of their studios. Others wish he would notice them, for his is the Midas touch. There is a story that Greenberg suggested to Franz Kline, the Abstract Expressionist, that he paint the large black-and-white canvases for which he is famous. The story is believed, though Greenberg does not remember saying it. Kline himself may have been the source of the story, and the large black-and-white paintings that appeared soon after Kline met Greenberg created a sensation and the artist's reputation. The story did little to hurt the fabled reputation of the critic's "eye." It was be-

lieved the more readily because Greenberg is not known to guard his tongue. He says what he thinks, quite brutally.

Harold Rosenberg tells how Greenberg once visited a Canadian artist at the request of Sam Kootz, the dealer, and after looking over the work reported back: "I think it's too soon to show him. But he's got something on the ball."

The words of a dealer, thought Rosenberg, offended perhaps as much by the braggadocio, the swaggering conceit of Clem's conviction, as by the words. Confidence is the secret of success. Self-assuredness, the arrogant cocksureness that admits no doubts.

Harold Rosenberg tells of visiting the collector Gifford Phillips in Los Angeles, when Phillips (nephew of Duncan Phillips, who founded the gallery in Washington, D.C., and himself a trustee at MOMA) waved his hand shyly at the Franz Kline painting on the wall: "Do you think Kline was dragging his brush when he did that?"

"Dragging his brush!" cried Rosenberg, all grizzled, bristling mustache, eyebrows, hair. "What does that mean? I don't even know what that means, dragging his brush!"

"Clem Greenberg says the picture is no good," said Phillips diffidently. "He told me Kline was dragging his brush when he did it."

So you see the power of this critic's "eye" as he repeats the declensions of art, each factor working on the others to increase his reputation, to establish his invulnerability, and to annoy his enemies.

Gene Davis, the artist, in an interview in *Artforum* described the electric effect of Greenberg's approval on the group of Washington artists experimenting in 1958 and 1959 with colors. He said:

> None of us knew quite where to go. I think it's a myth to perpetuate or advance this theory that there's a clear-cut father-son relationship in this business. Let's

just say we all had accessible to us the same sources. . . .

Q. Do you feel Clement Greenberg had any influence on the so-called Washington School?

Oh, undeniably. I'm perhaps overstating it . . . but we knew that he was a kingmaker; we knew that he had immense power, as evidenced by his piece in *Art International* in 1960 about Noland and Louis. The effect it had was very impressive.

Q. Was it demoralizing or impressive?

Maybe a little of both, I don't know. But this was the first time any such thing ever happened in Washington. Nobody had ever written up a local artist in a national art magazine. That made a tremendous impression on us. And who did it? Clement Greenberg. I didn't know him at the time, but he was a presence that we were all aware of. Later, of course, he put all five of us—Downing, Mehring, myself and of course Noland and Louis—in his post-painterly abstraction show. To that extent at least he was an influence.

For, yes, in addition to voicing his opinions and writing them, Greenberg has occasionally organized exhibitions. Sometimes expressly for dealers (Kootz, Samuels). Sometimes for museums. In addition, some galleries (Rubin, Emmerich, Kasmin, and Mirvish) rely on his opinions to such a degree that the art world finds it easy to attribute their shows too, in an indirect fashion, to Greenberg. In 1964 Greenberg organized an exhibition at the Los Angeles Co. Museum called "Post-Painterly Abstraction," which traveled to the Walker Art Center in Minneapolis and the Art Gallery of Toronto, and did much to establish the Washington Color School as a legitimate art movement. Greenberg, even as he organized the exhibition, tried to denigrate his own authority. He wrote in the catalogue introduction that this exhibit was merely one man's opinion. Apparently, not even the museums took the idea seriously. His power hangs over the art world.

Does it bother him? It is hard to know. There are no jagged edges on the cliffs of his character, so that after two hours of talking to him, one comes away hard put even to remember his face. Is it because the paintings in his apartment are so splendid, flashing brilliant yellows and pinks and diving into blues so deep and pure that it is impossible to tear one's eyes away to look at him? He is incredibly complex, tough. What is there physically to remember? His bald head half circled by a ring of black hair? Hazel eyes of no particular distinction? His high, hooked nose? His long, yellowish front teeth through whose clamped occlusion his words are pressed in lock-jawed, hypnotic softness? He curls his words in a New York Jewish accent, the tough-guy, straight-guy, no-crap Jewishness of New York. It's the toughness that relishes a prize fight, cuts the idealism. He'll take the world on its own terms and beat it, no mincing pretensions, not even about money.

Guarded, wary, bitter, amused, Greenberg does not bother to defend himself. "I knew it would come to this," he says. "That's why I decided to see you. The trouble is, you don't believe me, do you?" He answers direct questions bluntly unless side-stepping: "I don't want to talk about that. Ask another." He denies dealing. He says he's never taken money from dealers.

About French & Co.: "People saw me down there three days a week. They thought I was director. Well, of course, there was a director. There were two ladies, and Mr. Samuels was the president, but people said, 'Well, what you say goes.' That's true, but there's a tendency to put me in the art world."

As if he could be taken out of the art world!

"I never took money from a dealer," he asserts stubbornly, forgetting his $100-a-week consultant's fee and meaning, rather, that he has never written a dealer's catalogue introduction for pay, as other critics do.

He organized three exhibitions for Sam Kootz. One, with Meyer Schapiro, called "New Talent, 1950" (at which Kline was discovered), another, "Emerging Talent 1953," a third in 1959 of

a Hans Hofmann retrospective. He took no money for the
shows. "Not only did I never pay him," says Sam Kootz, "but he
was paid nothing for an exhibition he did for the Ringling Mu-
seum. He never received a nickel. He never had an idea of deriv-
ing money from art. Whatever he did, he did from his own con-
viction. All the derogatory comments," continued Kootz, "are
made by lesser men. Clem is a man with the greatest flair for
knowing the greatest coming art movement and the best people
in the movement than anyone I've ever come across in the art
world. . . . He's not profiting. He could have opened a gallery at
any time, and made a fortune. He never did. I offered him a fab-
ulous sum, eight or ten years ago, to take over my gallery. He
had no interest in it."

"I'm responsible to no one but my own conscience," said
Greenberg.

When asked about being executor of the David Smith es-
tate and the paid adviser to the widow of Louis, he nods
thoughtfully. "That's compromising."

He has written on how misinterpreted his words have
been, how illiterate people are to have twisted his intentions—as
if he could control the dictates of his eye, says he: his eye oper-
ates independently of volition. It finds its own delight. He has
said this in print, but people won't read. Moreover, his opinion,
he affirms, is merely opinion, and what concern is it of his what
other people do with his opinion? But he knows the joke is on
him, because he is judged by how others use his judgments.

And then later: "I did it for money! Say that. I thought of
all that money," he laughs, enjoying the money, enjoying the
joke. Oh, he could have refused to be the executor of the Smith
estate, refused to advise Mrs. Louis. But why? What difference
would it make? says he, falling back on our old nostrum of lack
of influence. Because in the long run, it's the picture that wins,
you see. Forty years from now what Greenberg said forty years
before won't make any difference. The picture will remain, and
then we'll see that—aha! his eye was right! Using none of the

six basic defenses, Greenberg falls back with a perverted delight on a seventh. A new argument, untested, untried; this honest man puts forth the defense, imagine! of moral aberration.

"A famous artist from Europe once told me something." Greenberg pulled on his cigar. "I thought it was one of the biggest clichés. He said, 'It seems to me a more inferior type person gets interested in art in the United States than abroad.' That was in the mid-Forties. Now I've been around a while more, and I've decided the kind of people attracted to art are often psychopaths. You can quote me on that," he adds, smiling, smiling broadly with his long, yellow teeth clamped together on his cigar. "In art and literature both. Do you know the difference between psychopaths and psychotics? Psychopaths are people with defective consciences. They can't tell right from wrong."

Throughout the 1960s the Revolution had been building, all through the Kennedy years, the Johnson years, Pop Art, Op Art, Minimal to Conceptual to Destructivist Art, building to the drumbeat of the Sixties, to civil rights, students' rights, riots, drugs, brutality, war. Artists were affected by the same despair as the rest of the world, were laden with layer on layer of libertarian guilt, and interlacing all, with the vision that the activities of the art world were representative of—were a reflection of the activities of the rest of the world: of government, politics, greed, power, war.

For the Art Workers the question remained: What is art? Why is one style touted and tooted and another disdained? It is the question always asked by undiscovered artists. They look around: so damned much bad art, just junk, being sold. How can they help but question? Each believes his own art is as good as the rest. Or they look at Ken Noland, Greenberg's friend, who, like many rich and established artists, mixes his paints, marks off his canvases with masking tape, and directs his two or three assistants (one of whom is his brother) to paint the stripes. Out

in New Jersey, a guy named Benny was turning out pseudo-Frank Stellas at around $200 apiece; they looked to the untrained eye plausibly like the $15,000 originals. Do you see why the Art Workers were dissatisfied? Why the murmuring rose of the corruption of the art world? The Mafia. Stella and Noland may hold a special vision superior to the copies and imitative attempts that abound. But the Art Workers had a point. It was the same as that of any group on the Outs who want In. The question became: What to do about it?

Collectors of Art

From the beginning the Art Workers attacked museums. Museums represented the art system. They were centers of power. Moreover, their anger against museums could be grasped, got hold of, as those with dealers or critics could not. The Art Workers could call for specific changes: black art in museums, a Martin Luther King Study Center at MOMA, mini-museums in "culturally deprived" ghettos, women artists exhibited in museums, an end to racism, war, sexism, repression.

They attacked museums, beginning with Takis's removal of his art from MOMA and continuing with bags of blood bursting in the MOMA lobby with fists clenched and screaming den-

tate mouths, with pickets and parades and, throughout, a certain perverse humor.

One night a group invaded a black-tie dinner of the board of trustees at the Metropolitan Museum of Art. The dinner was being held in an eighteenth-century French period room, where a long table covered with silver and cloths and delicacies had been spread for the epicurean delectation of the board. The Art Workers rushed in, a blur of beards and blue jeans, and poured a jar of cockroaches over the white tablecloth, to the horror of the museum director, Thomas P. F. Hoving. A guard wrestled little Jean Toche to the floor, pulling him down, while he yelled courageously, "Run! Run! Don't try to save me!" And one woman trustee cried, "Oh, you're the Art Workers! How fascinating!"

To the Art Workers the museums symbolized the Establishment. They were an expression of Establishment control.

Museums are important to the art market for three reasons. First, they remove art from the market. Once in a museum, chances are a painting will remain, never to be sold again. Both dealer and artist are pleased by this possibility. Second, museums set the standards for art: the painting is known to be of "museum quality." Other works by that artist rise in value. Museums provide pedigrees for Old Masters. For contemporary art they provide a sense of propriety.

Finally, museums are important because there people come in contact with art. Museums can provide exhibitions on a larger and more generous scale than most dealers can afford, and, being by reputation independent of the marketplace, they are trusted by the general public. Both artists and dealers are aware of these advantages and strive to place an artist's work where it will work for them.

The dealer gives a museum discount, and if the institution cannot afford even this low price, he may help convince a prominent patron, himself a collector or museum trustee, to buy and donate the work to the museum. Sometimes it is to the advantage of the collector as well to place a certain painting in a

museum, cynical as this may sound. The museum curator, mean-
while, who is building his reputation as an art historian, is like-
wise dependent on the good will of the dealer. Exactly how inde-
pendent the museum is from the marketplace, therefore, is a
subject of dispute.

The question must be answered. Is there a "system" of
art? The answer is yes, though it does not operate, as the Coali-
tion believed, as a cabal. The system arises from the interaction
of four distinct groups—dealers, critics, collectors, and muse-
ums—each going about its business blindly on its blinkered path.

The business of the dealer is to sell art. He must find and
promote artists whose works will sell. He may believe deeply in
art and his artists, but his function is to sell.

The function of the critic is to praise those artists he be-
lieves in. He never "betrays his convictions," but in some cases
he pushes artists with whom he associates, sleeps, and whose
work he collects.

The function of the collector is to collect. He does this by
following the advice of dealers, critics, and museum curators.
He reads art criticism and is delighted to see a picture in *Art
News* which the dealer may have paid for.

The collector is a trustee of the museum. He makes mu-
seum policy, and when he dies he bequeaths his collection to a
museum, receiving a tax deduction in return. The collection be-
comes immortalized as Art.

Once they saw this, the Art Workers felt they had gone
far toward explaining the definition of art.

They attacked the museums, therefore, on several
grounds. First, they deplored the narrow composition of the
boards, with their narrow views of art. They saw the trustees as
industrial tycoons, a diamond ring on one pinkie, a stogie in the
flash of teeth, who were using art and museums to turn a profit.
They were scandalized by the "collusion" they saw and the use
of museums to establish personal memorials for trustees.

It is generally held that the Rockefellers "own" the Mu-

seum of Modern Art, in the same way that Norton Simon "owns" the Los Angeles Co. Museum, that Robert Rowen "owns" the Pasadena Museum of Art, that Joseph Hirshhorn "owns" the Hirshhorn Museum. Each controls the trustees who dictate policy. The museums, in turn, define the public's view of art.

The stranglehold on art, then, was the first reason for the attack. The second was to reach the source of power. How else but through art could they hope to approach David Rockefeller or John Hay Whitney?

Third, they attacked on the philosophical grounds that the trend toward centralization, a monolithic organization governed by an unapproachable bureaucracy, was antithetical to the needs of the People (they talked like that). They felt that museums should democratize, decentralize.

We shall discuss some of these points later at length, for they are complex ideas, but the long and short of the problem was that the Art Workers saw the system as working for the benefit of the system—of dealers, critics, collectors. And nothing for them. The art world was run to make money for everyone else.

Finally they attacked the museums for perpetuating racism, sexism, war, and repression. They saw museums, which should have been a civilizing influence, as contributing in most subtle ways to the corruption of a corrupt society. Discrimination against blacks—who were excluded from the boards of trustees. Discrimination against women and black artists—who are rarely exhibited in museums or, if exhibited, are never given credit for being women or black. Repression of the poor—because high admission fees keep The People out of these temples to art. Repression—because those masterpieces exhibited in museums do not speak to the poor anyway: How was this art—a medieval altarpiece, a Cézanne—relevant to the social concerns of the day? And the Art Workers raged that the museums were governed by outdated elitist values. They ranted that museums

believed that taste is restricted to the upper classes, to a favored few with leisure and money to spend a lifetime in the time-consuming pursuit of beauty.

Why were museums not exhibiting art, they asked, that appealed to The People? Why were museums not involved, instructive, *relevant*? "If Art Can't Serve the Needs of the People," read one AWC sign, "then Get Rid of it." The Art Workers generally believed the slogan, without knowing exactly whose needs they intended it to serve or what form the service should take.

They attacked museums for almost anything they could think of, but all their rolling riot came down to one basic messy question about what is art and what is the purpose of a museum.

The museums were no help in finding an answer.

Curiously, it might never have occurred to the artists to demonstrate against the museums if the museums had not made the first move. The museums had raised their hopes. They were already trying to be "relevant." Or, in advance of relevant—avant-garde. Takis's original demonstration was not against MOMA for exhibiting the avant-garde, but for not living up to its rhetoric. It was for failing. This is the principle of raised expectations, and can be traced throughout history. Revolution does not occur when the populace is enslaved, but only after it has received some liberties. So Louis XVI did not lose his head until after he had ceded some divine rights to his people through the Tennis Court Parlement, and it was not under Czar Alexander's oppressive rule that people rebelled, but his sweet son Nicholas's, who started to reform and liberalize the country. Expectation shows up shortcomings.

In the 1960s the museums lusted after relevance. They wanted to be educational, "with it," involved with social issues, "where the action is." There is a style to years, and the style of the 1960s demanded aggressiveness, activity, excitement, even in museums, though the first purpose of a museum is to preserve the arts and uses of the past. That no one could define "rele-

vant" only made the use of the term in museums more frequent. "Relevant" was whatever got you in the news.

At first "relevant" meant exhibiting avant-garde art. Some people date "relevance" from the coming of Alan Solomon to the Jewish Museum in 1963. The Jewish Museum had been devoted for years to preserving the historic traditions in its vessels and chalices. Suddenly it turned about-face and marched after contemporary art. It was a shock. Everyone was talking about the Jewish Museum and about Alan Solomon, the director. It was showing Rauschenberg, Johns, Larry Rivers, Richard Diebenkorn, Ken Noland, Jean Tinguely, the F-111 . . . and later, an exhibit, a social documentary, of life on the Lower East Side.

Before the decade was out, the other museums had turned to the chase: the Smithsonian, the Metropolitan, the Corcoran Gallery in Washington, the Pasadena Art Museum, and numerous small museums around the country, sprouting as museums of contemporary art.

There was a time when a museum waited in the wings and at the end of an artist's career crowned him with an exhibition. Now, they were vying with dealers to see which could exhibit the most outrageous work. Relevant meant contemporary. Contemporary meant relinquishing the past. So the staid National Gallery of Art in Washington was shyly buying one or two pieces of contemporary art (the living artist raised his prices), and the Metropolitan Museum in New York announced it was "going to be where the action is" and collect only "newsworthy" items, and one Smithsonian museum started to sell off its old paintings to get funds to buy more contemporary art, and MOMA, which had a forty-year head start on the others, scrapped the concept of art entirely in one film program and announced that it was showing films on current events. Not to be outdone, the Metropolitan declared that to be relevant meant to change society. And this would have been all right, too, and no one would have paid attention except for the chest-thumping that accompanied the pronunciamentos.

There was general confusion about what constituted the purpose of a museum, and who the public was, though the attendance was increasing by leaps and bounds; millions of people flocked to museums. The American Association of Museums estimated that six bona-fide museums were being built in the United States each week, though not all were art museums. Most seemed to operate on deficits, frantically courting the audience that would support the exhibits that would attract the public.

The Modern put on an "Information Show," in which one artist, Hans Haacke, introduced a machine on which the people could cast a vote against Governor Nelson Rockefeller, and another exhibit questioned the bloody participation of David Rockefeller in the Vietnam war. The director of the Metropolitan stood up at one public meeting and bravely asserted that in the next decade the Met must address itself to three elements of our society: racism, commercialism, and the "filthy war."

"Because I frankly don't think that in the climate of the United States right now," he cried, incoherent with passion, "with these three elements the way they are, that the Metropolitan Museum and what it is doing at the present time gives much of a damn."

Then he refused to release the transcript. What were people to think? MOMA refused to participate with the Art Workers in a protest against the My Lai massacre, and a few months later installed a photo exhibit of the Kent State killings. The Guggenheim closed a show that included slum tenements but put on "Liquid Theatre," so that if anyone thought to find a coherent standard of excellence anymore in a museum of art, he was quite mistaken. No wonder the artists of AWC thought their work was equally deserving of museum exhibit. They saw only what they wanted to see, and, brash with youth and the thirst for change—any change, so long as it represented a departure from a present they did not like, from a past they had never known—they assaulted museums for the timidity of their

change; not for the changing, but for the slow pace of change. Each tentative attempt a museum made to change brought forth howls of rage from AWC and further upset the museums, which scrambled harder to silence the screams.

The Metropolitan was torn between the views of its curators and those of its management. MOMA was virtually without direction, having changed heads three times in twenty-eight months. Unable to decide what course to hold or what it was supposed to achieve, it floated in incoherent limbo. All these things contributed to the rebellion of the Art Workers, a sense of restlessness, though it would be impossible to quantify the phenomenon. At the Metropolitan Museum it was found after a while that the rhetoric of relevance, of being for the people, was coupled with an arrogant disdain unknown among museums in this century. The museum did what it wanted, considering the public apparently as so many peas to be mashed into purée, until its opponents decided that "relevant" meant stooping to the lowest practices of political exigence. If the Art Workers were running amok, the museums had gone equally mad. They were having fits.

The Arrogance of Power— or, How the Metropolitan Museum Tried to be Relevant, and What Happened

Thomas P. F. Hoving, Director of the Metropolitan Museum of art: Hoving in candy-cane shirt sleeves, striding up and down his office, his eyes sparkling, arms waving in long-toothed enthusiasm. He leaps out to see the construction work on his new plaza. Beautiful! He strides into the newly decorated Great Hall. Historic!

Hoving has all the qualifications of a museum director: graduate *summa cum laude* from Princeton, former Associate Curator at the Cloisters, who acquired for the museum among other items the twelfth-century ivory cross from Bury St. Edmunds. A medieval scholar with the proper social and political

connections, he became famous as New York City Parks Commissioner by bicycling through Central Park with his family—a photo so winning that August Heckscher, when he replaced Hoving as Commissioner of Parks, Recreation, and Cultural Affairs in 1967, also felt obliged to be photographed on a bicycle, though he is years older and much more the type to stroll through a drawing room, one finger floating over his teacup as he lifts it to his lips.

In fact, Heckscher is really the kind of man who pops to mind when one thinks of a museum director, and not this other type, leaping like a little boy from peak to peak. Hoving is a man of his times. Had he not rid us of our paralyzing fear of Central Park? Brought crowds into the park for concerts, happenings, art shows, picnicking, bicycling?

When he was appointed Director of the Met in 1967, he brought in a fashionable vocabulary: "nitty-gritty," "relevant," "total involvement," "architectural environment."

"These are revolutionary times," he said. "The social order is in flux and we must be relevant to it. The question is not *whether* but exactly *how* we're going to get into the swim. The alternative is the possibility of being pushed in."

Two years later, his museum was in a state of siege from without and revolt from within.

To a certain extent, the conflict is endemic in the contradiction of museums. On the one hand there is the curator (from Latin *curare*, "to care for"), who is dedicated to preserving the objects in his collections. On the other hand there is the administration, which is dedicated to aggrandizement: buildings, collections, visitors. The administration plays a numbers game. It wants more and more people crawling through the corridors. Six million visitors a year, boasts the Metropolitan; 16 million, says the Smithsonian Institution, and both look down on the Brooklyn Museum, where a mere 800,000 come to visit a collection that scholars agree is equally good. To the administrator the attendance proves the value of the collection; the curator views mass

visitation with concern. For him it is an ordeal to watch something like the Metropolitan's presentation of the Mona Lisa in 1963, when the line stretched for blocks outside the Museum—thousands waiting for a chance to file past the famous picture, while the guards kept order: "Keep moving," they repeated along the line. The curator asks: Is that what a museum is for?

Hoving has never doubted. "I do not believe . . . that quality should be reserved for a small, sophisticated elite." It was on these grounds that he was hired. For two hours he talked without notes, winning over Arthur Houghton, Jr., then the Met's president, and was named, at 36, the youngest museum director in the museum's history. What an honor! And what a mission to lead a people to art for the betterment of individuals, of society, of democracy. Yes, there was even a patriotic duty involved: "Francis Taylor [Met director from 1940 to 1954] said the museum is the midwife of democracy—and damn it, it is!" cried Hoving.

And this was the principal bastion of the fight within the Met—whether the museum should be devoted to the preservation of our past, to excellence, to the elite, and for an elite and learned audience; or whether it could be democratized, popularized, by exhibition techniques and mass technology, for a mass audience—without destroying the esthetic principles to which it owed its foundation.

The sides were by no means clearly drawn. At first the curators were enthusiastic at the idea of enlivening the museum, for change was in the air. Hoving had credentials, vision, and enthusiasm. Moreover, the museum was a semipublic institution, receiving more than one-fifth of its operating funds and most capital expenditures from the city, so that it seemed only right to try to enlist it in the great issues of the day.

Only things did not go as planned.

One of the first things that went wrong was an exhibit: "Harlem on My Mind." The year was 1969, and this was the first show of black culture in any museum. The exhibit was designed

by visiting curators (thereby insulting the jealous curatorial staff). It was designed to make the Met "relevant" to a whole segment of the city's culture. It was touted with the showmanship of Barnum and Bailey, anticipated, awaited . . . it opened, and suddenly the museum was attacked. It was attacked first by the blacks as racist, then by the Jews as anti-Semitic, finally by the art world as superficial. The day the exhibit opened someone scratched "H" with a ballpoint pen on ten paintings, including one Rembrandt, and the staff was left shaken and confused. It was tragic . . . or comic, if you prefer, for somehow Hoving emerged as a kind of martyr in the public mind, upholding freedom of speech. On the other hand, the museum trustees allegedly were so upset by the contrary criticism that Mr. Hoving was almost fired. He was saved by the loyalty of Houghton. And after that the museum seemed driven, bucking, twisting, contradicting the very principles of democracy and involvement that had so excited imaginations when Hoving arrived. It was as if he were helpless against his fate.

Planning to modernize the museum front, he cut down thirty-six large and healthy trees that shaded the museum. There was no advance notice. One day the chain saws were biting into the trees. The public outcry caught him by surprise. He was annoyed. He did not see why everyone was upset, he said, since the museum was going to plant eighty-one saplings as replacements. And he proceeded with his plans.

For the public, the first signs that all was not well at the Met appeared with the expansion plan—the "Master Plan," as the museum called it. The Met, already involved in a $3- to $4-million face-lift, simultaneously announced a $50-million expansion plan. The Master Plan is enormous. It gives the Met one-third again as much space as the present museum has: five acres of space, more than one and a half times the floor space of all the other museums in Manhattan combined.

Opposition there has been. I won't go into the pros and cons of expansion. Or the arguments for decentralization, or the

twisting of the terms in discussion (each side using them to serve its own view). Or the rage of the opponents of expansion at what they felt was arrogant disregard for their position. At a certain level, conflict comes down to those who want art and those who extend esthetics to grass and trees. It is an irreconcilable difference when the art is growing on Central Park and the grass shrinking. More interesting was the manner of the museum in winning its way. It became apparent that Hoving's first duty was to win. If he was aghast to discover himself ranged against the sum of public opinion, he never let it show.

The Master Plan consisted of three parts. On the north side of the museum would stand the Temple of Dendur, a Roman-Egyptian first-century B.C. edifice. It had already been acquired in 1968 by Hoving with flash and daring and $1.4 million of public funds that he had persuaded the city to cough up. On the south side, Nelson Rockefeller's Museum of Primitive Art would be built with private funds and maintained at city expense. It would look pretty much the same as the Dendur side, since it was designed, not form following function, but for esthetic balance. The Museum of Primitive Art had been founded in 1957 to house Rockefeller's growing collection. Some people felt that his hurry to dump his ten-year-old museum on the public trust, in memory to his son Michael, was a liability to an already overburdened public economy. In 1969, the announcement of the new acquisition was made by the Met, and right on its heels came the third acquisition: the $100 million Lehman collection of Old Masters. This was the collection whose acquisition Hoving said would be his greatest achievement as director of the Met. It was this collection that caused most controversy, for a pavilion was to extend out into the precious land of Central Park, and people wondered about this, remembering that one of Hoving's first acts as Parks Commissioner was to protest all intrusion into the public park. He had been the champion of free, open space.

Robert Lehman had been a trustee of the Metropolitan

for many years. He was in close touch with the museum. Mrs. James Rorimer, wife of the late director, remembers that Lehman telephoned her husband almost every morning at 6:40 to discuss the events of the previous and forthcoming day, while his masseur thumped his back. A shy, quiet man, he had great affection for his past and a deep pride in the collection that had been started by his father and completed by him. It is said to rival the Frick's. Occasionally the director might hint darkly at the value of the collection to the museum, but to release the collection to anybody was more than Lehman could bear, especially as the museum policy forbade accepting collections any longer as separate semi-independent entities. Any collection given to the Met would be dismantled and distributed throughout the departments as needed. Lehman knew this. He never offered the collection to the museum, and the museum, respecting his wishes, did not ask for it. Lehman, a trustee for twenty-seven years, vice-president of the board of trustees since 1948, longer than any other man, was not named president when the position became vacant in 1964. He was sensitive to the anti-Semitic implication, and openly bitter, but both museum and collector publicly denied there was a breach.

When Hoving became director in 1967, Lehman was an old man and very ill. That same year Lehman was named to the newly created honorary position of Chairman of the Board. Later Hoving visited him and asked for the collection, the young director at the old man's sickbed; and when Lehman died in 1969 and his will was opened, it was learned the collection would indeed go to the Met. The terms of the agreement were written out in many pages of legal document. They were kept secret at first, which stopped no one from discussing them.

"They were very simple wishes," explained one knowledgeable gentleman, a friend of Lehman. His explanation illuminates the relationship of collectors to museums. "Bobby Lehman wanted his pyramid, with plate glass before the artworks. See, Bobby knew about Macy's: the entrance is small, but the

display windows are large. Lehman also had a theory that art in the basement is not as good as art on the ground floor. It was a theory he learned in life. When you go into Macy's, the pots and pans are in the basement and the Lanvin perfume is at the entrance. Art today is a kind of cultural cosmetic."

The museum was secretive about the plan. It said the Lehman Foundation agreed to construct the building, endow it in perpetuity, maintain all expenses of gas, electricity, guards, and other services, and pay for removal of the interior staircase of the museum (at a reported cost of $2 million), which blocked the east-west vista to this Taj Mahal.

Later, a lawsuit forced divulgence of the terms. It turned out that the museum would have to cough up all construction costs, estimated at some $8 million, and there was some question whether the expenses of utilities would indeed be paid by the Foundation or laid onto the museum.

Not only did the museum keep the Lehman contract secret. It refused to release its transcripts of the public debates of the issues, and when I was looking into the Master Plan, there was always a runaround.

"Oh you have to ask Mr. Hawkins that," I was told. Ashton Hawkins is the museum secretary.

"I just asked him. He said to see you."

"Oh no," came the voice on the phone. "He's the only one that can give you that information."

Hoving was not available for comment, and neither was George Trescher, secretary of the 100th Anniversary Committee; and while there were three other young men in powerful administrative positions, none of them had been at the museum longer than six years, so it was easy for them to answer: "I don't know. I wasn't here then." Or, "You have to ask Mr. Hoving that."

The museum's decision to build a separate Lehman wing offended even friends of the museum. No one disputed the value of the collection. It was the terms of the agreement that dis-

turbed them. First, the collection, having been formed with the help of the museum curators, often paralleled the Met's own collections, so that some people questioned the wisdom of adding Rembrandts to Rembrandts, and particularly at a time when other museums in other cities had none. Moreover, the collection was not to be integrated with existing collections, or exhibited with the rest of the European paintings. For a scholar, therefore, to make a comparative study of two works, one in the Metropolitan and another in the Lehman collection, he would have to walk from one wing to another . . . or look at slides.

Finally, it was not that the museum was taking administrative charge of the collection and housing it elsewhere—in the Lehman mansion at 7 West 54th Street, for example—to serve, like the beautiful Phillips Gallery of Art in Washington, D.C., as a jewel in a distinctive setting. Or, in another more handsome mansion, a city landmark, perhaps, scheduled for demolition, so that a famous New York house would be preserved at the same time a great collection was displayed. Nor was the museum sending the collection, under its administrative aegis, to Kansas City, or Seattle, or Atlanta, or another city in another area that might have no fine European paintings.

Instead, it was paying to build a wing for the collection that would extend onto the grass of Central Park.

A committee was formed to halt the construction. It called itself "Museum Action," and it was composed not of the revolutionary Art Workers but of patrons of the arts, nature lovers, friends of Central Park, and various civic organizations, who combined in uneasy accord in this year of rebellion to stop the museum. Bravely they stood up to the monolith, David taking Goliath by argument, persuasion, public debate, decrying the trend toward centralization, the mutilation of Central Park, the lack of vision evidenced in a twentieth-century museum acting like a robber baron.

You can argue that secrecy is permissible in an institution that is public by function, private by foundation. Still, the city

owned the land the museum sat on. The city had originally constructed the building, kicked in some 20 percent of the annual $9 million maintenance budget, and, according to Louis Shulman, of the Capital Budget Division of the City Planning Commission, pumped $16 million into the building for capital expenses over the past thirty years. The museum denied it. "Absolutely untrue!" Hawkins told me. "The city has never put up that much in capital expenses." Hawkins is a bland, blond Harvard graduate, a former Assistant Attorney General of the State of New York, with impeccable New York social connections. It was unclear why he would make such a comment, but by then a credibility gap was developing about much that the Metropolitan was saying.

Not only secretive, the museum was shifting its facts as well. There was a grand staircase in the Main Hall which Hoving referred to as a "dull behemoth," and which some curators noticed was badly lit, as though in an attempt to make it look shabby. It was beloved in the city, as much a landmark as the great staircase of the Louvre, though not so graceful perhaps. Still, affection is not always related to grace and youth. The worn staircase was a public monument, soothing in a city where buildings rise and fall like children's blocks. It filled the heart with the same warmth of memory, the same continuity as those old elm trees; and it was regarded with the proprietary fondness that private individuals feel for public bridges, churches, even prisons if they have stood long enough in one place.

At first, reports of the staircase's removal were denied. Jerrold Ross, chairman of the Cultural Facilities Committee of Planning Board No. 2, said that during a talk to the board on March 19, 1970, Arthur Rosenblatt, the museum's administrator for architecture and planning, stated (though he later said he could not remember doing so) that, "all rumors to the contrary," the staircase would not be removed.

Yet, three weeks later, a plan to remove the staircase was presented to the staff. The justification for its removal was ar-

chitectural, in that, with the construction of the Lehman Pavilion, the architectural purity of the stairs would be destroyed, so that it might as well be too—a strange position, some curators felt, for a museum devoted to preserving the past. Another explanation was that the stairs obstruct the flow of traffic. And no one admitted that removal was part of the Lehman understanding, in order to provide an uninterrupted vista from the museum entrance straight through to the Lehman gift.

There were other contradictions.

There was Mr. Hoving at the lectern at a Parks Department hearing on June 4, 1970: "I have just received a communication from the trustees of the Lehman Foundation. They say that unless we build the Lehman wing as planned, they will offer the collection to a museum in another city." *The New Yorker* reported it was not true. "We didn't make that statement," said a trustee of the Foundation.

The museum issued a Master Plan fact sheet, entitled "The Metropolitan Museum of Art Master Plan for the Second Century" listing fourteen facts. Some were misleading.

Fact No. 7 states that "no new public gallery space has been constructed since 1926." Mr. Hoving repeated at the Parks Department hearing: "Not one foot of public gallery space has been added since 1926."

Yet the Cloisters were built in the Thirties and opened in 1938. And James J. Rorimer, the late director of the museum, announced a 42-percent increase in exhibition space and a 21-percent increase in service space in 1965, accomplished by lowering ceilings, redesigning halls, roofing over interior courtyards, and reworking the ground floor. This was done in an eight- to twelve-year expansion program, which by 1954 had already cost $7 million.

No. 9 on the Fact Sheet stated: "The proposed Master Plan construction will claim 38,000 square feet of green area." They meant 38,000 square feet beyond the existing boundaries. In fact, the minimum ground floor area of the proposed expan-

sion would come to 149,000 square feet, including grassy space now within the fence line.

Fact No. 10 asserted that "two glass-enclosed garden courts will be created, accessible from the park side of the museum and open to the public year-round." No one would say, though, which hours they would be open—park or museum hours. "That's a matter of administrative policy," said the consulting architect, Kevin Roche, and he was echoed in almost the same words by the museum's architecture administrator, Arthur Rosenblatt: "We'd hope it could be open all the time. We'll have to experiment and see." Provisions were made in the design to close the courtyard at the park side, if necessary. No wonder opposition to the Master Plan developed. No one knew if they would be charged admission for going into the courtyards, which formerly had been free public park.

No. 8 on the Fact Sheet stated that expansion was needed to provide exhibition space, arguing that in some departments more than half the collections were not on view. For example, according to the Fact Sheet 50 percent of the European paintings were in storage. Yet the reason the European paintings were in storage was that their newly renovated, permanent, air-conditioned galleries, so painfully installed just a few years earlier under Rorimer's reorganization, had been taken over by plush offices for the centennial-celebration staff and for temporary exhibits. Indeed, Claus Virch, curator of the European paintings department, resigned that spring, reportedly in protest over the treatment of his collection.

There was another confusing point in this case for more exhibit space. Hoving made it himself at a debate sponsored by the Municipal Art Society that summer of 1970. Did he bite his tongue as he heard himself say, in answer to a plea for decentralization, "Those people out there don't want second-rate stuff, and the majority of the objects in storage are not very good." If this was so, people thought, perhaps the majority of the $50-million expansion plan was not needed either.

Fact No. 9 promised no further expansion into Central Park after the completion of this project. Hoving explained that the role of the museum had changed. From then on it would redefine its collections. "We'll collect nothing unless we give something out," he said. But who could tell any more which Hoving to believe? There was Hoving saying, "The Centennial means we've reached a happy point. We have everything we need in the way of treasures. . . . Now we have to start thinking of ourselves principally as an educational institution." But Hoving was also saying, "The quality of the Temple of Dendur isn't high, but don't knock it. Its impact is extraordinary. It's an environment, something you can walk into. . . . any work of architectural sculpture I can get my hands on, I'll buy."

Again, "We're an encyclopedia. We have to have everything. The Monet [$1,411,200], for example. We had to have it because we have the greatest Monet collection." And also: "We have thirty-eight Monets. We could give away twenty-five."

"Nonsense," cried Hoving sweeping the opposition before him in staccato exuberance. "We're not a gallery of pictures. We have eighteen departments, six million visitors annually, eight hundred employees. We're an encyclopedic institution, a national museum, a museum of cultural history. . . . Thank God somebody decided to become a comprehensive institution. Our problem right now is we're not big enough."

Thomas P. F. ("Publicity Forever") Hoving laughed at himself. He was a man with a hundred interests, serving on committees dealing with pollution, drugs, broadcasting; he was co-chairman of the Committee of Independents for the Rockefeller team. This was the man who boasted that he got the Temple of Dendur with souped-up drawings and then told opponents of expansion that the temple could not be moved because the gift was "contingent" on placement on that site in Central Park. He was in such a hurry on the new museum façade that the Landmarks Preservation Commission, which by law must approve such projects before construction, and which had wanted

modifications of the plan, was unable to convey them to the museum in time. "He got ahead of us on that," said Allan Burnham, executive director of the Commission. "We could have had the steps torn down but by then . . ." And so the Commission had belatedly approved the new façade. It was watching the Master Plan with particular care.

As it happened, there was no need for the museum to misrepresent the Master Plan, for by a remarkable coincidence there was apparently no one in power who was willing to question the plan, not even the museum trustees.

The board of trustees of the museum had been created in the nineteenth century with both policy and operative powers. Administrative staffs everywhere, however, find their boards meddlesome, whether in hospitals, settlement houses, or museums, and it is natural that over the course of ninety years the staffs should have assumed power on the grounds of efficiency, until the trustees are left with a fund-raising function alone, and a shameful sense of inferiority in relation to the professional staff. So the Met trustees admitted to *The New York Times* that the board had not formally adopted the Master Plan, but voted on it piecemeal as various phases came up for implementation. The secretary to board President C. Douglas Dillon told me over the phone, in what one charitably hopes is a bad translation for "Tell her to go to hell": "You have to ask Mr. Hoving. Mr. Dillon knows nothing about the museum." And at one meeting between trustees and Art Workers, Mr. Dillon reportedly said, "You can't stop the expansion plan."

The Art Workers thought this was from malice or imperious self-confidence. They did not know that at board meetings, the trustees of the Met, conscious of the privilege that accrues by serving on the board and stunned perhaps by their museological nescience in relation to their energetic director, sit (as one trustee put it) "and wag their heads." The last thing the trustees wanted was to stir up controversy.

The best thing, therefore, was to approve the expansion

as quickly as possible, and since the Met trustees also serve on the various civic committees the museum must approach for permission to build, this is what they did. They got their plans approved.

Only two approvals from the city were needed for construction. One was that of Parks Commissioner August Heckscher, successor to Hoving. The other was that of the Art Commission.

For the Parks Department, approval was not a difficult decision. August Heckscher, administrator, and himself a voting member of the Metropolitan board of trustees, was said to be under pressure from the Mayor, for whom Hoving had campaigned in the last mayoral election. From the beginning he favored the plan. "I think it's a wonderful design," he said. ". . . I'm just afraid the project won't go through."

Evidently that was the feeling of the Art Commission as well, for in June of 1970, it hurriedly approved the plan "on principle." No building can be built on city property without the approval of the Art Commission. Yet four of the eleven members of the Art Commission were also on the board of trustees of the Metropolitan Museum. Mrs. Vincent Astor represented the New York Public Library (the Astor, Lenox, and Tilden Foundations). John R. H. Blum represented the Brooklyn Institute of Arts and Sciences. Robert M. Pennoyer represented the Metropolitan Museum of Art. Mayor John V. Lindsay represented the city. Two of them—Blum and Pennoyer—were on the Trustees' Architecture Committee, which was in charge of the building program. They also served on a committee on "Decentralization and Community Needs." This last committee had been formed only a few months before the announcement of the Master Plan. Its staff director was Harry S. Parker, III, vice-director for education. After about two months of study of what is surely the most complex philosophical question facing any museum at present, the committee issued a report stating that the Met would "decentralize" (enlarge) its educational services. The mu-

seum asked the New York State Council on the Arts for the funds for education, because its funds were tied up on building.

Several Art Commission meetings were held to vote on the Met's expansion plan, and one or another of the Metropolitan trustees was present at each one, some voting personally, some through delegates. No one thought to disqualify himself. Mayor Lindsay was so interested in the museum's expansion that he broke all precedents by sending Deputy Mayor Richard Aurelio to one meeting to cast his proxy vote. Commission members could not remember the Mayor ever voting at an Art Commission meeting. In one meeting the Metropolitan delegate to the Art Commission cast the museum's favorable vote on its own plans, a crude political exercise in which it was apparent that the trustees had forgotten the concept of recusal to avoid the appearance of conflict of interest.

Of three city hearings held on the plan, only one was before elected officials, and none had much legal power anyway over the museum. When the Landmarks Preservation Commission issued a report raising questions about the expansion plan, the report was not made public. Not even the commission members were given their customary copies, and news of the report did not leak out for months. Few politicians liked to criticize the Met or question the necessity for adding five acres of space for the city to maintain, though at every budget hearing Mr. Hoving had come forth to plead poverty, threatening to close down galleries for lack of maintenance staff. A year later he instituted a "voluntary" admission charge. One city councilman accused the museum of misusing $180,000 of city funds earmarked for a decentralization study and spent instead on the Master Plan. But no one could think what to do about it. That is the way with power in New York.

Meanwhile, a nervous distress was running through the cloistered corridors of the museum. Some curators were complaining of strong-arm tactics used by the museum administrators to achieve a united front at public hearings. Curators were

rounded up to sign petitions to the city officials favoring the plan, and for one meeting they were asked to volunteer for a telephone campaign to line up speakers and support. But the complaints ran deeper than the Master Plan. They concerned the very identity and purpose of the museum.

"Ninety-five percent of the curators are fed up to the gills," one curator complained, asking in the same breath not to be identified in print. "I'd be fired." Still another curator said he was not allowed to talk to the press unless a member of the public relations department was present. For proof of the troubled air, many curators pointed to the large number of the staff who had left since Hoving's arrival, some fifteen of the curatorial staff in only a couple of years. Hoving was aware of the opposition. He stopped a curator in the hall: "I know you're not happy here. Perhaps you should think of looking elsewhere." It happened more than once.

Some people within the museum administration passed off the curatorial turnover as natural attrition. But it takes a long time for a curator to learn a collection, and it is no easy step for him to leave.

"If I left, my objects would be orphaned. Who would look after them?" asked one. A museum curator is not like a university professor, who carries his lectures off with him when he goes. And when so many leave a museum of the caliber of the Metropolitan, one wonders why.

Was the administration aware of it, ashamed? When Claus Virch resigned in the spring of 1970, the only public announcement was in the last paragraph of a two-page press release stating, not that the well-known curator had left, but that a new curator had been named to the department.

When Henry Fischer, curator of Egyptology and the man who had acquired the Temple of Dendur, resigned the same spring, he was rehired as the Lila Acheson Wallace curator in Egyptology. There are two versions of the story. One is that Hoving went to Mrs. Dewitt Wallace, who, with her husband,

had founded the *Reader's Digest*, and who had long been interested in Egyptian studies; she arranged the new fellowship. The other story goes that Fischer was rehired at the shocked insistence of Mrs. Wallace. Whichever is true, he originally resigned in protest at the frenzy of Centennial activity. He wanted time for his objects.

Time for his objects. It is the perpetual cry in a museum: money and time. But there is no time because of the need for money. The way the Met raised money was by moving around. There was so much moving for the Centennial celebration that the personnel department issued a memo on May 1, 1970, stating that due to the "rush of activities, the personal injury rate at the museum has risen."

The Centennial celebration was originally supposed to attract money. Instead, it seemed to be spending it. There was a constant round of parties, lunches, dinners, receptions. In June 1970, four major parties necessitated the closing of public galleries during visiting hours. The party for 1,300 members of the American Association of Museums was described by the guests as a "shindig," a "blast," and by one member of the Art Workers' Coalition as "really great! We were throwing confetti around. Now I know what a museum is supposed to be. It was wonderful."

To the curators it was hell. They were asked to turn their exhibit galleries into pantries with equipment for heating food while they worried over the affect of the humidity changes on the art. They lent silver from the vaults to a private dinner party (overtime for two employees to deliver the silver to the hotel, wait for it, and return it to the museum). They heard stories of burning braziers of food in exhibition galleries with the flames leaping toward rare Chinese hangings, glass rings left on antique tables, cigarette burns in galleries where the public is not allowed to smoke. The trustees had dinner in the Wrightsman period rooms. "They have a perfectly good boardroom," cried a curator. "They don't have to eat in the period rooms!"

Stories of broken objects were whispered around the museum. There was a portrait of George Washington by Charles Peale ripped by careless hired movers. There was a Tiepolo accidentally scorched by being held too close to a light during rehanging. There was a statue in the Great Hall at the foot of the staircase called "The Struggle of the Two Natures of Man" by George Grey Barnard. When it was moved from one museum warehouse under the viaduct down to the museum (the curator being at the time on another job concerning the Centennial temporary exhibit, and the assistant out sick), the subcontractors lashed the heavy marble statue on a forklift by ropes and carried it to the museum on the forklift suspended over the back of the truck. The statue broke in two. The museum claims that the break resulted "from a previously existing but invisible fault line, rather than improper handling."

"Why does the board allow it?" cried one curator. He remembered how, during the war, the museum moved 15,000 objects out of the museum and back again without damaging a single one. "No activity of the museum should endanger the paintings," he continued fiercely. "The loan to the Boston Museum of our hundred best paintings . . . the people who are going to look at those are exactly the same people who would come to New York to see them. Their value is so great they are uninsurable. So we send them our hundred best paintings with no insurance!"

The museum administration insisted that the paintings were properly insured. The insurance company refused to comment; and whether the paintings were insured is not ultimately important. What is significant was the curator's doubt in the administration, the fact that he had lost his faith.

To the curators it was one indignity piled on another, vanity, vanity, and the frenzied hurry of the expansion program, which C. Douglas Dillon, president of the board of trustees, wrote should go through, despite a projected deficit of

$1,000,000. Never before had the museum had a deficit, and the curatorial staff wondered why there was no belt-tightening.

The Centennial spent money like water. The ceiling of a cloakroom was gilded ("Yes," confirmed the architect, "in gold leaf.") at a reported cost of $22,000. The gilt showed up the cracks in the plaster, and the ceiling was painted over white. A $15,000 birthday cake designed by a staff member turned out to be so vulgar that it was thrown away. Four museum galleries were decorated for the Centennial ball by such interior decorators as Billy Baldwin and Parish-Hadley. "Decorated!" cried a curator. "As if the objects were not beautiful enough, you need to decorate!"

At the 1969–70 budget hearings, Hoving told the city that the museum was so pressed for money that he would have to close some galleries on weekends because of insufficient guards. Yet six months later the museum found $5.4 million to buy a Velasquez at a London auction.

The director went on trips and left George Trescher, former promotion director of *Sports Illustrated* and a museum fund raiser, in charge of the museum. "Sometimes you don't know who's in charge," complained the curators.

The curators could not but help compare directors. Rorimer had not been easy to get along with either. Plenty of curators had found him secretive, stubborn, picky, too concerned with showmanship. "But Rorimer was a good director," said one curator. "Rorimer was first, above all, a museum man. Every minute of his time he was working for the museum, even when he was away." Another curator, speaking of Hoving: "He'll leave soon. He's a careerist. He's said he's going to leave. He's not interested in museums. He'll break a few toys and leave."

Perhaps. But at a meeting of the board of trustees that same year, Hoving reportedly stood up and announced that, contrary to rumors, he had no plans of leaving. When he finished, no one said a word.

Tom Hoving and Tom Lloyd

By the end of 1969 the Metropolitan was being attacked on almost all sides. First, there was pressure from white groups to "decentralize" the museum, spread the treasures around by one means or another, uptown, downtown—anywhere but in the precious grass of an over-used Central Park.

Second, there was pressure from the blacks (or rather from one or two individuals) to create a section for black and Puerto Rican artists, right there in the museum and not uptown in Harlem either, or out in Brownsville or Queens with hand-me-down art, but right here, baby, where the power is, declaring to all the world that black art and Puerto Rican art are every bit as

high-quality as white and Islamic and even the primitive art that would soon be placed on Fifth Avenue at Eighty-second.

Third was the pressure of the Centennial Birthday celebrations.

In January 1971, *Art News* devoted a special issue to the Metropolitan, "An Inquiry" on its hundredth birthday. Thirteen of the most distinguished names of the art world contributed articles, including Harold Rosenberg, Meyer Schapiro, John A. Pope, then director of the Freer Gallery of Art, Harry Bober, professor at the Institute of Fine Arts of N.Y.U., Linda Nocklin, Leland Bell, George Heard Hamilton, Fairfield Porter, and Rudolf Witthower. The Met was torn to shreds. So unanimous was the animosity that Tom Hess felt obliged to play the devil's advocate and add a few columns at the end of the Inquiry to defend the museum.

Some art-world figures, he explained, had not contributed to the Inquiry, because "they did not trust themselves to stay polite," or because they felt that a public attack on the most powerful art-world institution might harm their careers. The others attacked the museum (sometimes with delicate innuendo) for its massive weight, its gigantism, the new building program, the banality of its vision under Hoving, and for replacing esthetic considerations with sociological ones. Leland Bell, a painter, charged: "Those who clamor daily for innovation have never realized that the impossibilities of painting remain constant and awesome and have nothing to do with the masquerade of the New or the Old."

Poor Hoving. He saw himself as St. George, stalwart in defense of right, the fearless champion of the Left, standard-bearer to museums around America—and he found himself tittered about.

The opinion hurt. Thin-skinned, he did not like to be criticized. He was not above storming a magazine's offices with strangled threats of a libel suit, pounding the table and waving his arms, or throwing himself back in his chair (his two lawyers

staring at him with the same stolid surprise as the lawyers for the opposition) in helpless rage.

It seemed almost everyone was criticizing him. But he had the black community behind his expansion plan. He could congratulate himself on that. That was a feather in his cap.

The black community in the spring of 1970 was self-appointed in the person of Tom Lloyd, forty-one years old, five children, a militant artist who works with electric lights. Lloyd had screamed himself hoarse in Art Worker meetings about decentralization of art facilities and racism and more community centers in the black areas and more black artists in Establishment museums.

In the fall of 1969 the Art Workers' Coalition had formed a "Committee on Decentralization" and drawn up a proposal to "study the cultural needs of New York City communities and establish mechanisms for the growth of autonomous cultural centers." A number of Art Workers worked on the study. They agreed that Lloyd, being black, should field it for funding. He sent it to Hoving at the Metropolitan and to the New York State Council on the Arts. One week later (on March 3, 1970) Lloyd met with Hoving, and presto! he found himself almost that same day with $19,000 to study decentralized community centers. Hoving drove Tom in his limousine right then down to the Rockefeller Brothers Fund at Rockefeller Center to ask for money, and right then in Tom's presence he telephoned for more money to John Hightower, then director of the New York State Council on the Arts, who in only two months would become director of MOMA and himself thereby subject to Lloyd's persistent clamor for a Martin Luther King Study Center at MOMA.

Lloyd was enraptured by the precision of the white man's power, the swiftness of its execution. Imagine popping into a limousine and purring downtown to pick up almost $20,000, just like that! It is pleasant to be thought all-powerful, and Hoving did not disabuse Tom of his notion. As it happened, Lloyd's proposal had already languished on the desks of the Council long

enough to have been read. It was well thought out. In addition to Lloyd, it had been worked on by Lucy Lippard, the art critic, and Barry Schwartz, and a few others of the more articulate Art Workers. Hoving's participation, therefore, represented just a matter of speeding up a proposal that would probably have been approved anyway.

But for Lloyd everything changed.

Lloyd had the possibility (oh, God!) of being in the Met. It was no less than Lehman had. It is the temptation of the Devil . . . and Hoving, long, lean, striding across the carpeted office with that svelte, upper-class look as he extends a cordial hand to Lloyd, looking in his eyes as equals: Tom Lloyd . . . Tom Hoving. There might be a directorship somewhere, sometime. A secretary's sweet voice: "This is Mr. Lloyd's office." So in the next few months, Tom Lloyd argued against three or four demonstrations attacking the Met and MOMA, and he spoke up at one public hearing in favor of the expansion plan and numerous times in private.

"I believe in Hoving. He's a good man. He's going to come through. He promised us a wing for black and Puerto Rican artists." Not separate, but at the seat of power. "He promised us space when the expansion goes through. Right now there isn't any space. So I'm in favor of the expansion," explained Tom Lloyd.

Tom saw things in black and white. "The expansion plan is opposed," he rolled the words out of his mouth, bitter in his blackness, "by rich old elderly ladies on Fifth Avenue whose only concern is a few trees. They don't care about a whole people—" and he held on tight to that promise of Hoving's though it had been couched in the most elusive language, and there was no mention of a black wing in the well-publicized Master Plan. "I think it would be very beneficial . . ." Hoving had said agilely. "We would be very desirous of having a place where the community could be represented. . . . It shouldn't be restrictive."

Tom Lloyd did not know that about the same time, Ted Rousseau, vice-director and curator-in-chief, told a friend at lunch that the Met had no intention of creating even a black gallery: "We'll show a good black artist—if there are any," he smiled suavely. "But a black wing would be, well, racist." Moreover, having found Lloyd the grant, Hoving neglected to mention that less than a month earlier (on February 24) the trustees had formed a "Committee on Decentralization and Community Needs." The staff director, Harry Parker, III, never met Lloyd, and he forgot to send him a copy of the decentralization report when it came out, even for his information.

Meanwhile, on his side, Lloyd was busy too. Lloyd did not tell the Art Workers that the grants had been upped from $19,000 to some $30,000 and finally to $39,000, nor that the money was being transferred through the Metropolitan. The twenty-two surveyors, mostly black and Puerto Rican, set out valiantly to their assigned communities to question everyone they could find—men, women, children, junkies, priests, hookers, businessmen, and welfare recipients—about their esthetic needs.

The eight communities selected are among the poorest in the city. Art comes low on their list, somewhere after housing, drug addiction, crime, garbage, medical care, jobs, education. But the surveyors kept at it, grateful perhaps for a $125-a-week paycheck, and remembering Hoving's promise that the museum would be willing to assist communities with projects once they articulated their wants (though it would be arrogant, as the Met pointed out, for the museum to go in and high-handedly give the community something it never asked for. "They aren't interested in a Rembrandt.")

Then the community surveyors learned that the grant funds were channeled through the Met. They assumed the worst: Hightower and Hoving were buying off Lloyd in another example of Establishment duplicity. There may have been grounds for the assumption, but they misjudged the evidence. In fact, the money came through the museum because funds from

the Rockefeller Brothers must legally go to a nonprofit educational organization with a tax-exemption certificate. The easiest way to get the Art Workers their funds, apparently, was to give it to the museum, which would in turn distribute it to the surveyors.

The artists turned on Lloyd. Their anger had been building for weeks. They were annoyed to discover they were working for Lloyd, not as partners or equals in a participatory democracy, but as subordinates, paid by him. Barry Schwartz, especially, was upset, for he discovered that the Lloyd proposal was the same one prepared by the Coalition—minus the names of the Coalition and other Art Workers. He felt betrayed. Lloyd was getting the publicity. Lloyd was getting the grants. Moreover, he was paying himself two hundred and fifty dollars a week—double the salary of the others.

Then it came out that Lloyd had furnished an office in his house in Jamaica, Queens, with the grant funds and employed a secretary, though there was little enough secretarial work to do in connection with the survey. It was said the grant funds were deposited in Lloyd's personal account.

Lloyd felt Barry's animosity was "racial in a sense inasmuch as a black person was coordinator and designer of the survey. Barry was out to destroy the survey," says Tom Lloyd, "once he saw he couldn't be the good old liberal leader." Tom found it harder to explain the animosity of his blacks. The artists felt he was overbearing. Lloyd felt they were "ripping off." He refused to pay them for three weeks—until all their reports were in.

This made them so mad that one evening eight of them descended on Lloyd's office in Jamaica, demanding to see his books. They also demanded to see his survey, for the South Jamaica community, if he was asking to see theirs. He refused. An argument broke out. A fight. Lloyd called in reinforcements. Someone was waving a gun. Lloyd called the cops and had the eight surveyors arrested for criminal trespass.

The surveyors were filling out Vera bail forms at the police station when Lloyd dropped the charges. It was 3 A.M. They were mad.

The next afternoon they fell on Hoving. Barry Schwartz tells the story. They demanded that he telephone Lloyd and order him to pay them all for the three weeks' work. They threatened to stay in Hoving's office until they were arrested. Some were using the phone to call the press. They announced Tom Lloyd was fired! By them! Hoving tried to be calm, patient (according to the artists, for he does not talk to reporters about that afternoon). He announced that they were his guests, to whom he would extend every courteous treatment. He tried to murmur that the Met was divorced from political activity. The artist's voices rose in rage at Hoving for toying with them. They screamed so loud a windowpane shattered. Outside three paddy wagons and the police arrived. Hoving wanted the committee to sign a paper that they agreed at least to cooperate with the sponsors of the survey: the Met, the Rockefeller Brothers Fund, and the New York State Council on the Arts. After long arguments they agreed on the wording. Hoving then "asked pitifully" if Lloyd could not be retained on the survey. Lordly, the artists refused. Hoving escorted them to an adjoining room, where Tom Lloyd sat, waiting grudgingly to sign the paychecks.

And that was all that was heard of Tom Lloyd or of the Community Artists' Cultural Survey Committee, or of Hoving's foray into the black communities.

And Hoving? Was he shaken by the prospect that almost everything seemed to go askew? He had started his tenure on such a high note, the hero, the *condottiere*, as Murray Kempton called him, who would storm the iniquities of society and stir up the mettle of museums.

There was his joyous invitation to the Art Workers' Coalition, extended during the meetings of the American Association of Museums in May of 1970. AAM meetings traditionally are droning, sleepy sessions on such topics as "New Methods of

Exhibit Lighting," or "Sales Desk Stocks and Your Membership Fees." At the meeting in May 1970, the Art Workers stormed the podium, wrestled the mike from the chairman, and took over the meeting, demanding that the Association decide what museums could do about war, racism, sexism, repression. No wonder Hoving's imagination was fired! He could see that, yes, it was true! Museums did play a part in these things. When the resolution was put forth that a further meeting be called, it was Tom Hoving who leaped up to offer the facilities of the Metropolitan Museum of Art for the workshop. He seemed to want the museum involved in life on the streets, in partisan politics, in the great decisions of life and death that make a man's journey through life worth living. Over the summer the invitation was gracelessly withdrawn, and though a workshop was held in October in the newly redecorated lobby of an anxious museum, the participation was all on the part of the Art Workers. Their frustrated anger overflowed onto Hoving, who had offended them by having raised their hopes and then quashed them.

Then there was the "Eye-Opener," sent rumbling through the streets in August heat. This was a huge inflated plastic bubble mounted on a truck. It cost $25,000 and under its ballooning cover was an exhibit (how odd some people found it) of the spiral form: helices, vortices, spirals, curving in gay, spinning freedom, designed to open our eyes, inspire in our urban pickaninnies a rapt delight for barber poles, pinwheels, shellfish, and the other vortices of our environment. Unfortunately, on the first voyage of this mobile trailer to the Bronx, the irresistibly tempting plastic cover was ripped by a knife, and had to be withdrawn for repairs. Since then it has been repeatedly slashed.

Hoving seemed torn by conflicting images. On the one hand he might imagine himself (as in fact he had once been) the quiet scholar wanting only, like Candide, to cultivate his garden and contribute in a modest (though spectacular, historic, fame-ringing) fashion to scholarly discipline. A Berenson. A Baude-

laire. On the other hand, he seemed tempted by life in the streets, the New Left, the direct, tough, violent involvement with things, the confrontation of knives and drugs and city life.

Instead, here he was the director of a famous museum. He had stated the direction he wanted the museum to take. Yet, in spite of his best efforts, it was taking another course.

"What I'm doing here I could be doing for General Motors," said Hoving one day to a reporter for the *Village Voice*. With the ill luck that dogged him, the statement backfired and enraged his curators. For museums have their own pomposities, their own principles, and one is that it is *not* selling cars or images or persuading people to buy the latest fashion. This was just what the Met seemed to be doing. It was becoming a large department store, where the visitors could window-shop or even buy at the new polished bronze sales desks some of the excess objects from the museum collections.

The museum had a hold on Hoving. It was driving him in its own direction, which was greed. Lust powers every museum. It is tempered in most by poverty. The fabulously rich Metropolitan had no such inherent inhibitions. A more thoughtful man than Hoving, more moderate, might have been able to temper the museum's force. But Hoving's primal force was joy—an impulsive enthusiasm to accept any challenge. His drive, his hungry ambition fastened on that greed, coupled with it, and made of the museum a monster. His sense of competition made him grab everything around, looking over his shoulder at the nearest runner-up. When the Temple of Dendur was offered to the United States by the United Arab Republic, and it seemed the little temple might go to the Smithsonian Institution, Hoving raced to Washington to wrest the prize from his rival, Dillon Ripley. He returned to New York delighted with himself. The winning was what he loved. The prize was inconsequential. So he got the Lehman collection, Rockefeller's Museum of Primitive Art, the Velasquez, and he really *cared* that the works should not go elsewhere.

"If we don't get the Lehman collection, it will go to the National Gallery!" he cried, though in almost the same breath he was praising the Met as a national museum, with encyclopedic collections. Encyclopedic were his ambitions, and his energies, therefore, were buckshot scattered across the Panascopic screen of his activities.

The Smithsonian Institution— or, How the SI Tried to be Relevant and What Happened

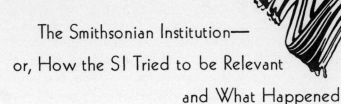

For a while the behavior of the Metropolitan Museum seemed an isolated phenomenon, and the museum was attacked as a deviate, a pervert in the community. Vanity, vulgarity, vainglorious aggrandizement. Beauty is not related to size. Is anyone impressed by size anymore? Or by a new plaza in front of the museum that, eliminating the carriage drive, causes traffic to back up on Fifth Avenue every time a taxi stops at the museum? Or by the new $3-million Great Hall with fewer public telephones than previously, and no toilets on the first floor—as if the design were all for looks and not for human use? Or by the three or four doors to the building that were closed for lack of guards

—while the museum started to construct five more acres of space? There was a certain irony in the fact that the city "owned" the building and yet had no jurisdiction over this Master Plan. The Museum was attacked for its unesthetic lack of moderation. But the Met was not the only museum gone queer. There was something in the air infecting museums. A contagious disease. It had already erupted as riots in the universities. Now it was hitting museums as well.

If the museums did not have troubles over relevance, they had quarrels with trustees, or directors, or over money or a general loss of purpose. The Boston Museum of Fine Arts was caught smuggling a Raphael through Customs, to the mortification of the trustees, who had known nothing about it. Then it turned out the picture was greatly repainted anyway, so that little enough was left to be called a Raphael. The director resigned. The Pasadena Museum was closing certain days for lack of operating funds. The Brooklyn Museum was closing half its galleries each day. The Corcoran Gallery of Art was hiring and firing directors as if in a wild death dance, and the state councils on the arts were eyeing the power of museums like hungry wolves, snapping their jaws over the private use of public facilities. They implied that government-operated museums would be better run. That this was not necessarily so was evidenced by the Smithsonian Institution in Washington.

There are three kinds of museums: those supported entirely by private funds, such as MOMA, those supported partly with private and partly with public funds, such as the Metropolitan, and those supported almost entirely by public funds—government museums, in a sense, whether federal or state. The largest of these is the Smithsonian. On analysis it does not seem that the behavior of any of the three is defined by its source of money. Yet any discussion of museums is inevitably reduced to anxiety about money and how and where to get more.

One is tempted to generalize that the larger and richer the institution, the more exaggerated its behavior, and to attrib-

ute the greedy goings-on at the Smithsonian to its Brobdingna-
gian scale. Except that other institutions, such as the Cleveland
Museum or the National Gallery of Art, reveal no such ambi-
tious incontinence. So what happened at the Smithsonian was
not merely the result of intumescent growth, but indicated a
general malaise of museums, the distress of the times.

Now, you will wonder why I suddenly shift the scene out
of town in this chronicle of New York, and why, if I am going to
do so, I choose the Smithsonian, which is hardly well-known
among the general public for its art (though the museums them-
selves are known). First, the activities of the Smithsonian at the
time were common to museums or would soon become so: the
sale of paintings from the collections, for example, the apparent
loss of purpose, a certain shifting in the consensus of what a mu-
seum is supposed to be and how it should reach its goals, a new
reliance on image and political maneuvering.

I used to work at the Smithsonian Institution, and I can
affirm that this change came suddenly in the middle 1960s. It
was not restricted to the Smithsonian either. I would be less
than candid, however, if I did not add the second reason for
describing the events at the Smithsonian, which is that the
material is in the public domain. At the end of the Sixties,
synchronous with the very period of art-world discord that over-
whelmed New York, Congress began an investigation of the ac-
tivities of the Smithsonian Institution in Washington, D.C. The
linen was publicly washed.

The Smithsonian. It is the colossus of American muse-
ums. It operates some fourteen semiautonomous bureaus, scat-
tered around the world. So extensive are its activities that one
hundred fifty-two pages were required in a Congressional hear-
ing to describe them all: research, education, collection, instruc-
tion, all proudly unfurled in the slogan "The Increase and Diffu-
sion of Knowledge Among Men."

The troubles began in the late Sixties when the new di-
rector, S. Dillon Ripley, II, arrived at the Smithsonian, hot to

make it relevant. Like Hoving, he had so many ideas. He was going to make the Smithsonian educational. A massive building program had been completed under the former secretary; Ripley would flesh in the invertebrate shell with visiting scholars, research fellows, popular exhibits. He would expand the Smithsonian services outside of Washington, around the country, with films, TV, books, a magazine, a membership of Associates, special lecturers, classes, books, tours. Oh, he had a lot of ideas, and many of them were very good. Only they all cost money.

First came a bank of administrators. "Ripley's boys," they were called. They formed a new unit, the "Secretariat," a managerial layer between the curators and museum directors and the secretary himself. This caused a jealous dissatisfaction in those who had formerly held the reins.

Having added administrators to execute his ideas, Ripley began to restyle the Smithsonian's image: to make it fun. He decorated offices and Smithsonian halls, grown shabby over the years, with rich Victorian decor—with rust-velvet settees and thick rugs, marbelized columns in gaudy orange and green and black, with potted palms and paintings from the collections, until it all looked like a movie set. Disneyland. On the Mall he put a pretty carousel and some models of dinosaurs for children to climb on. But let us quote Frederic M. Philips, director of the Office of Public Affairs, who defined the secretary's ambitions in a vanity publication:

> Rigorous emphasis has been placed on scholarship and research within Secretary Ripley's concept of the Smithsonian as a kind of open university in the manner of the earliest museums of classical times. . . . At the same time his determination that museums should serve a wide public in imaginative ways has provided livelier exhibit techniques and exhibitions. . . . The Festival of American Folklife, which annually draws more than half a million visitors; and a greatly expanded range of activities that has brought into being such units as the Anacostia Neigh-

borhood Museum, the Smithsonian Associates, and the Division of Performing Arts.

Some of this is puff, confusing the ambition with its accomplishment, but it shows what Ripley was trying to do. He was right on top of the "relevant." He had started a small Smithsonian branch in a Washington slum, and for a few years this brought wonderful press, though around 1970, the glamor having worn off, Anacostia began to have trouble finding funds. There was a puppet-show company in the Museum of Natural History, the Folk Festival on the Mall, the magazine, films, television. A lot of curators were disturbed at what was happening at the Institution—wondering how such massive diffusion could be accomplished without sacrificing depth.

Within six years, the Smithsonian had more than 3,000 employees. Federal appropriations for salaries had jumped from $3 million to $39 million in only fifteen years, and the total federal appropriations for the Smithsonian doubled in six years. No wonder the Institution, ballooning so fast, was crippled with gas pains.

Did they think that funds were unlimited? Suddenly, in 1969, odd reports erupted in the press. The older museums were being drained of funds as the Smithsonian supported new "public relations" programs. One staff member was charged with scholarly dishonesty—and his director was fired. Parties and balls filled the museums, while money was so tight that the Institution considered selling off items from its collections to buy the fashionable avant-garde, and the secretary himself was charged with using the facilities of the Institution in an improper fashion, causing a minor scandal in a city jaded by scandal.

A year later, in the summer of 1970—as the Met was being bombarded by AWC and MOMA was looking for yet another director—Congress was holding the first public hearings in a hundred trusting years into the affairs of the Smithsonian, and

the Secretariat, stunned, scurried through the corridors of its museum. How were they to know they had done anything wrong?

The troubles began in an art museum, which reflects perhaps the general state of art.

The National Collection of Fine Arts is noted mainly for its history of long neglect and poor collections. It was established in 1848 as a National Gallery of Art. Having no patron to care for it, the museum declined in unhealthy state until, in 1937, Andrew Mellon gave his art collection to the nation. At which point it nearly died. The Mellon collection was so fine that Congress crowned it with the title "National Gallery of Art." Congress then saddled the former National Gallery with the improbable name "National Collection of Fine Arts" (NCFA) and directed it "to foster . . . a growing appreciation of art" and "encourage the development of contemporary art." Having done its duty, Congress followed historical precedent by neglecting to provide much funds.

The National Collection, on its part, did little to encourage or promote contemporary art, because its long-term director, Thomas Beggs (1948–63) disliked the stuff; the Smithsonian scientists disliked it; and the general attitude in Washington was that collecting art less than thirty years old was injudicious, subject to the whims of fashion and fad. There was also an attitude that if modern art were ignored, it would go away. One must recognize the peculiar provincialism of our political capital to understand the distaste for the avante-garde which so often seems outrageous and offensive. The 1930s saw a liberal concern for contemporary art that was linked with the social concerns of the Roosevelt era. But the 1930s were over by the time NCFA received its mandate from Congress. The 1940s were taken up by the War, and the 1950s, when the New York art scene was bursting with creative expression, was passed in Washington with Eisenhower apathy. In the 1960s the memories of McCarthy purges left government bureaucrats still trembling. It

seems incomprehensible today, but throughout the 1950s and well into the 1960s, any radical leaning, except toward the right, was suspect. When David Scott joined the staff of NCFA in 1963 as the new assistant director (and the promise of the directorship) and hung in his own house his own Abstract Expressionist paintings, he was advised that he would lose his job. If it were known in 1963 that he was associated with Abstract Expressionism, his career would be dead. Having just spent his last $2,000 to move his family from California, he put away his recent work and hung paintings he had done thirty years earlier. I tell you this so you can see how far Washington had to go just to catch up with the art-world fashions of New York.

Tall, reserved, intelligent, a somber figure with a gray complexion, Scott determined to build the NCFA into a museum of consequence, a museum of American art. He wanted it to be the equivalent of the Whitney or the Tate—vital, vibrant, fashionable, discussed, a force in the art world. David Winfield Scott is a painter, a scholar, a teacher, with degrees from Harvard, Claremont Graduate School, and the University of California at Berkeley. He saw the museum as a repository for the history of American art. On his arrival he discovered that, except for two watercolors, there were only two pictures in the collections painted after World War II. One was a painting of a U.S. naval vessel that remained lest its disposal be construed as destruction of government property.

So Scott started making NCFA relevant. At first he was responsible directly to the secretary, Dillon Ripley. In 1968 a new position was created over him: Assistant Secretary for History and Art. Scott found himself responsible to Charles Blitzer —and his own power in the hierarchy reduced one step. Charles Blitzer was young, handsome, marvelously charming. He had taken his M.A. and Ph.D. at Harvard in political science, taught for ten years at Yale, and was a specialist in James Harrington, the seventeenth-century English theorist who said, "Give me

good men and I'll give you good laws." Soon after Ripley's ar-
rival, Blitzer had arrived at the Smithsonian as director of edu-
cation and training, with the responsibility for attracting post-
graduate and research fellows to the Institution. Within three
years he had moved from the $21,000-a-year job to become at
forty-one the $38,000-a-year Assistant Secretary for History
and Art. He gave an impression of immaculate precision, and
with his small frame and elastic, youthful step, his long, grace-
ful hands and his black hair sprinkled with distinguished silver,
he seemed the epitome of all the Smithsonian should represent.
How strange that he and Scott did not get along. Neither did
Scott and Ripley, for that matter.

The first open breach came over an NCFA staff member,
whom we shall call "Archibald Win."

Archibald was an associate curator at NCFA. He had
been hired as an exhibits technician of sorts, and after Ripley
came, he had been promoted year by year, beginning, according
to some catty sources, when he married one of Ripley's young
secretaries, the daughter of a good Washington family. Archi-
bald was regarded on the small, fluid staff of the NCFA as a jun-
ior curator, or perhaps one of the exhibits staff. He was charm-
ing and obliging. He would run errands up to the Hill or take an
afternoon off to get something done for you. He had a winning
way with people. During the Johnson Administration, he had
worked with the White House in a program that lent paintings
to top government brass to decorate their offices, and it was
agreed he had done it wonderfully well. There was a sweetness
about Archibald, a gentle, childlike, trusting, warm, obliging na-
ture that evoked reciprocal response. He had the sincerity of the
pure in heart, which makes a reprimand ricochet back onto the
rebuking authority so that it demonstrates not the wrongdoing
of the recipient, but the impurity, the sophisticated, calculating
evil, of the superior officer.

One day Scott discovered that Archibald Win's Form 57

was misleading. This is the Civil Service formal application for a job. Likewise, his biography in a Smithsonian publication, *Research Opportunities*, was exaggerated.

Checking uncovered that he had not had a full year of study and an honors degree at the University of London, nor studied the history of fine arts in depth for his masters degree, nor done full-time archeological work in Alaska. Actually, he had not lied. He had stretched the truth. He had studied for a while in London, and he had been stationed in Alaska on military duty, and he had gone on digs as a spare-time hobby.

There was no malice involved. Scott was sure of that. The deception had occurred out of a sincere desire to tell people what they want to hear, and Scott remembered how once a woman had telephoned NCFA to ask about a miniature she had left with the museum and which she wanted returned. Items were frequently missing at NCFA. One federal survey disclosed that out of 113 paintings chosen at random, the auditors had difficulty finding 51, and 5 remained permanently lost. On this occasion Win with the best intentions told the woman that he knew just where the miniature was, but it was locked in a desk drawer and he did not have the key. "I'll get it tomorrow," he promised, knowing the picture had not been seen in a year. Win had no feeling of having done wrong, and the uproar later over his Form 57 or a short lie in a publication seemed to him to be uncalled for and unfair. "Someone is being unfair or unkind to me," he said. "I don't know the reason for this inquiry. . . . It sounds like some kind of witch-hunt."

But that was later, for nothing happened at first. Scott did nothing about Win until one day when he was called to Blitzer's office and informed that Mr. Ripley planned to promote Win to curator-in-chief of the new Smithsonian Museum of Crafts, the Renwick Gallery.

Then he voiced his reservations to the young superior he so disliked.

"I don't think," said Scott cautiously, speaking in his

slow, deliberate, slightly stuttering fashion, "that the Smithsonian should get involved with someone who misrepresents the truth."

"What do you mean?"

"His Form Fifty-seven," said Scott. "Also his résumé in *Research Opportunities*. He hasn't done all these things."

Blitzer was angry. He thought it significant that Scott had known this for a year and said nothing. It amounted to vindictiveness, he felt—or possibly Scott had been waiting all this time, holding the information over poor Win's head. Scott was a trial in many ways, secretive toward the Smithsonian administration, and toward Blitzer himself. Merely getting him to send his memos to Central Archives was difficult.

And what could be done about poor Win, who had meant no harm? He was naïve as a child, and Blitzer, like Scott, was sure his act was not his fault; but now Blitzer was stuck with doing something about this when what he had wanted was to promote him to the Renwick Gallery.

"I don't know that I made the right decision," Blitzer mused unhappily. "I don't know what the right decision was." And he spent two tortured weeks trying to resolve the matter.

Eventually he decided to insert a letter of reprimand in Win's file, signed by Scott. It would remain in the personnel file one year and then be destroyed.

A letter was drafted and sent to Scott to sign. Scott refused to sign. He had decided that such a reprimand might be a federal offense. He consulted a lawyer. Then he returned the reprimand unsigned, suggesting the matter be sent to other channels. Blitzer was grinding his teeth with rage. But there was no way to force the director to sign. Blitzer had the personnel director sign the reprimand. It read:

> This letter constitutes an official reprimand. You are officially reprimanded for providing misleading and inaccurate information on your Form 57. . . . Misleading, in-

accurate or inflated entries constitute a serious offense
. . . and is a serious breach of faith and trust. You will be
required to substitute a revised, completely accurate ap-
plication form. . . .

Your conduct on the job here has been satisfactory in
all respects and must continue in the same manner.

Some people felt the action was lenient. Others were
shocked at Blitzer for writing two memos to Ripley who was
himself, it seemed, personally interested in Win's case. One
memo, marked "personal and confidential," confided to the sec-
retary that yes, there was no doubt that Win had purposely "fal-
sified" his résumés. It suggested that "this is not the time to re-
ward Archie with a promotion." He continued that the Smithso-
nian might find:

some way of directing his activities toward the Renwick
Gallery without making him Curator-in-Charge, and giv-
ing him a promotion. . . . If we are to follow this course
. . . First, you should talk to Archibald and explain the
decision and its logic: that he has behaved improperly,
that you have decided not to dismiss him (although some
people have recommended that you should) but that you
cannot under the circumstances reward him at this time
(particularly since Charles Sawyer will be watching with
interest to see what you do), and that the possibility of a
promotion at a later time under happier circumstances re-
mains open.

The second course of action available to the secretary
(Blitzer carefully spelled it out) might be "simply to . . . proceed
as planned." In which case, Charles H. Sawyer, chairman of the
Smithsonian Art Commission, should be placated with a letter
stating that the "whole question seems to have been magnified
out of all proportion." Blitzer did not recommend that course of
action:

Particularly in view of what I now take to be the cer-
tainty of further and worse trouble with David Scott, I

think it is important that in this case we should behave in a way that we will be able to defend (if necessary publicly) in the months ahead.

Win was not promoted, and the incident was forgotten. The case, however, afforded the first direct confrontation for Scott and Blitzer.

The next one came when Scott accused his superior of trying to sell an NCFA painting off his office walls. He went so far as to write his charge to a member of the Smithsonian Art Commission. Blitzer denied it. He said that he might idly, in a conversational way, have asked one or two visitors what they thought the picture might be worth, "if it really were a Turner"; but that he had never tried nor would he try to sell the picture.

The third confrontation arose over the proper use of a museum, for the Smithsonian, like many museums, was entertaining lavishly.

Giving parties is a good way to make a museum "relevant," especially if the party gets in the papers. The Smithsonian parties were particularly successful because the person in charge of arrangements discovered early-on that if he eliminated the mixer from the punch it saved money. He would mix whiskey, ice, lemon, and a little water in a big bowl and call it punch. The parties were considered great fun.

A few months after the Archibald Win affair, Scott received notice that in May 1969 the Secretary wanted to hold a dinner party for an anthropological symposium in the NCFA Lincoln Gallery. Ripley wanted to make this elegant white gallery, where Lincoln had held his Inaugural Ball of 1865, into a permanent reception hall. Scott had planned it for exhibits. It was true that Scott held his own receptions before exhibitions openings, but he drew a distinction between a discreet NCFA affair with a cold buffet, well away from the pictures, and a full-scale seated dinner party for several hundred anthropologists

with waiters, caterers, and steam tables near the objects. He had little enough space without removing his exhibits periodically for parties.

Scott refused. Ripley insisted. Scott was fired. The party was held.

The party hit the papers:

> Boxes piled against a Francis Bacon painting. Boxes stacked against a Dewasne enamel. Steam tables of hot food next to a Ronald Kitaj mural. An art museum used like a cafeteria. Concerned protest by the museum's director, David W. Scott. The director fired for insubordination. The secretary of the Smithsonian, S. Dillon Ripley, expansive after his coup in ousting the director, pointing to the artistic heritage of America while billows of cigarette smoke enveloped paintings by Ryder, Cassatt, Eakins, Whistler, Cropsey, and Cole. Carpets burned underfoot by carelessly dropped cigarette butts. Liquor and coffee spilled on the floor. Glasses smashed on the marble tiles. . . . Such was the scene Friday night, May 16, in the Lincoln Gallery of the National Collection of Fine Arts [at a] final night's dinner party for the Smithsonian's symposium on "Man and Beast: Comparative Social Behavior."
>
> "We behave culturally," one symposium speaker had said the day before, "because it is in our nature to behave culturally." . . . Professional art museum people . . . had objected to the secretary's party, knowing that the [purpose of an art museum] is to . . . protect paintings and sculptures from chance damage in uncontrolled circumstances. . . . They are our artistic heritage. Destroy them, modify them, and you modify each and all of us.

Ripley quickly denied the reports. He wrote one Congressman that the newspaper account "bears no relationship to facts and is scarcely worthy of comment by me. I would only say that the guests at the dinner behaved with the decorum one would expect of such a group and that no damage was done." His letter would have had more effect, had not other letters ap-

peared in the *Evening Star* from witnesses at NCFA, one an Associate Curator, that corroborated the report.

Now let me introduce Robert H. Simmons, a private citizen of Washington and Massachusetts. A gnat in a thunderstorm, a stocky little rooster of a man, holding himself stiff and erect from years as an officer in the merchant marine, his brown eyes filled with anger and pain at the humiliation, the degradation he felt in his fallen ideals of the Smithsonian Institution. He saw in David Scott the nobility of mind and purpose, the honor, the integrity, the dedication to a higher vision that corresponded to his own views of how a man should lead his life. He was the more pleased to discover Scott had served in Antoine de Saint-Exupéry's unit during World War II. Simmons was working at the NCFA, and he started an explosive chain of events that ended in a Congressional inquiry. What was he thinking of? Not the demogogic democracy of the Art Workers' Coalition, for Simmons believed in a natural elite, an aristocracy, not of birth but of talent and vision—the very opposite point of view of the egalitarian Art Workers.

Not everyone approved of Simmons. He was strange, said the Smithsonian archivist Samuel T. Suratt, who lived near him on Capitol Hill. The opinion was based on the fact that Simmons lived in misanthropic seclusion among the friendly residents of the Hill. He never entertained. A loner, people said. He had traveled a good deal and started to collect Oriental and African art, some of which, to people's surprise, was good. A strange hero for our art world.

Simmons was forty-six years old. He got his B.A. in English and art history at the University of California at Berkeley in 1949, served in both the merchant marine and the U.S. Naval Reserve, and in 1965 had retired to Washington to devote himself to art. He had written a couple of books and museum catalogues, and he was working in June 1969 at the NCFA organizing an exhibit on the American Negro artist Henry Tanner with a $5,000 grant from the Kress Foundation. He began to watch

what was happening around him. The more he saw, the angrier he became. It was Bob Simmons who fiercely wrote the Sunday *Star* account of the events of the anthropologists' party in the Lincoln Hall. That was just the beginning.

After Scott was fired, the assistant director, Robert Tyler Davis, became acting director. He was in his sixties, and long associated with the art world as director of several museums, professor of art history, and museum consultant to French & Co. from 1960 to 1968. For all his experience, he was a disappointment to NCFA. One day an NCFA staff member was in Simmons's office.

Simmons asked about Davis.

"Oh, he's doing a lot for us," came the enthusiastic reply. "He's evaluating all those paintings and tapestries we're going to sell."

"What do you mean, sell?" Simmons's ears pricked up. *"Sell the taxpayers' property?"*

Soon after, while placing a memo in the central file basket, Simmons spotted a letter to a New York dealer. It regarded the exchange of a painting. Simmons found that Davis had traded a painting, "Virgin and Child" attributed to Jan Masys, a sixteenth-century Flemish artist, for a picture "Helen Brought to Paris," by an American artist, Benjamin West. He got a photo of the Masys, and judged it was worth about $30,000. The West was priced at $10,000. Graham Gallery immediately put the Masys up for sale at $35,000. Simmons felt sick. It turned out that the museum had asked for only one informal appraisal of the value of the Masys, and this from Parke-Bernet auction galleries. The Old Masters expert reportedly looked at the painting for a few minutes and gave his opinion of its worth. This is quite different from a formal P-B appraisal, which is the notarized consensus of two or three experts and requires hours of research.

An explanation of the difference in prices was later given to the General Accounting Office when it investigated the trans-

action. The Masys was valued at auction at from $6,000 to $8,000 because interest in the painting was limited and there would be only a few days in which to arouse a buyer's interest. The Parke-Bernet expert said he would not be surprised, however, if a dealer could get $15,000 or $20,000 for the picture, since he could wait for an interested buyer.

Simmons flew to New York and negotiated to buy the Masys from the Graham Gallery. He got the price down to $30,000. He put a $500 deposit on the picture and left. Then he started telling everyone he could find that NCFA was selling off the national treasures. He wrote to Congressmen, to the Smithsonian Board of Regents, to the Internal Revenue Service, to the FBI. No one seemed to care. No one did anything. He watched the memo baskets, reading and Xeroxing, recording the sale of three paintings by the acting director between June and December of 1969.

One was a Guardi sold at London auction without first seeking the three public bids normally required for the sale of public property. Another was a landscape by the eighteenth-century artist Richard Wilson; it netted about $14,000 cash. At that time the Smithsonian Board of Regents had not established a formal policy on whether works of art should be sold or exchanged, nor under what procedures. At least three art advisers to NCFA were strongly opposed to the sale of the nation's paintings. The disposal of valuable paintings, they had written earlier to the secretary, "has almost invariably, in the perspective of time, proven to be a mistake." The sales came out in the press. Blitzer, who had just issued a public statement that no further paintings had been sold, was reported by Jack Anderson to be frantically telephoning New York in an attempt to get the Wilson returned.

It should be noted that the first sale of a painting had been undertaken the year before by Simmons's hero, David Scott. Scott had discovered, as he struggled to build up his museum as the center of American art, that there was very little

out of the 13,000 works of art that he cared to show. Moreover, he never had more than about $20,000 a year for acquisitions, which won't buy much in today's market, where a single Warhol can sell for $40,000, or more.

In 1968 the contents of the studio of a major nineteenth-century American sculptor, Hiram Powers, came on the market. Scott had no money to buy. He went down to the basement, dusted off some paintings, and came up with a Francesco Guardi, "Ruins and Figures," which had been donated to the NCFA in 1919, a very important, fully signed and documented painting, with no strings attached regarding its disposal. He sold the painting at London auction and with the $107,000 reimbursed the Smithsonian's private funds for a loan to the National Collection to buy the contents of the Powers studio.

Davis, therefore, was merely following the former director's lead. It is a tricky transaction, to sell objects from a museum collection. Some museum directors believe in a practice of continual sifting and sorting, culling the collections to preserve only the best of their chosen field, and in this way wasting no funds on the preservation of the inutile. Others, more orthodox, believe the practice almost invariably proves a mistake, since opinions change as doggedly as museum directors. In between, the range of museological opinion plays treble to bass, in every key of how, why, what, and when.

A year or so later, for example, the Metropolitan Museum caused a stink when word swept the art world that the museum was putting up for auction a number of pictures so important that no one denied their value in any museum collection. One was Picasso's "Woman in White." In a flurry of adverse publicity about a publicly supported museum selling off the objects that it has previously purchased (or which, by accepting from a donor who deducts it from his taxes, the public has indirectly purchased), the museum withdrew the objects from sale. Denied, in fact, that any such sales had been contemplated.

But at the Smithsonian the objects being sold were not so fine as "Woman in White." Nor was the NCFA endowment so generous as that of the Met. The temptation to sell, therefore, was the more exquisite. The sales raised questions not only about proper procedure—the Smithsonian admitted it—the lack of safeguards for selecting, verifying, pricing, and approving of objects to be sold; they drove to the very roots and philosophy of a museum. To what purpose is a museum collecting? What is it trying to accomplish, and does the sale of works of art hamper or assist the purpose?

Charles Blitzer said he left to the director of each Smithsonian museum responsibility in regard to the sale of federal property. He was careful to make this point, seated in sartorial immaculacy before the Congressional subcommittee: "These transactions were carried out by the staff of the NCFA, and, if I may, I would say that they were all initiated by the staff of the National Collection." Despite his flexible position, he defended the transactions before Congress. What else could he do? And so he justified the sale of a Guardi and the purchase of the Hiram Powers collection by his rival, David Scott: "The historic, artistic and scholarly value of the Powers collection is enormous, particularly for a museum specializing in the history of American art.

"The monetary value of the collection can only be estimated, unless it is thought necessary to pay for one or more formal appraisals."

Apparently, a formal appraisal was considered unnecessary, for Blitzer preferred to quote instead the estimate of an anonymous "leading authority on nineteenth-century American sculpture" who estimated the value of the collection—which had been purchased by the Smithsonian for $99,408.05—as actually $168,800!

Desperate to stop what he saw as the attrition of national treasures, Simmons went to the FBI. Word got back to the Smithsonian administration, and on June 20 Simmons was locked out of his NCFA office. A memo was issued to the guards:

June 20, 1969

Re: Robert Simmons:

Mr. Robert Simmons must not be admitted to any office or service areas during open hours and is not to be admitted at any time when the museum is closed to the public.

The room 253 which he has been using as an office is closed to him at all times. (There is no key to this room.) If he has left any personal belongings behind these will be given to the guard at the main entrance where he can pick them up.

If he comes to the building again, please try to get any other keys he may have. (He has already turned in key to room 281.)

Simmons was especially angry because the Smithsonian went through his personal papers and effects. One day he was in the NCFA public galleries with his fiancée, an NCFA staff member, when a guard took the girl aside. "This man is dangerous," he told her. "We have orders to keep an eye on him at all times."

But let us hear it in his own words, speaking before the Congressional inquiry in July of 1970, in response to Blitzer's remark that Simmons had never come to the Secretariat with his charges on these subjects, as he could have done.

MR. SCHWENGEL: Is that true, Mr. Simmons?

MR. SIMMONS: . . . One major reason was that I was locked out of the National Collection of Fine Arts. I believe it was known that I was investigating these funny procedures.

MR. SCHWENGEL: . . . You say you were locked out?

MR. SIMMONS: Yes. That is another story. But I will describe it. I was working in the National Collection of Fine Arts, not as a member of the staff, but under a contract, preparing this exhibition of Henry Tanner. While I was there, it came to my attention that there had been a big party for anthropologists thrown in the National Collection's Lincoln Gallery sometime in May. I went up to the Gallery a couple of days later and saw it was still sort of a mess. A witness told me of very irregular procedures that hap-

pened in that event. This was described in an article that I wrote for the *Washington Star* on May 25, 1969.

When Mr. Ripley heard about this or read this letter, this article, he was infuriated, I suppose, because he felt it was not true. Letters came to him from various Members of Congress and he wrote back to the Members that my article was very irresponsible, completely. But my article was based on what people had seen. . . .

In June . . . three letters appeared in the *Washington Star*, corroborating my report. These were letters from eye-witnesses to the events and, the following day, I was locked out of the Museum. I was no longer able to continue the organization of this exhibition.

MR. SCHWENGEL: You mean you weren't allowed to go into the museum?

MR. SIMMONS: No longer allowed into anything except the public galleries. They confiscated one of my own paintings that I owned, worth about $1,200, and I didn't get this back until some time in September. They furthermore confiscated all of my notes to a catalogue, which was published in part through the efforts of the Smithsonian . . . it was a very irregular practice, academically speaking, I believe.

Concurrent with this, I had discovered on June 16 a memo in the memo basket, in taking some of my own memos in to throw them in this basket, which was from Robert Tyler Davis to an art dealer in New York, saying that he was very pleased that an exchange had been effected between this gallery and the National Collection of Fine Arts. He noted that it was an exchange of a Benjamin West painting for a Jan Masys painting. I requested people in the Registrar's Office to give me some information on these two paintings. I saw a photograph of the Jan Masys painting. I judged that this was worth about $30,000, whereas the price on the other painting was only $10,000.

At that time, I went to the Internal Revenue Service, where I knew they had a board of review about this sort of thing, I guess on the 17th of June. They directed me to the Federal Bureau of Investigation, where I went and made a report on this. I also went to my Congressman,

Mr. Keith, at that time, . . . because this possibly was a very funny irregularity.

So things were beginning to go in that direction at that time. I believe it became known to members of the staff, because I told a friend of mine, who was involved in it, that I had gone to the FBI. So I don't know whether I was locked out only because these letters [about the party] appeared in the *Washington Star* or because I had gone to the Federal Bureau of Investigation with findings of irregularities.

But, whatever, I was locked out of the museum and so I had no reason ever to consult these people again. It was my feeling that there were basic irregularities.

When Simmons could arouse no one in the government bureaucracies to the activities at NCFA, he took the matter to Washington columnist Jack Anderson, the muckraking successor to Drew Pearson, who began to publish acutely embarrassing reports. Dillon Ripley, reached by Anderson's office at his country house in Litchfield, Connecticut, and asked how national art could be sold without his knowledge, allegedly replied, "I can't check every day to see if the janitor's buttons are polished."

Anderson learned that on at least two occasions Ripley had borrowed NCFA paintings for his Washington house—a private use of government property that is considered improper. There were stolen delivery records, spies, smuggled notes, cautious night approaches to peer in the windows of Ripley's house to spot the pictures—and a final confrontation by phone between a reporter in Anderson's office and the Secretary of the Smithsonian Institution. Ripley explained that he had borrowed the paintings for a period of one or two weeks for a party he was giving for the Board of Regents.

Then Anderson wrote that Ripley was sent by the Smithsonian on an Aegean pleasure cruise in a 110-foot luxury yacht, the *Pacific Gold*, which rents for $480 a day, during which time

he "quaffed fine drink, lolled on beaches, sampled succulent Palaiokastritsa lobsters and viewed antiquities, all at public expense." Smithsonian officials reluctantly conceded that the cruise had cost the Institution $2,800, not counting air fare and incidental expenses. The money came from a grant intended to be used in connection with a symposium on Bronze Age Culture, and though Ripley is a bird rather than bronze expert, and though his official mission was to search for the Audouin's Gull (he sighted not only the Gull but a fading Eleonora's Falcon as well), he assured the donor of the grant that he would visit archeological sites as well.

The Smithsonian was mortified by the publicity. It didn't look good. Once started, it did not seem to stop.

The institution discovered itself criticized by Senator Barry Goldwater for neglecting the National Air and Space Museum, which for months had been without a director, for unsound fiscal procedures, and for asking federal employees on the public payroll to work on projects for the private sector.

A General Accounting Office audit was ordered. It was discovered that $40,000 had been used by the Smithsonian to finance the cost of altering one building, when it had been authorized by Congress for construction for another.

Forty thousand dollars is a piddling sum. "However, there is a principle involved here," said the report, "and that principle is that the law says appropriations shall not be used for any other purpose except that which it is appropriated for, whether it be $40,000 or $40 million. . . . The Smithsonian Institution in this case does not agree that what they used those funds for were illegal under the law. We do feel that they were illegal expenditures."

Dr. Richard Cowan, Director of the Museum of Natural History, reported to Congress that so much money was being spent on the fashionable favored projects of the Secretariat that there was none for the proper functioning of the museum. The scientific staff of the museum had fallen below the level of three

years earlier. The number of lab technicians available to assist
the scientists declined, forcing relatively high-paid scientists to
spend their time typing manuscripts, preparing slides, and per-
forming the other duties of a support staff. The research depart-
ments, moreover, were being deprived of several hundred thou-
sand dollars a year in grants from outside agencies. According
to the GAO report, the total amount of money received by the
Smithsonian from grants and contracts ran in excess of $11 mil-
lion. In the Museum of Natural History the suspicion arose that
the funds were being unevenly funneled into other projects
more popular with the Smithsonian management.

Senator Barry Goldwater charged that the Smithsonian
publications office was unable to support the research staff, be-
cause the editors, who were all on the federal payroll, were de-
voting their time to books that were for sale by the private side
of the Smithsonian to finance its own revenue-producing activi-
ties. This was the more noteworthy since under the previous ad-
ministration the Smithsonian had maintained clear lines of de-
marcation between editors on private and public payrolls.

Well-publicized fellowships and intern programs were
straining Smithsonian's resources. Yet sharp reductions had
taken place in library services, and supplies.

In May 1970, the scientists learned to their distress that
the Smithsonian Institution, with its $50-million budget, was out
of money. The deficit was to be made up by cutting the operat-
ing budgets of various bureaus, with a considerable amount rep-
resenting the share of the Museum of Natural History.

All of this came out in the Congressional inquiry in the
summer of 1970, a catalogue of uneasiness and distress.

One brave band of laborers testified that hiring and pro-
moting at the Smithsonian was governed by favoritism and nep-
otism, that personnel practices were blatantly discriminatory by
race and sex. This has long been true at almost all museums.
Ripley said he left all such matters to Personnel.

Six months later the subcommittee issued a report mildly

chastising the Institution for its financial management, its handling of the Hirshhorn Museum, its employee relations. The criticism was couched in such courteous and quiet terms that only a member of the inner circle could have read their hidden threat, and neither did the criticism do anything to clarify how an art museum should conduct itself, or what the purpose is of collecting art, or what art it should collect.

But the hearings had their effect on the Smithsonian. They made it nervous. Blitzer could not quite understand the brouhaha, nor Simmons's obsession with the Institution, for Simmons was by no means finished merely because the Congressional hearings had come to naught. Having stopped the unauthorized sale of pictures, he turned his attention to Hirshhorn and to the Hirshhorn Museum. Simmons frightened Blitzer a little. He was not sure what Simmons would do next, and he did not want any more stories written. It would hurt the Smithsonian.

The Institution asked Congress for much more money in the following year's appropriation in order to manage its programs better.

Images and Ideals

The change in museums occurred so quickly in the 1960s that it was hard to grasp, and the suddenness with which change came accelerated the crisis. Museums, accustomed to a crawling turtle-time, had no chance to catch their breaths. Everything was happening at once, and they had all they could do just to keep up.

First was the question of who was running them. The first American museums were founded in the nineteenth century for the enlightenment and education of the people. They were largely run by men of exceptional ability, who perhaps due to their strength and vision, attracted weaker men, and these

220

eventually succeeded them. The third generation saw museums
staffed by homosexuals, women, and the castoffs of society, who
retained nonetheless the dedication to their vestigial vision:
their purpose was to collect. After World War II art became
synonymous with money, and museums discovered they had de-
veloped until they were handling millions of dollars. They at-
tracted men who were attracted by power. A curator, a "mu-
seum man," was no longer the logical choice for a director, but
neither was there training for the job. And that was why, in
1969 and 1970, there was such a switching of directors. Not
knowing the purpose of a museum, no one knew how to run it.
The trustees were firing directors. Bankers were naming them-
selves as heads of museums, or were looking for management
analysts and wondering why suddenly things were going wrong.
The idea that the problems of museums could be solved by ad-
ministrators reflected the current tendency to think in manage-
rial terms, as if all problems are merely questions of efficiency
and cost-studies. There was even a magazine published called
Arts Management.

No wonder the museums were rocked by an identity cri-
sis. It was almost as severe as their monetary crisis. The muse-
ums made solecistic reference to themselves as "in transition,"
as if they knew where they were going. They were torn between
their two ideas. On the one hand, they clung to their antique
view that the art object is precious in itself, perfect in its
beauty, and that they have purpose enough in merely preserving
it from the ravages of time and man. On the other hand, they
understood that a work of art demands that someone appreciate
it. What sense in locking a work of art in a dark basement, never
to be viewed? Why bother to preserve it, if it is not seen, and
more than seen, admired, and, more than admired, used to in-
spire other works?

Museums discovered they had a relationship to the public
and a relationship to the object, and while the two had comfort-
ably coexisted for roughly a hundred years, they were suddenly

found to be mutually exclusive. Loyalty to the public demanded that art serve for the pleasure, education, or benefit of the people. Loyalty to the art demanded that the object remain above the immediate interests of one transient generation. The object is ideal, perfect in its beauty.

Now it was no longer enough to collect without being admired for the task. Can you sympathize with the loneliness of the museum director, sitting over treasures in unpeopled rooms, wondering if anyone values them but himself?

Once art is seen as in the service of the people, its service is necessarily determined by the numbers of people served. The museums found themselves measuring the value of their objects by body count. Body count likewise determined the nature of their exhibitions: swift-changing, temporary shows, each publicized as an immortal experience. It is still the pattern. The visitors are herded through, their ears filled with rented acousti-guides and their hands with pamphlets. They are processed through a gluttonous smorgasbord like so many sausages stuffed with education and considered improved by the experience. No one seems to understand that the treatment shows respect for neither the people nor the objects.

The museums require the crowds, moreover, in order to ask their trustees and city councils for more funds for more exhibits, until the definition of a good exhibit has come to sound like the U.S. Pavilion at the Osaka Expo '70, where the key to the design was to allow 10,000 people an hour to pass a particular point. Impossible to measure the *quality* of a visitor's experience. Everything reinforces the museums in their criterion of *quantity*. Their task takes on a subtle shift: to attract people. They beat the drums.

Now, when a museum moves from its sphere of preserving art (much like medieval monasteries, which became sanctuaries of learning) and starts declaiming . . . leading the populace to enlightenment, one's expectations are raised. No getting around it: you expect something terrific to happen. Pri-

vate pleasure becomes a public right. And when a mass public can't get it, they feel cheated. They'll turn on the museum, or university, or Bastille, and tear it down.

Art is, in the final analysis, a private communication. Whatever happens occurs between the object and the eye. It is quite ordinary, a thrill of pleasure. There is no uplifting holy conversion, no exaltation, no inspiration. It is merely visual delight. The museums in the 1960s, determined to be educational, inspirational, proclaimed all kinds of pomposities about art, at the same time feeling obliged to explain things to the masses. Ironically, the more the ideal is explained with slides, guides, sound, films, flash, the less it is respected. Perhaps this explains why, having expected something great from the exhibit, the public comes away feeling cheated. It has been cheated. It has been cheated of that special one-to-one relationship with an object, the solitude in which to fall in love, and the self-respect implicit in the outdated attitude of the original museums, wherein the visitor, alone with the object, was assumed to be intelligent enough to find something of interest.

The museums had no time to think of that. Their job was to drum up trade. In addition to proclamations of educational inspiration, they proclaimed the avant-garde. There were a number of reasons for this, but one was that the art of the past was so . . . passé. It was not *alive*. Contemporary art was exciting. It brought in hordes of people. You had only to compare the scattered tourists in the European Paintings Department at the Metropolitan with the crowds at MOMA to see how lively was contemporary art. Moreover, by comparison with Old Masters, the paintings were cheap. The administrators, having generally no museum backgrounds, did not overly concern themselves with the paradox implicit in developing museums of modern art.

In turning to the avant-garde, the museums added the third element in their identity crisis. They couldn't tell anymore what was art. Does this sound weird? You will say that museums have often collected contemporary art, and that MOMA it-

self is an example. But this is not true. When MOMA was founded in 1929, it was collecting the art of 1880 to 1920. The trustees and visitors were not familiar with the art, but Alfred Barr, the director, was, and it was already forty years old when he started to collect. Eventually the paradox caught up with MOMA, when MOMA caught up with its age. There was nothing left to collect. The museum had two choices then. It could become a serious and scholarly study-center of modern art, accepting its role as tastemaker and putting on exhibitions of such certain quality as to contribute to the history of art—or it could forge ahead and buy the avant-garde quick, while it was cheap. It could (as it did) buy three Jasper Johns paintings at the first one-man show of the then unknown artist, and put on shows of contemporaneity that vied with any dealer's for crowd-gathering verve. Most museums depend on the gate. Most, like MOMA, were choosing the latter path, with the result that they found the prices of the unknown, unshown artists rising out of their reach as they tried desperately to collect them before it was too late. It was not the fault of any one museum. Their competition had a cumulative effect. Also, they discovered that they were more and more confused about what avant-garde meant. Except that it was "relevant." They could tell it was relevant because it attracted crowds. It spoke to people. It was instantly understood. Since anything becomes a work of art simply by being in the museum, the problem became one of separating the relevant from the art. Current events become art. Computers are art. Concerts, theater, puppet shows, a dancer in the nude.

At the exhibit of nineteenth-century Victoriana at the Metropolitan Museum of Art, one lady turned to her friend: "I never realized this furniture was so attractive before."

"No," answered the other, "I never liked it before."

Of course not. It had not been approved before by museum exhibition. The redecorated lobby of the museum is a work of art. Parties at the museum are works of art, and so, by extension, are the guests who attend.

All of this affected the museums. If they were unsure of what constituted art or the proper interest of a museum (especially as the artists had decided that politics was art, just as the museums had decided that re-creating society was "relevance"), they plunged ahead anyway, never daring to look ahead or even behind them, but only glancing across their shoulders at each other to make sure they were still in the race, measuring their money and time by everyone else's performance, and trying desperately to deny that their Midas touch turned everything to art.

Exhibiting the avant-garde creates serious problems for museums. First, they end up showing almost exactly the same things that are being shown by dealers. Second, and more serious, in the competition to get on the bandwagon, to compete for the most newsworthy and most outrageous, the museums suddenly find themselves creating the fashions they are supposed to record. Recently it was reported that a writer still in his twenties received a letter from a well-known university library. The library wanted to collect his future, as yet unwritten, manuscripts and letters. They were betting on him for posterity. The writer declined the flattering offer, on the ground that he did not want the knowledge of his future greatness peering over his shoulder as he worked. The same mentality affected the art world. Ten years ago an artist of my acquaintance received such a letter from a university museum requesting his "archives." He did not reply. But consider: by collecting future works, the university is speculating. It is meddling with the judgment of posterity. Assuming that the artist fails to create an immortal work, the museum or university then has the choice of either dumping the junk or, after waiting fifty years to see if the work will be posthumously recognized, perhaps deciding it has an interest in making him recognized. Given human nature, which do you think most likely?

This is what the museums were doing with their frenetic collection of fashionable art. They were circumventing what the

New Yorker called that "marvelous and mysterious process by
which a generation selects the best works of the preceding gen-
eration and transmits them to the generations that follow."
They were tampering with our future past.

In the system of art it is the museum, finally, to which we
turn for an independent view of art, a dedication not only to
beauty or excellence, but to humanism, courage, honor, to those
qualities that uplift man and his surroundings. It is to the mu-
seum we turn to forget the cheapness and expendability of
things.

And this is why the corruption of the museums was at the
same time the most subtle of the art world and the most sad.

Surely a museum should be like a sea anchor, a drag on
society, way back there keeping our balance. This thing—the
museum, our cultural history—must be in retard, slow, slowly
evolving, slow because truth is not easily discovered and it *is not
subject to change*. Think of that! Excellence does not change.
Our eye may. What one generation appreciates may be different
from what its fathers valued, but the excellence remains.

The museums were no better than those who ran them,
and they, poor mortals, had become as confused as everyone else
by fashion in art, by how to measure quality. There was a time
when museums knew what art was. It was what was in the mu-
seum. This was true because enough time had passed between
the execution of the work and its museum collection for a con-
sensus to have developed about the work—which is the only
definition possible for art.

The museums measured contemporary art by the only
standard they could—by what everyone was saying about it, by
the crowds, the articles in *Vogue* or *Time*, and the opinions at
parties—until they were as confused as the rest about whether
they were being talked about for art or fashion. Fashions in liv-
ing, in decorating, beauty, make-up, fashionable books to read,
fashionable artists to cultivate, fashion, which, by definition, is
short-lived.

There was a model, Loulou de la Falaise, who was frequently in *Vogue*. One month she was glorified with four pages of photos shot by Richard Avedon. "Look at Loulou now," sang the parapoetry of fashion. "All shine and dandy for evening . . . big blue eyes rimmed with kohl paper clip thin. . . ." "Look at Loulou as the night goes on. . . ." "Look at Loulou kicking up her heels. . . ." "Look at Loulou in feathers and furs, a little funky monkey."

Funky! Queer, inverted values of fashion. "Funky" means hideous, frightening, horrifying, causing to flinch or cringe. Where else but in *Vogue* was "funk" thought beautiful? Why, in art. Funk Art, which was the rage of San Francisco, being pushed by the director of the University Art Museum at Berkeley.

A woman at Ivan Karp's gallery was walking through the exhibit of plaster figures. "Art doesn't have to be beautiful," she said uncertainly to her friend. "It can be ugly too."

"Of course," interrupted the tour guide suavely. "Goya, for example."

Things become confused. Some people hire public relations firms to remake their images to correspond to the *Vogue* ideal. When everyone hires firms to create an image, to tell him what to wear, what parties to give, whom to invite, where to be seen, to get his name in *Vogue* and later in "Suzy Says" or *Newsweek*, when all his friends are also working through their public relations firms, the time comes when he sees no wrong with an institution of learning—a museum or university—applying the same principles of image and p.r. The standards become queered.

The confusion in museums lay in mistaking the image for the ideal. The tracking after truth, the dedication to quality (the ideal) has nothing to do with what people think of you (the image). Or whether anyone thinks of you at all. The ideal is substantive, indivisible, unable to be fractured or measured. The ideal exists apart from man, unattainable. The image, on the

other hand is simplistic in order to be grasped, superficial, frag-
mented, fragile. The image is artificially created, and it can be
measured by the artificial devices of crowds, questions, and
polls, for it exists only in men's minds.

Look at the verbs: you *make* an image, *have* an image, *de-stroy* an image. The ideal is unchangeable, indestructible. The
image reflects. The ideal uplifts.

And here is where our museums went off course, for they
had apparently lost their purpose and ideal. To gauge excellence
by an attendance figure is a travesty of judgment. The adminis-
trators, products of their times, intent on "involvement," fash-
ion, public relations, a Madison Avenue approach, install a self-
congratulatory room at the Met where the public mawkishly
mimes over closed-circuit television its pre-taped applause to the
art on the walls, as if the plaudits would reinforce the art. Reli-
ance on image indicates a lack of respect for the museum, the
objects, the public, all of which, like the image that is so ad-
mired, become subject to manipulation. This is what the muse-
ums were doing. Without ideals, without philosophy, and appar-
ently without respect for others, the museums like drug addicts
were searching for their identity in the immediate, the short-
term, the instancy of self-gratification. They swayed with every
breeze.

They contributed to the sense of discontinuity of the
times.

In a city like New York, where change is the single focus
of society, where newness becomes an end in itself and anything
new is news, the corruption of museums was the more awful.
We find ourselves eliminating all the things we can relate to. We
take away the comforts of landmarks, the line of trees, the fa-
miliar walks, even ideas. We build to gigantic scale and then dis-
cover that the human soul, unable to relate comfortably to the
hugeness of that scale, rebels. Rebellion leads to further change,
and change to repression. There is no resting place for the social

misfit, and we are all made misfits by the lack of continuity of our culture, the restless unfamiliarity of our changing city.

And the museums, whose task should be to provide continuity, to teach grace and form, the moderation of exquisite proportion, were contributing to the discontinuity. I do not believe the Art Workers—the revolutionaries—understood this as one source of their unease. Furious, they wanted to destroy all institutions for their arrogant disregard. Neither did they see that rioting at museums resulted not in brave voyages in search of museological purpose, but in retrenchment. Perhaps partly to control rebellion, our institutions enlarge, grow, merge, become absorbed into mercantile giants, effecting further centralization, rigidification, control through whatever means necessary. In the end they are isolated from the causes of revolt, causing further revolt.

Power to the People

There was a certain irony to the demands of AWC; what with all their foul language and furious revolutionary poses the Workers were so middle class. In spite of themselves, they envisaged that old American dream of a Better Way of Life. And a lot of people speculated rather cynically that if any one of them had been approached by a dealer or offered an exhibition at MOMA, he would have split the cause and run, tongue lolling, after success.

The Art Workers spent considerable time discussing the financial plight of impoverished artists. At one meeting the question was raised why there could not be a government sti-

pend for artists—a grant, not to museums to produce more exhibitions, but to artists to produce more work.

There was a pause. The idea was staggering.

"Survival is owed to us!" cried someone, suddenly seeing things in a whole new light. "It is our right as artists!" The meeting immediately degenerated into the old quarrel over how one defines an artist. Who would qualify for support?

"Anyone is an artist!" came the answer.

"But wouldn't that be the same," someone asked confused, "as a guaranteed minimum income?"

The Art Workers knew very little about the Establishment, but they knew it did not favor social change, and the Art Workers were determined to make the Establishment see the need for change. That was why they started invading various business meetings in the spring and fall of 1970, storming podiums and taking over the mikes. Often the audience walked out.

Lauren Reichen understood the irony better, perhaps, than the others. Lauren is twenty-eight and looks forty. He has a mane of black hair, a thrusting bush of black mustache, and his face, unlike the grim visages of most Coalition members, knotted in humorless intensity, radiates warmth. He looks like a kindly professor behind his thin tortoise-shell glasses, his mouth turning up with a joyous, infectious lilt. Lauren, a graduate of Brandeis, was co-chairman of the Sociology department at Adelphi University in Garden City, Long Island. Both parents were artists. According to Lauren, his father, Leo, had shared a studio with George Rickey and Kunioshi. He had worked in the WPA, the 1939 World's Fair, and various government-sponsored art projects; so that Lauren was brought up (he dissected his situation scientifically) in an environment of creativity, an atmosphere whose principle doctrine was "What I am doing teaches me what I am."

In 1964 Lauren was hurt in the Harlem riots. He was working as a volunteer in Harlem. Caught on the street with

two young kids, teenage friends of his, he suddenly found them panicking at the bullets and leaping terrified onto his back, using him as a human shield. They cracked his vertebrae. He spent two years off and on in the hospital, and suffered a permanent back injury. That made no sense to him. He was not even beaten up by cops.

There were other contradictions. He was moved by contradictions: his parents' struggle to live, conflicting with their desire to create art—the constant compromise of survival and creativity. Lauren himself wanted to be an artist. All his life he watched his father remain consistent to his own style, becoming in his faithfulness "critically irrelevant" to the next generation. He was upset at the contradiction. He was upset at the difficulties of merely living, which seemed so unnecessarily time-consuming, and at the changes of a city around him, visibly decaying before his eyes. And he was only twenty-eight! He had lived for five or six years in his apartment on Tompkins Square in a railroad flat in a five-story brick building, and in that time he had seen the rentals rise and the neighborhood decline until it was unsafe to go on certain streets after dark. The sagging, brick houses nearby were gutted, their windows covered with boards or, more often, left with their jagged broken glass jutting up against the black holes, havens for junkies. Shopkeepers pulled steel grates across their windows at night. Residents walked German shepherds on the garbage-littered streets. Lauren had been mugged six times in one year, and he lived in constant fear (because of his back injury) of being surprised. He was looking for another place to live. It was not easy to find, and there was a certain irony in this fact, too, for was he not on a city commission helping artists find places to live and work in the Soho district? The City Planning Commission had ruled recently that artists were exempted from city regulations preventing residents from inhabiting the abandoned cast-iron industrial buildings south of Houston Street, so artists could buy or rent huge lofts (for prices that were swiftly rising to $300 and

$400 a month, as the landlords discovered a lucrative new source of income). How ironic that the Planning Commission would do for these people, as artists, what it would not do for others. The Planning Commission accepted the thesis that artists need space, as much to satisfy their psychic creative urges as to spread out canvas to paint.

"If Art Can't Be Used to Serve the Needs of the People, GET RID OF IT" read one of the Coalition signs. Lauren stuck it over his desk, though he was uncertain whether he agreed that art is, *primo*, pragmatic. It blinked out at him, together with a mass of newspaper clippings, cartoons, lists of things to do, pictures, phone numbers, bills.

"If anyone had told me when I was younger," he said one day, "that I wouldn't be able to live on my money, I would have laughed in their face. Shall I tell you what I make? I make six thousand a year. I'm a single man. I don't have any luxuries." He looked around at his bare splintered floors, the shabby, cast-off, sagging furniture. "And I can barely support myself. On six thousand a year. By the time I pay gas and electricity and rent. I never take taxis, I always travel by subway. And taxes: Do you know, one-third of my income goes to taxes? Two thousand dollars. I can't afford to get sick. I couldn't afford a doctor."

What was appalling was that no one seemed to care. Lauren was convinced that if only they knew, the people in charge would change things. Lauren and the other Art Workers, you see, saw power as monolithic. Having none themselves, they envisaged a power structure that was centralized, controlled, a hierarchy of omnipotent, omniscient autocrats. They thought the art-world powers (who, by chance, are often the same as those in government or business) manipulated things according to a grand design.

Of all the Art Workers, Lauren had the clearest idea of what the Coalition should be, and he knew what it would never be. The only way to create a decent environment for artists, he felt, in a society that at bottom despises art, is for the artists to

stop "ego-tripping, competing for art historical reputations."
They had to get political power. Lauren had already had more
experience with Establishment power and the intricacies of
foundation funding than most of the other Art Workers. In
1967, after starting his M.A. and teaching at Adelphi, he had run
across some friends doing a play protesting the draft. He fell in
with the group and started producing political scenarios. It was
called Free Theatre. Lauren defined it as "a critical radical thea-
ter to catalyze social change." It was comprised of forty or fifty
people in summer, and perhaps ten in winter, setting up on
street corners like medieval mummers, drumming up an audi-
ence and performing for free, except for the passing of the hat
at the end. The hat went round also to foundations, and was
filled, too, by the Rockefeller Brothers Fund, the New York
Foundation, and some small foundations. The theater received
$5,000 from the National Endowment for the Arts, and some
more from City Affairs. The gifts left Lauren with no gratitude
and no less scornful view of the society he wanted to change. In
fact, in the three years he worked on the theater, helping to
raise funds, learning the operation of local, state, federal and
foundation bureaucracies, only one thing became clear: that the
Establishment had sucked them up.

"We killed ourselves," he murmured, explaining the
course of events. "To survive we had to become integrated into
the system, and then—" he glanced up with pained eyes "—and
then we betrayed the original radical intent."

From the theater group, he moved to the Coalition. He
met the Art Workers by accident at one of the early demonstra-
tions at MOMA. He had wandered into the museum courtyard,
and there was Alex Gross and his wife, Aline Astrakhan, and
Lucy Lippard, and Bob Hewitt, and Farmon, the poet, and the
artist Hans Haacke. They were all milling around the garden
yelling about injustice and inconsistencies. "It was like coming
home," says Lauren, and he threw in his lot with them.

On a gut level he found the Art Workers were tuned in to

what was wrong, but they had no ability to formulate intellectual concepts about the commodity system of art, or the cultural institutions that Lauren saw as a part of a larger system, administered as if they were major corporations. The Art Workers had no coherent social analysis. Lauren worked on them, indoctrinating them, commanding them to think in political, economic, and social terms, until his ideas, as he put it, "became everyone's property." He hounded them to attend professional conferences: Associated Council for the Arts, Business Committee on the Arts, the American Association of Museums, the Museum Directors' Association. He brought newsletters to the Coalition meetings from the Business Committee on the Arts. His explanations were schematically simplified in order for the others to understand.

"Look at this. This is what it's all about. For Christ's sake, stop the fucking rap and learn. This is the Business Committee on the Arts. *Where* is it? Rockefeller Center! *Who* started it? David Rockefeller! Who is *on* it?" He would go down the list, haranguing them:

"Robert Anderson, Chairman, Atlantic Richfield Company; Douglas Dillon, Director of U.S. and Foreign Securities Corp.; Arnold Gingrich, publisher of *Esquire*; Katherine Graham, president of the *Washington Post*.

"These are the people who define what art is. It's not your dealers or critics. It's *collectors*. They are the people who say what's bought and sold. What do they know of art? Art is what will make money for them. They pretend this organization is for the betterment of art. Listen to the names: Houghton, Irwin, Devereux, Josephs, Marcus of Neiman-Marcus, Morton D. May, Chairman of May Department Stores, Mellon, Rockefeller, Thomas Watson, Chairman of IBM. . . . This committee is a propagandizing effort. The idea is, now businessmen can support the arts. Look at the names. The lists of corporation presidents, publishers of newspapers. Look at their sense of what is art! BCA is replete with self-descriptive ads. 'Improve your image,'

it says, 'by supporting arts in the ghetto.' If your business is in an urban area and you want to sustain your image, maintain stability for your industrial environment—that means preclude riots [laughter], then support the arts. That's what they're saying! Hire bright long-hairs to work for your corporation and change your image. Keep down revolution by giving out a handout."

The Art Workers growled their anger, and since few of them cared to wade through the wordy pamphlets, they accepted Lauren's interpretation of the Committee without further thought.

"The Business Committee on the Arts," cried Lauren, "points out that corporations have not been taking advantage of tax laws. Save money. Give to the arts. That's their purpose! Before 1969, businesses could give seven percent to the arts. They were giving three percent! If giving four percent more saves business money, says the BCA, we should educate businesses to the value of art." And Lauren paused to glare around at the upturned faces of the artists of AWC.

"This organization isn't for the arts," he continued. "It's to save money for businesses. These men don't give a fuck about art. I ask you, is this going to serve the needs of *art*, or does it serve the needs of *business?* The organization was organized by businessmen, in order to stimulate business interest in the arts. It is my opinion that in the name of supporting art, they serve as a buffer zone between dissident arts and the Establishment! They serve to maintain the status quo."

The status quo was what the Art Workers wanted to destroy, but in 1970 they became caught up in the antiwar movement and could not hear, though Lauren was convinced he was speaking out against the war as well. Weren't these leaders of business and art the same men who ran the government too? He saw an obvious interlocking of Congress, the Pentagon, and the business corporations, a systemized official government subsidy passing from one to the other, so that these oligarchies—Con-

gress, the military, the corporations—maintained each other symbiotically, protecting and feeding each other. It was only through the sidewise relations of business interest in the arts that Lauren could get at the Establishment, could voice his displeasure.

"It is a free welfare system to the upper classes," said Lauren impatiently. "Don't you see it? Those cost-plus contracts to the aerospace industries are giving *our tax money* to *private corporations* through military contracts. The money stays with the corporations. It does not return to the Treasury. Oh, NO! That's *our* money going in *their* pockets."

In April 1970, Lauren and Alex Gross traveled to St. Louis to disrupt conferences. Three organizations were meeting simultaneously: the National Endowment for the Arts and Humanities, the Business Committee for the Arts, and the Associated Councils of the Arts. The first two are grant-giving organizations, one public, the other private. The third is a membership organization of state and local art groups, created to help secure a higher priority for the arts in our society. Some people think the three form the interlocking directorate of the art Establishment. The Business Committee for the Arts was meeting to present the twentieth annual *Esquire* magazine BCA awards to industries and companies that had substantially contributed to the arts.

On the third day, Alex and Lauren wangled tickets to the lunch and awards presentation, and, after sitting blue-jeaned and quiet through a delicious lunch, listening to the awards and speeches (their bullhorn under the table at their feet), they rushed to the podium. Lauren took the microphone. Beneath him, on the floor of the ballroom at the Chase-Park Plaza, three hundred businessmen were rising from the circular tables covered with sparkling white cloths, with silver and china and flowered centerpieces, scraping their chairs and conversing about the next round of meetings.

"If under the tax laws," cried Lauren desperately into

the microphone, "corporations merely paid the taxes they are supposed to, there would be in the federal treasury enough money to support health, education, and welfare without having to beg you to give your private wealth. Because your private wealth is our ripped-off public dollar! When I ask you for charity, I'm asking the return of my own money!"

Down on the floor, no one was listening. The businessmen were filing out.

It was tragic. All Lauren wanted was to show how public money is utilized and called private. Lauren was not a destructivist, like Kes or Jon Hendricks. He wanted only to make the capitalistic system work in a proper middle-class way. His strategy, as he saw it, was simple. It was American, really. In every situation he gave the extreme radical analysis, in order to try to gain meaningful reforms.

"The reality of Imperial America is such," he explained, "that the best we can hope for is creeping socialism. All I want to do is show how these people are feeding off our money. They don't understand what they're doing. You see a group of private trustees treating the Metropolitan Museum, for example, as if it were their own turf, for their own private parties. Yet they ask for public money to maintain it. If only they could be made to see!"

The Princes of Power

"The museum is no longer the living room of the very rich," said Hoving as he prepared a transmogrification of halls into a fantastic fairy land of Arabic tents, discotheques, and Belle Epoque salons, gilded a cloakroom ceiling, and planned, due to the press of impending poverty, what amounted to a one-dollar admission fee—except for members.

It is true that some of the 2,800 Centennial guests were not of the usual set to consort with trustees: they were the movie-star, jet-set, publicity-conscious demi-monde of New York, whose star-studded names sprinkled the pages of glamorous gossip; and if there was a dash of black to salt the party,

239

there was no one present who could not joyously afford the $125-per-person admission charge ($40 for those under thirty-five) to the Metropolitan's Mardi Gras.

What riled the Art Workers was that, whenever it suited their purpose, the museums fell back on the excuse of trustees: "Oh, we can't do anything about that. That's up to the trustees. You have to ask the trustees." But the trustees were inaccessible.

The Coalition soon concluded that museums supported by either private or public funds were operated by their unpaid board at and for the pleasure of the trustees. Museums were at the mercy of trustees. Sometimes, in their humiliated frustration, they overreacted: "A museum operating under guidelines that served perfectly well two hundred years ago is a threat to art." Gregory Battcock, a young critic, read his remarks at an open hearing at MOMA in April of 1969, three months after Takis's sit-in. Was he delirious?

> . . . the museums today, such as the Modern, the Whitney, (God forgive us) and the Metropolitan, are dangerous institutions that, in modern society, have no justification except for the fact that they offer solace, amusement, and distraction to the very rich. That's not all they do, however. If it were there would be insufficient reason to protest. Today the museum activity supports antiquated values and distorted obsessions that are not simply hypocritical—they are positively oppressive, reactionary, culturally debiliating, and socially and esthetically dangerous. The simple fact is that those who control the museum—whatever museum— . . . are the super-rich who control *all* legitimate communicative agencies. The trustees of the museums direct NBC and CBS, *The New York Times* and the Associated Press, as well as that greatest cultural travesty of modern times— the Lincoln Center. They own AT&T, Ford, General Motors, the great multibillion-dollar foundations, Columbia University, Alcoa, Minnesota Mining, United Fruit *and* AMK, besides sitting on the boards of each other's museums.

. . . Do you realize that it is those very art-loving, "culturally committed" trustees of the Metropolitan and Modern Museums who are waging the war in Vietnam? . . . They are the very same people who called in the cops at Columbia and Harvard; and they are justifying their sick, disgusting slaughter of millions of people struggling for independence and self-determination by their precious, conscious support of Art. Anyone who lends themselves to this fantastically hypocritical scheme needs their head examined.

To extirpate the hypocrisy, he called upon the director and trustees to turn MOMA over to the Department of Defense. He called for the resignation of all the trustees from MOMA, the Met, and the "scandalously corrupt Whitney museum," which was peddling chromographs (he choked with rage) "in conspiracy with Brentano's [in a] deliberate attempt to undo what one hundred years of esthetic cerebral labor and artistic effort" had achieved.

He demanded that MOMA director Bates Lowry "disclose his role in the worldwide imperialist conspiracy" and stand trial before a "people's tribunal," a "democratic fact-finding court." Moreover, he said he was sick and tired of the museum's continuing policy of no free admission.

About a month later, Lowry was fired from MOMA, and it was only human nature for the artists to strut pigeon-breasted, or ponder with varying degrees of anxiety what part they may have played in his liquidation. They redoubled their efforts, at getting to the trustees as soon as they returned from summer vacations.

They never did meet with the MOMA trustees. But a year later, in the summer of 1970 and the spiritual winter of the Kent State murders, the trustees of the Met agreed to sit down with Coalition representatives to discuss the war. In the anticipatory rush of triumphant elation, the artists thought they had won. Some reveled in the *schadenfreud* prospect of telling their bet-

ters how to behave, others in the apotheosis of proximity. None anticipated the soft, squishy, Medusal response of the princes of power. Here is Roswell Gilpatric, partner of the law firm of Cravath, Swaine and Moore, former Under-Secretary of the Air Force and Deputy Secretary of Defense under Kennedy, answering the Coalition's challenge to the Met trustees to broaden their vision by adding black and Puerto Rican trustees to the board: "Let me say a word about that . . . I don't see why it shouldn't be done, in time, which shouldn't be too far away."

C. Douglas Dillon, president of the Met's board, director of the U.S. and Foreign Securities Corp., former ambassador to France (1953–57), Under-Secretary of State (1959–60), Secretary of the Treasury (1960–65), responded to the Art Worker's pained accusation of racism on the board: "Very stimulating and educational. . . . Very interesting to all of us here. . . . We'll continue to learn from this sort of thing. . . . Maybe we haven't done enough. . . . We want to hear what life impression we as individuals are making."

Some trustees glanced at their gold watches and after a time walked out, while the museum administration fell into vulgar and abusive language that might have surprised the Art Workers had they not held meetings previously with Hoving and his staff.

"For God's sake . . . what the hell is this . . . damn it, Ralph . . . For God's sake, if you don't get your goddamned inaccurate information out of here!"

Later I heard one of the blurry, twangy Coalition tapes of the three-hour event, in which the banalities of both parties bobbed to the surface between grateful periods of static and screams. As if the trustees could care about the artists' views of museums! They have their own concerns.

How disappointed the artists were. Many of them secretly suckled a belief in the existence of noblesse oblige, that the higher the responsibility and power of an office, the wiser and more visionary the man who holds it. Their initial regard for

trustees had been based on the courtliness of distance and, buttressed by the reverential respect extended to trustees by their museums' staffs, the awe that blinked in the eyes of a director. It did not immediately strike the artists that this respect was not always inspired by personal contact as much as by the fact that the director's job is held at the whim and whimsey of the board.

Didn't Bates understand this? Did he think his relations with the trustees was on a professional level?

The trustees of museums are the last bastion of influence in the art world. So rarely are they seen and so powerful seems their command that many people in the art world regard them with awe, wondering what they think about and how they live. The trustees rule the museums, and in museums in most cities their reigns are governed by an eerie aerial silence, except for an occasional rumble of power, like the thunder of the gods, as they fight with or fire the director.

Trustees have other uses for a museum than have the artists and public, and their own reasons for serving on the board, and that was why the artists' approach *au point d'appaui* to demand an end to war and injustice seemed—well, sweet, sort of, and naïve, if anyone could think of them as sweet.

Racism and war? The trustees could hardly manage their own museums. At MOMA the Olympian trustees were messing about as if with a plaything, and at times with the concentration span of children, so that the museum was rocked by anxiety and change. It was as if the trustees were driven by all thoughts equally and acted on whatever crossed their minds the last.

Poor trustees. They were trying desperately to keep from change. *Didn't Bates understand this business? Didn't he know how a trustee hates change?*

In the library of the University of Chicago rests an unpublished Ph.D. thesis by Peter Clarke that points out that service on the board of trustees of a nonprofit, charitable organization, whose aim is the advancement of community good, confers,

in American mercantile society, great honor and prestige. Privilege is derived in direct proportion to the distance from those elements whose welfare is being advanced. A position on the board of a church, for example, or the YMCA, confers considerably less honor than a similar position on a great cultural, educational, or medical facility. And so we find the boards of the large, old universities, hospitals, and art museums limited to the great inherited or industrial wealth. Membership becomes a symbol of social achievement, surpassing mere wealth.

The reason that cultural, medical, and educational boards define the Everest of social elevation may be found in their rarefied air. They admit no controversy. There is no turmoil, no political or sociological importance to the trusteeship of a hospital, a college, an art museum, or the symphony orchestra. It is these boards which contain the fewest political implications, and which confer on their members the greatest honor.

Not that the civic leader, a lion in his business, is necessarily afraid of controversy, but he cringes from unpleasant publicity. This is why it was so awful for the trustees of universities during the student riots, or for the museum trustees when the Art Workers were demonstrating and parading and denouncing them for the war, exploding bags of blood in the MOMA lobby and crashing their parties with cockroaches. It seemed unfair, somehow, to be accused of responsibility for racism or war, or of being tyrants in control of our culture, when all they saw themselves as doing was handling the finances of an uncontroversial cultural institution. What could be more stable, more inconsequential, than art?

Look, it is simple. When a man has made a certain amount of money, hundreds of millions, and he has bought several houses and untold trips to Europe and Japan, a yacht and two Rolls Royces, and a chauffeur, and numerous other servants, and several wives, and when his daughters have been put through the best boarding schools and his sons saved from blackmail, when he is on top of the heap and looks about, he still lacks

the scepter of achievement in his hand. He needs some symbol. What can he do? Collect art.

There are benefits to art.

Art is money. Art is business—big enough to serve oil-rich Charles Wrightsman, a Metropolitan trustee, as the basis for a lawsuit to recover $26,552 as a business expense on federal taxes. "Investment in art," argued his lawyers, "is and has been an economic reality." (Wrightsman's arguments on how he collected eighteenth-century French furniture only for economic reasons may be found in Appendix C.) Between 1960 and 1967, one witness testified, an index of art prices rose 225 percent, while a common-stock index rose only 163 percent. Unhappily, Wrightsman lost the case on appeal, the IRS discerning a sensitivity in the collector that he himself denied.

Art is beauty: art is civilization, culture. It is music of the eye. It is held to be a universal communication, transcending the barriers of language and custom. Art is truth and revelation, and all these qualities are conferred on the owner of art.

Art is immortality. Go through the Metropolitan Museum. See the collections viewed by millions: the Steven C. Clark Collection, the Bache Collection, the Altman Collection, the George Blumenthal Spanish Patio. There is a memorial more lasting than a marble mausoleum, preserved in perpetuity and worshiped, yes, worshiped, by millions. Why, it's almost as if it were the owner being worshiped in that graceful curve, that marble, that Ingres nude. Augustus Caesar personified and at once deified in his statues.

Also, art is class. It's clout. You get invited to openings. You hobnob with the brass. No wonder it is an honor to be an honorary trustee of a museum—which allows them no voting rights, though they participate in the presbyterate, and define thereby their power and prestige.

Museum trustees can be divided into two types: those who collect and those who do not, although most trustees eventually indulge, for they are men who thrill to the power of pos-

session. Consider collecting, a need deep-rooted in human nature. Some people collect stamps, buttons, coins, cars; there is even a woman, I have heard, who collects woodpecker holes. Collecting art derives from similar greed. It begins with one painting, one small bronze. By accident a man acquires another. Then he has a collection. Soon the collection takes on a life of its own, and the collector is the one possessed.

The wives come and go; the paintings stay on the wall. When Nelson Rockefeller and his first wife, Mary Clark, were divorced in 1962, she kept the lovely triplex at Fifth Avenue and 62nd, with its two murals by Matisse and Légèr. The Governor—Pyramus burning for his Thisbe—bought the adjacent apartment and cut a door in one wall to gain occasional access to his art.

The collector gives his wife for Christmas what he wants for his collection. The collector settles on the rug after a dinner party to leaf through portfolios of prints, recounting the rise and fall of each price for the delectation of his guests, and where each print was acquired, and by whom desired. The true collector rejects his personal taste, accumulating not what he likes, but what fits and fills the collection. He torments himself through years of tantalizing search for the missing tiddlywink. The collection acquires its own life in his eyes, and his interest in the museum for which he serves increases, and narrows, until determinations are made not on principles concerning the proper function of a museum, but on how well-equipped is the place to preserve and display his collection, his art, to attract admiring throngs that will march past like the paid mourners of the last century weeping behind the hearse.

The collector, you see, has his own ideas of a museum, and they have little to do with the concepts of the Art Workers or even at times with the goals of the professional staff.

Didn't Bates know this? Didn't he understand the precarious relation of a director to his trustees?

It is known to the art world. It was apparent in the stories that drifted east from California, where the Pasadena Museum of Art had run through four horrified directors in seven years, savaged by trustees. One trustee showed so little interest in the museum that he refused to lend a painting for the opening of the newly constructed building, while two former presidents of the board, as if to compensate for his disregard, appointed themselves to the staff, one as a curator—though few enough were her scholarly qualifications—the other as director of the museum. In 1970 John Coplans, the curator of the Pasadena Museum, resigned and sent a blistering four-page single-spaced letter to the board, a catalogue of abuse, ignorance, and neglect.

With the departure of one director, James Demetrion, which precipitated a walkout of the professional staff, the museum, Coplans charged, had almost no professionals qualified in art history or museum work. The exhibition department operated with one man. The Oriental Wing had no curator, no collection, no endowment, no staff, no money. The salary for the museum director was $16,000 at a time when a full-scale electrician with all the side benefits could make $18,000 a year.

The museum had erected a new $4.5-million building, continued Coplans, so badly designed that $50,000 were required after it was completed in order to correct the deficient lighting. Despite repeated curatorial warnings about the lights, the trustees ignored the situation until two weeks before the opening, when, spotting funds that had been put aside for the purchase of a Mondrian painting, they quickly spent it on the lighting. The museum could not buy the Mondrian. The corrected lights allegedly are so harsh that they are harmful to the fragile Paul Klees in the collection, and they cast three- to four-inch shadows on the paintings in deep frames.

Fifteen years earlier the museum had acquired the Gulka Scheyer Bequest of Klees, Kandinskis, Jawlenskis, and Feinin-

gers—on condition that a catalogue be published immediately. Though the gift was legally contingent on a catalogue, the collection had not yet been catalogued fifteen years later.

The Pasadena Museum had owned no paintings executed after 1946 (continued Coplans) until he personally acquired a half million dollars' worth of works, in conjunction with the opening of the new museum. These were primarily gifts, not from trustees, but from artists, and many were only photographs. Yet, Coplans charged, some trustees were busy building their private collections on the knowledge of the museum staff, at the expense of the museum. They were happily paddling in the museum's affairs like ducks in the mud after a rain. So privileged was their puddle that some would not even cooperate with one of their own—Tom Terbell when he moved from banker to museum head; they splashed and quacked, tails waggling with exquisite joy.

The situation was not much better at the Los Angeles County Museum, which a few years earlier had been rocked by the repercussions of the power-starved trustees, all bickering, biting, quarreling savagely over the monuments to their cultural sensitivity. Things got so bad that the County Museum finally put up three buildings connected by underground tunnels, each with the name of a different donor, and the battle over what would go into one building was settled only when Bart Lytton reduced his contribution to $250,000. His name was first chiseled off the façade and then relegated to a plaque on the second floor. The trustees were running all over the buildings during construction, so that the architect, William Pereira, finally burst out, "I think I spent more time on the names than on any other feature of the building."

Multimillionaire Norton Simon removed from the walls a number of works he had lent to the museum and talked about building his own museum, and he returned to the fold only after Howard Ahmanson, another member of the board and a re-

ported rival, died—though now you will hear that he and Ahmanson were friends, at least toward the end.

The New York directors blessed their luck that in the East, the power of trustees is sheathed. The trustees of museums, theaters, the opera are Old Family, trained by generations of civic duty, and those with long memories dutifully put out of their minds how Arthur A. Houghton, Jr., president of Steuben Glass, and chairman of the board of the Cooper Union Museum, decided in 1963 that the museum should be dismantled. Houghton was also trustee of the Met.

There was no argument over the value of Cooper Union. The Cooper Union Museum for the Advancement of Science and Arts contained 100,000 objects that comprise one of the finest collections in the country of the decorative arts, with unequaled examples of textiles, wallpaper, metalwork, glass, porcelain, furniture, architectural and decorative drawings. It had the world's best collection of medieval fabrics. Its library was unsurpassed in the United States, and its collection of drawings and prints superb. Its Winslow Homers alone, more than 300 works, were worth well over $1,000,000. The museum grew out of a trust set up by philanthropist Peter Cooper and approved by the New York State legislature in 1859 for an institution to advance "science, art, philosophy, and letters," and to collect "artistic models, books, drawings, pictures, and statues." Some considered the collections equaled only by the Victoria and Albert in London or the Musée des Arts Decoratifs in Paris.

The museum was in financial trouble. One day Houghton was seen touring the study collections with James Rorimer, director of the Metropolitan Museum.

Later, Metropolitan curators were asked to list those items from the Cooper Union collection they thought the Met might like. In June a low-key press release announced the closing of the museum to all but scholars and professionals, who would be able to see the collections by appointment only. The

museum's president was quoted as saying that "both Cooper Union and the people of New York would be best served by the discontinuance of the museum and the relocation of its collections."

There was no explanation of why, if the museum was in such poor financial shape, the four trustees had not launched a fund-raising drive; or why the museum had been closed without notifying the staff or advisory council in advance of a news release; or why the Metropolitan staff had been chosen to study the relocation of the collections.

As far as Houghton was concerned, it was a matter of efficiency. He was disturbed that attendance at Cooper Union was only 13,000 a year, hardly more than the attendance for one Sunday at the Met.

The plan did not succeed. An outraged Committee to Save the Cooper Union Museum developed almost overnight, raised the funds to maintain the museum, and later arranged to have it incorporated as a bureau of the Smithsonian under the name of Cooper Hewitt.

The following year, in 1964, Houghton was named president of the board of the Met, and six years later, as the addition of the Lehman collection stirred storms of protest about the iatrogenic effects of museum mitosis, he was named chairman of the board.

The trustee gains power from museums and a multiplicity of favors performed by the museum staff—advice, tours, favors to family and friends—for which he pays over years and years in the form of annual donations, gifts, work, and annuities to the museum. David Rockefeller pledged five million dollars to MOMA in 1968. Why should he not receive special attention in return? For a number of years Nelson Rockefeller had Christmas shopping done by the MOMA staff. He gave a curator his list of people and prices, and in early December, in a room at MOMA or in one of the offices belonging to the Governor (one year at the Museum of Primitive Art), the prospective gifts

would be assembled. The governor would sweep through the display, checking off his list. "I'll take that and this . . . that . . . that . . . that." The rejects returned to the dealers.

Surely Bates understood. Bates, who arranged the sale of the Stein collection for a syndicate of patrons, murmuring half-desperate that it is "so difficult to distinguish between the museum and the . . . people in it," and ignoring the contemptuous charge of one black director that curators "are the purchasing agents for the rich." When the Gertrude Stein collection was on the market—thirty-eight works by Picasso and nine by Juan Gris—David Rockefeller formed a syndicate of five men to purchase the works. The syndicate members were himself (he was chairman of the museum), William Paley (the president), Jock Whitney (a vice-chairman), Nelson Rockefeller (a trustee), and André Meyer (a patron of the collections). The museum, having arranged the deal, was given one painting by each collector, with the promise that more might come. Bates felt the museum had done a good job, but some people wondered if the trustees had not won, for there is no rule that a man may not change his mind or will before he dies.

Robert Rowan, president of the Procrustian board at Pasadena, has built a valuable collection of contemporary art with the assistance of various directors. The directors each, he graciously explains, contributed substantially to the reputation of the museum (though not enough, you know, to forfeit the necessity of their resignations). Rowan claims to be collecting to benefit the museum, and adds that he has bequeathed the entire collection to Pasadena, his project, his pride. Yet he sold two Warhols when the prices approached $48,000.

"I couldn't resist. I thought they were overpriced."

He realized a profit on two other paintings as well, by selling them to another museum. He was quite within his rights. But how strange. Was he collecting for Pasadena or his pocket?

He sold one Frank Stella, bought for around $1,300, to the San Francisco Museum for $15,000 (and glad they were to

get it!). The painting was shipped directly from Rowan's house to the museum. The $15,000 was sent to the Emmerich Gallery in New York, where Mr. Rowan, by adding a little more, bought a terrific Morris Louis and avoided, at least temporarily, the capital-gains tax on about $13,700.

If a trustee is not ready to sell, he can place works on loan in the museum. Merely being exhibited at a museum will raise the value of a painting. Some people wonder, is this not dealing too?

Art investment companies have formed with the express purpose of buying art, lending it to museums, and selling at a profit.

Museum trustees rarely discuss the possibility of conflict of interest. They do not raise the topic at meetings or even, so far as is known, during the pre-dinner cocktail before a ball or the quick limousine ride when so much museum business is informally conducted. Their responsibility toward profit-taking is discharged in most museums by excluding dealers from the board—though J. Frederick Byers, the son-in-law of Bill Paley, backs the Bykert Gallery, while sitting on MOMA's acquisitions committee for painting and sculpture. Rarely does a transaction grow nasty. Rarely is it even discussed, so that when Susan Hilles, a member of the committee, protested a transaction between MOMA and the Bykert, her objections were met by the trustees with a kind of confused surprise.

The disagreement arose when Carter Burden, who is the nephew of one trustee and the ex-son-in-law of another, himself a member of the Painting and Sculpture Committee, and the brother-in-law of Jeff Byers, offered the museum its choice of two Ralph Humphrey paintings from the Bykert Gallery, each valued at around two thousand dollars. He offered to pay fifteen hundred dollars toward the cost of either painting. This amount represented the "full museum price," that is to say, the discount of the picture that any gallery would offer a major museum. Susan

Hilles was sitting at the end of the large U-shaped table, near Bates Lowry.

"Isn't this conflict of interest?" She passed the note across Walter Bareiss, the chairman, to Bates. He passed another solemnly back, across the trustee.

"No. Jeff put his gallery into a foundation."

"Isn't that the same thing?" she wrote back.

Bates scribbled on the paper. "Are you aware of the relationship between these two young men? They are brothers-in-law."

"That makes it worse!" She passed it over to Bates.

By then everyone was aware of the secret exchange. Carter Burden remarked uncomfortably, "I suppose you think I should have offered to pay the whole thing?"

"That would have made it all right," said Mrs. Hilles stiffly. She was so offended by the museum's position that she resigned from the committee and cut MOMA out of her will.

The affair is less indelibly inscribed on Mr. Burden's mind than on Mrs. Hilles's. He does not remember that his offer caused any controversy—he never knew until recently that Mrs. Hilles had cut MOMA out of her will because of this event. And since he was paying the full "museum price," he saw no conflict of interest.

For Bates as well, the Hilles affair was insignificant in an organization where finances loomed elephantine. He was annoyed by the entire business. A tempest in a teapot. A tantrum over nil. If Carter wanted to support his brother's gallery, why should the museum mind? If the museum got a painting, what difference for what reason? He did not ask if the acquisition of a Humphrey by the museum changed the status of the art. He had no time. It was all he could do to keep his footing on the slippery finances of the museum. Or the politics. Where for forty years the museum had functioned, informal, familial, under the paternal eyes of Alfred Barr and Rene d'Harnoncourt, director for

more than twenty years. It had always raced its deficit—which
was always picked up by the trustees. D'Harnoncourt, a tow-
ering figure, with the impeccable credentials of a man comfort-
able both in Europe and the States, did not run things at MOMA
so much as *ease* things along by flattery, humor, suasion, and
sway. When he needed money he merely telephoned a trustee—
as was the practice as well of the heads of the departments,
lords of their own little fiefs. MOMA was a family, though
whether the trustees were the parents or children was hard at
times to know. Its finances were a mess. When Barr found a
painting he wanted, he would present it to the collection com-
mittee and look around for someone to buy it. Few were so ec-
centric about the arrangement as Mrs. Hilles. At the first com-
mittee meeting she ever attended, having just been invited to
join, she crept shyly in, shrinking, frightened, flattered at the re-
sponsibility placed on her: to help select those works which
would thereafter lie immortal in the Museum of Modern Art.
Once in the large committee room, she slipped to the wallflower
line of straight-backed chairs that were reserved for staff.

"May I sit here?" She prayed not to be noticed. Not until
she understood what was required. The paintings were brought
out one by one. A huge painting appeared.

"Mrs. Hilles," said Barr, shooting out one finger at the
end of a pike of an arm. "What do you think of it?"

"Oh dear," cried Mrs. Hilles nervously. "I feel I'm all tied
up in strings!" And then because something more was clearly
expected—what? An opinion? "I've never liked that artist."

The museum found her very queer.

To talk of museums is to talk of money. There are always
problems of money, and suddenly in 1969 and 1970, all the mu-
seums were feeling the pinch. MOMA was skittering toward the
red maw of deficit, which swelled from nine hundred thousand
to one million dollars, to one million two hundred thousand. Be-
fore long it gaped at one million eight hundred thousand. The

museum's generally stable level of income was offset by increasing demands and increasing costs of operations. This was true of almost all philanthropic institutions. Rockefeller University, which for over sixty years had been supported largely by an endowment provided by the Rockefeller family sources, found in the later 1960s that funds were inadequate to meet $15 million for normal operating needs; it began to launch for the first time a public campaign.

The dependence of a museum director on his trustees hinges on the need for money. Not many museums are so fortunate as the Cleveland Museum of Art, which in 1956 was left more than $30 million by Leonard C. Hanna, Jr. Hanna was the nephew of Marcus A. Hanna, and son of one of the organizers of the M. A. Hanna Co. (mining, shipping, iron, and steel products). His primary interests lay in art, music, theater, and sports. His collection of French Impressionists and Post-Impressionists, valued at $1.5 to $2 million, was also bequeathed to the Cleveland Museum. The Hanna bequest makes Cleveland one of the wealthiest American museums, and liberates the director from some of the petty dictates of trustees that may fall on the heads of poorer museums. The fact is not without significance when contemplating the reputation of Sherman Lee as the best museum director in the country.

Yet even for a large and rich museum, money is a problem. Staff at the Metropolitan remember that the museum had a number of large pieces of fifth- and sixth-century Chinese sculpture. There were no galleries to exhibit them in and no money to install them. The objects lay in the museum basement for years, until a doctor, Arthur M. Sackler, himself a collector, approached the museum director, James Rorimer, and offered to donate a gallery if the objects were credited to him. In 1965 the objects, which are now exhibited in the Arthur M. Sackler Gallery, just north of the balcony on the second floor, were reaccessioned and credited to the generosity of the New York collector.

The role of a museum trustee is to:

1. Find a director. Fire him.
2. Raise money.
3. Approve the budget.
4. Approve the program.
5. Approve the acquisitions.

All but the first can be done by the museum staff. There is actually only one duty of a board of trustees, and that is to provide continuity. Directors die or go deranged. The board remains. So the purpose of the trustees is to perpetuate themselves, to ensure that no change overtakes their collections, or change so slow as to be almost imperceptible. Self-perpetuation implies self-satisfaction.

There is no training for the position of trustee, besides a willingness to donate money. How a trustee uses his power, therefore, comes down eventually to a matter of relationships, and what the museum does at any time is the result of a subtle shifting of the sands of power, a constant moving and sorting out that manifests itself in different ways in the multifarious museums across the United States. Some trustees, such as those at the Met, trust to the professional capabilities of the staff and defer to the director. Some, as at MOMA, take a personal interest in the functioning of the museum. Some, as at the Corcoran or Pasadena, not content with serving on the board, name themselves to positions on the staff. Happy the museum where the lines of power are finely drawn: the Seattle Art Museum, where the founder, Richard Eugene Fuller, is himself the first director and an Oriental scholar; the National Gallery of Art or the Cleveland Museum, where the director is not immediately dependent on his trustees for funds. Three things must be remembered about trustees. The poorer the museum, the more power the trustees wield. The younger the museum, the more power

the trustees wield. The younger the museum, the more nouveau-riche the trustees will be. Charles Parkhurst, director of the Baltimore Museum of Art, suddenly found himself putting down a palace coup in 1969 as his trustees slipped behind the lines to direct the curatorial staff in how to hang exhibits and choose frames. He succeeded in fighting off the attack, but, wounded, fled to the National Gallery of Art. The National Gallery had become by 1969 a haven for museum directors and curators, perhaps because, by comparison, it seemed less subject than other museums to the malaise of 1969.

That was the year the museum directors were fired. There was Bates Lowry, eliminated after nine direful directorial months. David Scott at NCFA, Jim Harithos at the Corcoran, Jack MacGregor at the DeYoung Museum in San Francisco, Jim Holliday at Oakland. There were rumors that Hoving was almost fired after "Harlem on My Mind." And the conflagration grew, until the Association of Art Museum Directors drew up guidelines for the proper behavior of trustees. It was as if the trustees of museums had gone nuts too, infected like the Art Workers, and jumped the tracks. Forces converged in 1969. The firing of Bates erupted in a dazzling pyrotechnics display that lit the star-chamber proceedings of the royal demesne. The power of the trustees was discovered to operate not, as had been thought, by ideal hegemony of unity and accord, but by snapping and infighting and petty power struggles, the multiple fracturing of selfish aims that was reminiscent of nothing so much as the Art Workers' participatory democracy.

What was the matter with Bates? Didn't he understand what trustees ask of a museum? God knows, he had warning.

The museum director has no written contract. He serves at the grace of the trustees. He is paid by the trustees. He stands as the extra man at a dinner party—invited without his wife. He collects for the trustees. He provides a memorial for them, soothes their egos, and in return he is sometimes tossed

some money and works of art for his museum. Charm and his knowledge of art are the only weapons of the director. He bows to the hierarchy, knowing that no director can escape.

Not even Alfred Barr escaped. Alfred Barr, former director of the Museum of Modern Art, lean, ascetic, disciplined, a missionary, firm, quiet, perhaps the most powerful voice in modern art. He was director of MOMA, a high priest bestowing communion, salvation in the form of visual sensation. What Barr defined as art was art, and every small provincial museum fell in line behind Barr's decisions. His power is attested by a three-inch column in *Who's Who in American Art*.

Yet even Barr had been fired once. It happened in 1943. He was, after fourteen years as director, asked to "devote more time to his writing." Bitter gall to swallow for a man who, at twenty-nine, was shaping the course of a new museum, of the entire American culture. Everyone there was around thirty in those green beginnings, when Abby Aldrich Rockefeller (wife of John D., Jr.) and Miss Lillie P. Bliss and their friends began the museum. To have his peers, his students, his acolytes turn on him after fourteen years—ah, it leaves a bitter taste. He said nothing. He crept to a tiny corner of the museum, wrote his books, and waited, watched, offered advice when solicited, smiled when necessary, but always he was there, through the Forties, Fifties, and Sixties, talking to the staff, the director, the trustees, until his services were again indispensable. He was curator of collections, and far more powerful than that title would suggest. When he retired in 1968, almost simultaneously with Rene d'Harnoncourt, he remained at the museum as a research associate in retirement, watching, waiting, as Lowry was fired too, and after him John Hightower. He is said to have played a part in removing Bates before the new director could damage the direction of Barr's museum.

It is a delicate relationship that exists between the trustees and the director of a museum.

Study the lists of trustees, and the first thing you see is

the members are related. The same names, the same families, run the museums. In New York, the names are Morgan, Rockefeller, Guggenheim, Whitney. There are the three Cushing sisters. One married Vincent Astor, one married John Hay Whitney, one married William Paley. Each serves on his own museum.

On the board of the Metropolitan are two wives of the late Vincent Astor, his second wife, now Mrs. James W. Fosbourgh, wife of the classical painter, and his third wife, Brooke Astor, head of the Astor Foundation.

"That was probably a mistake," said the trustee of another museum thoughtfully. But how can you ask a patron to leave after years of service? And how easy it is to transact business when the group is so intimate that a smile, a raised eyebrow, conveys a wealth of information.

Mrs. Whitney is on the board of the Whitney; her husband is on both the Modern and the National Gallery of Art in Washington; his sister, Mrs. Payson, is on both the Modern and the Metropolitan; Whitney's brother-in-law (Paley) is on the Modern, together with an ex-son-in-law and that boy's uncle.

Rockefellers are on all the boards except the Metropolitan, to which John D., Jr., gave the Cloisters and most of its exhibits, and $10 million to endow it. (Nelson, an honorary trustee, has no voting rights.) No matter. Their interests are served by proxy; if the families are joined by birth and marriage, business connections complete the ties. R. Richard Dilworth, Arthur Houghton, Roswell Gilpatric, and John Blum all have connections with the Rockefeller brothers. Most of the thirty-four trustees serve together on other boards, and as directors of each other's companies. For example, six of the thirty-four-man Metropolitan Board serve on the twenty-two-man board of the New York Public Library.

Banker-heavy are the boards, with lawyers, and for balance one media representative on each. Not that these men are used in their professional capacity. Battcock was wrong about

his conspiracy of communications. A lawyer on the Metropolitan does not advise on the law: the museum retains its own firm for that. Neither does a media head advertise the coming exhibitions through his communications empire. He serves because he has achieved success: William Paley, chairman of CBS, closed in a curtained office that looks like a decorator's idea of the Century Club, all dark greens and walnut paneling. Roswell Gilpatric on the fifty-seventh floor of One Chase Manhattan Plaza, with a plate-glass view that extends from Ohio to Washington, D.C., the view from a bomber plane. They are men accustomed to giving orders. Yet they have reached the presbyopic age when they turn every morning to the obituary columns and so often find the names familiar. Each sees his pitiful mortality gathered in the glance of a museum director, his menial, years his junior, his to hire and fire.

The director smiles, inclines his tall, lean form with cordial, gracious tact. He teaches the trustee, guides him in his drive to possess, this aggression that is collecting.

At the Virginia Museum of Fine Arts, it is considered prestigious to buy at the Collectors' Corner. A museum representative travels to New York to buy "whatever I think is pretty." The arrangement is mutually satisfying. It saves the museum the embarrassment of rejecting collections it dislikes and the unsure collector the embarrassing ordeal of working with dealers.

A museum director arrived at the office of a self-made businessman. They had never met before.

"I've decided to start collecting art," he said. On the table was $900,000 worth of paintings. Nine hundred thousand dollars does not go far these days. There were five paintings. "Okay. What do I buy?"

Three qualities are sought in a trustee: wealth, wisdom, and work. Wealth is first on the list.

They smell of money. The man who gets his shoes shined in his office during an interview. He tips back in his chair, hands

clasped behind his head, so far removed is he from embarrassment at having a man work on his feet as he expounds, and surely feeling none at having him listen: servants do not hear. He changes a finished foot for an unfinished one without dropping a participle in his deliberations.

He is urbane, cultivated, sophisticated, cool, suave, controlled—and Protestant, our typical trustee of a giant museum. If the rest of the art world is Jewish, the apex is not. Occasionally he is graced with a sense of humor. He is what Norman Mailer calls "the odorless Wasp," though there is a sprinkling of odorless Jew as well on the great Establishment boards: a token Jew on the board at the Met, the Art Institute of Chicago; a Dillon, Lehman, Straus.

"I don't suppose you can call Straus Jewish, though, can you?" said one trustee with a smile. There is a certain Wasp understatement. To the Wasp this is not so much anti-Semitism as a sense of belonging, amusement at the idea of a Guggenheim who became Episcopalian three generations ago, a certain awareness of the place of things.

"What do you mean, 'no Jews?' " laughed a trustee of the thirty-four-man board at the Met. "We have five and a half!" The half is Dillon.

Dillon sent his two daughters in the 1950s to Foxcroft, a small and exclusive Episcopalian boarding school in Virginia. Years later, the headmistress was asked by one offended alumna how it was there were no Jews in the school. "How could that have been possible! And why?"

"Why, my dear," answered Miss Charlotte in surprise, "of course there were Jews. The Dillons, for instance."

You see, there are degrees of belonging, even in America. The rationale for the homogeneity of the boards is that it creates a smooth atmosphere for the trustees to raise the gigantic sums of money expected of them.

So homogeneous is the board of the Art Institute of Chicago that collections have been lost. Nathan Cummings, director

of General Foods, offered money to the Art Institute and dangled his collection before the board. He was never invited to join, and he took his Impressionists off to display them elsewhere. They were being wooed by the National Gallery of Art and the Met, and eyed by MOMA and others.

Richard Feigen, the dealer, has given some $50,000 to the Art Institute over the years. He was never invited to dinner at the museum. "I'm invited to the opening, but not to dinner. That hurt. I'm waiting with the great collectors of Chicago: Morse, Newman, others. The double-doors open and in walk all my friends in black-tie, the trustees of the museum. I went to school with them, and they don't have an etching on the wall."

The Jewish collectors of Chicago, miffed at the museum, finally organized their own Museum of Contemporary Art.

Do you see how astonished the trustees were, then, to be confronted at the end of the 1960s with the concept that their boards should include blacks? All the museums in New York were seeking to enlarge their boards by 1969, in order to attract new money. But the Art Workers kept talking about widening their vision, enlarging their circle of acquaintance, making the boards "representative" (whatever that was)—as if the trustees had not spent their lives in an effort to elevate themselves above the brush and brouhaha of crime and blacks and bankruptcy.

"Oh, I don't think we're looking for blacks," explained one trustee at the Modern with charming suavity. "Good heavens, he would be as uncomfortable as we were, knowing he is on the board because he is black. Of course, if we found someone qualified who also happened to be black, why then, of course, his name would come up along with the other names for consideration."

It is hard to find a black collector who moves in the right circles, or can take correct advantage of the museums. Pressure was too much for the trustees, however, and reluctantly some boards began to look for blacks and, if they had previously excluded them, for women.

What we are talking about is a range of money. The kind that can raise $1,411,200 for Monet's *"La Terrasse à Sainte Addresse"* by lifting a telephone. ("A preposterous price," said the director of an equally great museum. "That's the sort of painting that will come to the museum anyway. You don't have to buy it. You just wait for it to be given.") The Metropolitan can afford to buy it. André Meyer gave $2.5 million in 1965 to New York University. Arthur Houghton, president of Corning Glass and a collector of rare books ("He must be smart. He got into that book business before anyone else thought of it"), built the Corning Glass Museum in Corning, New York, and gave the Houghton Library to Harvard. He owned one of the three privately owned Gutenberg Bibles in the world and is said to have an orchard (he will offer a guest an apple) at his house on Sutton Place.

Money does not need to come to the museum as cash. It is equally valuable as stock or in the form of a collection. So the director of a museum cultivates the collector, longs for a Lehman or a Norton Simon, who headed a $1 billion conglomerate (Hunt Foods, Canada Dry, *McCall's*, and others), who can peel off $1.2 million for his third Rembrandt, $1.5 million for a Renoir, $1 million for a portfolio of Lorrain drawings, $200,000 for a Brancusi, or have his foundation buy the mansion plus the $15-million art collection of the Duveen Gallery (one of the world's leading art galleries; it started in 1869 and was instrumental in forming such collections as the Frick, Mellon, Bache, and Kress). Norton Simon built a $100-million collection over a sixteen-year period. He spends—add it yourself—$6 to $8 million a year on a collection that ranks, in his opinion, just after the top six museums.

Eight million dollars a year. That's half the value of the Wrightsman collection. Charles Wrightsman, trustee of the Metropolitan for more than ten years, is the septuagenarian son of an Oklahoma wildcatter. He accumulated his own fortune. It is estimated as probably not a billion, though in 1960 he was clever enough to find his taxable income around one million dol-

lars, and in 1961 had reduced even this to $500,000. In the 1930s he had been an enthusiastic polo player. Twenty years later he decided art was a good investment and began collecting eighteenth-century French and English furniture. His wife, thirty years his junior, learned French, the better to pursue the interest, and both she and her husband traveled, studied, entertained, and bought until the collection, insured by them for $16 million, is of the finest quality. Each item has been diligently catalogued and described by Mrs. Wrightsman in twenty-six three-ring binder volumes that take up five feet of shelf space. Mrs. Wrightsman's devotion is unusual, for wives usually loathe their husbands' collections.

It was Wrightsman who bought for $392,000 Goya's "Duke of Wellington," a purchase that stirred such nationalistic fever at the prospect of the treasured painting's leaving England that in a flurry of publicity the National Gallery bought it back at the same price. The Goya was then stolen from the museum and held for ransom in pathetic hope of starting a fund to provide lonely, impoverished, old people with the means to purchase TVs. It was four years before the painting was recovered, though no one considered paying into a pension fund.

Wrightsman has willed part of his collection to the Metropolitan. Norton Simon has "demonstrated confidence" in the Los Angeles Museum by lending sculpture to the outdoor plaza named for him. "As long as I'm able to buy works of art, I'll buy things that tie in with what Los Angeles wants and needs," he has said.

Still, the museum director knows no peace. He needs those collections. He remembers how Chester Dale put his collection in the Chicago Art Institute with the unwritten understanding that he would donate it after his death, and for years the museum collected around it. Then Chester Dale was made director of the National Gallery of Art. He took his collection with him, leaving a hole behind. Or Steven C. Clark, who was such a devoted trustee of the Modern Museum of Art that he

gave $25,000 each year to the museum. Only, when he died his collection went to the Metropolitan, because that museum, unlike the Modern, would keep the collection intact in the donor's name.

"We don't like that sort of thing," muttered a trustee of the Modern. It's up to the museum director to see that it does not happen. When Robert Lehman cooled to the Metropolitan and his collection was seen walking out the doors—one thousand paintings, by El Greco, Cézanne, Rembrandt, Renoir, Monet, Botticelli, Goya, Van Gogh, Bellini, Matisse (it brings tears to one's eyes), walking out the door, to be snatched up by the National Gallery, perhaps, or Cleveland—a new position was made for him, Chairman of the Board of Trustees. A gesture, a gentle honor that brought the collection home. The director must never, never—not ever (as Lowry did) offend a trustee.

The director moves through the galleries with the politesse of a funeral-parlor director on learning of the death of a ninety-year-old millionaire, bowing without a smirk, for the director is not without his own acquisitive, nervous nose, a twitch of the upper lip at that scent of . . . possessiveness. He bows, leading the way to Valhalla, to the museum, to immortality, a monument in perpetuity, closed, changeless, a shrine to the invincibility of power . . . leading to their death.

Bates Lowry Is Fired

The firing of Bates Lowry was handled with dispatch. Very few people in the art world knew exactly what had happened, but the stories circulated the more deliciously for that, in inverse proportion to the knowledge. None of the stories had to do with Lowry's ideas about the functions of a museum.

It was said that he drank too much, or that he did not "act like a gentleman." There was a "communications problem" with the trustees, crooned one knowledgeable pederast, and another gentleman of indeterminate sexual proclivities murmured that Bates's sin lay in changing things in the museum, so that the trustees who had started the place forty years earlier grew

upset, anxious at the newnesses. Shortly after his arrival; for example, Bates turned his attention to the offices.

Now, you have to understand that the decor of MOMA offices had remained the same since the end of Alfred Barr's directorship in 1943. The walls were white, spare, prim, the corridors unclad. When Bates arrived, he ordered carpeting laid down. He painted the walls and gave the staff the option to pick the colors or combinations of colors for their offices. He painted the entrance hall and put down new tiles. The museum was shocked, though anyone entering would have been hard-put to find extravagance in the mouse-brown rugs and tiles.

There were problems of money. It was said that Bates was incapable of getting along with Walter Thayer, a new trustee who had been brought onto the board to organize a large fund-raising drive.

"It is impossible for me to work with Bates," Thayer was quoted as saying (for the art world knows just what everyone says). "He will have to go."

Bates was professional. He came from a university background, and he did not understand the peculiar delicacy of relationships in museums. He had not known what he was getting into at MOMA. This is the place where the curators burn important memos for fear of their being picked out of the wastebaskets (a practice at the Met as well, which its curatorial staff call "Paranoia Palace").

Bates was reserved and formal. The staff, conditioned by the easy cordiality of twenty-four consecutive directorial years, found Bates a martinet. A wave of nerves passed over the museum. The staff worried about their academic qualifications. Bates was a university professor.

"He's acting like a university professor," ran the underground comment. "He expects Ph.D.'s from everyone," and each staff member wondered how much weight was carried by the fact that despite his lack of degrees he had what is called "museum experience." Bates's stiffness was upsetting. It was consid-

ered offensive. One of Rene d'Harnoncourt's last acts as director was to install personally a show of Picasso sculpture. One day he mentioned to a curator, not critically, mind, but bemused: "Do you know," he said, shaking his head, "that Bates never said a word about my show, not a word about 'that's a nice installation,' or 'good show.'" D'Harnoncourt was not annoyed, merely surprised, and the staff member raised his bushy eyebrows and shook his head with sympathetic astonishment at the naïveté, the *sangfroid* that made it seem that Bates was out to destroy himself deliberately. "No one could have unlodged Bates but Bates himself," purred the curator later, months later, with the smug satisfaction that attaches to those who survive a tornado.

After Bates left MOMA and suffered a heart attack, another MOMA staff member wrote him a letter of sympathy. Bates never acknowledged the letter. This lost him another friend and left our curator, when he heard of it, nodding his head at the corroboration of his theory: that Bates was deliberately and arbitrarily rude. Bates, on the other hand, saw the letter as a hypocritical gesture from one of a staff, which in time of trouble had not backed him up.

It is important to remember that Bates was fired after only nine months as official director. But he had been appointed two years earlier and had been at the museum for almost a year. From September to December of 1967, he had come from Brown University about once a month to familiarize himself with the workings of the museum. On January 1, 1968, he had begun full-time in the Paintings and Sculpture Department, and on July 1 he took charge as director.

Everyone agreed that if Rene d'Harnoncourt, the director, had been around, he would have eased the transition to Bates's rule. But Rene was unexpectedly, tragically killed, run down at 11:40 one August morning by a woman with two children in her car, as he walked back from the Post Office at his country place. Rene was dead, and Monroe Wheeler had retired after thirty years as director of publications and exhibitions,

and Barr had retired as director of collections (though still trudging in daily to his duties); and everything was topsy-turvy with change.

Bates was on his own.

When Barr resigned as head of the collections—in charge of films, photos, prints, drawings, paintings, and sculpture—the position was retired as well. It had been created especially for him, and the time had come to have one curator for each department: one for prints and drawings, another for films, a third for painting and sculpture. Unfortunately, the museum officials could not agree on who should head the Painting and Sculpture Department. It was the most important department. Bates decided to take on the job himself until a curator could be found. So, in addition to his duties as director, he was undertaking the job that had been divided previously among three giants.

The temporary post dragged on and on. Pretty soon Bates was spending, it was said, more time on curatorial than directorial functions. This did not please some trustees. They wanted a fund-raiser, a director, not a curator. It also did not please some other curators, who eyed the large office that Bates was using as curator of the Department of Paintings and Sculpture and wondered at the fact that the curatorship was held by a man whose area of competence was Renaissance architecture.

Financial problems loomed large. As in many museums, duties were divided between a business manager (Richard H. Koch) and an art manager, in this case Bates. To his consternation, Bates did not seem to know how much was being spent. Every department was in debt, but no one knew how much was spent in any budget. The deficits were always larger than projected. At Bates's request, David Rockefeller sent two men to look at the museum finances. They found a 30- to 40-percent difference between the estimated income and the available funds.

"No one could run a museum on the information you've been getting," one told Bates as they walked back from lunch

one day. And he asked (queer question): "Did Koch want to be director of the museum?"

As things got tense, it was said that Bates was drinking more than usual. This would not be difficult. In his social circle he was often required to go out four nights in a row, sometimes to two or three parties in an evening. There could be a museum opening with drinks, followed by a cocktail party and then a dinner engagement that would begin with a drink and end with brandy and liqueurs. Hopefully, he would have his weekends free for his family, but sometimes his presence was required on weekends, too, at parties in the country. Then he said things to trustees that he could not unsay, scolding and admonishing them. The next day he would talk to a different trustee: "Oh, I said the most awful things last night to ——."

"Don't worry, don't worry," the trustee would say. "It will be forgotten." Bates made the mistake (said one curator with a twitch of a smile) of thinking it would be forgotten.

The reasons for his firing will never be resolved. For William Paley, enough that "He was not the right man for the job. . . . He had problems of administration, in a place as large and complex as a museum." Bates himself is not sure of the causes, and sees in the action mainly the palace politics of the museum. He knew only what happened to him.

He was appointed in the spring of 1967, to the enthusiastic acclaim of d'Harnoncourt, Barr, and the trustees, by Phillip Johnson, Mrs. Bliss Parkinson, who was president of the museum, Blanchette Rockefeller, of the selection committee. Bates rises six feet, three impressive inches tall, a long, gangly creature with brown hair and gray eyes, and at the time did not sport the thick, brown mustache that now droops over his mouth. He graduated from the University of Chicago, was on the faculty of the Institution of Fine Arts, a professor at Pomona, head of the art department at Brown University, and founder in 1966, after the floods in Florence, of CRIA, the Committee to Restore Italian Antiquities.

He accepted the position as director at MOMA with the understanding he would not take office until the fall of 1968.

In February 1968, Paley replaced Mrs. Parkinson as president of the museum. He brought in Thayer. Some months later Rene talked to Bates, concerned about the changes on the board. He did not like to see big business get in a position of power. He was concerned that those men would judge the museum by standards of efficiency. Moreover, he was disturbed at the number of changes all taking place at once: a new director, a reorganized staff, new officers on the board, the resignation of Victor D'Amico, director of education, the initiation of a fundraising drive, of plans to construct a new building. Be careful, cautioned Rene.

In the spring of 1968, several months before he took office, Bates began to sit in on museum meetings, and discovered—the place was a financial disaster. There had to be a fundraising drive. Immediately! He took office. He was director exactly nine months.

Tuesday, April 22, 1969. At 4:30 or 5:00 P.M., Bates was to attend a meeting of the Hospitality Committee at the apartment of Mrs. Gardner Cowles. Around 3:00 he met with board president William Paley. Paley was seated at the round eighteenth-century gaming table that serves as his desk in the glass and granite CBS building, just down the block from MOMA. Paley owns more than 103 paintings—mostly Post-Impressionists—bought cheap in the 1930s. His dark green office is decorated with Picasso, Rouault, Derain. Bates assumed that he had been called down to discuss the policy meeting of trustees that was scheduled for the following day, and in fact the conversation began with the topic, by mapping out the program of events. Then Mr. Paley changed the subject.

"Are you happy here?" he asked, to Bates's surprise. He answered, yes, though he knew there were problems to be ironed out in the museum.

"I've heard so many staff complaints about you."

"Oh," said Bates. "I'm surprised. I suppose there are a few."

"No," said Paley. "There is so much staff dissension of every kind that I think you must submit your resignation. Of course, I cannot divulge who is upset, but a significant number of trustees are concerned about the future of the museum in your name." Bates's mind was reeling. It did not occur to him that Paley was trying to give him a graceful out, the chance to take the initiative and resign himself. "The disquietude is general. I wouldn't want to put it on one man . . ." And when Bates made no move: "If you don't submit your resignation, I shall be forced to ask for it."

Bates hardly knew what to say—it was so sudden. "Does David know?" he asked, meaning David Rockefeller.

Paley answered, "No, David doesn't know I'm asking for your resignation, but he's informed of your problems."

A secretary ran in with a message. Bates was due at Mrs. Cowles's house to meet with the good ladies of the Hospitality Committee.

"Tell them I'm delayed. I'll be a little late." He asked Paley, "Do you mean now? My resignation now?"

"Only this morning, I was talking to the National Endowment of the Arts about you," said Paley, with the generous offer of a position. At this level, a man is rarely left to the wolves. He is helped to find another job, often at a higher salary, so that no discontent ruffles the surface of polite accord.

"Do you think I could handle that job, if I haven't done well in this?"

Paley glared at him. "Why haven't you worked with Walter Thayer?" he asked.

"I was not aware that I have not worked with Mr. Thayer," said Bates stiffly.

"You didn't do what I told you. You didn't support him. And I have to support him," said Paley, then softened: "Well,

well, perhaps we had better talk about this tomorrow. I may
have gone too far."

Bates found that comment curious. "What about the pol-
icy meeting tomorrow?" he asked, and now the rest of the meet-
ing was like a dream, though fragments of the conversation
were to float through his dreams every night for weeks there-
after, until he had memorized each gesture, tone, and intona-
tion.

"I can't get there until late," Paley said. "You'll have to
start the meeting without me. You can do that."

"I don't want to go through that meeting." Did he think
it or say this aloud? He could not remember. By now he was late
to the Hospitality Committee. Paley offered his limousine.

"Take my car," he said generously.

"Yes, I will. Because I'm late. I would like that. I don't
want to go through that meeting."

He went through all his meetings, of course, first the Hos-
pitality Committee meeting, and then, on the following day, the
policy meeting, at which he and assembled trustees discussed
the future finances of the institution. What a magic meeting
that was! Marvelous! How exciting it was to listen to the plans,
the projects the trustees wanted to effect! Bates sat in astonish-
ment, wondering what all this meant. The ideas were sound: to
make MOMA a study center, a place of scholarly research, an
educational institution—no longer merely a *kunsthall* to display
the dealers' choices, but a museum with an unyielding vision of
art history. Bates was just beginning to regain a semblance of
self-belief or disbelief, as if he had dreamed up that meeting
with Paley in his large, green office, when later, as the trustees
gathered for drinks on the ground floor, the president ap-
proached him again: "I just want to discuss what means we
should take to terminate the relationship. Whether you hand in
your resignation—"

"Under the circumstances, your determination is new to
me," said Bates incoherently. "Whether the trustees let me re-

sign or you fire me, I'll let you know." That night he went to dinner at the house of Ralph Colin, a close associate of Paley's. Bates did not know if Colin knew of Paley's decision, and no one mentioned it. The dinner proceeded all suavity and logical graciousness.

Four days passed. The museum was busy re-installing the sculpture collection and preparing for a reception in connection with the Tamarind Print show. Whether in a sign of strength or shock, Bates did not tell even his wife that he had been fired.

He received a cable from Walter Bareiss, who was returning from Europe, asking him to lunch on Friday. At lunch, Bates found Bareiss very sweet, and shocked at the sudden decision. Bareiss told him that Paley was adamant that the move be made immediately, though Bareiss himself did not know why.

Re-installation and modernization of the exhibits continued, of those same exhibits that had been planned years earlier by Alfred Barr and the curator Dorothy Miller and Jim Soby. John de Menil, a trustee, quoted Soby as saying, "When I saw those paintings going off the third floor, I could have cried." And Bates wondered how much the changes in the museum had to do with the decision to let him go, though the changes had been requested by the trustees themselves.

There were too many changes at once: d'Harnoncourt, a new director, a fund-raising drive.

That night Bates told his wife he had been asked to leave. They went away for the weekend.

On Monday, April 28, Irene Gordon, Bates's assistant, and fanatically devoted to him, returned from vacation. She was rattling on about St. Martin's when she realized that Bates was staring morosely out the window into the MOMA garden, not listening at all. She did not know what was wrong. That afternoon he called her in. Irene noticed that Bates's secretary looked as if she was crying.

"Oh, God, I've got a lot to catch up on," she thought.

"I've called you in to tell you I'm leaving the museum," said Bates.

"I knew you had doubts." She raised her eyebrows caustically. "But why?"

"Because I'm being asked to."

"By whom?"

"Bill Paley."

"Oh, come on!" Irene had been brought to the museum by Bates. She had been long associated with MOMA as a free-lance editor, but this was her first job there. She is a bitter woman, enormously intelligent and filled with hostility and vituperation. "Is this just some discussion?"

"No," said Bates slowly, "it's serious."

"Fight it!" said Irene fiercely.

"No, I can't."

"Don't be a damn fool."

"Oh, Irene, who's going to support me?"

That evening was the *vernissage* at the museum for the "Homage to Lithography" show. There was the usual assemblage of the art world, the fashionable people in the outrageously fashionable clothes, ogling each other and praising the paintings and sculpture. "Oh, darling, how are you!" and the kissing on the cheeks, on foreheads, on lips, in ears, the drinks and little canapés, and the cocktail chatter rising in shrill gaiety, the stamping of tiny-heeled shoes, or the bored pacing of the solemn couple attempting in the hubbub to appear above the gossip.

"Oh, did you see . . ."

"What do you think . . ."

Bates had received a message from Paley. He wanted Bates to introduce him at the dinner that evening in the Founder's Room, on the sixth floor, and when Bates arrived at the door, he found Babe Paley waiting for him with a pleasant word, and Bill Paley cordially clapping him on the back, and he decided he understood nothing, nothing about this art world.

On Wednesday, a week after his initial meeting with Paley, Bates called the curatorial staff to his office one by one and told each one he had been fired.

When they heard of his firing, Bill Lieberman, Liz Shaw, and Bill Rubin paid a call on Mr. Paley to ask if the decision was final. It was.

Many of the MOMA trustees were in London when Bates "resigned," and others learned of his dismissal only after the press release announcing it. John de Menil, a Houston millionaire, was so incensed at the high-handed display of power by the board officers that he talked to Grace Glueck of *The New York Times*. An outraged story of the proceedings came out, and it was hard to know which upset the trustees more, the facts of the firing, or the embarrassing peepshow into the discord; for the first duty of a trustee is to present a united front.

A few days later Nelson Rockefeller was asked at a press conference when he first knew of Bates Lowry's firing.

"Two days before," he answered.

"How did you hear?"

"My secretary told me."

Irene Gordon garnered deep pleasure from her rage. "The trouble with you," she told Bates, "is you thought those people were better than you, better than other people. I've always known those sons of bitches for what they were."

He shook his head mutely. "Well," she continued fiercely, "you've always been raised to believe the Rockefellers, Paleys, the Whitneys were wonderful people. Now they've punished you, censored you, and you feel now you question everything good and bountiful about our nobility. Whereas I," she said, "I was always raised from the womb to know the Rockefellers were s.o.b.'s. I've just corroborated what I've known all my life. And look at it," she said, "look at it. No one stood up. Not one trustee defended you. Not even Colin. You don't break the code of the club, damn it, because some day you'll be in a position to do it yourself—principle be damned!"

Actually, Irene was not right. Ralph Colin had stood up. Colin had been for forty-three years Paley's lawyer and confidant, for fifteen years a member of the MOMA board of trustees, a collector, a founding force of the Art Dealers' Association, vice-president of Parke-Bernet Galleries before its acquisition by Sotheby's in 1963. Colin was deeply involved in the art world. He had seen many things. He had personally blown the whistle on some of the most disreputable dealers and he was one of the few men who could cross Paley, the king surrounded by his sycophants. But you have to understand the position of these men of giant wealth. Old men, for the most part, reared on the romantic beliefs of the last century, raised on ideals of Darwinian survival, order, aristocracy, a sense of the degrees of quality (good, better, best) that shade into such chiaroscuro as would astonish the Art Workers. The problem was that the old school ties and loyalty to . . . certain principles . . . had become clouded, blurred by the passage of time, perhaps, so that all that remained of those drummed-in ideals was the memory of the school or group of friends that had once demanded their application. What remained was loyalty, as in fealty sworn to your king. Colin alone resigned.

Colin is a grave, quiet gentleman, of moderate height and dress. He is tinged with melancholy. He has tasted of the cup of power. Here is his story:

On Wednesday, April 30, Bates announced his resignation to the staff. On Thursday, Bill Lieberman called me. He said: "What are we going to do about this crisis?"

I said, "Which crisis is this?" thinking that perhaps Lowry had been hit by a car, like poor Rene.

He said, "Bates has been asked to resign."

"When did this happen?"

"It was announced to us yesterday," said Lieberman over the phone.

"I don't know anything about it," I said. "It hasn't been announced to the trustees."

On the following day, Friday, the staff appealed to

Paley. They were told the decision was irrevocable, and on Saturday it appeared in the papers.

Sunday I called Henry Allen Moe and Jim Soby and asked if either of them had been consulted. Moe said yes, and Soby said no.

And on Tuesday or Wednesday I got a hysterical call from de Menil. He said he had not been consulted. The firing should not have been done on the merits. I told all three I intended to resign.

I said that the hiring and firing of a director was the single most important decision a board could be consulted on. If the board members were not consulted, there was no reason for him to be on the board. He should resign.

Then I got a call from Bill Paley. "Ralph, have you heard any flack about Lowry?"

"Yes," I said, "and I've created a considerable amount of my own." I repeated that the hiring or firing of a director was the single most important decision a board of trustees could make, and that it should only be done with the consent and approval and studied decision of the full board.

"What do you mean? You received a telegram Friday night."

"No, I did not," I said. "But even if I had, that would not have been a satisfactory substitute for a meeting of the board."

"We sent telegrams to every member of the board."

"Well, I never received one. Nor did Jim Soby, nor did a lot of others. I feel so strongly about this, I'm going to resign."

"You're going to do it without hearing how it all came about?" Paley was astonished.

"I don't care." I was speaking softly. "Because this one essential fact is, the decision was made without discussing it with anyone."

"It was decided we had to act quickly," answered Paley. "I therefore consulted a selected group including the chairman and ex-presidents of the museum."

"Bill," I said, "you may think I'm immodest, but if you were going to consult with anyone, I think my position as a vice-president and my activities over the last years

would have warranted your including me in those con-
sulted. Regardless of who was consulted, however, no
final action should have been taken without a board
meeting." That was the conversation with the man whose
attorney I had been for forty-three years.

About a week later there was a board meeting. I had
decided it would be cowardly simply to resign without
more ado. It was now almost two weeks after the *Times*'s
article announced Bates's resignation.

Someone at the meeting moved to accept Bates's resig-
nation. . . . Gardner Cowles, who was presiding in the ab-
sence of David Rockefeller, the chairman, asked for com-
ments. De Menil talked at length about a conspiracy.
Well, there was no evidence of that, and the idea col-
lapsed like a balloon.

"Are there any other comments?" asked the Chairman.

"Yes," I answered. "As I have said, the hiring and
firing of a director is the single most important decision a
board can be called upon to decide. If that is not submit-
ted to the board, what should be? Therefore the fashion in
which this decision was made was most improper. It was
a highly irregular procedure."

Mr. Paley said, "Mr. Colin has changed his position
since he talked on the phone to me. At that time, he said
he was upset because *he* was not consulted."

"I'm sorry I'm forced to contradict the President," I
said. I was speaking very quietly, as softly as I am now.
"I did say that if anyone was consulted, I should have
been included in that group. But I distinctly made the
point that regardless of who was consulted, no final ac-
tion should have been taken without a board meeting.
However, I have registered that objection," I said. "The
important thing now is to present a united front to the
public. I move that the board, and I hope unanimously,
will approve Mr. Paley's action."

Paley said: "I wish Mr. Colin would withdraw his
amendment."

"At the President's request, I withdraw the amend-
ment."

Later I learned that a batch of telegrams sent to the
trustees in London went out and that by some oversight

the others did not. I left the meeting with Walter Bareiss. We walked to the corner. The next morning I got a call from Mr. Paley's secretary asking if I could come down to his office to meet him. I said yes.

When I got there he was in his big office. He remained sitting. [A flicker passed across Colin's face at the memory of the snub.] He didn't move from behind his desk. He said, "I've thought long and hard about this. I want to terminate our relationship, and I want no discussion."

"Since you want no discussion," I said, "there will be none." And I turned and walked out. That ended a relationship of forty-three years."

Why was Paley so arbitrary? What impelled these autocratic acts, made without the discussion or approval of the whole board?

"He's a man who is used, at CBS, to giving orders," explained Colin in the same soft, melancholy voice. "For a long time I was the only one who could tell him where to stop. I was independent. Then . . ." He shrugged.

But that is not all. For the older trustee MOMA was different now. Not as much fun. The great leaders were dead or dying, and they—the princes of power—were in their seventies or close thereto. Time was catching up. They had been forced in the last two years to increase the board by ten members. To bring in young people. Young. In their forties and fifties. Who did not see the museum in the same way as the original founders.

They had started the museum, opened it, built a building, enlarged it, made a collection. What fun it had been in those days! How alive they had all been, filled with a sense of mission, laughter, enthusiasm for the museum and contemporary art. And now: 1969, 1970, 1971—the years ticked off, one by one. Barr was seventy years old, and failing. Rene was gone. And art today was ugly. Paley, the president, found himself working with David Rockefeller, and David was his junior by a generation. It was David's mother who had invited Bill Paley onto the

board in 1930. He was twenty-nine. TV had just been invented then. Radio was new, and Bill was forging a chain of stations that would extend across the country and make him one of the single most influential forces of our culture. Millions of people—millions listened to CBS radio, to the Columbia School of the Air and concerts from the New York Philharmonic Symphony. Everything was still hope, still waiting to be accomplished, and they were young, witless, idealistic, overflowing with joy and life. They had begun the museum, quite a venture when few people in New York had ever seen a Cézanne. Mrs. Rockefeller, David's mother, who was his contemporary, invited him to join. What a beautiful woman she was, Abby Aldrich. She too was dead. Why could not these abrasive young directors, these revolutionaries, why could they not understand that, at a certain level, change is not a force for life—but dying. Death. Change of people, places, perceptions, ideals. Change for no earthly good or cause. Except to disrespect the past. Reject the brave accomplishments. If only things could stay the same, as they had been under Rene and Alfred and Monroe, when the museum was fun and worked. Why could the museum no longer be as much fun? As alive? It used to be so vital and alive. Why did things have to change?

Sound the Hirshhorn!

Basta! Stop! Enough of this hangdog morbid moping over art, fidgeting with failure. I want to tell of heroes and the glitter of success. Sound the Hirshhorn! He touched the top: Joseph H. Hirshhorn, Latvian immigrant and self-made millionaire, the American dream. He is mad about art. He started buying modern art before it was the thing to do; spurning the idea of mere trusteeship, he made his own museum: the Joseph H. Hirshhorn Museum and Sculpture Garden on the Mall, in gracious Washington, D.C., almost directly opposite the National Gallery of Art. Sound the Hirshhorn! He made a grand gesture and pulled off a good deal. He got the government to foot the bill for his

ten- to sixteen-million-dollar museum, designed by the architect
of his choice. His name chiseled across the door, like the lights on
a theater marquee—The Joseph H. Hirshhorn Museum and
Sculpture Garden—and the whole museum maintained at the
taxpayer's expense "in perpetuity." Is that all? He got a lifetime
deal for his private curator, Abram Lerner, who became director
of the museum. He got to choose half the members of the board
of trustees—the better to self-perpetuate the spirit of the place.
Is that all? His sculpture garden straddled the Mall.

Only three men in our nation have been awarded monu-
ments that traverse the Mall, that great, green sweep that
stretches straight and clean from the white pinnacle of the Capi-
tol Building 2.4 miles to the gray Potomac River. The heroes of
our country: George Washington, who fought for its freedom;
Abe Lincoln, who fought for its union; and Joe Hirshhorn.

Not that other museums do not line the Mall—the Smith-
sonian complex of art, science, and history. But none traverses
it. No man ever asked or received so much as plucky little Joe
Hirshhorn, the collector. Charles Lang Freer, founder of the
Freer Gallery of (primarily Oriental) Art, paid for construction
of the building and endowed his gift for maintenance. Andrew
Mellon, former Secretary of the Treasury, donated the nucleus
collection of a National Gallery of Art, built the building, and
endowed it, at the same time insisting that his name should not
appear on public property. Hirshhorn, little Joe, bridles at the
comparison. "That's just too bad," he says. "Mellon was Mellon,
and I'm Hirshhorn. I can't afford to please everybody. I couldn't
afford to put up that building without robbing my family."

But that's not the entire truth. The truth is that Mellon
was playing by nineteenth-century rules and Hirshhorn by the
art-world rules of his age. Hirshhorn is tougher, bigger, brasher,
bruising. He has a certain style. Hirshhorn managed by sitting
back and letting everyone knock himself out competing for the
collection.

"I never offered it to anyone," he snaps impatiently.

"They all came to me." "They" were (it was given out) England, Israel, Zurich, New York State, Baltimore, Beverly Hills, Los Angeles, and the U.S. government—all competing in the middle 1960s at the peak of the art boom to build him a building, landscape a sculpture garden, and maintain his collection, and all bidding up the price. In addition, he had offers from about twenty colleges and universities.

Hirshhorn is only five feet, four inches, but everything about him is big. Hirshhorn doesn't just make money. He makes a hundred million dollars. Some people estimate his fortune at $130 million, but he denies it: "I'd feel vulgar if I had $130 million." Hirshhorn doesn't just buy one or two paintings by an artist. He buys a roomful. He doesn't just stake out a mining claim. He stakes out 56,000 square acres of claims. He hasn't had just one wife. He's had four, and, not content with four children, he adopted two more.

Hirshhorn buys so much art so fast that no catalogue has ever been printed. "It's no use," says Abram Lerner, his gentle curator. "It would be out of date immediately."

No one knows exactly what there is, but the numbers are repeated like prayers: four thousand paintings, mostly contemporary American, sixteen hundred pieces of sculpture, ancient and modern, from all parts of the world. There are forty-three Daumiers, seventeen Rodins, twenty-two Degas, twenty-two Giacomettis, fifty-three Henry Moores, twenty-one Matisses, twenty-six Manzus, thirteen Jacques Lipchitzes, one hundred ninety-four Louis Eilshemiuses, ten Calders. There are paintings by Eakins, Homer, de Kooning, Ken Noland, Ben Shahn, Jackson Pollock, Stuart Davis, Milton Avery, Larry Rivers, Andrew Wyeth, Picasso . . . the mind balks, bogged down in figures that become meaningless. Fifty-six hundred pieces, the result of forty years of passionate wholesale buying, and said to be worth $25 million—or more! $50 million! as the government proudly announced.

It was all the result of buying in bulk. According to re-

ports, Hirshhorn buys almost every day. If he can't decide which of an artist's paintings he likes, he buys them all, sweeping into a gallery, picking up six or eight paintings in the course of thirty minutes, and returning to his meetings of the board. His dealers all agree he has terrific taste. Put him in a room with twenty paintings, they say, and he'll pick the five best. No one had seen the collection in its entirety, but everyone agreed it was the biggest collection of contemporary American paintings around, and one of the finest of ancient and modern sculpture. But the first catalogue ever published was the seventy-four-page double-column list in eight-point type that forms the appendix to the forty-five-page ten-point Senate Hearing held in 1966 on whether to acquire the museum; and even this list, admitted Abram Lerner with a smile of sweet, gentle pride, may be off by as much as one thousand pieces.

That it would come to Washington was exciting. Sherman Lee, the renowned director of the Cleveland Museum of Art, wrote to Ladybird Johnson expressing reservations about the wisdom of creating a museum named after the donor. Experience has demonstrated, he said, that the donor's name discourages further gifts and contributions. He further advised that while the collection seemed strong in the area of sculpture, the painting collection was uneven in quality, quixotic, and reflected so personal a taste as to be unsuitable for a national museum.

His caution was laughed at as the pompous purisms of one director jealously sniffing at another's prize. In 1966 his reservations were brushed aside in infectious enthusiasm for Hirshhorn and his museum, which would bring contemporary art to Washington and put Washington in the swing of the relevant avant-garde; and no one cared that Hirshhorn had a monument nonpareil or that the U.S. government was furnishing $10 or $15 million in public funds to establish a memorial to Joe Hirshhorn —or if they did care, then that too seemed only just, for he was our idol, rags to riches, the new legend, Horatio Alger topped with the custard of culture.

Brash, bragging, arrogant, lover of art and of mankind—
and particularly, it turned out, of womankind: he has been mar-
ried four times but was never without a wife for much more
than a year. He has three girls and a boy of his own, but adopted
two more girls.

"I'm just a little Hebe from the gutters of Brooklyn,"
said Hirshhorn, knowing he was the success story of the century.
He was born in Latvia, the twelfth of thirteen children. In 1905,
when he was six, his widowed mother brought her ten remain-
ing children to America (three had died, so that Hirshhorn was
actually raised as the ninth of ten children—a mathematical
computation that, baffling the biographers, causes countless con-
flicts in the published accounts of his siblings).

His mother worked twelve hours a day, six days a week in
a pocketbook factory. She received $12.50 a week.

"Poverty has a bitter taste," Hirshhorn has said, and
again, "We ate garbage."

At fourteen he took a job as an office boy on Wall Street.
At seventeen he entered the New York Curb Market as a broker
with $255, and in one year increased it nearly 660-fold to
$168,000. (The Curb Market, notorious even in pre–World War I
days for shady practices, was closed by the SEC in the 1930s, and
with it went some of the most thrilling opportunities for for-
tune-hunting.)

At the end of World War I, however, Hirshhorn mis-
judged, lost everything but $4,000, and had to begin anew. By
the time he sold out in 1929, just before the crash, he had $4 mil-
lion. He was twenty-eight years old, and still hungry.

"I'm not an investor," he once explained savagely. "I'm a
speculator. I'm not interested in blue chips and their dividends.
They're okay for grandma and the kiddies, but I've always
wanted the proposition that costs a dime and pays ten thousand
dollars."

So he bought 470 square miles of land in Canada and

started mining. "I'll mine anything," he snaps. "Copper, uranium, anything that makes a profit."

Uranium makes the most profit. By 1952, having listened to Franc Joubin, a geologist who had been ignored by the other mining concerns, Hirshhorn had the biggest uranium deposits ever discovered.

Hirshhorn started collecting art in the 1930s, long before it was fashionable. As a little boy he used to pin reproductions from the Prudential Life Insurance Company's free Christmas calendars to the wall above his bed: animal paintings by Sir Edwin Landseer and bewigged ladies by Bouguereau. Later, in his possessive love affair with art, he started buying it en masse, storing it in three offices, three houses, an apartment, and the Manhattan-Morgan warehouse in New York. By the mid-Sixties he was said to be worth $100 million and his collection another $25 to $50 million. He was the American dream. He had done better than Andrew Mellon, Secretary of the Treasury, or Widener, the ex-butcher (who once paid $100,000 for a fake Velasquez, having been convinced that the one in the Doria Gallery was a copy), or steel magnate Henry Clay Frick, who locked himself up with his art in Pittsburgh while his striking workers were ridden down by the police. Or even J. P. Morgan, who had to pay for his own mausoleum.

One balmy day in May 1966, Hirshhorn formally gave his fifty-six hundred pieces of art to the United States of America, together with one million dollars (principal not to be touched) for an endowment fund.

President Lyndon B. Johnson formally accepted the collection on behalf of the American people in a little ceremony in the White House rose garden.

Hirshhorn is a sentimental man. He was not lying when he said of his collection, "It doesn't belong to one man. It's gotten very big. It belongs to the people."

He was not lying when he explained why he was giving it

to the United States. "Well, a lot of people wanted it. But I could not have done what I did in any other country. What I did I accomplished in the United States. It belongs here."

And again later: "I am an American. I was born in Latvia. My mother brought her ten children to this country and went to work in a pocketbook factory . . . the things I did in my life can only be done here."

Then he threw a casual arm up almost twelve inches and over the shoulder of the hulking President Johnson, called Abe Fortas "a darling . . . man," and applied the same adjective to Ladybird.

The bill to establish the museum galloped through Congress in six months. It would be hard to say who was more pleased with the museum: Hirshhorn, who got his name guaranteed "in perpetuity," the Smithsonian, which acquired even more prestige and power as evidenced by an even longer letterhead, or the American people, who received this colossal collection of contemporary art. Only NCFA remained impoverished, still searching for its destiny and some art to fill its building and fulfill the mandate of promoting contemporary art.

In 1970, four years after the rose-garden scenario, and while the bulldozers were tuning up a cacophonous chorus to clear the museum site, adverse reports about Hirshhorn began to surface. He was a "sleazy stock manipulator," said Jack Anderson, twice convicted and fined for violating the Foreign Exchange laws of Canada, and once ordered deported from Canada for a million-dollar stock manipulation deal—an order he had appealed and won, it was learned, by reclassifying himself a landed Canadian immigrant. (So much for the land of the free.) Later, in 1945, he had been fined $8,500 for an illegal securities sale and thirty-five hundred dollars for trying to smuggle $15,000 in cash out of Canada illegally. In 1951, under attack in the Saskatchewan legislature for his stock finagling, he was characterized as a "racketeer."

It came out that his U.S. stock dealings had attracted the

attention of the New York State Attorney General. Then questions arose about the queer evaluation of the $25- to $50-million art collection, which only ten years earlier had been evaluated at $1.5 million. It came out that the curator, Abram Lerner, had insisted in a memo to the Smithsonian that the art works be evaluated by the artists' dealers—which, as one columnist put it, is like asking a producer to evaluate his own films.

Bob Simmons, the retired ship's officer, brought this to light, and so indignant was he that almost single-handed he forced the Congress to hold the subcommittee hearings into the Smithsonian activities that so embarrassed the Institution.

He scored the Smithsonian before Congress for "misinformation, error, deception, and cynical distortion of facts," for the "most flagrant violation of this public trust . . . in the promotion of that vast memorial complex," the Hirshhorn museum. He condemned the design, its position of honor on the Mall, the fashion in which the project had whisked through Congress in a quick six months with no investigation into either the merits of the collection or the legalities of the private contract negotiated between a private citizen and a governmental agency.

But Simmons is his own best spokesman.

"Misinformation was given to Congress even at the beginning." Simmons was seated at the rectangular walnut table in the hearing room before the bored representatives on the raised dais before him, ruffling their papers and notes. The air conditioning hissed. L'Enfant himself, said Simmons, had described the purpose of the memorials on the Mall: "To perpetuate not only the memory of such individuals whose councils or military achievements were conspicuous in giving liberty and independence to this country, but also those whose usefulness hath rendered them worthy of general imitation: to invite the youth of succeeding generations to tread in the paths of those sages or heroes whom their country has thought proper to celebrate."

Secretary S. Dillon Ripley, II, had taken the lead in cele-

brating Joe Hirshhorn for this role. As early as December 18, 1964, he had suggested the Mall site to Hirshhorn, saying, "The names of Mellon, Freer, and Hirshhorn would be associated together at the nation's 'court of honor,' which is the Mall."

In testimony before the House Subcommittee on Public Buildings and Grounds, June 15, 1966, Secretary Ripley had stated: "Mr. Hirshhorn represents the kind of catholicity of taste which I think is in the highest tradition. . . . His outstanding collection includes West African Benin bronzes, which have influenced many of the painters, particularly of the Post-Impressionists, and Degas and early Abstract."

He was in some error there, Simmons pointed out acidly, for Degas and the Post-Impressionists were not at all influenced by African sculptures; rather they were influenced by Japanese painters and printmakers.

Simmons quoted the encomiums to Hirshhorn: Donald J. Irwin, Democrat of Hirshhorn's home state of Connecticut, called Hirshhorn "a man raised in this country and shaped by our institutions. Joseph H. Hirshhorn represents the opportunity and dynamism of America." Representative Michael J. Kirwan, Democrat of Ohio and a member of the Smithsonian Board of Regents, cried, "Like many people, Mr. Hirshhorn gave his blood, and I mean his blood."

Simmons choked with rage. "In 1944, while American boys were dying on battlefields in Europe and in the Pacific, the man who will be memorialized on the Mall, the man who 'gave his blood' and was 'shaped by our institutions,' and who 'represents the opportunity and dynamism of America' was apparently engaged in the activities recorded in the Toronto *Daily Star*, June 26, 1945—to be found in the Library of Congress." The activities of a convicted money smuggler.

Moreover, no experts in the field of art had been asked to judge the collection.

"There were no experts there. This is a question I didn't really want to get into. But there were no art experts at all. . . .

They asked people who didn't know anything about art to testify on these matters."

Simmons's heart was breaking.

The intention of my remarks about the L'Enfant design here and the meaning of the Mall is this. It means a great deal more to us now than it did one hundred years ago, perhaps, when it was just a big swamp down there.

This is a highly symbolic area in this country. It is the one most sacred place in the whole United States. We cannot, in my poor humble opinion, erect a monument to a man with the kind of past that is found in the public record of Joseph H. Hirshhorn. This kind of past—I don't know. I have not looked into Mr. Yale. I don't know what Mr. Harvard and others' pasts were. But they are not on the Mall.

The event of erecting the Freer Gallery was not involved in the same thing at all. The reason they put the Freer Gallery there is at the time they were looking for some land. That land was available down there. So they stuck it there. It wasn't because he was considered to be one of our heroes. The reason Smithson got his name on the Mall, as I said—it possibly could have been taken off—was sort of by accident.

This is a tremendous memorial. We had plans for a national sculpture garden. This national sculpture garden has now been renamed the Joseph H. Hirshhorn Sculpture Garden. We had in mind a national museum of modern art some years ago. That notion was transferred to the National Collection of Fine Arts. This national museum of modern art, however, now is to be called the Joseph H. Hirshhorn Museum, and the plan seems to be to make it so important that in 1976, which is the two-hundredth anniversary of the Independence—

Representative Schwengel broke in. He had been on the Committee on Public Works, whose work Simmons was condemning, and he wanted to make sure everyone knew that he had raised Simmons's questions at the time—off the record—and said that;

If there had been any suggestion of his disreputable character . . . there would have been some action. . . .

Now I would like to have you put into this record at this point what you believe is disrespectful or wrong about Mr. Hirshhorn and why we shouldn't have named it that.

MR. SIMMONS: I haven't made a value judgment in my statement. What I am doing is simply bringing facts before this subcommittee which I think should be done for the committee to make value judgments on memorials, you see.

It may be true that 25 percent of the people in the United States may be scoundrels. They, perhaps, should be represented on the Mall, you know. There may be this kind of argument. But you do have to make up your mind about that.

I say that the public has never been introduced to the facts that I have dug up after months and months of research, after hours and days and weeks scouring newspapers, Canadian newspapers, in the Library of Congress, which is a source of information to the Smithsonian and to Congress, you see, scouring for these facts that I finally dredged up about this man's actual past.

He, Mr. Schwengel, has had clever men who have been public relations men for his companies. He is a powerful man. He is said to have a fortune of $100 million. I don't know that. You read that occasionally.

But the man, if these moneys are based on the kind of things that I am trying to report in this report here, on stock manipulation, which he, in a report, in a newspaper report or in a magazine report, dismisses, as saying they are trying to hang him, you see. Whereas this Gunnar Gold Mines, Ltd., investigation of the Ontario Securities Commission back in 1935 named him as a stock manipulator, you see.

I think that is pretty serious, especially today, in what we have up in Wall Street and this turmoil in our economy today, which is in part caused, as we read in every newspaper, by people who have little sense of public morality.

You can read this, please. I will enter this entire report of the Ontario Securities Commission in the record.

I would like to add also two more articles from the *Toronto Daily Star* concerning Mr. Hirshhorn's activities during World War II, when you and I and the others of us here were doing something for our country.

I was in New Guinea in May 1944, when Mr. Hirshhorn was engaged in what was termed in the *Daily Star* as "illegal securities sales" up in Toronto, when he was arrested at the airport in Toronto attempting to smuggle a little money across the border. And even when he was taken to the room to be interrogated, he didn't confess up.

He finally said, "I have $15,000 in my pocket."

This activity is something to consider.

Simmons's words could not help but affect the subcommittee, and, coupled with the charge that the collection itself was controversial and undisclosed, they made the Smithsonian very uncomfortable. The Congressmen started asking about the million-dollar endowment that Hirshhorn had promised the museum, and which had been generously transferred instead toward construction costs when the prices rose. He replaced his cash endowment with the extra million dollars' worth of accumulated art. The subcommittee asked question after question.

It turned out that though title to the collection would not pass until the building was completed, the U.S. treasury was paying for framing, cleaning, and preparing two hundred "of the choicest items" in readiness for the opening exhibition. It was also paying salaries and expenses of the collection, to the tune of $375,000 in fiscal 1970, with the estimated for fiscal 1971 almost doubled, to $726,000. Moreover, no board of trustees had yet been appointed, though the terms of three potential trustees had already expired. Testimony on trustees sheds light on the relations between a museum staff and its board of trustees.

Representative Frank Thompson, the subcommittee chairman, was questioning the Under Secretary of the Smithsonian, with the same wonder as the young man who watched Father William balance an eel on the end of his nose.

MR. THOMPSON: Three terms have expired at this point. And yet no one has been appointed a trustee. What efforts have you people made to have the trustees appointed by the President?

MR. BRADLEY: We have corresponded with Mr. Hirshhorn, who has nominated enough candidates so that four may be appointed by the President.

We have alerted the Board of Regents [of the SI], and they have agreed upon a certain number, possibly thirteen, from which the President can appoint four. We have two *ex-officio* members, the Chief Justice and the Secretary of the Smithsonian. . . .

MR. THOMPSON: So, in effect, what you are doing is performing the functions of the board of trustees in the absence of one. Is that correct?

MR. BRADLEY: Mr. Thompson, I don't think that we are performing the actions of the board of trustees. We have had a long experience in getting a museum actually under construction. It was our judgment that we didn't need a board of trustees until we had something for the board to do.

MR. THOMPSON: You do interpret, notwithstanding that you don't yet have title to the collection, that there is a museum in fact, do you not?

MR. BRADLEY: Yes sir.

MR. THOMPSON: Under that interpretation, you have made a determination that what you are doing with respect to curatorial work and so on is perfectly legitimate, there being a museum in existence?

MR. BRADLEY: Yes, sir.

MR. THOMPSON: And yet, it would seem to me that if there is in fact a museum in existence as you interpret it, that certainly then it should be imperative that the trustees be appointed.

MR. BRADLEY: Sir, may I examine just quickly?

MR. THOMPSON: Let me follow with the question.

You made reference to Mr. Hirshhorn and his nominees. He hasn't yet nominated anyone?

MR. BRADLEY: He has, sir, to the White House.

MR. THOMPSON: They are being screened?

MR. BRADLEY: Oh, yes, to be sure.
I think the basis I would like to offer you is this. The function of the trustees run to matters of art, not to matters of administration. Administration is vested in the Secretary under the regents.
There have been that I know of no trading in art, no determinations made as to the policy about art, and no determinations made about the exhibition of art.

MR. THOMPSON: How, then, is the distinguished curator, Mr. Lerner, proceeding?

MR. BRADLEY: He is proceeding with an existing collection, plus a supplemental collection that Mr. Hirshhorn is going to give to us.

MR. THOMPSON: But doesn't this involve working with art?

MR. BRADLEY: Indeed, it does, sir.

MR. THOMPSON: Then I don't understand what you just said.

MR. BRADLEY: Then I would like to say it again.
The trustees are vested rather uniquely with final determination in matters of art. The donor is proceeding to purchase art. He could purchase art whether we had a board of trustees or not and offer it. If they don't want, they don't take it.

MR. THOMPSON: As a matter of fact, he could, until title passes purchase a work of art and put it into the collection and take one out; could he not?

MR. BRADLEY: He could.

MR. THOMPSON: Let's assume you determine, or the curator does, that he is preparing things now or looking after things now. Let's assume he works on five works of art. And before title passes, Mr. Hirshhorn says, 'I think I will take those out, replace them with five others.' He could do that; could he not?

MR. BRADLEY: He could, sir.

 The act also provides that any money that results from any exchange, purchase or sale of works of art remains to the credit of the Hirshhorn collection. . . .

MR. THOMPSON: If there were losses, Mr. Hirshhorn would replace those losses?

MR. BRADLEY: I don't think that that follows: I think it is this. When you get through, if you do any trading, whatever cash is available stays with the fund for the use of the board of trustees when they come.

 The Smithsonian was trying desperately to recoup. During the summer, a Smithsonian official telephoned Ralph Colin, counsel to the Art Dealers' Association, asking if the ADA would appraise fifteen paintings and five pieces of sculpture from the collections.

 "Do we get to pick which items we appraise?" he asked.

 "No," said the unknown voice on the phone. "We'll tell you which ones we want."

 "Then we won't do it. No."

 "What do you mean, you won't do it?"

 "The selected items may be atypical," said Colin. "Appraising twenty works would make it look as if all the rest of the collection is on a par with these. No, we won't do it. We'll do the whole collection, if you want, or we will appraise sample items of our own selection."

 Apparently the suggestion was unsatisfactory. ADA was pursued no further.

 The phone call did not come out in the course of the Congressional questioning. The Smithsonian submitted letters in its defense from H. Harvard Arnason, a trustee of the Guggenheim, who had organized two museum exhibits of Hirshhorn's collections, and who is a member of the Smithsonian advisory council; also from Roger Stevens, Chairman of the Board of the John F. Kennedy Center for the Performing Arts—which is

likewise associated with the Smithsonian. Stevens was a Broadway producer *(Mary, Mary)*, fund raiser, and real estate dealer, and why his testimony on contemporary art should carry weight was uncertain, for he was not one of the art crowd.

Later, under continued criticism, Ripley denied any responsibility for the collection. This was in contradiction to his earlier boasts to a reporter of having personally discovered the collection, pressed its acquisition with the President and Ladybird Johnson, and won it proudly from the Queen of England, the nation of Israel, and the cities of Baltimore and Los Angeles. Indeed, if one looked deep in the Smithsonian files, it was said, he would find memos indicating that the Institution had worked hard for the collection. One notes that Hirshhorn "would like some renewed attention from Mrs. Johnson—a phone call or some such." Before Congress, however, Ripley told a different tale: "[T]he collection was accepted for the United States by the President of the United States. We have been informed that the President does not accept collections for the United States without suitable inquiry. We were also informed that at that time an inquiry was made as to the character and so on of the donor.

This is not then a germane subject for the Smithsonian Institution, who then are, as it were, handed the collection, the gift, by the President of the United States."

Charles Blitzer leapt to the Secretary's defense: "May I make one observation? I think among the various factors that this committee will have to weigh in reaching a decision about that is the question of the effect of all this on possible future gifts of art to the United States of America. . . . I personally deeply regret that this has now come up. . . . If this is the price that someone pays for making a gift of this sort to the United States, I think it will have a dire effect upon our attempts to get such gifts."

The Congress does not recognize greed as legitimate justification for behavior. Mr. Thompson's plump, pink cheeks flushed red: "You don't mean to imply that the question

shouldn't be raised about donors of something, however valuable? Is your implication that if such an inquiry as this were pursued further, or a similar inquiry in the past, we might jeopardize the acquisition of works of art and therefore we should ignore matters which come to our attention?"

MR. BLITZER: I think the only implication I would make is that this should be done as discreetly as possible.

MR. THOMPSON: [a hard edge creeping into his voice] Do you think in any way it has been indiscreetly done?

MR. BLITZER: Not by this committee, no.

MR. BRADEMAS: Would the chairman yield?
 I, too, Mr. Blitzer, think on reflection you may wish that you had the opportunity which we inflict upon ourselves in the House of Representatives to revise and extend, because one of the things that has so annoyed me through all of these hearings—which I hope my observation has made clear—is we have been kept in the dark about all of this. I believe in original sin. I just don't like to take at face value everything that is represented in the press, and I am still more annoyed at having to take at face value matters that are not represented at all before a subcommittee that has some responsibilities with respect to this matter.
 I have been doing a little talking around about this whole Hirshhorn operation, and I would be less than candid if I didn't tell you I have some profound misgivings. It isn't the character of Mr. Hirshhorn that is the cause of concern to me, but frankly, it is the character of the architecture and what you are going to do to the Mall, which I think is not yet appreciated by the people of this country.
 You may yet—I have an open mind on this—but you may yet find that this period of the Smithsonian, for all of the great works that it accomplishes, may not, for that single reason, be looked upon as being as noble as I should like to hope that it will be.
 I don't know if you understand what I am talking

about. I like that view from here down there—Capitol
Building to Washington Monument. I think it may well
be that, just as the monstrosity in which we find ourselves
meeting today [the Rayburn Building] was inflicted upon
the sensitivity of the American people, another is about
to be inflicted upon our sensibilities.

One reason I was glad, Mr. Chairman, to be able to
move from the Longworth Building to the Rayburn
Building is that I don't have to look at the Rayburn
Building when I am in it. . . .

MR. THOMPSON: I would like to make something clear to Mr. Blit-
zer.

For the first time in over one hundred years, a commit-
tee of the Congress with legislative responsibility as dis-
tinguished from appropriations—the latter is essentially
a closed process—has given the Smithsonian an opportu-
nity to explain its growth, its activities, its plans for the
future, and so on, and you have done admirably, all of
you.

The Chair fully expected that controversy relating to
the Hirshhorn Museum would arise and fully anticipated
that there would be some questions about personnel poli-
cies and some of the management practices, but this has
been anything on earth but a witch hunt, nor has it been
in any sense indiscreet.

I don't know whether I will be back here next year or
not, or if I am, whether I will chair this subcommittee.
But I can assure you and everyone else that I conceive it
my responsibility to learn what the plans are, to learn
what the activities and operations are of the Smithsonian,
of the Library of Congress, and of whatever else this sub-
committee has jurisdiction over, and if my colleagues and
I deem it necessary or desirable, we will feel perfectly
free to look into the background, in every detail, of every
gift, notwithstanding that it might cause the loss of some
gifts, as you implied in your earlier statement.

You might be quite accurate, though you are speculat-
ing. Notwithstanding his troubles, Mr. Mellon accom-
plished his gift. It is apparent that Mr. Hirshhorn has ac-
complished his, subject perhaps to a few remaining
conditions.

That doesn't mean, however, that everyone should agree about either your plans for the museum, the value of the collection, or indeed of the architecture or the placement of the museum on the Mall.

Blitzer shrank visibly. He sat rigid at the table before the raised dais of the Representatives during this monologue, and stared at the meat of his finely manicured hands poking out of one-half inch of elegant white cuffs. The tension in the room tightened, climbed to a single, screaming high C—until it snapped with the cherubic look-about-him smile of Chairman Thompson and another innocuous question.

Later Blitzer half rose, crouching forward toward the witness table in the humility of apologetic intrusion.

"Mr. Blitzer?" The Chairman recognized him.

"May I make one final remark?" he asked. "In a rather chastened mood, I apologize if what I said before was offensive to the committee. I think perhaps I expressed myself badly."

MR. THOMPSON: There is no need to apologize, Mr. Blitzer.

MR. BLITZER: What I intended to say really is what you and Mr. Brademas have been saying, that if this whole matter of the Hirshhorn gift had been considered at the appropriate time by this committee, I think we all would find ourselves in a much less awkward situation than we do now.

Ah, the pusillanimity of power. It was not a praiseworthy performance for the Smithsonian Institution. But no worse than the antics of the rest of the art world. Old Joe Hirshhorn didn't come out too badly by comparison—financier, convicted money smuggler, stock-market manipulator, "racketeer."

Well, he may not seem like much of a hero, our Hirshhorn, but you can see after three hundred pages of human frailty that he is the best we have, excepting little Bob Simmons, perhaps, whose valor is on a higher plane. We have seen Greenberg and Rubin, Hoving, the Art Workers, Wrightsman,

and Ripley, and William Paley, and now we know the kind of man the world admires. By art world standards Hirshhorn is the top of the heap. So let us tip our hat to Hirshhorn, who reaped the rewards of the world of art.

The plans for Hirshhorn's sunken sculpture garden were changed after the 1970 Congressional hearings, so that the garden, Hirshhorn's monument, would not squat centered on the Mall aligned with the Capitol and the Washington and Lincoln Monuments. It was set back into the trees, though it still projects farther across the Mall than any other structure. Is it not fitting that contemporary art should hold such a place of honor? Surely now no one will be able to say he does not know what is art.

Conclusion:
Nostrums of Normalcy

By 1971, having survived, to our astonishment, our Presidents Johnson and Nixon and the Vietnam war and Mr. Agnew's solipsisms, and the riots, and demonstrations for blacks, women, and homosexuals, long hair and hot pants, and having learned perhaps the energizing effects of sustained crises; having become bored, in other words, by maintaining a high pitch of excitement, the fit passed. Much had happened, and nothing had changed.

The Art Workers' Coalition flailed itself to pieces. Only Lauren Reichen seemed to regret the change. One leader, Alex Gross, was busy forming a National Art Workers' Community.

He had a list of names of people across the country who wanted to join. He was putting out a monthly newsletter. Lucy Lippard was defining the artists' plight in feminist terms, and in their mutual dislike, Lucy and Alex split the Coalition into two ideological sects. Attendance at the Monday night meetings was reduced to a pathetic cell, though the brave band continued to hope for better days.

Lauren was sorry to see the attrition of membership, and even more to note the split. He knew that the only way to gain political power was to mass and grow. Instead, the artists "were ego-tripping, competing for art historical reputations." They were being seduced by society, integrated into the system, and he felt doubly betrayed, for this was the second time that he had watched a group "betray its original radical intent."

Alex Gross felt no such melancholy. He had applied to various government agencies and received $17,000 in grants to unionize artists, provide technical assistance to them, send out his newsletter, do research on the conditions of artists in our society. And he was right there, on top—a large telephone dial hung around his neck and bumping up and down with each bouncy step—organizing artists with a diminished, but paid, small staff.

The passions of the Coalition, though, had passed to museums. By 1972 curatorial staffs were organizing into unions, holding explosive all-night meetings, and talking about formulating museum policies together with the trustees. The museum staffs wanted higher wages and job security. At MOMA the staff went on strike. At the Met the staff, less volatile, was defanged by Hoving's political prescience.

As the frenzy died down in New York, Indians stormed a museum of Indian culture in California, and some people predicted that the fits of New York were moving west.

The state of art was directionless for the moment. Dealers were selling many styles and artists producing all kinds, and no one knew where things were going or why great art was not

being produced. The critics, therefore, were also in a state of flux, directionless and searching for the Movement, the discovery of which would make their reputations.

The Guggenheim museum canceled an avant-garde exhibit of sociopolitical art.

MOMA fired its new director, John Hightower.

The Smithsonian watched the rise of the Hirshhorn Museum.

The Metropolitan bought the $5.5-million Velasquez and continued its plan to bankrupt itself building the biggest pedestrian mall in the world, while the Brooklyn Museum closed its doors two days a week in frantic efforts to remain open at all. Things were back to normal. Much had happened, and little there was to show for it all.

Author's Note

I have been asked what changes could be instituted to make the art world more responsible. Fraud and corruption will always be with us, people say, and there is no way to root them out. This is so because people are trained to take advantage of situations. But corruption can be reduced. It need not run unchecked. Part of the reason for the corruption of the art world lies in the fact that the business ballooned so fast in the Sixties that everyone was caught off guard. Art was suddenly big business, and the behavior of the art crowd was of public concern. It can no longer pretend to be a family affair, in which fraud is excused as indiscretion.

Here are, therefore, a number of precise, limited, but in the art world radical changes in procedures, which would reduce the temptations now inherent in the business. Some of the procedures are so simple as to require little implementation, others more complex. Some are already practiced in other countries, others have never been tried before.

DEALERS

During my investigation for this book, I ran across one law suit concerning a forgery by a gallery. The collector sued in federal court. The case was settled with an agreement between the collector and the gallery that all testimony, photographs, and other evidence be impounded and appear in no public records. As a result, there is no way for anyone to know that the gallery—which is still in business—was ever charged with repainting a picture or purposely commissioning a forgery.

This is wrong. Judges should ensure that all testimony in a suit should remain in the public realm. It is part of the public's right to know, and part of the defendant's right to a free and public trial.

AUCTIONS

The auction houses should abolish the secret reserves. There is nothing wrong with an owner requesting a reserve price on his painting, but, as in the horse auction, the reserve should be publicly recorded in the pre-sales catalogue, and it should be reiterated by the auctioneer before the bidding begins.

CRITICS AND MAGAZINES

An art magazine publishing a color plate provided by a dealer should credit the dealer: "Color plate provided through the generosity of XX Gallery."

An art magazine publishing an article paid for in whole or part by a dealer should state in the author's squib that the

dealer contributed to the author's pay. Both dealers and magazine editors tell me that there is nothing wrong with a dealer subsidizing the critic's research; therefore, there can be no wrong in publicly recording the source of pay.

An art magazine publishing an article by a critic who is a friend, spouse, or relative of the artist in question should state the critic's relationship in the author's squib. This is a common journalistic practice. When John Galbraith, for instance, praises George McGovern in *Saturday Review*, the squib reads that he is "professor of economics at Harvard, former Ambassador to India, and a long-time friend of Senator McGovern." Only in the art world do we consistently find the relationships between critic and artist disguised.

An artist writing criticism should write under the same name he uses as an artist. An art magazine publishing an article by an artist using a pseudonym or contraction of his name should note in the author's squib that the writer is an artist, and it should give the artist's name.

A critic should never accept paintings as a gift or at a reduced rate from an artist about whom he writes. If, having accepted a painting, he decides at a later date to write about that artist's work, he should either return the picture to the artist or donate it to a museum. He should receive no tax benefit from his donation and no profit from the sale of the picture.

MUSEUMS

A museum curator should not form a personal collection in his field of professional competence. A curator of contemporary art, for example, could collect Peruvian gold, but not contemporary painting and sculpture.

A museum curator who had a personal collection, whether in his field of competence or not, should when selling a work first offer it to his museum at the original purchase price. If the museum does not want it, he is then free to sell it on the open market.

A museum curator should never accept works of art as a gift or at a reduced rate from an artist whose work is exhibited in the museum.

A museum should be given no discount on purchases of works of art by a dealer. Museums will say they will be forced out of the market entirely by this practice. Chances are, however, that they will be able to persuade donors to give them works. The restriction on discounts would serve to stabilize the market. It would help prevent dealers from using the museums to raise the price of their other artists' work, and it might reduce the museums' temptation to snatch up everything quickly before the prices rise—a temptation that contributes to the price rise.

Museums should require a collector bequeathing a valuable collection to provide an endowment amounting to 50 percent of its maintenance care for fifty years. If the collector will not provide for the maintenance, the museum should have the discretion to sell enough works from the collection to maintain the remainder for fifty years at no public expense.

Museums are not tax shelters for the rich, and the rich should not be permitted to put their money into art, raise its monetary value through exhibitions at a museum, and then leave the collection to a public institution at what may be a crippling expense. The public in this transaction pays twice for the privilege of looking at the art: once by "buying" it from the collector in the form of a 100-percent tax deduction, twice by maintaining it for him in perpetuity, often with rigid strictures on its exhibition or future sale.

Items to be sold should be publicly announced, independently appraised, and sold on the open market.

The Art Dealers' Association, the International Association of Art Critics, the Association of American Museums, and the Museum Directors' Association should form professional committees to examine their own practices, establish codes of ethics, and discipline their own members, for if the art world

does not clean its own house, housekeeping will be done by the government at even greater expense and perhaps damage to the system.

Leaders of the art world should be willing now to bring discussion of problems out into the open. The art world operates by whispers. It is time to put ideas in the open, examine them, and try to deal with them.

I am not going here into such complex questions as broadening the representation of boards of trustees, nor federal support of the arts, guaranteed incomes to artists, or copyrights on works of art. These are questions beyond the scope of the present discussion.

I will, however, make one more proposal with regards to museums. This was first suggested to me by James Crimmins, a businessman on the Junior Council of MOMA, and it is so simple that I cannot believe it will not some day be effected: museums must stop competing and instead cooperate in the exchange and exhibition of pictures.

Every large museum has hundreds of works of art in storage which it has no space to show and on which it pays high insurance. Every small museum is crying for works of art, which it has no funds to buy. There should be established, perhaps under the aegis of the Smithsonian Institution, a central organization to keep a registry of works now in storage that would be available to museums on long-term loan.

A museum in the central states could borrow through the Art Registry works from the Metropolitan or the Seattle art museum, which in turn would also borrow works, hang them for five or ten or twenty years, and return them when the home museum requires them.

Insurance and shipping costs would be paid by the Registry through the federal government. The borrowing museum would be responsible for the security of the borrowed work.

One function of an art museum must be to educate in the arts, and this long-term loan program might allow works to be

seen throughout the country instead of hogged in storage on the East Coast. The more art is seen, the more people will be interested in art, and the more art will be produced. Perhaps we would even find that, accustomed to viewing art and producing it, we might treat objects of beauty—do you think it possible?— not as something to be hypocritically worshiped or bartered into profit, but as an ordinary pleasure of life, like sunlight, our natural due.

Appendix A:
From the Transcript of
the Broady Trial

The People of the State of New York
against
John G. Broady, defendant

Court of General Sessions
of the County of New York

Part VI October 1955 Term Continued
Held in Part VII Courtroom

TRIAL
Indictment No.
1322–1/2–55

Trial continued at:
100 Centre Street
November 23, 1955
2:45 P.M.

STENOGRAPHER'S MINUTES

AFTERNOON SESSION

Michael J. Mickell
Reginald C. Mershon
Official Stenographers

Mickell—Take 4–1

(Mr. Melia, Mr. Birns, Mr. Gelb and Mr. Steinberg and the defendant are present.)

THE COURT: Get the jury in.

(The jurors and the alternate jurors enter the courtroom and take their respective seats in the jury box.)

THE CLERK: Jurors in the case on trial, please answer.

(Whereupon, the jurors and the alternate jurors were called and each answered present.)

MR. BIRNS: Mr. Rousuck.

EMANUEL J. ROUSUCK, residing at 110 East 48th Street, New York, N.Y., called as a witness on behalf of the People, having been first duly sworn, testified as follows:

DIRECT EXAMINATION
By Mr. Birns:

Q: Now, Mr. Rousuck, will you speak up loudly, please, so that the last juror can hear you. A: Yes.

Q: What is your business or occupation? A: Art dealer.

Q: And where is your place of business? A: 19 East 64th Street.

Q: And under what name do you do business? Or are you connected with any firm? A: A firm, yes.

Q: What is the name of the firm? A: Wildenstein Galleries.

Q: And what is the nature of that business? A: Buying and selling pictures.

Q: What type of pictures? Any type? A: Any type.

Q: How long have you been in the art business? A: About 20 years. Over 20 years; since about '31.

Q: Always in New York City? A: Always in New York City.

Q: Do you know the defendant? A: Yes.

Q: How long do you know the defendant? A: Oh, about eight or nine years.

Q: In what capacity or under what relationship have you known the defendant? A: Well, I met him first in a social way; and then

from time to time he checked on various people for me, got infor-
mation for me. When I wanted to get the pedigree of a man or
something, he would find out as to what he was and so forth.

Q: Aside from the field of investigation, was there any other relation-
ship at any time between you and the defendant? A: I don't
know what you mean.

Q: Well, did you know what business the defendant was in? A: Well, I
knew he was a lawyer.

Q: Did he ever represent you in any matters? A: No.

Q: Now, do you recall seeing the defendant sometime in the summer of
1954? A: Yes.

Q: Where was it that you saw him? A: Well, he came in my office.

Q: At 19 East 64th Street? A: Yes.

Q: Was anyone else present? A: Well, in my office I was alone.

Q: Did you speak with the defendant at that time? A: Yes.

Q: Did the defendant speak with you? A: Yes.

Q: Will you tell us, please, what the conversation was? A: Well, on the
day that you are talking about he came in and he said, "Where is
your men's room?" and I said, "It is across the hall," and he went
across, and then when he came back—

Q: No. I am sorry to interrupt you. He left your office to go to the
men's room? A: Yes.

Q: Was anything left in your office? A: Yes. He had a brief case with
him and he left it there. And then when he came back, he opened
this brief case and took a film from one side and put it on the
other and played back my conversation while he was out of the
room.

Q: Well, had you had a conversation while he was out of the room? A:
Yes. I talked to maybe one or two people, you know, asked me a
question or two, stuck their head in; I may have answered the
phone once or twice.

Q: So that you had conversations with about two persons while the de-
fendant was out of the room? A: About, yes.

Q: And you have had a telephone conversation? A: I may have had it,
yes.

Q: Now, when the defendant returned to your office, you described
that he did something with respect to the brief case. A: What?

Q: You said that he did something with respect to the— A: Yes, he
took a piece from one place and put it in another, and it played
back the conversations.

Q: Which conversations did you hear? A: Well, all of them. Whatever
had transpired while he was out of the room.

Q: You heard the telephone conversation? A: Well, I heard—yes, I think so, yes. I mean my conversation.

Q: Not the other side? A: No, I don't think so.

Q: Now, did you have any conversation with the defendant at that time? I will withdraw the question. When the defendant went to the men's room, where was the brief case? A: In my office.

Q: Now, what conversations did you have with the defendant after he replayed— A: Well, he said that it was a very good thing to get information from time to time, and if I ever need it, he could use it, and it was perfectly legal.

Q: And what did you say? A: Well, I said if, I'd think about it; if there is any time I thought I needed it, I would be in touch with him.

Q: Was that all to the conversation that day? A: About, yes.

Q: Did there come a time when you again saw the defendant? A: Yes.

Q: How long after the meeting? A: Well, I don't exactly remember, but I saw him two or three times after that.

Q: Well, can you recall the conversation at either one or both of these meetings? A: Well, he would say, "Do you ever need it? Do you ever need it?" And at one point I said to him, I said, "Yes, there's a rival that knows a lot about what is going on in my business affairs—"

MR. GELB: May we have the date of this?

Q: Can you fix the date of this meeting? You said the first meeting took place in the summer of '54. A: Uh-huh.

Q: Can you fix the date of that meeting? A: No, I can't.

Q: Can you tell us, with relation to that first meeting, how long after? A: Well, I think it was in September sometime.

Q: Of '54? A: Yes.

Q: Well, will you tell us that conversation, please? A: What conversation?

Q: When you discussed the rival. A: Oh. And I said, "Do you think you could get me the information as to what has been going on because this man has—"

MR. GELB: I didn't hear that. May I have it read, please, Your Honor? (Court Stenographer read the last question and answer.)

Q: Go ahead, please. A: "—attacking me and appears to know a great deal about my business."

Q: Did you have any other conversation at this time? A: No, I don't think so.

Q: Did you mention the man's name? A: Yes.

Q: You told it to the defendant? A: Yes.

Q: What name did you tell him? A: Rudolph Heinemann at the Ritz Tower, New York City. And he said that, if I wanted, that he could get that done, and that it would cost, I forget, $125 or $150 a week.

Q: Was Rudolph Heinemann the only name that was mentioned at that time? A: I think so, yes.

Q: Aside from the name of the individual, Rudolph Heinemann, did you mention the name of any other business or firm at that time? A: well, I told him a bit about Heinemann. I told him that Heinemann was doing business with several other art firms.

Q: Did you mention the names of any of these other art firms? A: I may have.

Q: And what names did you mention? A: Oh, I don't recall at the moment. I mentioned three or four art firms.

Q: Have you no recollection of any of the art firms whose names— A: Well, I mentioned Knoedler for one.

Q: The Knoedler Art Galleries? A: Yes.

Q: You mentioned that to the defendant? A: I think so.

Q: During this same conversation? A: I think so, yes.

Q: What else was said, if anything? A: Nothing else, I think.

Q: What did the defendant say at that time? A: He said that he thought he could do it for me.

Q: Now, what is the next thing that happened after this conversation with the defendant? A: Well, then he said that he would send these things to me.

Q: What things? A: These discs, these plastic things; and when I got through with them, I would return them to him; and that is what I did.

Q: Well, did he say how he would send them to you? A: With a messenger.

Q: Did he tell you what messenger? A: I don't recall, but it was with a messenger.

Q: At the time you got the discs? A: Once a week.

Q: Now, did there come a time when you did receive discs from a messenger? A: Yes.

Q: What is his name? A: Louis Arion.

Q: How long did you know Louis Arion? A: Oh, I have known Louis Arion off and on for a long time.

Q: Restricting ourselves to the first delivery by Arion, at that time what, if anything, did you receive? A: I received a box with a disc in it; one of these things that you play on, a recording, these machines.

Q: Recording machines? A: Recording machines, yes, that you play back; that you can talk into and it plays back.

Q: Now, was the disc just handed to you or was it in a package? A: In a package, in a paper package.

Q: Can you describe the package? A: A brown paper package with cord on it, cord or a rubber band; I don't know.

Q: Was it stapled or sealed in any way? A: Yes, there were staples.

Q: And you opened this package? A: Yes.

Q: The delivery was at your office? A: Yes.

Q: What did you do with this first disc when you received it? A: Well, I went and I played it on this machine.

Q: What kind of machine did you play it on? A: A recording machine.

Q: And where was the recording machine? A: In my home.

Q: In your apartment? A: Yes.

Q: Did you have a recording machine at the time you first spoke to the defendant? A: No, I went out and I got one.

Q: Do you recall what kind you purchased? A: No.

Q: Now, you played this disc, is that correct? A: Yes.

Q: What did you hear? A: Well, I heard conversations, telephone, telephone conversations; I heard bells ringing, and I heard conversations.

Q: Did you recognize any of the voices in these conversations? A: Well, I assumed it was this Heinemann.

Q: Well, you know Mr. Heinemann, do you not? A: Yes, yes.

Q: How long have you known him? A: Ten or twelve years.

Q: Well, now, when you heard these reels, did you recognize any voice? A: I would think it was his voice, yes.

Q: Now, restricting ourselves again to the first reel, after you heard the conversation, after you played it upon your recorder, what is the next thing, if anything, that you did? A: What is that?

Q: I will rephrase the question. A: Yes.

Q: Did you keep the reel? A: No. I, when I got through with them, I returned them and, as the messenger would bring me additional ones, I would give these back to him.

Q: What would you do about payment, if anything? A: As I said, I gave the messenger once a week the amount.

Q: How much did you give the messenger on this initial occasion? A: One hundred and twenty-five or one hundred and fifty; I don't recall exactly.

Q: Now, did you receive reels over a particular period? A: Yes.

Q: Over what period did you receive these reels? A: Well, over the pe-

riod, the period, I think, I received them about four or five months.

Q: Commencing when? A: Well, about the latter part of September.

Q: And ending when? A: Ending when this raid occurred.

Q: Sometime in the month of February? A: Sometime in the month of February, yes.

Q: Nineteen fifty-five? A: Yes.

Q: Now, how much money did you pay to the messenger over the period of months that you mentioned? A: I would think about $2,000.

Q: Well you paid about 125— A: Fifty, it was 125 or 150.

Q: A week? A: I think so, yes.

Q: For the months from September? A: Yes.

Q: October? A: Yes. Then I was away a week or two at a time during that time, so it wasn't continual.

Q: Yes, sir. During the period of time that you were receiving these packages from Arion, did you at any time speak with the defendant? A: On the telephone occasionally.

Q: Can you recall any particular conversation? A: Well, I told him once that I wasn't—I wasn't getting very much information out of them.

Q: What did he say? A: Once or twice.

Q: What did he say? A: Well, he said, "That's the chance you take," or something, words to that effect. I don't remember exactly.

Q: Did you ever have any other conversation? Can you fix the time of that conversation? A: No.

Q: Did you ever have any other conversation with the defendant during the course of these deliveries? A: No, I can't remember any others.

Q: Did you ever have any conversations with the defendant concerning money? A: Oh, once or twice, when I would miss a payment, he would call and say, "How about the payment."

Q: And what would you say to him? A: I would say, "Well, I will give it to him the next time he comes."

Q: Now, during the months that we have mentioned, did you listen to any other reels? A: What do you mean by "any other reels"?

Q: Well, aside from this first one that we were talking about. A: Oh, yes; yes, I listened to—

Q: Do you remember any of the conversations that you heard by playing these reels back during that period of time? A: Well, I remember that he was congratulated on selling a painting.

Q: He was what? A: Congratulated on selling a painting.

Q: Who was? A: Heinemann.

Q: Do you remember what painting it was that was sold? A: Yes, a painting sold to a museum.

Q: What was the name of the museum? A: Frick Museum.

Q: Do you remember the name of the painting? A: A Van Eyck.

Q: Is Van Eyck the artist's name? A: Yes.

Q: Do you remember the subject of the painting? A: No.

Q: Now, these conversations that you heard, were they in English? A: Well, no. Most of the conversations were in French and German, which I don't understand.

Q: Any other languages? French, German and English? A: Other languages, I guess.

Q: Did you hear the voice of any other person aside from that of Heinemann? A: No one that I knew, no, or recognized.

Q: Do you know the people at the Knoedler Art Gallery? A: Yes.

Q: Do you recall now whether you heard any of the voices of those persons on these reels? A: I wouldn't recognize their voices, but I know that he called Knoedler's time and again.

Q: You mean Dr. Heinemann did? A: Yes.

Q: Do you recall with whom he spoke? A: To the various men in there. He spoke to the librarian; he spoke to the other people there.

Q: Did you during this period of time call Heinemann on the telephone? A: Yes, I did, once.

Q: Did you hear that telephone call? A: Yes, I did, yes.

Q: In other words, did you hear it when you played back this reel? A: Yes, once.

Q: Do you know a man named Gilbert Kahn? A: Yes.

Q: Do you recall any conversation relating to Gilbert Kahn? A: Well I remember Heinemann asked him to have dinner with him one night.

Q: I didn't get that, sir. A: Asked him to take dinner with him.

Q: Do you know a theater ticket agency called the Acme Theatre Agency? A: Yes.

Q: Did you hear any conversations concerning that agency? A: Yes, he was talking to them about bad tickets or bad theatre tickets.

Q: Who was? A: Heinemann.

Q: Now, each time you received a reel, you played it? A: Yes.

Q: And then you returned it? A: Yes.

Q: And you returned it to the same messenger? A: Yes.

Q: Who delivered it to you, this man, Louis Arion? A: Yes.

MR. BIRNS: Just one moment, please.

Q: Now, would you please describe the reels that you received? A: Well, there was a disc and then there is this plastic around it. That is about all I can tell you.

Q: Well, there was a disc? A: Yes.

Q: And what did the disc contain? A: A plastic film.

Q: Did it resemble what you had first seen in your office? A: No.

Q: That is, did it resemble the piece that you said the defendant— A: Well, it was the same material.

Q: I am talking about the appearance of the disc. Was it the same as— A: It was larger, much larger.

Q: Were there any markings on these discs? A: None that I remember, no, I don't think so.

Q: The payments that you made, were they by cash or by check? A: Cash.

Q: Did you ever speak with the defendant about ending these services? A: Well, I told you I said that I didn't think it was worth it.

Q: What did the defendant say? A: Well, I don't remember exactly; but, at any rate, we continued them.

Q: At the time you first spoke with the defendant, you mentioned the name of Heinemann and you told him that he resided at the Ritz Towers. A: Yes.

Q: Did you discuss his telephone number at that time? A: I don't remember, no.

Q: Did you give him the telephone number at that time? A: I don't recall, no. I mean, it would be easy; it is in the telephone book; it isn't—

Q: You mentioned the word "gum plastic." Is that on the disc, on the face of the disc? A: No, no, no, no.

Q: Are you talking about the tape itself? A: The tape itself, yes.

MR. BIRNS: You may inquire.

MR. GELB: Your Honor, I asked Mr. Birns before we went to lunch if I could read these minutes, and he said not until the man takes the stand, and just a few minutes ago I got them. I must ask Your Honor's indulgence for a few minutes. I hate to ask for— What are you going to do?

THE COURT: Whatever you suggest.

MR. GELB: Will you declare a short recess?

THE COURT: All right.

Members of the jury, you are admonished and it is your duty not to talk among yourselves on any subject connected with the trial; not to permit anyone to talk to you about the case; not to remain in the

presence of anyone discussing any part of the case. You are fur-
ther admonished not to form or express any opinion as to the
guilt or innocence of the defendant until the case is submitted to
you.

Judge Gelb, how long will you take?

MR. GELB: Oh, ten minutes.

THE COURT: All right. We will take a ten-minute recess.

(To Witness) Mr. Rousuck, you are instructed not to talk to anybody
about this matter while you are a witness.

THE WITNESS: Will I sit here?

THE COURT: You may step off for just a moment.

THE WITNESS: All right.

(At this point a short recess was taken.)

AFTER RECESS

TRIAL RESUMED

*(Mr. Melia, Mr. Birns, Mr. Gelb, Mr. Steinberg, and the defend-
ant are present.)*

*(The jurors and the alternate jurors enter the courtroom and take
their respective seats in the jury box.)*

THE CLERK: The jurors in the case on trial will please answer.

*(Whereupon, the jurors and the alternate jurors were called and
each answered present.)*

EMANUEL J. ROUSUCK, continued:

CROSS EXAMINATION BY MR. GELB:

Q: Mr. Rousuck, you said you knew Mr. Broady for ten years? A: About
that.

Q: And you said first socially and business-wise? A: Yes.

Q: Is that right? A: Yes.

Q: And during the course of these years, from time to time you used
Mr. Broady's services? A: Yes.

Q: To check on certain people for you? A: Yes.

Q: Obtain information? A: Yes.

Q: As to the background of people? A: Yes.

Q: When you used the word "pedigree"— A: Well, I meant back-
ground.

Q: Background? A: Yes.

Q: And you paid him for his services? A: Yes.

Q: And then there was an occasion when he checked something that in-

volved your brother—when I say involved— A: Yes, for my brother.

Q: In which he was interested; is that right? A: Yes. Well, I did that on my own, yes.

Q: You were interested? A: Yes.

Q: Now, there is testimony here that Heinemann's wire was tapped beginning about February 1954, now did you have any interest in Heinemann's telephone conversations in February, March and April and May? A: No, I don't think so.

Q: I beg your pardon? A: It started in the fall.

Q: It started, you said, late September? A: Yes.

Q: That is, the conversations? A: Yes.

Q: You don't know anything about whether the telephone was tapped? A: I don't know yet whether it was tapped.

Q: That's right. I am talking about, there is testimony in this case that there was a tap put on Heinemann's wire in February, 1955.

MR. MELIA: '54.

MR. GELB: '54, excuse me.

Q: You received no conversations? A: No.

Q: Until late September? A: Yes.

Q: I beg your pardon? A: Yes.

Q: All right. Now, you received no conversations from any Knoedler telephone? A: No.

Q: Only from Heinemann? A: Yes.

Q: There has been testimony here that a tap was put on those, on a Knoedler telephone, three Knoedler lines, beginning January, or February 1955, and running—

MR. MELIA: '54.

MR. GELB: '54, I mean.

Q: —running to the fall of '54? A: Yes.

Q: You did not— Did you ever receive any such conversations? A: I don't think so. If I did I didn't know it, I don't think so.

THE COURT: Didn't you tell us a moment ago, or a short time ago, some of the tapes were of conversations with people connected with Knoedler?

THE WITNESS: Yes.

Q: From Heinemann to Knoedler, you said? A: Yes, they are very closely allied.

Q: Yes, but all you said was conversations on Heinemann? A: Yes.

Q: On the Heinemann telephone to Knoedler? A: Yes.

Q: But you say you never got any telephone conversations from Knoedler's telephone? A: No.

Q: All right, and that period you are telling us about is from late September, 1954, until the following year? A: Yes.

Q: Is that right? A: About six months.

Q: Now, when Broady told you that he could obtain conversations— Did he say he could obtain conversations from people? A: Yes.

Q: And you say he told you: "It is without tapping?" A: He said—yes, he said without tapping.

Q: Without tapping? A: Without tapping, he said no wire tap, he said, "It is perfectly legal."

Q: Did he explain to you what he meant? A: No, if he did, I wouldn't know.

Q: Did he say anything about an induction coil? A: No.

Q: Where you wouldn't have to connect with any wire? A: I think he did, I think he said you don't have to connect any wires.

MR. GELB: That is all, Mr. Rousuck.

THE COURT: Just one moment. Juror No. 2 hands up this question: "Were the phone calls by you to Broady in regards to the time from September of 1954 until February, 1955, made to Broady's office or home?"

THE WITNESS: I never called Broady—I mean—no, I never called Broady at his home. It must have been his office if I ever did.

THE COURT: All right. I will hand this question to the Clerk for his records.

All right, that is all.

(Witness excused.)

MR. BIRNS: Louis Arion.

LOUIS S. ARION, 1025 Girard Avenue, New York City, Bronx, called as a witness on behalf of the People, having been first duly sworn, testified as follows:

DIRECT EXAMINATION BY MR. BIRNS:

Q: Mr. Arion, would you be good enough to speak up so the last juror can hear you? A: Why, sure.

Q: What is your business or occupation? A: I was an operator for the Commercial Crime, of which the principal is Charles Lester.

THE COURT: What is that? Read the answer.

(The stenographer read the last answer of the witness to the jury.)

Q: Is that the Commercial Crime Research Bureau? A: Research Bureau.

Q: And where is it located? A: It is located at 19 Rector Street.

Q: On what floor? A: New York City.

Q: On what floor? A: 28th floor.

Q: Do you know the defendant? A: Mr. Broady?

Q: Yes. A: Yes, sir.

Q: Do you know his business or occupation? A: He is a lawyer.

Q: Do you know where his offices are at? A: 19 Rector Street.

Q: On what floor? A: 28th floor.

Q: Room number? A: 2805, I believe.

Q: How about the Commercial Crime Research Bureau; what is the room number of that? A: Well, it is 2805.

Q: Is there a switchboard up there in that office? A: There is a switchboard.

Q: Does the switchboard handle the calls for both the defendant and Commercial Crime Research Bureau? A: Yes.

Q: How long have you known the defendant? A: Oh, about ten years, all told.

Q: How long have you known Charles Lester? A: The same, about the same time.

Q: Now, you, yourself, have you ever held a license as a private detective? A: I have.

Q: During what years, sir? A: 1954—or rather, 1949 to about 1951, to the best of my recollection.

Q: And since '51 you have been working for the Commercial Crime Research Bureau? A: Yes, sir.

Q: During that period of time have you ever done any work of any sort for the defendant? A: Yes, I did.

Q: Have you? A: I did.

Q: Do you know Warren Shannon? A: I do, sir.

Q: When for the first time did you meet him? A: Oh, to the best of my memory sometime in the spring of this year, of last year, I should say.

Q: 1954? A: 1954, yes, sir.

Q: Where did you first meet him? A: I first met him in the office of John G. Broady.

Q: Did you at or about that time speak to the defendant about Shannon; did you have any conversation with the defendant about Shannon? A: Mr. Broady told me at the time that if he ever wanted an errand run, or so, I should take care of it because he is a friend of the office and that at times he gets complaints from some of his clients that their wires are being tapped and Shannon helps him to find out—whatever process that is.

Q: Shannon helps him find out? A: If they were not, in other words—he helps him try to find out if they have been tapped, or not.

Q: Do you know where Warren Shannon lived in 1954? A: 1954.

Q: Yes. A: I believe, if I am correct, 360 East 55th Street.

Q: Were you ever at that address? A: Yes, sir.

Q: Were you ever in Shannon's apartment? A: I was, sir.

Q: Do you recall the first visit to Shannon's apartment? A: No, I don't, I couldn't remember, I don't remember the exact date.

Q: Well, without asking you for the exact date, do you recall the circumstances surrounding your first visit to Shannon's apartment? A: Yes, sir, sometime there in the spring, or so, or shortly after that, I delivered a bag for him. It was given to me by Mr. Broady.

Q: What kind of a bag? A: It was at that time I believe it was a—well, like an airplane bag, from Mr. Broady.

Q: Where? A: 19 Rector.

Q: In his office? A: Yes, sir.

Q: What did Broady tell you at that time? A: Just told me to deliver it to him.

Q: To where? A: To 360 East 55th Street.

Q: Did he give you the name of any person? A: Yes, Shannon.

Q: And did you deliver that bag to Shannon? A: Yes, sir.

Q: Do you know, or did you know at that time, what was in that bag, if anything? A: No, sir.

Q: Now, from the time of the first visit to Shannon's apartment, on how many other occasions did you visit Shannon's apartment? A: To the best of my memory it might have been a dozen times.

Q: And during what months did you visit Shannon's apartment? A: During the period from the spring until about the early part of February, or so, to the best of my memory.

Q: February, 1955? A: '55, yes, sir, that is right.

Q: Now, on the occasion of any one of these visits, did you ever receive anything from Shannon? A: No, sir.

Q: Did Shannon ever give you anything? A: Will you make that a little clearer for me—he gave me a package to take back, if that is what you mean, also a bag—I mean, a bag.

Q: Now, can you describe the texture of this bag? A: Well, at times I would have a canvas bag like an airplane bag, at other times I would have like a small diplomat bag.

MR. GELB: What kind?

MR. BIRNS: Small diplomat bag.

THE WITNESS: What they call diplomat.

Q: Would you bring the bag with you from the defendant up to Shan-

non's apartment? A: Either from there, or back from up there.

Q: Or back from Shannon? A: That's right.

Q: To where? A: To 19 Rector Street.

Q: Did you at any time know what was in the bag you were carrying? A: No, sir.

Q: Did you at any time carry any paper bags? A: No, anything I carried would be in another bag, in a bag.

Q: Did you at any time carry any stapled packages? A: Yes, stapled—

Q: Please describe them. A: The package would be possibly like an envelope.

Q: Can you tell, can you give us the size of the envelope? A: To my best knowledge of sizes, it would be about possibly ten or twelve by fourteen, something like that.

Q: And could you describe the outside of this envelope, how it was fastened, how it was made up? A: It was, sometimes it might have Scotch tape on it, and sometimes the pins—what do you call them?

Q: Staples? A: The staples.

Q: Was there any occasion where anything was marked on any of these envelopes? A: Yes, sometimes the envelopes would be marked "Personal, Confidential."

Q: And what would you do with these envelopes on any occasions when you received them from Shannon? A: Bring them back to Mr. Broady.

Q: Now what was—was there any occasion during the year 1954—

MR. BIRNS: I will withdraw that question.

Q: Do you know a man named Emanuel J. Rousuck? A: Yes, sir.

Q: How long do you know him? A: I have known Rousuck for possibly twenty years.

Q: Did you see him on any occasion during the year 1954? A: Yes, sir.

Q: Do you recall when it was that you first began to see him in '54? A: To the best of my memory it was around the fall of '54, up to the latter part or the early part of '55.

Q: Restricting ourselves now to the first meeting with Rousuck in 1954, where was it you saw him? A: The first time I saw him was when I brought something up to his office at the Wildenstein Gallery.

Q: And where was that? A: That was, if I remember correctly the number, I think it was 19 East 64th Street.

Q: What were the circumstances surrounding your first visit to Mr. Rousuck at his office? A: I just announced that I had something for him. That is about as far as I can remember.

Q: Did you have anything for him? A: Yes, I had the bag with what-
ever contents was in it.

Q: Can you describe the bag that you first brought to Mr. Rousuck,
what kind of a bag was it? A: Well, that is either a brief case—
sometimes we would use a brief case, sometimes a small diplo-
mat bag.

Q: What did you give Mr. Rousuck? A: What did I give him?

Q: Yes. A: A package, like an envelope.

Q: Can you describe the envelope you first gave Mr. Rousuck? A: Well,
it was about that size, as I said before, about to my best knowl-
edge, about twelve by fourteen, or ten by fourteen. I wouldn't
know exactly.

Q: Was it fastened? A: Fastened, either that or cellophane, I mean—

Q: Was anything marked on it—you mean Scotch tape? A: Yes.

Q: Was anything marked on it? A: "Personal, Confidential."

Q: Whom did you receive this package from to bring to Rousuck? A:
Mr. Broady.

Q: What did Mr. Broady tell you? A: Just told me to deliver it. I was
just making deliveries.

Q: Did he tell you anything else? A: Not that I can remember.

Q: Over what period of time—excuse me—did you continue to deliver
packages of this type to Broady? A: Yes, I did.

Q: I beg your pardon—for Broady? A: Yes.

Q: Did you continue to deliver packages of this kind to Rousuck? A:
Yes, sir.

Q: Over what period of time? A: Sometimes, to the best of my memory,
in the fall of the year, until about the end of January or so.

Q: Did you on the occasion of any of these visits during the fall of '54
receive anything from Rousuck? A: Yes, sir.

Q: What? A: Some cash.

Q: How much? A: Oh, sometimes a hundred, and sometimes he would
postpone it and tell me to get it at some later date.

Q: At the time that you received cash from Rousuck, what did you do
with it? A: I gave it to Mr. Broady.

Q: Where? A: At his office.

Q: At the time you received cash from Mr. Rousuck did you ever re-
ceive anything else from him. A: Anything else?

Q: Beside cash? A: Sometimes, on occasions I would get some grip to
take back for him to Mr. Broady.

Q: What? A: Take a grip back, one of those airplane bags, or the diplo-
mat bag.

Q: Did you ever receive any packages to return to Broady? A: A package?

Q: Yes, the kind you describe? A: Well, to the best of my memory, I don't remember it.

Q: Well, you would bring— A: It would be generally—

Q: You would bring the diplomat bag with you, wouldn't you? A: But he would sometimes give me his bag, too, to bring back, his own bag.

Q: On the occasions when he would not give you his bag to bring back, did you bring anything back? A: He sometimes gave me a package that was tied up.

Q: What kind of a package? A: Small package.

Q: What would you do with it? A: Bring it back to Mr. Broady.

Q: Where? A: 19 Rector Street.

Q: Did you receive any salary from Shannon? A: Did I receive any salary from what?

Q: From Shannon? A: No, sir.

Q: Did you receive any salary, at all, during the year of 1954? A: 1954?

Q: Yes. A: Yes, sir.

Q: Who paid your salary? A: Well, since—sometimes Mr. Broady, and sometimes Lester. If Mr. Broady was out, Lester would pay me, or if Mr. Lester would be out, Mr. Broady would pay me.

Q: When did you stop, or when did you make your last visit to Mr. Rousuck's office? A: To the best of my memory, it would be around the end of January.

Q: When did you make your last visit to Shannon's apartment? A: The early part of February, to the best of my memory.

Q: Now you said you made your last visit to Shannon's apartment sometime in February? A: Yes, sir.

Q: I beg your pardon? A: The early part of February.

Q: Early part of February? A: Yes.

Q: Did there come a time when you learned that there had been a raid on Shannon's apartment? A: Why, yes, I heard of it.

Q: Who did you learn it from? A: From the papers, when I saw the papers.

Q: Prior to that time did you learn it from anyone? A: Not that I can remember.

Q: Do you recall being in—

MR. BIRNS: Would Your Honor bear with me a minute, please?

Q: Do you remember being in the Grand Jury on April 1st, 1955? A: I don't remember the date, but I know I was before the Grand Jury.

Q: The fact of the matter is that you were in the Grand Jury on two different occasions? A: On two different occasions, that's right.

Q: Do you recall being questioned by me in the Grand Jury? A: Well, as well as my memory will go, I remember it, you questioning me.

Q: Do you remember that I asked you this series of questions and that you made this series of answers—I am reading from page 510.

"Q: Now do recall learning about—"

MR. GELB: I wouldn't have it.

MR. BIRNS: No, I appreciate that.

THE COURT: All right.

Q: "Q: Now, do you recall learning that the apartment of Shannon, at 360 East 55th Street, had been raided sometime in February, 1955?" and you answered, "Yes, I remember."

"Q: Whom did you first learn it from? A: I was going out to the hall, the elevators in front of the office.

"Q: Whom did you first learn it from? A: Broady.

"Q: What did he say to you? A: He said, 'Did you hear Shannon's apartment was raided?'

"Q: Was this before it appeared in the papers? A: It appeared to me—I think it was before.

"Q: You think it was before? A: Before, before the papers." A: Well, I probably said that, but then I thought and I think I spoke to you about the fact that I might have made a mistake on that, that I thought it might have been after.

MR. BIRNS: I have no further questions.

MR. GELB: I was just handed this at this time. I will need ten minutes again to read this.

THE COURT: All right.

MR. GELB: Would you mind?

THE COURT: Not at all. Members of the Jury, you are admonished and it is your duty not to talk about this case among yourselves, or any subject connected with the trial, and not to permit anyone to talk to you about the case, not to remain in the presence of anyone discussing any part of the case.

You are further admonished not to form or express any opinion as to the guilt or innocence of the defendant until the case is submitted to you. We will take a ten-minute recess.

(Whereupon there was a short recess.)

AFTER RECESS

TRIAL RESUMED

(Mr. Melia, Mr. Birns, Mr. Gelb, Mr. Steinberg, and the defendant are present.)

(The jurors and the alternate jurors enter the courtroom and take their respective seats in the jury box.)

THE CLERK: The jurors in the case on trial please answer.

(Whereupon, the jurors and the alternate jurors were called and each answered present.)

THE COURT: Proceed.

LOUIS S. ARION, continued:

MR. GELB: No questions, Your Honor.

THE COURT: All right, you are excused.

(Witness excused.)

MR. BIRNS: Dr. Heinemann.

RUDOLPH JACOB HEINEMANN, 465 Park Avenue, New York City, called as a witness on behalf of the People, having been first duly sworn, testified as follows:

DIRECT EXAMINATION BY MR. BIRNS:

Q: Dr. Heinemann, would you speak up so that everybody in the courtroom can hear you, please? A: I will.

Q: Do you live in the City, Doctor? A: 465 Park Avenue.

Q: Park Avenue? A: Park Avenue.

Q: Is that the Ritz Towers? A: Ritz Tower Hotel.

Q: How long have you lived there? A: About 12 or 14 years.

Q: Incidentally, what is your business or occupation? A: I am an art historian and an art dealer.

Q: Just what does that mean, sir? A: I deal in paintings, mostly buying. I am a student of the history of art. I have a doctor's degree.

Q: Do you have your own office in the city? A: Yes, sir.

Q: Where is your office located? A: In my own apartment there.

Q: Are you connected with any art gallery in the city? A: No.

Q: Is there any art gallery with whom you deal? A: Yes, there are.

Q: Is the Knoedler Art Gallery one of those with whom you deal? A: Yes, it is.

Q: Who is the President of the Knoedler Art Gallery? A: Mr. Charles R. Henschel.

Q: Where is the Knoedler Art Gallery located? A: 14 East 57th Street.

Q: Now, do you have a telephone in your apartment? A: Yes, sir.

Q: What is the number? A: Plaza 8-0864.

Q: How long has that been your number? A: Why, I think that is the last ten or twelve years.

Q: During the year 1954 or at any other time, did you ever give any person authority, permission, or consent to intercept your telephone conversations? A: I did not.

Q: Now, did you, or do you use your telephone for the conduct of your business? A: Quite frequently.

Q: In using that telephone, do you speak English, or do you speak any other language? A: Mostly English. Sometimes I speak Italian, sometimes German, and sometimes I speak French.

Q: Now, during the fall of 1954, did you have occasion to call Knoedler Art Gallery on the telephone? A: Very frequently.

Q: And with whom would you speak? A: Mostly with Mr. Henschel, who is the president of the firm, sometimes with the library, sometimes with other men, like the Vice President of the firm.

Q: During the fall, during the year 1954, did you have occasion to sell a Van Eyck painting? A: Yes, to the Frick Museum in New York.

Q: And when was that? A: In the spring of '54.

Q: And what did you sell it for? A: How much—

Q: Or how much was it sold for? A: It was sold for seven hundred and fifty thousand dollars.

Q: Now, when was there first any publicity about this sale? A: I think the publicity was the end of August, or September, it was during my absence from the United States.

Q: And when were you absent from the United States? A: I left the United States about the 20th of June and came back about the 12th, or the 14th of September.

Q: And it was after you, after your return, that there was some publicity about the sale? A: About the same time—I think the Frick's gave a release—

Q: Did persons call you on the telephone with respect to this sale? A: You see, it was a rather important transaction.

Q: No, did they? A: They did.

Q: Now, during the—incidentally, do you know a Gilbert Kahn? A: Yes.

Q: Was he ever a guest at your home for dinner? A: Very frequently.

Q: During the fall of 1954 did you ever have an occasion to discuss Mr. Kahn's presence at dinner over the telephone? A: Yes, quite frequently.

Q: Did you know the Acme Theatre Ticket Agency? A: I do.

Q: And during the fall of 1954 did you have occasion to call the Acme Theatre Ticket Agency? A: I did.

Q: Using your home telephone? A: Yes, I did.

MR. BIRNS: I have no further questions.

CROSS EXAMINATION BY MR. GELB:

Q: Just a couple of questions, do you say that the publicity concerning the sale of that painting to the Frick Museum started, or took place, after September 12th? A: No, I didn't say that, I said—

Q: You said it was after you returned from Europe. A: I heard about the publicity, it took place in August or September, I said.

Q: Well, it was a secret up to then? A: Yes.

Q: And after you came back didn't people call you up to congratulate you? A: So far as I remember, yes.

Q: So it was after September 12th that people called you up to congratulate you? A: Yes.

Q: On this coup? A: It wasn't a coup.

Q: It wasn't a coup? A: No.

Q: Well, they were congratulating you? A: It was a very important picture coming to the Frick collection.

Q: All right. I used the wrong word, I realize that. A: Yes.

Q: Now, you dealt with other art galleries? A: I did.

Q: You mentioned Knoedler, what other art galleries? A: I dealt with Rosenberg and Steibel.

Q: Who else? A: With a Mr. Mont.

Q: Yes, what others? A: To my knowledge, to my remembrance, there is nobody else I can remember now.

Q: Did you speak to these people on the telephone? A: Yes, less frequently than with Knoedler's.

Q: Pardon? A: Less frequently than with Knoedler's.

MR. GELB: All right, that is all.

MR. BIRNS: May I have one question?

THE COURT: Yes.

REDIRECT EXAMINATION BY MR. BIRNS:

Q: This picture you sold to Frick's Museum, what picture was it that was sold to the Frick Museum? A: A picture by Van Eyck.

Q: How do you spell that? A: V-a-n E-y-c-k.

Q: The name of the picture? A: The Rothschild "Triptych."

MR. BIRNS: No further questions.

 (Witness excused.)

CHARLES R. HENSCHEL, 1 East 66th Street, New York City, called as a witness on behalf of the People, being first duly sworn, testified as follows:

DIRECT EXAMINATION BY MR. BIRNS:

Q: Mr. Henschel, you can hear me, if you— A: If you will talk a little louder I will appreciate it.

Q: I will come closer. What is your business or occupation? A: I am President of the—President of Knoedler & Company, Art Dealers.

Q: And where is Knoedler located? A: 14 East 57th Street.

Q: And how long have you been connected with the Knoedler Art Gallery? A: 51 years.

Q: Now, is that 14 East 57th Street, sir? A: 14 East 57th Street.

Q: What is the phone number? A: Plaza 3-9742, and then there is five other numbers.

Q: Would they be four, five, six, seven, eight—up to Plaza 3-9749? A: Yes.

Q: Now, do you have a switchboard, or is there a switchboard? A: A switchboard.

Q: In your place of business? A: Yes.

Q: Did you have a switchboard in your place of business during the year 1954? A: Yes.

Q: Did you at that time, or at any time, ever authorize any person to intercept the telephone conversations of the Knoedler Art Gallery? A: I did not.

MR. BIRNS: I have no further questions.

MR. GELB: No questions.

THE COURT: All right, that is all.

 (Witness excused.)

THE COURT: Members of the Jury: You are admonished and it is your duty not to converse among yourselves on any subject connected with the trial, not to permit anyone to talk to you about the case, not to remain in the presence of anyone discussing any part of the case. If a juror, or anyone else, talks to you about the case, it is your duty to report it to me.

 You are further admonished not to form or express any opinion as to the guilt or innocence of the defendant until the case is

submitted to you. Also bear in mind the admonition that I have given you frequently during the trial not to read any item concerning this case which may appear in the newspapers, or any item in the newspapers on the subject of wire tapping, and not to listen to any radio, or television program that makes any mention of the case, or in any way refers to the subject of wire tapping, because those admonitions are important, because you must decide the case not on what appears in the press, or radio, or television, but what you have heard from the witness stand and then applying the law as I will declare it at the proper time.

We will now take an adjournment until Monday morning at 10:30.

(Whereupon the further trial of the case was adjourned until Monday morning, November 28th 1955, at 10:30 o'clock, A.M.)

Appendix B:
The Ashton Affair

October 3rd, 1960
I. MEMORANDUM FROM DORE ASHTON
TO JOHN CANADAY

This is in reply to your memorandum to me dated Sept. 29th,
1960.

You have maliciously impugned my professional integrity. I demand an immediate retraction of your charges.

For five years the New York Times has carried reviews and articles by me, under my byline. These columns were regarded as columns

of opinion, not only by editors of the Times but by the general public.

Your strident attack on me appears to run along two principal lines:

1. That I'm not qualified to be an art critic because I am acquainted with a large number of people in the art field, among them artists.

2. That there is a "group" of artists advanced by me for improper motives.

As an art critic I have the right to express my opinions concerning the value and quality of the works of art I view. In fact, that is precisely my duty. Your attack sounds like a rude clamor to drown out a critical voice that differs in tone from your own. Isn't the New York Times large enough to give coverage to divergent viewpoints?

When you state that I "tend to rate" artists according to an "arbitrary" standard, you realize, I hope, that the burden of proof lies with you.

Your argument that art critics should disassociate themselves from artists runs counter to history and common sense.

Surely you are aware that the history of art has been written largely by people acquainted with artists. In the 3rd century B.C. Xenocrates discussed the works of his contemporaries and close friends—Xeuxis and Parrhasios among others. It is largely through Xenocrates that we have been able to "place" the works by these artists.

You as an art critic and historian could never have been able to write a book if there hadn't been hundreds of critics before you who knew the artists and recorded both facts of their lives and interpretations of their work. Moreover, you and everyone else writing art criticism are obliged to depend on written documents by critics who vigorously voiced their opinion of the value of certain artists' work.

For example, in your own book, *Mainstreams of Modern Art*, p. 172, you refer to Emile Zola, journalist among other things, who wrote an article in defense of Manet. You quote Zola:

A place in the Louvre is reserved for Manet. It is impossible, impossible I say, that he will not have his day of triumph, that he will not obliterate the timid mediocrities surrounding him.

You wrote:

Furious objections poured into the offices of l'Evenement (not from everybody—some readers thought Zola was joking), and

Zola who had asked special permission to write a series of articles lost his post as art critic of the journal.

My point, if I need stress it, is that Zola, a good friend of Manet, wrote enthusiastically about his work and was dismissed. This, under your logic, would be "prejudicial" and "arbitrary" art criticism. Yet, you have had recourse to it, and without Zola's work, and that of other sympathetic and passionately convinced critics, your own work would not exist.

The same is true of your description, p. 203, of the temperament and personality of Degas. How, if not through having read accounts by Degas' friends and acquaintances, could you possibly have these "facts"?

Your suggestion that critics who associate with artists are "suspect" is, of course, belied by the fact that eminent critics currently and formerly employed by the New York Times and other major newspapers—in music, drama and art—were and are similarly associated. Are you asking that critics live in cultural isolation?

You direct me to tell you "which artists are friends or opponents of your *group*." This is a very grave charge. Its innuendoes are obvious. Art is not competition. There can be no opponents.

I demand that you document your charge that I sponsor a certain group. In my ten years' work as an art critic no special group has been singled out for praise by me. As you are well aware, those artists whose work I have applauded have been acclaimed by many other critics and professional institutions.

I categorically deny your following defamations:

1. That I have used the columns of the New York Times for the professional or financial advantage of my husband or friends.

2. That I have advised galleries to exhibit or exclude the works of certain artists.

3. That I have abused my position as a critic.

4. That I have written a "virtual commercial."

These charges are wholly untrue and I demand immediate retraction. I have never used my position on the Times to advance my husband. I was married to Adja Yunkers two years before I was employed by the Times. This was well known to the Times and to the art community. At that time Adja Yunkers was very well known. The fact

that the Baltimore Museum, the Museum of Modern Art, the Whitney Museum, the Philadelphia Museum, the Guggenheim Museum, and scores of others have bought major works by Adja Yunkers has never had the slightest bearing on my work. Indeed, on numerous occasions I have sharply criticized these institutions.

I have never used the Times to advance my friends. As the files of the Times will show, I have consistently called the shots as I saw them. What you really object to is that you would not have called them the same way.

Your comments on the Baltimore Museum story are, in my opinion, a slur on the Baltimore Museum as well as on me. The Sunday editors of the New York Times long before your advent considered the story a good one. The Baltimore Museum is one of the most important in the country and its collections have been praised by many responsible critics. On your claim that my article was a paean to certain "contemporary artists" which I was "interested in": the files of the Times and my other writings will demonstrate that many of the artists mentioned have been adversely criticized by me.

Your insinuation with respect to the Ford Foundation story is a calumny against the foundation, my husband and myself. The program for aiding artists and the arts was covered nationally in the press. The Times itself covered it several times in several departments. On August 25, 1958, the Times editorially praised the foundation and the director of the program, W. McNeil Lowry. You neglect to mention in your memo that awards were made *solely by nomination* and by an anonymous jury. No artists were able to apply for grants. As for my husband's eligibility, he like thousands of others, is over thirty-five years old.

Next, in regard to the Grove Press:

It is not odd that you "could not help noticing" that the only interview I sent from Paris was with Marcel Jean, the author of the first history of surrealism to be published in the United States this fall by Grove Press. The fact is *that you approved in writing* a memo in which this interview was listed as a possible *free-lance* story from Europe.

Concerning the Emmerich Gallery: I did not "collaborate with the Emmerich Gallery" on my book *Poets and the Past*. This anthology of poetry was conceived many years ago and was a labor of love. The plan for the book was made in 1956, at least two-and-a-half years before my husband associated himself with the gallery.

Finally, I was requested by Mr. Preston to cover for him the Trabia Gallery show. I have never written critically of my husband's work

in the past. This was merely an accommodation to a colleague. I will not here respond to other charges. They can all be easily refuted.

—DORE ASHTON

II. THREE ARTICLES MENTIONING ADJA YUNKERS DISCUSSED IN MR. CANADAY'S MEMO TO MISS ASHTON

The New York Times, February 5, 1960, p. 24.

ART: DOUBLE ANNIVERSARY CELEBRATED AT EXHIBITION
HANS BOEHLER MARKS 50 YEARS OF WORK
ARTISTS GALLERY TURNS 25—OTHER SHOWS
by Dore Ashton

In an exhibition called "Small Masterpieces" at the Trabia Gallery, 14 East Ninety-fifth Street, ten artists of note are exhibiting moderate-sized oils and water-colors. It is a refreshing exhibition. There are superb collages by Esteban Vicente; compelling gouaches by Philip Guston; oils by Jack Tworkov, and drawings by Stephen Greene. Then, there are vivid oil sketches by Helen Frankenthaler, a fine oil by Joan Mitchell, gouaches by Adja Yunkers, drawings by Robert Motherwell, oil sketches by Nicholas Carone, and finally, drawings by Mark Tobey. Altogether a cheering selection.

The New York Times, Sunday, July 26, 1959, II, p. 12.

MODERNS IN BALTIMORE
by Dore Ashton

The intrepid few in Baltimore who years ago bought paintings by living and imaginatively inclined artists—sometimes called "avant garde" artists—were scornfully regarded as eccentrics by the community. So much so that Dr. Claribel Cone, who together with her sister Etta formed one of the most distinguished collections of modern art in the United States, sternly warned in her 1929 will that the pictures would go elsewhere if the people of Baltimore didn't show more interest in modern art.

Happily, Dr. Cone's threat was lived down and the Cone Collection is safely installed in the Baltimore Museum. Even better, the peo-

ple of Baltimore have shown sufficient interest to enable the museum to install the current exhibition: "New Paintings and Sculpture from Established and Newly Formed Collections." This show presents more than sixty works of contemporary art from no less than seventeen private collections. The Cones and that other notorious modern art "eccentric," Saidie A. May, would have been overjoyed to see it.

There is nothing half-hearted either about the contemporary nature of the choices. Almost two-thirds of the show consists of paintings by American contemporaries, many of them completed during the past two or three years. In addition, they are almost without exception works of a non-traditional character.

How did this relatively sudden change of heart occur? The museum assures us that such an exhibition could not have been compiled five years ago. Baltimoreans who have followed the situation are unanimous in attributing the new interest to the convergence of three factors:

MUSEUM'S AIMS

The first is, of course, the museum's own attitude toward contemporary art. In the tradition of the Cones and Saidie A. May, the museum has worked steadily building its own collection of modern painting and sculpture. And, as a concurrent summer exhibition on now of works from its own collection proves, the museum has done extremely well. One need only mention from among the exhibits in this show the magnificent Giacometti pointing man, the Matisse bronze standing girl, the strange and powerful Rothko painting, and outstanding works by Motherwell, Hofmann, Gorky and Pevsner.

The second factor contributing to the favorable "modern" climate is the rental gallery within the museum that was founded five years ago. During that time, an active and discerning committee has made regular forays to New York, returning with paintings and sculpture of solid, adventurous quality, which they urged Baltimoreans to select for their homes. Over the years they have stimulated many of the collectors represented in the show. In fact, more than a fifth of the exhibits were purchased directly from the rental gallery.

Finally, everyone agrees that the show would not have been possible without the appearance several years ago of unexpected press support in the person of Kenneth B. Sawyer, art critic of the Baltimore Sun. Sawyer's unstinting enthusiasm for contemporary art was expressed so forcefully and imaginatively that he won many adherents to the cause, as well as an award for outstanding newspaper art criticism.

With these three elements working in harmony, Baltimore's holdings in the modern area have increased substantially. In addition, Baltimore has managed to acquire a good many outstanding paintings by artists who are now considered major painters in America. To mention only a few of these: In the exhibition there is a large "Black on Red," by Mark Rothko, that would stand out in any contemporary exhibition for the queer, tenebrous mood it purveys with its black lake sunk in fields of red. Then, there is a lovely tracing of anxiety by Arshile Gorky dated 1945. There are also paintings by Pollock, Tobey, Tworkov, Motherwell, Vicente, Baziotes, Yunkers, Diebenkorn, Avery, Appel and Scott, all meriting praise.

Among sculptures exhibited, there are several of outstanding value. Perhaps the most important of these is the "Standing Nude" by Matisse, dated 1906. Then, too, there are a Calder mobile, an early cubist work by Lipchitz, and a bronze standing figure by the gifted young British sculptor Eduardo Paolozzi.

Among the "established" collectors who show up in the exhibition as unmistakably established are two physicians, Dr. Israel Rosen and Dr. Edgar Berman, and among the "newly formed" collections is that of another doctor, Winston Price. Other collectors contributing include Mr. and Mrs. Alan Wurtsburger, whose sculpture collection is well known and who last year contributed an entire collection of pre-Columbian sculpture to the museum; Mrs. Harry Bernstein, Mr. and Mrs. Edward Benesch, Mr. and Mrs. Arthur U. Hooper and many others.

The New York Times, Sunday, November 8, 1959, II, p. 15.

ART'S DIRECTIONS OLD AND NEW
by Stuart Preston

Although the School of Paris at its zenith outnumbers other representation among the nineteenth- and twentieth-century paintings and drawings at the E. & A. Silberman Galleries, the show itself contains some surprises, none more so than Degas' "Wounded Jockey" painted in 1866. Implicit rather than explicit drama was Degas' forte and a dramatic incident of this sort, showing a frightened horse running away from a fallen rider, is essentially foreign to the character of his mature work. But a superb rarity it remains.

Signac's rosy "Mont St. Michel" is a dignified Pointillist essay and the Redon "Flight into Egypt" a genuinely moving piece of religious symbolism. Most memorable here, however, are the pitiless and eerie figure drawings by Egon Schiele, and Kokoschka's big, unnerving portrait of Prince Dietrichstein and his sisters, painted in 1916. It is a rather morose group, expressing aristocratic hopelessness as night fell on Hapsburg Vienna.

BECKMANN

The impressiveness of Max Beckmann's eight bronzes, on view at the Viviano Gallery, makes one wonder why this painter did not more often apply his powerful and rather sinister imagination to sculpture. These pieces date from his later years, consist of figure studies and portrait busts and throb with feeling that is exempt from the coarse exaggeration that sometimes mars his paintings. They are not overwhelmed by "tragic" overtones. They simply grasp the human form in the most straightforward and forceful of grips.

FIFTY YEARS OF LHOTE

In holding a retrospective (1906–59) of paintings and watercolors by André Lhote, the Juster Gallery honors a distinguished French artist, though perhaps more important as a teacher and writer, whose fate was to have been associated with contemporaries of greater inspiration and intensity. He is the perfect satellite, a fauve in 1906, a cubist a few years later, something of a hedonist à la Dufy in the Nineteen Twenties, and more recently the complete academic embodiment of the twentieth-century French esthetic revolution. Not one of Lhote's intelligent semi-abstractions, both landscapes and figures, fails to deliver the French message. But their air of theory and demonstration all but extinguishes the small flame of spontaneity in front of a subject.

MAGIC REALISTS

The success or failure of magic realism lies in the quantity and quality of the "magic" extracted from the realism, the poetry-making elixir that an artist stirs into his ruthless literalism. Two younger American painters showing their work this week demonstrate how much more there is than meets the eye. Both are technical virtuosos.

Of the two, Wynn Chamberlain, whose egg-tempera paintings are at Gallery G, is the more ambitious and imaginative, although his imagination has cooled from the heated bizarreries of earlier work. Chamberlain is at his best when associating a figure with landscape, the one strongly reinforcing the meaning of the other, a double identifica-

tion that works like a Yale lock in "New Bedford Fisherman." Nor are thoughts of Paul Valéry inappropriate when contemplating the pathos of Chamberlain's graveyard by the sea, but in some other pictures, where the note is forced, the magic evaporates.

Richard de Menocal's still-lifes at the Iolas Gallery appear to be bathed and petrified in some crystalline fluid. But the "magic" here is not so much a question of poetry as that of an almost uncanny good taste in design.

ABSTRACTIONISTS

Color is the principal spell-binder in exhibitions by three contemporary abstractionists. Of this trio Adja Yunkers, showing heroic and sultry pastels at the Emmerich Gallery, is the most romantic, stoking the fire of color and shape to degrees of thrilling intensity.

Yunkers, who uses pastel with verve and assurance, organizes restless compositions in a truly symphonic way, summing up a complex infinity of shape and color for the majestic "scoring" of these beautiful and impressive pictures.

In paintings by the German contemporary, E. W. Nay, at the Kleemann Gallery, color, harmonized and contrasted with exceptional skill, swirls serenely in circular shapes that resemble the heads of peonies or sunflowers. They suggest very little outside of themselves but they exist as a garden of visual delight. Finally, Carl Holty, at the Graham Gallery, whose milky blues, greens and reds, floating on cloud-like shapes, set the spirit soaring. The décor-serenity of this work is bound to appeal to the most innocent, and to the most sophisticated eye.

III. A LETTER TO *The New York Times*, February 26, 1961, CONCERNING THE WORK OF JOHN CANADAY

To the New York Times:

Reading Mr. John Canaday's columns on contemporary art, we regard as offensive his consistent practice of going beyond discussion of exhibitions in order to impute to living artists en masse, as well as to critics, collectors and scholars of present-day American art, dishonorable motives, those of cheats, greedy lackeys, or senseless dupes.

Here are some instances:

Sept. 20, 1960: ". . . a situation built on fraud at worst and gullibility at best has produced a school of such prolix mediocrity. . . ."

July 24, 1960: "The chaotic, haphazard and bizarre nature of modern art is easily explained: The painter finally settles for whatever satisfaction may be involved in working not as an independent member

of a society that needs him, but as a retainer for a small group of people who as a profession or as a hobby are interested in the game of comparing one mutation with another."

Sept. 6, 1959: "But as for the freaks, the charlatans and the misled who surround this handful of serious and talented artists, let us admit at least that the nature of abstract expressionism allows exceptional tolerance for incompetence and deception."

"In the meanwhile, critics and educators have been hoist with their own petard, sold down the river. We have been had."

Sept. 11, 1960: ". . . for a decade the bulk of abstract art in America has followed that course of least resistance and quickest profit."

"There is not a dealer in town, nor a collector nor a painter hoping to hang in the Museum of Modern Art, who doesn't study each of Mr. Barr's syllables in an effort to deduce what he should offer for sale, what he should buy or what he should paint. . . ."

October 23, 1960: ". . . brainwashing . . . goes on in universities and museums."

Mr. Canaday is entitled, of course, to the freedom of his opinions regarding works of art. We submit, however, that his terminology of insults is scarcely adequate to describe the emerging art works and tendencies, and we scorn this waging of a polemical campaign under the guise of topical reporting.

If Mr. Canaday has a political or social or esthetic "position" or philosophy, let him state what it is and openly promote his aims. Every style and movement in art history contains examples of work by imitative or uninteresting artists. To keep referring to these in order to impugn the whole, instead of attempting to deal seriously with the work of the movement, is the activity not of a critic but of an agitator.

JAMES S. ACKERMAN, *Professor of Fine Arts, Harvard*
WILLIAM BARRETT, *Professor of Philosophy, N.Y.U.*
DONALD BLINKEN, *Collector*
WALTER BAREISS, *Collector*
BERNARD BRODSKY, M.D., *Collector*
JAMES BROOKS, *Painter*
JOHN CAGE, *Composer*
BERNARD CHAKT, *Chairman, Department of Art and Architecture, Yale*
HOWARD CONANT, *Chairman, Department of Art Education, N.Y.U.*
STUART DAVIS, *Painter*
EDWIN DENBY, *Writer*
HENRY EPSTEIN, *Collector*

JOHN FERREN, *Painter*
ALFRED FRANKFURTER, *Editor and President "Art News"*
PERCIVAL GOODMAN, *Architect, F.A.I.A.*
ADOLPH GOTTLIEB, *Painter*
JACK M. GREENBAUM, *Collector*
MR. & MRS. I. HAROLD GROSSMAN, *Collectors*
DAVID HARE, *Sculptor*
BEN HELLER, *Collector*
THOMAS B. HESS, *Executive Editor "Art news"*
HANS HOFMANN, *Painter*
SAM HUNTER, *Director, Rose Art Museum, Brandeis*
KENNETH KOCH, *Writer*
WILLEM DE KOONING, *Painter*
STANLEY KUNITZ, *Poet*
KERMIT LANSNER, *Writer*
BORIS LEAVITT, *Collector*
ERLE LORAN, *Painter and Teacher*
ARNOLD H. MAREMONT, *Collector, Chicago*
ROBERT MOTHERWELL, *Painter*
E. A. NAVARETTA, *Poet and Critic*
ALBERT H. NEWMAN, *Collector*
BARNETT NEWMAN, *Painter*
RAYMOND PARKER, *Painter*
PHILIP PAVIA, *Sculptor, Editor "It Is"*
GIFFORD PHILLIPS, *Collector, Publisher, Frontier Magazine*
WILLIAM PHILLIPS, *Editor "Partisan Review"*
FAIRFIELD PORTER, *Art Critic, "The Nation"*
DAVID A. PRAGER, *Collector*
HAROLD ROSENBERG, *Writer*
ROBERT ROSENBLUM, *Assistant Professor, Dept. of Art & Archaeology, Princeton*
BARNEY ROSSETT, *Publisher, Grove Press*
IRVING SANDLER, *Writer and Critic*
KENNETH B. SAWYER, *Art Critic, Baltimore Sun*
DAVID SMITH, *Sculptor*
WHITNEY S. STODDARD, *Director, Lawrence Art Museum, Williams*
MEYER SCHAPIRO, *Professor of Art, Columbia*
PAUL WEISS, *Professor of Philosophy, Yale*

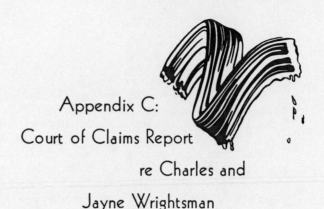

Appendix C:
Court of Claims Report
re Charles and
Jayne Wrightsman

Report of a Trial Commissioner of the Court of Claims 4/16/69 concerning Charles and Jayne Wrightsman, in which it was found that the Wrightsmans could claim tax deductions amounting to some $26,000 plus interest for expenses incurred in collecting art. The decision was reversed 7/17/70, on the grounds that the purpose of the Wrightsmans's art collection was personal use and enjoyment rather than investment.

[7910 Charles B. Wrightsman and Jayne Wrightsman v. The United States. U.S. Court of Claims, No. 364–66, 4/14/69]

[Code Secs. 212 and 1211]

Deductions: Expenses: Property held for production of income: Works of art: Investment v. hobby: Intent.—On the evidence, the Trial Commissioner was satisfied that the taxpayer acquired and held works of art primarily for investment purposes; motivation for such acquisition was found in (1) a change in the taxpayer's financial position in 1951, resulting in a large cash flow available for investment purposes, (2) the taxpayer's fear of investment in corporate stock, and (3) the taxpayer's belief that works of art were an excellent hedge against inflation and devaluation of currencies. As a consequence, expenses incurred in connection with the works of art were deductible, as was a capital loss incurred on the sale of certain works of art in one of the years in issue, subject to the $1,000 limitation. Back references: 2006.01 and 4711.19.

Hugh F. Culverhouse, Suite 1211, 100 Biscayne Bldg., Miami, Fla. for plaintiff. William Laverick, Richard C. Pugh, Acting Assistant Attorney General, Philip R. Miller, Joseph Kovner, Department of Justice, Washington, D.C. 20530, for defendant.

REPORT OF COMMISSIONER TO THE COURT *
OPINION

Hogenson, Commissioner: This is a federal income tax case, involving joint returns of husband and wife for taxable years 1960 and 1961. Plaintiffs paid deficiencies (principal plus interest) assessed by the Internal Revenue Service. Their timely claims for refund were thereafter denied. Plaintiffs seek recovery of $5,911.20 plus interest of $1,847.25 for 1960 and $21,199.78 plus interest of $5,352.22 for 1961, plus statutory interest on the amounts of recovery. Plaintiffs are entitled to recover, with the amounts of recovery to be determined in further proceedings.

The basic issue is whether plaintiffs were acquiring and holding works of art as investments or collecting them as a hobby for their personal use and enjoyment. If such activity was investment, consideration must be given to the deductibility of claimed expenses attributed thereto. Also involved is plaintiffs' claim of entitlement to deduction of $1,000 as part of a capital loss incurred on the sale of works of art during 1961, as to which defendant conceded entitlement to recovery, if plaintiffs were investors in their works of art.

It would seem obvious as an abstract proposition, that works of

* The opinion, findings of fact, and recommended conclusion of law are submitted under the order of reference and Rule 57(a).

art could be the subject matter of investment. However, because of defendant's contentions to the contrary in pretrial procedures herein, plaintiffs undertook and have proved convincingly by expert testimony and authoritative exhibits that there exists and has existed an established art market, in which sellers and buyers are motivated by investment purpose, aside from enjoyment of the artistic beauty of the objects themselves, and that investment in art is and has been economic reality. Of course, consideration must be given to all of the facts and circumstances in evidence in determining the issue as to whether the plaintiffs were investors in their works of art, rather than indulging in a hobby by acquiring and holding such for personal use and enjoyment. Plaintiffs have both participated in the activities involved, and for convenience are referred to by their first names, Charles and Jayne. Their acquisition of works of art commenced in 1947, when concededly their activities were in the nature of a hobby, but their purposes changed prior to the taxable years involved, as hereinafter shown.

From Charles' standpoint, the extensive acquisition of works of art was motivated by the combination of three major factors: (1) A substantial change in his financial position in 1951, resulting in availability thereafter of a large cash flow for investment purposes; (2) his personal fear of investment in stock of any corporation, in which he lacked intimate knowledge of its operations and had no management control; and (3) his firm belief in certain theories concerning long-range economic trends.

Charles' fear of conventional investments in the stock market stemmed from his experiences in his youth in observing his father's disastrous investments in securities. His father had engaged in numerous oil ventures, and throughout a number of years had made several fortunes through sale of oil properties. On several occasions, he sold out his interests in his oil ventures for at or about one million dollars, when he promptly moved to New York City, and proceeded to lose his fortune by investments in the stock market. Charles was most forcefully exposed, considered by him to be a very shattering experience, to his father's loss of a fortune in the stock market while Charles was attending Columbia University and living with his parents in New York City.

The one investment in which Charles was able to combine his requirements of knowledge and management control was in the Standard Oil Company of Kansas. In 1918, after active service in the United States Navy, Charles moved to Fort Worth, Texas, where he engaged in the oil business as a lease broker and in several oil ventures. He accumulated sufficient funds by 1930 to purchase and did purchase at pri-

vate sale the shares of the largest stockholder of Standard Oil Company of Kansas. He was then elected to the board of directors, and in 1932, became president of that company. He held such office through January 1951, when liquidation of that company, commenced in 1949, was concluded, at which time, Charles owned 93.7 percent of the outstanding stock.

Upon the liquidation, Charles received a 93.7 percent interest in all of the properties, including one million dollars in cash distributed to him. With the removal of the corporate structure, his financial position changed from stock ownership to direct ownership of oil-producing properties, which he has continued to operate as an individual under appropriate arrangements with the owners of the 6.3 percent interest. Thus he commenced and has continued to receive directly a large cash flow, which had previously gone into the corporate coffers.

Aside from his investments in Standard Oil of Kansas, Charles' ownership of stock, as well as that of Jayne, has been quite limited. In 1959, Wrightsman Investment Company was organized with Charles as the sole stockholder, owning minor Oklahoma oil properties contributed by Charles and the land on which plaintiffs' Palm Beach, Florida, home is located, and limited assets previously owned by Charles in New Mexico, Mississippi and Nebraska. Plaintiffs acquired 1,583 shares of Wrightsman Petroleum Company in 1960 and in 1961, a company which had been organized by Charles' father. At the time of the trial of this case, Jayne was the beneficial owner of a trust for which a bank, as trustee, had purchased stock.

From his studies of economics in college, supplemented by frequent discussions with persons knowledgeable in that field, Charles by 1953 formed definite beliefs as follows: That the trend of worldwide economics was toward an ever increasing spiral of inflation; that world currencies would be continually devalued; and that his investments would have to take account of such factors. He believed that oil was one of the best possible investments, if selectively made. His trips to the Persian Gulf countries in the mid-1950's indicated to him that there was a possibility of an oil glut, which caused him to conclude that he should make an effort to hedge his investments in oil with investments of other kinds. He sought advice from qualified employees. The certified public accountant in charge of his accounts recommended purchase of unimproved real estate and stock in corporations not in the oil industry. These recommendations were not followed.

By this time Charles had formed the belief that works of art were an excellent hedge against inflation and devaluation of currencies,

that they represented portable international currency, since there were no restrictions on export from the United States, and that works of art were appropriate assets for investment of a substantial portion of his surplus cash being generated. These beliefs and investment intent were expressed to numerous friends and associates and the employees of his business office.

Jayne's assets have been derived from income through Charles under community property laws and from funds received from Charles in the form of gifts. Jayne fully shared Charles' beliefs and intent concerning investment in works of art. Their marriage has obviously been one of constant association and travel together, with common interests and goals.

Plaintiffs first began to purchase works of art in 1947, their marriage having occurred in 1944, and in that initial year, their expenditure was $3,741. By the end of 1960, their purchases totaled $5.2 million, and by the end of 1961, $300,000 more. As of March 31, 1967, their total purchases exceeded $8.9 million, held by them and insured for over $16.8 million.

Plaintiffs have specialized in the acquisition of 18th century French works of art. Jayne is not just a nominal party herein because of the filing of joint returns by the parties. She owns about three-fourths of plaintiffs' works of art, either by number or by value. Their activities in acquisition and holding of such works of art have been conducted jointly.

Charles and Jayne, without any prior formal education with respect to works of art, have since the late 1940's consistently and diligently pursued a course of self education in that field, visiting major museums and art dealer establishments in the United States and overseas, studying works of art themselves, reviewing auction catalogues and price lists, and engaging in discussions with recognized art experts, such as collectors, museum curators, dealers and others knowledgeable in the world art community. They have reviewed all of the leading art periodicals, and engaged in extensive reading in their chosen field of 18th century French art and related areas. They have acquired a substantial art library, and Jayne has engaged in extensive research, while Charles has concentrated on the restoration and conservation of art objects and the conditions of the art market. They study art daily, and their social life at home and abroad centers around people knowledgeable and interested in the field of art. Jayne has educated herself in the use of the French language, to be qualified to engage in discussions and reading of materials in that language concerning 18th century French furniture and works of art.

On September 17, 1956, Charles was elected to the Board of Trustees of the Metropolitan Museum of Art, and became a member of its Purchasing Committee, and a Trustee-Visitor of its Department of Conservation. He subsequently became a member of its Executive Committee. As a member of the Purchasing Committee, he has participated in the Museum's acquisition by purchase and by gift of art objects involving millions of dollars annually.

Jayne has been elected a member of the board of the Metropolitan Opera Association, and was one of a committee of six persons who supervised the decoration of the new opera house at Lincoln Center in New York City. She participated in the redoing of the White House during the tenure of President Kennedy.

On March 25, 1963, plaintiffs both became members of the Council of Advisors of the Institute of Fine Arts of New York University.

Plaintiffs' mode of living from 1947 to the present time has been to reside from the latter part of November until late April at their home in Palm Beach, Florida, with occasional trips to New York City or elsewhere. Commencing about the first of May, they live for about 30 days in New York City, staying since 1956 in their Fifth Avenue apartment. From June 1 to the end of September or early October they are in Europe, where they live exclusively in hotels.

Charles and Jayne have constantly associated with well-known experts in the art world. They are art experts in their own right, as recognized by others, particularly in the testimony of Mr. Francis J. B. Watson, Surveyor of the Queen's Works of Art and Director of the Wallace Collection of London, and Mr. Joseph V. Noble, Vice Director for Administration of the Metropolitan Museum of Art.

In the acquisition by plaintiff of works of art, each art object has been invoiced, assigned an inventory number, and noted as an approved purchase by one of the plaintiffs. The invoice is sent directly to plaintiffs' Houston, Texas business office for payment. There the approved invoice is checked for accuracy, and a check request is prepared, following the usual business procedures employed in Charles' investments in oil and gas properties. The check request, a copy of the check, and a copy of the original invoice are kept in the Houston office file. The original invoice, marked paid, with date and check reference, is returned to plaintiffs' personal files, which follow them from the Palm Beach home to their New York apartment as the occasion warrants. Each item is reflected in the investment control account of the general ledger maintained in the Houston office. A detailed investment card record is kept with respect to each item in the works of art collection. On each card is

noted the original purchase price, the date of purchase, and any items deemed to be of a capital nature, and accordingly, to require capitalization on the investment books of the plaintiffs.

Plaintiffs have consistently catalogued their purchases of works of art. At the time of the trial herein, these catalogues consisted of 26 three-ring binder volumes, requiring a shelf space of about five feet. These catalogues are unique, represent 20 years of work by Jayne, and have considerable value. Partially on the basis of this extensive cataloguing, the Metropolitan Museum has published two volumes and is in the process of completing the publication of a five-volume work on the Wrightsman Collection, authored by Mr. Francis J. B. Watson, which will be a treatise on 18th century French works of art.

Plaintiffs' works of art are of high quality. Over the years, items have been placed on display by plaintiffs at the Metropolitan Museum and at other museums abroad. Such displays enhance the value of such art objects.

Except for occasional displays of items at other locations, plaintiffs have kept their works of art in their New York apartment, their Palm Beach home, and in the Metropolitan Museum on loan for display by that institution. As of March 31, 1967, about 77.8 percent of such objects (on an insurance evaluation basis) was in the New York apartment, about 17.7 percent in the Palm Beach home, and about 4.5 percent in the Metropolitan Museum. The works of art are on display, or in use as in the case of such items as French period furniture, in the New York apartment and the Palm Beach home, except that a small amount of furniture is stored in one room at Palm Beach.

Plaintiffs have provided air conditioning and humidity controls considered necessary for the preservation of works of art, similar to those employed in the Metropolitan Museum. In this respect, the New York apartment is better equipped, accounting for the concentration of works of art there. Such apartment occupies the entire third floor of the building. Storage facilities for works of art have not been readily available, to provide the required atmospheric controls, especially needed for paintings and furniture.

The facts and circumstances in evidence in this case clearly establish that in the taxable years involved, and for several years prior thereto, plaintiffs held their works of art as investment properties. Their personal declarations of investment purpose and intention, consistently made during that substantial period of time, are supported by circumstances and conduct evincing such intention. *Tatt v. Commissioner [48–*1 USTC 9219], 166 F 2nd 697, 699 (5th Cir, 1948). Their ex-

tensive and thorough study and exploration of the field of 18th century French art and related fields, their devotion of much personal attention and time to the acquisition and holding of their works of art, their maintenance of businesslike methods of accounting for their acquisitions and holdings, and their consultations with art experts, all confirm investment intent. *Amos S. Bumgardner* [CCH Dec. 20, 151(M)], 13 CCH Tax Ct. Mem. 128, 130–131 (1954).

Fully consistent with their expressions of investment intent was the conduct of plaintiffs in purchasing and maintaining their large New York apartment and providing air conditioning for preservation of the large quantity of art objects kept there, even though plaintiffs spend relatively little of their time there. Charles has had a long and successful career investing in oil and gas properties, and it is and has been fully consistent with his character, that he would invest surplus funds in quality works of art, clearly shown by the evidence to be an excellent field in which to realize capital gains. Very little of their art objects have been sold by plaintiffs, but this circumstance is fully explained by the constant appreciation of value of those retained. Plaintiffs have demonstrated that they will sell and have sold items which fail to increase in value. The inference is inescapable in this case, aside from their direct testimony, that plaintiffs have never had any need to sell their works of art, and it is and has been obviously reasonable for them to continue to hold such assets. This conduct conforms with their declared purpose of investing in art objects as a hedge against inflation and any disruption of Charles' oil and gas production business.

Defendant relies heavily on the fact that plaintiffs' works of art are generally on display or in use to some extent in their New York apartment and in their Palm Beach home. One of the items, 18th century oriental wallpaper, had been installed by the previous owner, and has remained installed on the walls of plaintiffs' Palm Beach home. Another item, 18th century French parquet flooring, was installed and remains installed, by plaintiffs on the floors of both their Palm Beach home and the New York apartment. Charles' bedroom in the home and his bedroom in the apartment are furnished with 18th century French furniture and fixtures. Jayne's bedroom in the apartment is furnished completely with Louis XV matching furniture and fixtures. Plaintiffs' apartment has other rooms containing matching furniture and fixtures, part of their works of art collection.

Of course the utilization of an object for the satisfaction of personal needs might tip the scales against the conclusion that the holding of the object was for investment purposes. The statutory problem

arises because of the non-deductibility of personal living expenses under §262 of the Internal Revenue Code of 1954, and the deductibility of expenses under §212, providing:

> In the case of an individual, there shall be allowed as a deduction all the ordinary and necessary expenses paid or incurred during the taxable year—
> (1) for the production or collection of income;
> (2) for the management, conservation or maintenance of property, held for the production of income. . . .

However, the conclusion would be unreasonable that the use and enjoyment of property precluded its treatment as investment property, no matter how plainly established and paramount was investment purpose.

Concerning the distinction between a hobby and investment, Treasury Regulations §1.212–1(c) provides:

> (c) Expenses of carrying on transactions which do not constitute a trade or business of the taxpayer and are not carried on for the production or collection of income or for the management, conservation, or maintenance of property held for the production of income, but which are carried on primarily as a sport, hobby, or recreation are not allowable as non-trade or non-business expenses. The question whether or not a transaction is carried on *primarily* for the production of income or for the management, conservation or maintenance of property held for the production or collection of income, rather than *primarily* as a sport, hobby or recreation, is not to be determined solely from the intention of the taxpayer but rather from all the circumstances of the case. For example, consideration will be given to the record of prior gain or loss of the taxpayer in the activity, the relation between the type of activity and the principal occupation of the taxpayer, and the uses to which the property or what it produces is put by the taxpayer. [Emphasis added.]

The principle of primary purpose or intent seems applicable to the statutory problem involved in this case, and is applied in favor of plaintiffs under all of the facts and circumstances in evidence, i.e., that plaintiffs' investment purpose was principal, of first importance. *Malat v. Riddell* [66–1 USTC 9317], 383 U.S. 569, 572 (1966).

Treasury Regulations §1.212–1(b) provide the answer as to whether receipt in the taxable year of income from investment prop-

erty is a prerequisite to the applicability of 1954 Code §212, in the following relevant language:

> (b) The term "income" for the purpose of section 212 includes not merely income of the taxable year, but also income which the taxpayer has realized in a prior taxable year or may realize in subsequent taxable years; and is not confined to recurring income but applies as well to gains from the disposition of property. . . . Expenses paid or incurred in managing, conserving or maintaining property held for investment may be deductible under section 212 even though the property is not currently productive and there is no likelihood that the property will be sold at a profit or will otherwise be productive of income and even though the property is held merely to minimize a loss with respect thereto.

Thus, plaintiffs' retention of their works of art, without engaging in profitable sales thereof, is no bar to their recovery in this case. *Higgins v. United States* [48–1 USTC 9120]. 110 Ct. Cl. 204, 210 75 f. supp. 252, 255 (1948).

Even though the plaintiffs employ part of their collection to fulfill personal needs, this does not require characterization of their overall activity as a hobby. The factual pattern is analogous to farming which was first undertaken as a hobby but which during the taxable year in question was a trade or business.[1] The fact that the farm is in part used for personal purposes, while a factor in determining the overall nature of the activity, is, once the activity is held to be a trade or business, still relevant in reaching an allocation between those expenses attributable to business and those related to personal living. *Dewey F. Cobb* [CCH Dec. 17, 213], 13 T.C. 495, 503–504 (1949), rev'd and remanded on other grounds [50–2 USTC 9508], 185 F. 2d 255 (6th Cir. 1950).

Plaintiffs rely heavily on *George F. Tyler* [CCH Dec. 15,671(M)], 6 CCH Tax Ct. Memo. 275 (1947), in which the court allowed deduction of a loss sustained in the sale of part of a stamp collection, the acquisition of the stamps being a transaction entered into for profit, though

[1] The 1954 code section involved in such a case is 162(a) providing a deduction "for ordinary and necessary expenses paid or incurred during the taxable year in carrying on any trade or business. . . ." However, the distinction between business and hobby is useful in determining when the latter becomes an investment. Except for the requirement under 162(a) that the income-producing activity qualify as a trade or business, §212(1) and (2) are in *pari materia* with §162(a). *United States v. Gilmore* [63–1 USTC 9285], 372 U.S. 39, 45 (1963).

not connected with a trade or business. The court found that the taxpayer derived personal pleasure and satisfaction from the ownership, possession and handling of the collection, but that his principal motivation in acquiring and holding the same was realization of pecuniary gain, and held that the claimed loss was accordingly allowable.

Defendant responds that *Tyler* is readily distinguishable on the facts. It is true that Tyler entered into stamp collecting as an investment from the outset, whereas plaintiffs commenced their acquisition of works of art as a hobby. While prior status as a hobby may make a claimant's burden of proof more difficult, no irrebuttable presumption or inference arises, precluding proof by substantial and reliable evidence of a change in motivation. *Norman C. Demler* [CCH Dec. 27,971 (M)], 25 CCH Tax Ct. Memo. 620, 626 (1966). Also, defendant points to lack of any finding in *Tyler* that the stamp collector used any stamps in his collection to mail any letters, whereas plaintiffs did make use of various items of their works of art. But defendant relies upon this factual difference only to support its contention that plaintiffs have always held their works of art primarily for pleasure and as a hobby, a contention which cannot be sustained under all of the facts and circumstances in evidence. Pleasure derived from investment property does not preclude deductions. *George F. Tyler*, supra, at 280; *Norman C. Demler*, supra, at 626.

The ultimate finding that the primary intent, principal and of first importance, was one of investment is not reached without consideration of the fact that there was no substantial relationship between plaintiffs' works of art activities and Charles' principal occupation of oil and gas production. While a close relationship might be weighty in arriving at investment purpose, lack of relationship would seem to have little significance as a general rule. It is axiomatic that a taxpayer can have two unrelated businesses, and it would seem plain that he could have a business and an unrelated investment activity.

The parties agreed that the following expenses were incurred in connection with and are directly attributable to plaintiffs' works of art:

Item	1960	1961
Insurance	$3,953.48	$ 5,433.65
Maintenance	3,057.00	11,307.05
Subscriptions and services	200.63	286.99
Expenses and shipping	2,033.16
Miscellaneous	1,074.91	310.69
	$8,286.02	$19,371.54

However, it must be determined from the evidence the proportion of these expenses proximately related to the investment function of the works of art other than attributable to the personal use of various items.

The expense items of $200.63 and $286.99 are allowed in full as they seem wholly unrelated to personal use. The other items seem of the type which benefit both the investment and use function of the works of art. Bearing in mind that plaintiffs have the burden of proof and that their collection was held primarily for investment purposes, one-third of the remaining above expenses is disallowed. *Cohan v. Commissioner* [2 USTC 489], 39 F. 2d 540 (2d Cir. 1930). Thus, of the above expenses, the total deductions allowed are $5,590.89 for 1960 and $13,010.02 for 1961.

Without benefit of a stipulation regarding relationship to works of art, plaintiffs contend that they are entitled to deductions of the following items of claimed expenses:

1960

VOUCHER NO.	PAYEE	EXPLANATION	AMOUNT
12–11	Charles B. Wrightsman	Entertainment of Watson & McGregor	$359.75
12–43	Eastern Air Lines, Inc.	Fare for Watson & McGregor	359.38
11–228	Sofia Brothers, Inc.	Transportation services	34.00
11–118	First National Bank of Palm Beach	Safety Deposit Box Rental	55.00

1961

1–89	Eastern Air Lines, Inc.	West Palm Beach to New York	292.50
3–45	Eastern Air Lines, Inc.	Mr. Papper—New York to Palm Beach	188.65
	Rebate on Air Line fare		(94.32)
4–204	Charles B. Wrightsman	Entertainment of Dauterman, Redmond and Cox	401.00
4–86	Chase Manhattan Bank	Safety Deposit Box Rental	82.50
6–140	J. H. Small & Sons	Flowers for Mr. Walker	16.83

Cost allegedly incurred in 1961 in acquiring and subsequently releasing a painting due to inability to obtain an export permit and for other works of art expenses 10,000,00

No attempt was made to relate to plaintiffs' works of art the above expenditures represented by vouchers Nos. 11–118, 1–89, 3–45, 4–86 and 6–140, and accordingly these claimed deductions are disallowed in full.

The evidence shows that the expense for transportation services, voucher No. 11–228, was incurred in movement of plaintiffs' El Greco

painting to the art restorers. This deduction is allowed. Also, the transportation and entertainment expenses for Messrs. Watson and McGregor, a total of $719.13 (vouchers Nos. 12–11 and 12–43), are deductible, since a memorandum attached to voucher No. 12–43 indicates that such expenses were incurred when these gentlemen came to Palm Beach to appraise plaintiffs' collection. The entertainment expense claimed for Dauterman and Richmond [sic] (voucher No. 4–204) is deductible, as a notation indicates that they were appraising plaintiffs' works of art. The entertainment expense for Cox (included in voucher No. 4–204) was indicated as spent for a man on a business conference, and no relationship to works of art is shown. However, since such expense would nevertheless be deductible under §212, as one incurred for the production or collection of income, and since no objection was raised to the admission of this evidence, the petition is deemed amended in that respect pursuant to Rule 22(b). The expense represented by voucher No. 4–204 is deductible in full.

The remaining item of claimed expenses is the $10,000 sum. In their 1961 return, plaintiffs claimed a deduction of $39,588.76 as Foreign Administrative Expense. Such an account was maintained to cover travel and entertainment expenses incurred outside of the United States in seeking investment opportunities in oil and art. Charles usually designated whether a particular expense would be charged to Foreign Administrative Expense or to an account called Works of Art. Such designation was often made by a note on a support for a voucher, and in the case of expenses designated Works of Art, there was often a separate note clipped to the voucher.

Plaintiffs do not seek as a deductible expense the entire sum of $39,588.76, but have restricted their claim to $10,000 thereof. The original petition herein attributed the $10,000 to "Cost incurred in acquiring and subsequently releasing a painting due to inability to obtain an export permit." The incident referred to was the unsuccessful attempt by plaintiffs to acquire a portrait by Goya of the Duke of Wellington. The painting was sold at auction in London in June of 1961. Plaintiffs arrived there in advance to study the painting and prepare for bidding. Charles was the high bidder at $392,000. The English press attacked the removal of a national treasure to the United States and an export permit was refused by the English government. Charles freed himself of a painting which he could not export by releasing it to others who paid the $392,000 he was obligated to pay. However, he did not recover in the transaction any expenses incurred in traveling to London and staying there to study the painting and participate in the bidding.

Plaintiffs' amended petition expanded the claim for deduction of $10,000 in expenses by adding "and for other purposes germane to the management, conservation and maintenance of investment properties."

The evidence adduced by plaintiffs consisted of the testimony of Mr. William Edward Will, manager of Charles' Houston office, and an exhibit made up of a substantial number of vouchers and support sheets, totaling the $39,588.76 originally deducted in the 1961 return. There was no testimony or evidence showing how any of these expenses were related to the oil and gas production business. Plaintiffs' claim for deductibility of $10,000 must be supported, if at all, by relating these expenses to their investment in works of art. The testimony in this respect focused on the abortive purchase of the Goya and concentrated on the events from June 6 to 15, 1961.

For items not shown to be connected with the Goya painting, plaintiffs have not met their burden of proof. There is no indication as to why plaintiffs remained in Europe or why they incurred most of the expenses claimed.

There are four voucher items shown to be related to the Goya purchase. Voucher No. 5–48 represents the cost of transportation of plaintiffs to London by way of Geneva. Since the travel by way of Geneva is unexplained, an adjustment must be made, and the deduction allowed is $1,500. Voucher No. 5–233 was for a $1,000 preliminary payment to a London hotel for rooms for plaintiffs during the pertinent period, fully allowed herein as a deductible expense. Transportation expenses while in London of $329.83 were reflected in Voucher No. 6–193. Since plaintiffs have not shown that all transportation in London was connected with their investment activity, they may deduct only $210.

The fourth voucher is No. 6–139, covering various expenses for the period June 6 to 15, 1961, totaling $1,491.46. Of this total, only $1,149.69 are attributed to London, and of that amount, only the following deductions are allowed as shown to be related to the Goya purchase: The sum of $319.31 paid on the balance of the London hotel bill, tips for hotel services, and airport fees; and the sum of $489.27 expended for entertainment of various art experts and their wives, the advice and opinions of which art experts were provided to plaintiffs without charge prior to the purchase of the Goya. Because of lack of proof of investment connection, other entertainment expenses are considered non-deductible, even though some of the people entertained were art experts, as such entertainment is deemed basically social in nature, in the absence of proof to the contrary.

Thus, of the $10,000 item claimed, plaintiffs are entitled to deduct $3,518.58.

In 1961, plaintiffs occurred a loss of $4,693.41 on the sale of fourteen items of porcelain and a pair of Meissen figures of Louis XV with ormulu bases. Defendant conceded that a determination favorable to plaintiffs on the deductibility of expenses incurred on their works of art is dispositive of the issue as to whether they are entitled to a long-term capital loss deduction on the 1961 sale. The parties are in agreement that such deduction is limited to the amount of $1,000 pursuant to §1211(b) of the Internal Revenue Code of 1954. Accordingly, it is held that plaintiffs are entitled to a capital loss deduction in that amount.

In summary, plaintiffs are entitled to deductions in the sum of $6,344.02 for 1960 and in the sum of $17,929.60 for the year 1961, and judgment should be entered accordingly, with the amounts of recovery to be determined in further proceedings.

* * *

["Findings of Fact," "Ultimate Findings of Fact and Conclusions" and "Recommended Conclusion of Law" omitted.—CCH.]

Appendix D:
Price Increases for
Selected Artists

By 1972 the museums found they had priced themselves out of the art market. Some people say it was the collectors who had priced them out, buying art as a hedge against inflation. But since the big-time collectors buy only what they know the museums value, the fault must be laid on museums, both American and European, which suddenly after 1965 started chasing contemporary, speculative American art. By 1972 art prices were rising so fast that museums could not afford even the new realists.

The chart illustrates the rise of prices for six artists in the decade following their first exhibitions (or, in the case of Rothko, the first show in his characteristic style). Prices for a new Rothko rose about 800 percent, for Johns over 2,000 percent, for Stella about 1,000 percent, for Lichtenstein over 4,000 percent. The prices of the sharp-focus realist

(PRICES GIVEN IN FIVE-YEAR INTERVALS; ALL PRICES DIRECTLY UNDER DATES ARE FOR NEW WORK.)

	1950	1955	1960	1965	1970
Rothko (*large*)	$1,200 (first year of his characteristic style; already well-known for work in semi-Surreal style)	$3,000	$10,000	$35,000	$80,000
Johns	1958 $1,200 (year of first show)	1963 $15,000 (an exceptionally large work of that year brought $30,000)	1968 $30,000	Present $100,000 (small encaustic Flag sold in 1969 for $100,000. Firm offer of $200,000 for early "Still Life with Plaster Casts" recently rejected)	
Stella (*large*)	1959 $1,200 (black pictures included in MOMA's "16 Americans," his debut)	1964 $2,500 (black and aluminum pictures bring $6,000)	1969 $13,000 (black and aluminum pictures bring $25,000)	Present $17,000 (black and aluminum pictures now $40,000)	
Lichtenstein (*large*)	1962 $1,200 (year of first show—cartoon pictures)	1967 $15,000 (early cartoon picture sold in 1968 for $40,000)	1972 $50,000 (cartoon pictures as high as $80,000)		
Estes (*large*)	1968 $1,500 (year of first show)	Present $25,000			

FOR COMPARISON:

	1950	1955	1960	1965	1970
Matisse (*large cut-paper pictures; posthumous prices*)	1957 $30,000	1962 $60,000	1967 $120,000	1972 $250,000–$500,000	

Richard Estes jumped in only four years more than 1,700 percent. This is more than twice as fast as Lichtenstein's over the comparable period of their careers.

Note that the figurative paintings in general are more in demand than non-figurative. Having created a market where a living artist's work brings half the price of a Matisse ten years after his death, the museums can no longer afford to buy, a fact that will probably bring a "technical adjustment."

Appendix E:
Sources of Information

Most of the information in this book came from interviews. These were supplemented by copious reading of newspapers, books, and magazines. Not wishing to bore anyone, however, with petty references to news clippings or fragments of articles from art magazines, most of which form only background material, I have decided to include no scholarly bibliography. Instead, I list the people interviewed for this book. Some were interviewed once, others many times. For example, fifty-four people were interviewed for Chapter 13 alone. Some of them I talked to again on other occasions, concerning other aspects of the book.

A few people have requested that they remain anonymous, and I have followed their wishes scrupulously. Not included here are those whom I approached but who refused to see me. The identifications refer to positions held at the time of the interview.

AGEE, WILLIAM, *curator, Pasadena Museum of Art*
ALLOWAY, LAWRENCE, *critic*
ARISMAN, MARSHALL, *artist*
ASHER, BETTY, *staff, Los Angeles County Museum*
ASHTON, DORE, *critic*
BADER, FRANZ, *dealer*
BARANIK, RUDOLF, *artist*
BARBER, ALLEN, *artist*
BAREISS, WALTER, *trustee*
BARNET, WILL, *artist*
BARWICK, KENT, *executive director, Municipal Art Society*
BEETS, VIRGINIA, *staff, Smithsonian Institution*
BELLAMY, RICHARD, *dealer*
BENNO, BENJAMIN, *artist*
BERGER, JOAN, *formerly Wall Street Journal*
BERNSTEIN, SUSAN, *staff, Museum of Modern Art*
BERNSTEIN, THEODORE, *staff, New York Times*
BIRO, YVAN, *artist*
BLITZER, CHARLES, *staff, Smithsonian*
BLUM, JOHN R. H., *trustee*
BLUM, IRVING, *dealer*
BOBER, HARRY, *professor, Institute of Fine Arts*
BRAITERMAN, MEYER, *staff, New York State Council on the Arts*
BRADLEY, FREDERICK, *trustee*
BREESKIN, ADELYN, *curator, National Collection of Fine Arts*
BROWN, JAMES, *director, Virginia Museum of Fine Arts*
BROWN, J. CARTER, *director, National Gallery of Art*
BROWN, RICHARD, *director, Kimbell Art Museum, Fort Worth*
BUCHANAN, JOHN, *staff, Metropolitan Museum of Art*
BUECKNER, THOMAS, *director, The Brooklyn Museum*
BURDEN, CARTER, *New York City councilman*
BURNHAM, ALAN, *staff, Landmarks Preservation Commission*
BURNHAM, ALEX, *staff, Time magazine*
BURTON, RICHARD, *staff, Cleveland Museum of Art*
BYERS, J. FREDERICK, *trustee*
CAHILL, VINCENT, *AWC*
CANADAY, JOHN, *critic*
CANFIELD, GABRIELLA
CARPELL, BERNARD, *staff, MOMA*
CARTER, ROBERT, *staff, MOMA*
CASTELLI, LEO, *dealer*
CATLIN, STANTON L., *dealer*

CHAPIN, ALDUS, *director/trustee, Corcoran Gallery of Art*
CHRISTENSEN, DAN, *artist*
CIVIL SERVICE COMMISSION, *staff*
COLIN, RALPH F., *attorney, trustee*
CONSTABLE, ROSALIND, *critic*
COPLANS, JOHN, *curator, critic*
COWAN, RICHARD, *director, Natural History Museum, Smithsonian*
COWLES, CHARLES, *publisher, Artforum*
COWLES, GARDNER, *trustee*
CRIMMINS, JAMES C., *former chairman Junior Council, MOMA*
CROSS, DORIS, *staff, Jewish Museum*
CURTIS, CHARLOTTE, *reporter, The New York Times*
D'AMECOURT, JOHN, *staff, House Subcommittee on Library and Memorials*
DAVIS, MARY M., *vice-president, Kress Collection*
DENNIS, JESSE MCNAB, *curator, Metropolitan*
DEWEY, KEN, *artist*
DIAMOND, WILLIAM, *planning board #8, New York City*
DILLON, C. DOUGLAS, *trustee*
DONARSKI, RAY, *artist*
DONOHUE, KENNETH, *director, Los Angeles Co. Museum*
DOSKOW, AMBROSE, *Art Dealers' Association*
DOUGHERTY, FRAZER, *artist*
DOYLE, TOM, *artist*
DREXLER, ARTHUR, *curator, MOMA*
DURK, DAVID, *former dealer*
EASTMAN, LEE, *attorney*
EDELMAN, ROBERT, *architect*
EGAN, CHARLES, *dealer*
EMMERICH, ANDRÉ, *dealer*
ERPF, ARMAND, *trustee*
FARMON, *A WC*
FEIGAN, RICHARD, *dealer*
FELD, STUART P., *dealer*
FERBER, HERBERT, *artist*
FISCHER, HENRY, *curator, Metropolitan*
FISHER, CLARE, *curator, Chase Manhattan Bank*
FOUCARD, XAVIER, *dealer*
FRANK, DICK, *A WC*
FRANKENTHALER, HELEN, *artist*
FREEMAN, PHYLLIS, *writer*

FRIEDMAN, DORIS, *New York City Parks Department, Cultural Affairs*
FRIZZELLE, JACK, *staff, Metropolitan*
FRY, EDWARD, *curator, Solomon R. Guggenheim Museum*
GELDZAHLER, HENRY, *curator, Metropolitan*
GELLER, STANLEY, *attorney*
GETLEIN, FRANK, *critic*
GILL, BRENDAN, *critic*
GILMAN, MAX, *dealer*
GILPATRIC, ROSWELL, *trustee*
GLUECK, GRACE, *reporter, The New York Times*
GOLDWATER, ROBERT, *critic, director, Museum of Primitive Art*
GORDON, JULIETTE, *AWC*
GORDON, IRENE, *staff, MOMA*
GORMLEY, DONALD, *executive secretary, Art Commission*
GOTTLIEB, ADOLPH, *artist*
GOTTSCHALK, MR. AND MRS. ROBERT
GRAFF, MILDRED, *writer, horticulturist*
GREEN, ROBIN, *staff, Guggenheim*
GREENBERG, CLEMENT, *critic*
GREITZER, CAROL, *New York City councilwoman*
GROSS, ALEX, *AWC*
GUTH, PAUL, *attorney*
HAMMER, JOLIE, *staff, New York City Council President's Office*
HARITHOS, JAMES, *former director, Corcoran*
HARRIS, SAM, *attorney*
HARRISON, RICHARDSON, *cartographer, conservationist*
HAWKINS, ASHTON, *staff, Metropolitan*
HECKSCHER, AUGUST, *Commissioner, N.Y.C. Parks, Recreation and Cultural Affairs Administration*
HENDRICKS, JON, *artist*
HESS, THOMAS, *critic, editor*
HIGHET, KEITH, *attorney*
HIGHTOWER, JOHN, *director, MOMA*
HILLES, SUSAN, *collector*
HIRSHHORN, JOSEPH, *collector*
HOOPES, DONALDSON, *curator, The Brooklyn Museum*
HOPPS, WALTER, *director, Corcoran*
HOROWITZ, MICHAEL, *attorney*
HOVING, THOMAS P. F., *director, Metropolitan*
ISLEY, DARRYL, *curator to Norton Simon*
JANIS, SIDNEY, *dealer*
JOHNSON, PHILIP, *trustee*

JOHNSON, POPPY, *A WC*
JONES, MR. AND MRS. WILLIAM, *collectors*
KAPLAN, MRS. JACOB, *collector*
KARP, IVAN, *dealer*
KARPINSKI, CAROLINE, *staff, Metropolitan*
KEMPTON, MURRAY, *writer*
KENDE, HERBERT A., *dealer*
KERTESS, KLAUS, *dealer*
KOOTZ, SAM, *dealer*
KRAMER, HILTON, *critic*
KRIMGOLD, ARLENE, *staff, Smithsonian*
LARABEE, ERIC, *Executive Director, New York State Council on the Arts*
LASSITER, BARBARA, *collector*
LAVARTY, FRANK, *artist's agent*
LAWSON, TED, *staff, American Association of Museums*
LEPERCQ, PAUL, *businessman*
LERNER, ABRAM, *curator to Hirshhorn*
LEIBOWITZ, IRWIN, *New York State Attorney General's Office*
LIBERMAN, ALEXANDER, *artist*
LINDSAY, G. CARROLL, *staff, New York State Museum*
LIPPARD, LUCY, *critic*
LITTLE, LISA, *staff, Museum of Primitive Art*
LLOYD, GILBERT, *dealer*
LLOYD, TOM, *artist*
LOWRY, BATES, *former director, MOMA*
LYNCH, ED, *A WC*
LUPO, CAROL, *staff, The Brooklyn Museum*
MAKLA, ROBERT M., *attorney*
MARDON, ALAN, *artist*
MARTIN, ZORA, *curator, Anacostia Neighborhood Museum*
MASON, ROBERT, *staff, Smithsonian*
MAXON, JOHN, *staff, Art Institute of Chicago*
MCCLELLAND, DONALD, *staff, Smithsonian*
MCGRATH, KYRAN, *director, AAM*
MESSER, THOMAS, *director, Guggenheim*
MILLER, RALPH, *former director, Museum of the City of New York*
MOE, HENRY ALLEN, *trustee*
MUELLER, FREDERICK, *dealer*
MYERS, JOHN B., *dealer*
NARRAMORE, ELAINE, *staff, MOMA*
NEWTON, ROBERT, *curator, Museum of Primitive Art*
NICHOLS, MARY PEROT, *writer*

NIEMAN, MARLYS, *staff, Metropolitan*
NOEL, GEORGES, *artist*
NOLAND, KENNETH, *artist*
NORDLAND, GERALD, *director, San Francisco Museum of Art*
NORTON, THOMAS, *executive vice-president, Sotheby Parke-Bernet, Inc.*
OLIVIERI, ANTHONY, *assemblyman*
ORDOVER, JERRY, *attorney*
PALEY, WILLIAM, *trustee*
PARKER, III, HARRY, *staff, Metropolitan*
PARKHURST, CHARLES, *director, Baltimore Museum of Art*
PARSONS, BETTY, *dealer*
PELL, ROBIN, *staff, National Gallery of Art*
PERLMUTTER, JACK, *artist*
PETLIN, IRVING, *artist*
POLLOCK, LEE KRASNER, *artist's wife*
POONS, LARRY, *artist*
POPE, JOHN A., *former director, Freer Gallery of Art*
POST, HERSHEL, *junior executive director, Parks Council*
POWERS, PETER G., *staff, Smithsonian*
PRICE, STANLEY, *New York State Attorney General's Office*
QUINN, JOHN, *AWC*
REED, HELEN SCOTT TOWNSEND, *collector*
REICHEN, LAUREN, *AWC*
REIS, BERNARD, *accountant*
RICHARDSON, CAROLINE, *staff, Metropolitan*
RICHARDSON, JOHN, *staff, Christie's*
RINGOLD, FAITH, *artist*
RIPLEY, II, S. DILLON, *secretary, Smithsonian*
ROBBINS, DANNY, *director, art museum, Rhode Island School of Design*
ROBBINS, ELIZABETH, *staff, Parke-Bernet*
ROBBINS, WARREN, *director, Museum of African Art*
ROCHE, KEVIN, *architect*
ROCKEFELLER, DAVID, *trustee*
RORIMER, MRS. JAMES, *wife of former director, Metropolitan*
ROSE, BARBARA, *critic*
ROSEN, MARC, *staff, Parke-Bernet*
ROSENBERG, ALEXANDRE, *dealer*
ROSENBERG, HAROLD, *critic*
ROSENBLATT, ARTHUR, *staff, Metropolitan*
ROSENQUIST, JAMES, *artist*
ROSS, JERROLD, *Planning Board #2*
ROTHMAN, JOSEPH, *New York State Attorney General's Office*

ROUSSEAU, THEODORE, *staff, Metropolitan*
ROWAN, ROBERT, *collector*
ROWELL, MARGIT, *curator, Guggenheim*
RUBIN, LAWRENCE, *dealer*
RUBIN, WILLIAM, *curator, MOMA*
RUBINOW, RAYMOND, S., *trustee, Kaplan Fund*
SAARINEN, ALINE, *critic*
SAMUEL, LILIAN, *dealer*
SAMUELS, SPENCER, *dealer*
SANDLER, IRVING, *critic*
SCHLIESSER, PETER, *businessman*
SCHOENER, ALLON, *New York State Council on the Arts*
SCHUMACH, MURRAY, *reporter, The New York Times*
SCHWARTZ, BARRY, *critic*
SCOTT, DAVID, *former director, NCFA*
SEGAL, MARK, *staff, MOMA*
SELZ, PETER, *director, University Art Museum, Berkeley*
SELVIG, FORREST, *Editor, New York Graphic Society*
SHAPIRO, JOSEPH, *collector*
SHAW, ARTIE, *collector*
SHAW, ELIZABETH, *staff, MOMA*
SHULMAN, LOUIS, *budget office, New York City*
SIFF, ANDREW, *attorney*
SIMMONS, ROBERT, *formerly NCFA*
SKILES, JACQUELINE, *A WC*
SMALL, MARVIN, *collector*
SOLINGER, DAVID, *trustee*
SOLOMON, RICHARD, *associate of David Rockefeller*
SONNENBERG, BENJAMIN, *collector*
SPEIER, JAMES, *curator, Chicago Art Institute*
STEINBERG, LEO, *critic*
STEINER, MICHAEL, *artist*
STEVENS, MAY, *artist*
STONE, JOSEPH, *judge, criminal court*
SURATT, SAMUEL, *staff, Smithsonian*
TAYLOR, LISA SUTER, *director, Cooper Hewitt Museum of Decorative Art*
TERBELL, THOMAS, *director/trustee, Pasadena*
THAW, EUGENE V., *dealer*
TOCHE, JEAN, *A WC*
TORREY, MARJORIE, *staff, International Foundation for Art Research*
TOURTELLOT, ARTHUR BERNON, *associate of William Paley, CBS*
TRUMAN, JOCK, *dealer*

TUCK, EDWARD HALLAM, *attorney, former president, Parks Council*
TUCKMAN, MAURICE, *curator, Los Angeles Co. Museum*
UHT, CAROL, *curator to Nelson Rockefeller*
UNTEMEYER, JUDGE IRWIN, *trustee*
VON BOTHMAR, DIETRICH, *curator, Metropolitan*
VASS, GENE, *artist*
VASS, JOAN, *editor*
VISSON, VLADIMIR, *dealer*
VON ZIEGESAR, MRS. CHENEY, *collector*
WAITZKIN, STELLA, *AWC*
WALKER, JOHN, *former director, National Gallery of Art*
WARDWELL, ALAN, *curator, Chicago Art Institute*
WARWICK, KATHERINE, *staff, National Gallery*
WASHBURN, MARTIN, *critic*
WASHBURN, WILCOMB, *curator, Smithsonian*
WEBER, IDELLE, *artist*
WEIL, STEVEN, *staff, Whitney Museum of Art*
WEINER, DORIS, *dealer*
WEITZMAN, JERRY, *staff, New York State Council on the Arts*
WESTBY, LAURA, *artist*
WHITE, NORVAL, *advisory committee, Municipal Art Society*
WHITTEN, LES, *reporter, Jack Anderson's office*
WISE, HOWARD, *dealer*
WITTENBORN, GEORGE, *publisher*
WOOD, JAMES, *curator, formerly Metropolitan*
WYETH, JAMES, *artist*
ZAPKUS, KESTUTIS, *AWC*
ZION, ROBERT, *member, Art Commission*

Suggestions for Further Reading

BALZELL, DIGBY. *The Protestant Establishment: Aristocracy and Class in America.* New York: Random House Inc., 1964.

BARR, ALFRED. *What Is Modern Painting?* 5th ed., rev. New York: The Museum of Modern Art, 1956.

BEHRMAN, S. N. *Duveen.* New York: Vintage Books, 1952.

BROOKS, JOHN. "Why Fight It?" (Profile of Sidney Janis). *The New Yorker*, November 12, 1960, p. 59.

CANADAY, JOHN. *Mainstreams of Modern Art.* New York: Simon & Schuster, Inc., 1959.

————. *The Embattled Critic: Views on Modern Art.* New York: Farrar, Straus & Giroux, Inc. 1962.

"The Canaday Affair" (Talk of the Town column). *The New Yorker,* January 4, 1964, p. 20.

CAUMAN, SAMUEL. *Living Museum: Experiences of an Art Historian and Museum Director—Alexander Dorner.* New York: New York University Press, 1958.

CLARK, PETER B. "The Chicago Big Businessman as a Civic Leader." Ph.D. thesis, Department of Political Science, University of Chicago, 1959.

COOPER, D. *Great Family Collections.* New York: The Macmillan Company, 1965.

CUBANNE, PIERRE. *Great Collectors.* New York: Farrar, Straus & Giroux, Inc., 1963.

DORNER, ALEXANDER. *The Way Beyond Art.* New York: New York University Press, 1958.

ESTEROW, MILTON. *The Art Stealers.* New York: The Macmillan Company, 1966.

GIMPEL, JEAN. *The Cult of Art, Against Art and Artists.* New York: Stein & Day Publishers, 1969.

GIMPEL, RENÉ. *Diary of an Art Dealer.* Translated by John Rosenberg. New York: Farrar, Straus & Giroux, 1966.

GOODRICH, LLOYD and JOHN; BAUER, I. H. *American Art of Our Century.* New York: Praeger Publishers, Inc., 1961.

GREENBERG, CLEMENT. *Art and Culture.* (Critical Essays). Boston: Beacon Press, 1961.

HODGINS, ERIC, and LESLEY, PARKER. "The Great International Art Market." *Fortune,* December 1955, p. 118, and January 1956, p. 122.

IRVING, CLIFFORD. *Fake. The Story of Elmyr de Hory, the Greatest Forger of Our Time.* New York: McGraw-Hill Book Company, 1969.

KILBRACKEN, LORD. *Van Meergeren, Master Forger.* New York: Charles Scribner's Sons, 1968.

KURZ, OTTO. *Fakes: Archeological Materials, Paintings, Prints, Glass, Metal Works, Ceramics, Furniture, Tapestries.* New York, Dover Publications, Inc., 1967.

LORIA, JEFFREY H. *Collecting Original Art.* New York and London: Harper & Row, 1965.

MacDONALD, DWIGHT. "Action on West Fifty-Third Street" (Profiles of Alfred Barr and the Museum of Modern Art). *The New Yorker.* December 12, 1953, p. 49, and December 19, 1953, p. 35.

MCDARRAH, FRED. *The Artists' World in Pictures.* New York: E. P. Dutton & Co. Inc., 1961.

MYERS, D. H. "The Thursday Evening Art World; The Alfred Weary Lectures." Transcribed and introduced by D. H. Myers. New York: The McCall Publishing Co., 1970.

POINDEXTER, JOSEPH. "What You Should Know About Art and Taxes." *Auction* magazine, October 1970, p. 30.

READ, HERBERT. *Grass Roots of Art.* New York: Meridian Books, 1961.

REITLINGER, GERALD. *The Economics of Taste: The Rise and Fall of Picture Prices 1760–1960.* London: Barrie & Rock, Ltd., 1961.

ROSENBERG, HAROLD. *The Anxious Object: Art Today and Its Audience.* New York: Horizon Press, 1969.

RUSH, RICHARD. *Art As an Investment.* New York: Bonanza Books, 1961.

SAARINEN, ALINE. *The Proud Possessors.* New York: Random House, Inc., 1958.

SALINE, CAROL. "Will the Real Picasso Stand Up? (Are You Collecting Prints or Are You Collecting Fakes?)" *Philadelphia* magazine. December, 1970, p. 63.

SAVAGE, GEORGE. *Forgeries, Fakes and Reproductions.* New York: Praeger Publishers, Inc., 1964.

TOMARS, ADOLF. "The Sociology of Art." Ph.D. thesis, Columbia University, 1941.

TAYLOR, J. R., and BROOKE, BRIAN. *The Art Dealers.* New York: Charles Scribner's Sons, 1969.

TOMKINS, CALVIN. *Merchants and Masterpieces: The Story of the Metropolitan Museum of Art.* New York: E. P. Dutton & Co., Inc., 1970.

———. "Profile of Henry Geldzehler." *The New Yorker,* November 6, 1971, p. 58.

TOWNER, WESLEY. *The Elegant Autioneers.* New York: Hill & Wang, 1970.

VOLLARD, AMBROISE. *Recollections of a Picture Dealer.* New York: Dover Publications, Inc., 1967.

WRAIGHT, ROBERT. *The Art Game.* New York: Simon & Schuster, Inc., 1966.

Index

A

H